The Eye

teNeues

Fotografiska

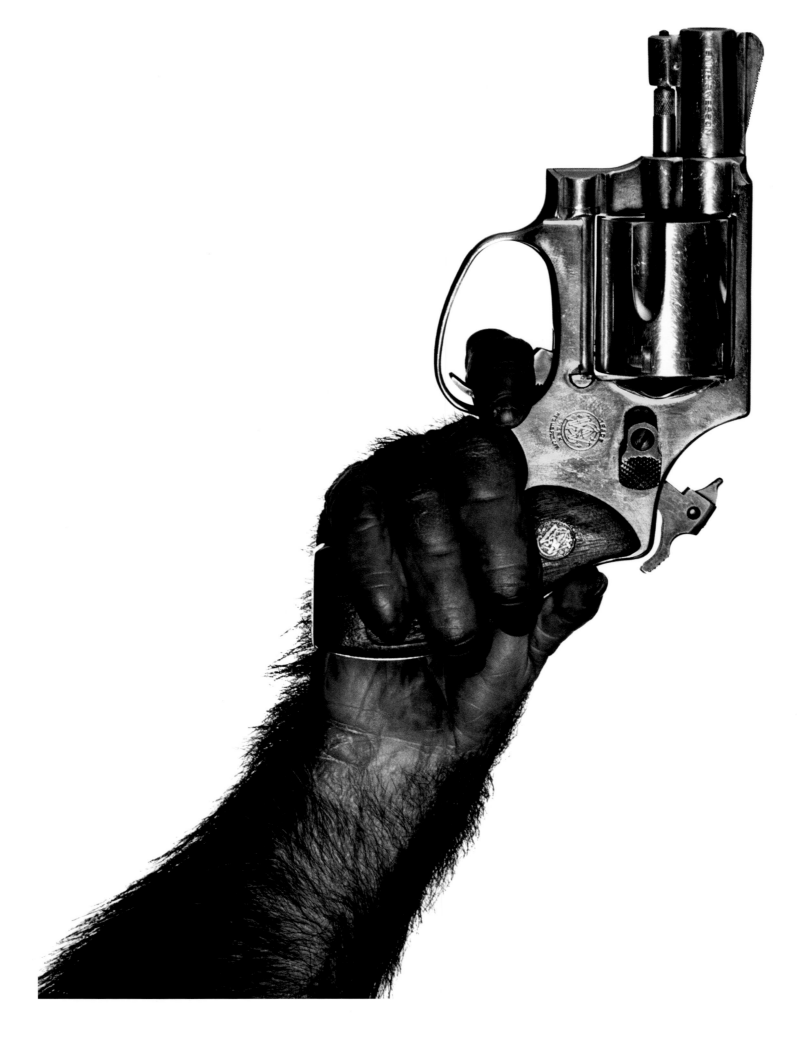

ALBERT WATSON

Monkey with Gun, New York City, 1992

The Power of Photography

BY ALBERT WATSON

The secret of photography is hidden in its communicative power. It can show every aspect of the human condition. It can show a mountain, it can show a bird. It can show the face of a laughing baby. It freezes time. And in the modern world, photography is now truly for everybody.

Non-photographers can now take high-quality photographs with a click on their smartphones. In the past, and definitely when I first picked up a box Brownie camera in the 1950s, photography was somewhat mysterious to the average person. What was an f-stop? What was the best situation for a 50mm lens?

This veil of mystery has now been lifted, and a smartphone is available to everyone. Within seconds, their photos can be sent instantaneously around the world. The power of photography has never been greater.

However, not everyone is a master of photography just because they can snap thousands of photographs with a device that fits in their pockets, so the power varies. Give me an electric guitar, and I'll never be Jimi Hendrix.

So, what makes a great photograph? For me, as in much of art, it is simply memorability. The image can be minimal but still incredibly powerful, as in a breathtaking seascape by Hiroshi Sugimoto. Or the image can be very complex and graphically challenging, as in the many amazing photos of Henri Cartier-Bresson. I also strive for memorability in my own photography, such as "Monkey with Gun, New York City, 1992." The photo is stark in its simple, minimalist approach, but also graphically powerful. It is also conceptual, so the viewer can approach it on many different levels.

Sometimes the photographer is just intent on recording world events, but the image can turn into art. The power in the 1968 photograph by Associated Press photographer Eddie Adams of the execution of a Viet Cong soldier is a chilling example of the power of photography. As Adams once said, "Still photographs are the most powerful weapons in the world."

In the beginning, photographers were seemingly tied to following techniques used by portrait painters. But later, as cameras became smaller and more portable, this changed and soon the entire world became available. Anything was possible.

Another aspect of photography that has always fascinated me is what happens to the image afterward: the print. This can be as powerful and as important as the photograph itself, especially in a museum or gallery setting.

There was a moment of complete amazement when I saw for the first time, in the amber light of a darkroom, a photograph that I had taken only the day before appear on a piece of white paper. Pure magic!

I have always maintained that the photographer who takes the photo should see it through to the print itself, whether it's in an old-fashioned wet darkroom, or nowadays in front of a computer before making a digital print. The variables are too great to allow another person to interpret the image and make a print of a photograph taken by someone else.

Unlike when I first started making gelatin silver prints in the 1960s, the computer adds another level of control to the final image. In the right hands, the computer can give even more artistic results, as long as that original photograph is memorable, of course.

Whether it's a mother's iPhone snapshot of her daughter, or a sophisticated portrait by master photographer Irving Penn, the power is there.

ALBERT WATSON
Photographer

THRON ULLBERG

Giganten, 2012

True Bromans

BY JAN BROMAN AND PER BROMAN

From a very early age we were intrigued by the magic language of photography. Our father was a printer at the leading newspaper in Sweden. He was passionate about his work. Not just about the final image, but the whole process, from idea to eye to shutter to the perfect print. Through his stories around the dinner table we followed the leading photographers on assignment. Celebrities they met, wars they covered, the beauty they captured, the truth they revealed. To us photography was neither art nor news; it was both. There was nothing fancy, exclusive, strange, or difficult about photography, it was natural to us. We talked about images at home. There were prints laying around on the kitchen table, cameras to pick up and fire away. But of course, when we were young, film had to be processed before you could see the image. In our case that was not a big deal. There was a darkroom in the basement. And a father who could make the perfect print.

Many years later we are still sitting together at a table full of prints, now as grown-up men, drinking coffee instead of hot chocolate. Our father has passed away but his stories and legacy remain our main inspiration. The prints on the table are signed by names like Moon and Mann, Corbijn, Speers, LaChapelle, and Watson. And we are sitting in the office of the house we created dedicated to photography. The road from one table to another, from our early experiments in the darkroom till today's travels between Fotografiska in Stockholm, New York, and London, have been a wonderful but bumpy voyage.

If the passion was fueled in our childhood, the idea of showing photography to the masses came decades later in 2008. We had been working with fairs and smaller exhibitions when we decided to put all our faith and money and what little prestige we had into a giant exhibition in a conference hall outside Stockholm. Maybe we hesitated a little when we had booked the giant space, and stood there looking at each other and the empty walls, the fluorescent lights fluttering a little hollow, wondering if any people would show up.

A few months later, the walls of the hall were full of the most colorful photography you can imagine. David LaChapelles commenting on contemporary society in bubblegum colors, Tivoli style. People from all over Stockholm traveled to the awkward address, and the newspapers were reporting that the event was the talk of the town. From that moment we were sure that this would work on a larger scale and we started to plan a permanent space for photography—a museum that would be privately owned without any governmental support.

With nothing more than a bold idea we started to look for investors, and we ran head-on into the recession of 2008. To invest in a museum was not exactly what venture capital had in mind at the time. After wrecking our knuckles on too many closed doors we turned to the core of the idea instead: the photography. We knew that if we could show that we were backed by the giants of photography that the money would come. There was one minor problem, though: after investing all our money in the LaChapelle exhibition we were broke. We scanned the Internet for the cheapest plane tickets to the major cities of the world. Then we started to book meetings. Nobody knew who we were. Two brothers from Sweden wanting to open a museum. Everybody was not thrilled. A lot of e-mails and calls remained unanswered when we took off. But we went anyway, to Paris, to Berlin, to New York and started knocking on doors of galleries, institutions, and famous photographers. Some of whom actually let us in and a few who even extended a handshake.

If the timing was bad with the investors we had another momentum working for us—the age of the image. In the last decade photography has been revolutionizing our society as a result of the symbiosis between social media and the smartphone. Images have emerged as the most important means of communication, dominating the interaction between humans, more powerful than writing or speech. In hindsight, we are sure that our time will be compared to the breakthrough of the written word by Gutenberg, not as a technical feat but as an example of what can happen when potent tools of communication become easy to share. It happened to words 600 years ago. It is happening to photography now. Only two decades ago we were rolling film into our expensive camera bodies in order to make an image. Very few of us had a father processing our artistic attempts; to most it was a difficult and expensive task. And we had to gather relatives to show the result. Today, anybody can shoot endless amounts of photographs and show them to the world in an instant. It has made photography a concern of the masses.

Regardless of the technical revolution the fundamental quality of images has always been there, this straight line to our emotions. Pictures have been the most intriguing content ever since some caveman with an artistic stroke forced his image onto a rock. Technology did not change that. It only made it possible for everybody to interact on, let's say, an imaginary level. And it raised awareness of photography. It democratized the image. Which is exactly what Fotografiska is about.

To us the democratic quality is very important. We will never be, want to be, or be able to be a place for the elite. Our whole mission is to bring color to the world, even if it's in black and white. It might sound pretentious but we truly want to make a difference, we believe that photography can change perception, and by that, the world, and we want to reach as many as possible in the process. That's why we want to export Fotografiska to the world. But that's also why the house of Fotografiska is open from early morning to late evening, every day of the week, almost every day of the year. This is accessibility and democracy in the most basic, yet still important, form. Our philosophy is also reflected in the broad range of exhibitions we produce. From the very accessible, likeable if you want, to hardcore conceptual and thought-provoking. To us they are all equally important expressions of photography. We are in a way the antidote of the traditional art museum. We have a very casual approach to what is considered trendy or fine and very keen to explore what is odd, crazy, misplaced. We want to be pioneers in that regard. Questioning the traditional ways to do things, challenging the rules. We rather play by the book that is not yet written.

When we finally opened Fotografiska in 2010 we were nineteen dedicated people in the house working day and night. Now we are 135. Just before the opening we realized that we had been so focused on the exhibitions that we totally forgot that a great museum probably needs a decent café. Jan took the car to the supermarket, stuffed the trunk full of coffee and cakes, and talked our mother into managing the café during the first months. Today our restaurant is ranked the best museum restaurant in the world, which makes both us and our mom a bit proud. Nowadays we also have a professional team managing our exhibitions so that Per no longer has to spend his nights changing the lightbulbs in the exhibition halls.

Annie Leibovitz, who, together with the legendary Lennart Nilsson, had the first main exhibition at Fotografiska, told us that the world was watching. It was. But we were not worried. Maybe it would be humble to say that we took a chance, that we followed our dream no matter what, that our passion for photography made us jump into the dark just hoping that enough people would share our view. That's the way many enterprises start. And almost as many fail. But that's not true. We had a pretty good notion that somehow this would work. We had our lifelong faith in the power of photography. And most importantly, we had each other.

JAN AND PER BROMAN
Founders, Fotografiska

"Our mission is to bring color to the world, even if it's in black and white."

Photography Now

BY CATHERINE EDELMAN

The photographic image has been around for more than 190 years, influencing artists, writers, philosophers, educators, scientists, and our understanding of the world. It's documented wars, celebrations, family gatherings, weddings, births, deaths, and everything in between. Yet since its birth, photography has had to prove itself again and again as an art form, challenged by the art market, critics, and collectors. Only a half-century ago, colleagues of mine fought the good fight, trying to sell photographs by Ansel Adams, Edward Weston, and Alfred Stieglitz for $75 each and struggled to find buyers. Today, many of these works sell for six figures.

There's no definitive answer as to why photography has become such a large part of the art world, when only fifteen to twenty years ago I was still explaining its value. From makers, to sellers, to buyers, to museum collections … photography has found its seat at the table, as more and more people support the medium. It's easy to credit Cindy Sherman, Andreas Gursky, or Richard Prince, who were among the first living photographers to see their works sold at auction for $1,000,000 plus, elevating photography's importance. But I prefer to credit the rise of photography to all the galleries worldwide, whose passion for the medium outweighs profit, and who continue to exhibit and support photographic work, highlighting its unique power to communicate.

Recently, the impact on the photo market by artists who often shun the "photographer" label has become undeniable. Their influence is palpable, as more and more artists bypass traditional photographic education, using the camera as a tool without regard for expertise. But for me, the real change in the photographic market can be traced to two developments: the Internet and the cell phone. Many of us in the art world were slow to understand the Internet and its capabilities. I didn't have a website until 2002, failing to realize its educational and international reach. Today, almost 100 percent of my interactions with clients are with or through my website. The second biggest change happened in 2007, when the iPhone hit the market, convincing people that a phone was really a camera. Facebook, Snapchat, and Instagram followed, capitalizing on people's need to photograph their daily lives, sharing images with family and strangers alike.

And herein lies the current problem with photography today. Everyone thinks they are a photographer, worthy of an exhibition

and monograph. Thirty years ago we had to visit bookstores, galleries, and museums to see the latest art. Now, curators, gallerists, and collectors search Instagram, looking for the next superstar. Photographic galleries have done such a terrific job educating, exhibiting, and contextualizing photographic images that the public feels empowered, replacing connoisseurship for likes and followers. As more and more buyers enter the market, photographers need to stay honest about their intent, and true to their vision, ignoring the mega-dealer headlines that sell newspapers.

While today's technologies grant us access to a worldwide audience, I still believe there is a need to see art in its original form, in its original size, and without the clutter and deluge of online platforms. Museums, galleries, libraries, cultural centers, and even art fairs are crucial resources for understanding art. Looking at art on a smartphone or tablet is fantastic, but there is simply no substitute for the real object. In the last decade, photographers have been more obsessed with their followers than with their ideas. But recently I have started to see a change. Whether capturing the majestic glow of a sunset, family gatherings, a war zone thousands of miles away, or protests happening along Main Street, the camera has once again become a witness.

While we know photographs can lie, in today's tumultuous times I take comfort that more and more photographers are turning their cameras toward social and political issues that directly confront environmental and human rights abuses around the world. This, I believe, is why photography is so prevalent today, and why we see it embraced by the public worldwide. Photography has the rare ability to record, to bear witness, and to fictionalize real truths. This is the ultimate power of the camera, and while everyone is a photographer, not all images evoke wonder, question norms, challenge ideologies, and effect change.

CATHERINE EDELMAN
Owner Catherine Edelman Gallery, Chicago. Former President of the Association of International Photography Art Dealers

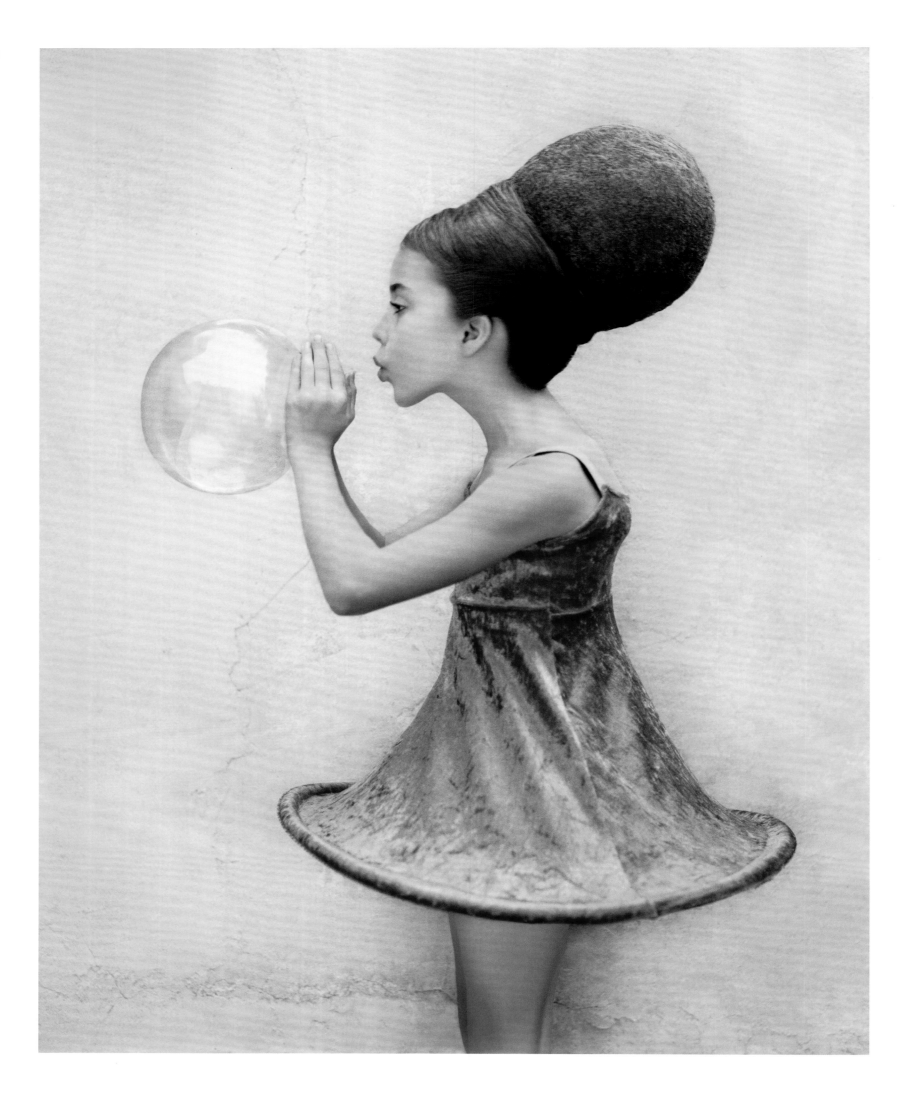

VEE SPEERS

Untitled No. 16, from the series *The Birthday Party*, 2007

Navigating the World of Images

BY VEE SPEERS

For an artist, photography can be many things. It is magic, a way to remember, or a safeguard to create a legacy. It can be for ourselves, for our family, or displayed for all to see.

Photography can capture a decisive moment, reveal the soul of our subject, or tell a powerful story. It is bold or delicate, a kaleidoscope of color or the world rendered in shades of gray. It is an idea, a chance encounter, an unexpected experience, or a vivid dream that drives us to conceive, create, and tell the story. Like an animal tracking its prey, we chase the light to fill a void.

The last decade has seen photography coming fast and furious, flooding into our daily life from all angles, filling our senses and filtering reality. As we scroll through endless images that seem to span from the mostly ordinary to the sometimes extraordinary, we are drowned in an excess of often forgettable and uninspiring repetition. In the end, there is no truth or lies, only countless images to silently gaze upon.

Photography now belongs to everyone, is free to take, and can last forever. In the beginning, it was destined to be permanent, yet today it is also the opposite—a story can be seen for just one day or disappear instantly as soon as it is viewed. We can curate our lives day by day, share it with friends, and propel it to an anonymous audience. In doing this, our desire and efforts to belong to a community are recognized, and therefore we feel we can validate our existence through posting images or sharing stories.

And yet, in a world that seems to encompass everything visual but inspires little dialogue, and where we are often immersed in a deluge of banality, Fotografiska takes us by the hand and guides us to higher grounds. It is a haven of innovation and free expression, a place to explore, discover, and sail with the rising tide of the photographic image. The museum's open spaces give room for the viewer to quietly contemplate personal impressions of unique and powerful images, from the past or present. Embracing the traditional and englobing the contemporary and conceptual, Fotografiska forges the path to educate our community and establish a renewed global connection through the power of photography.

VEE SPEERS
Photographer

Eight Years and Onwards

In July 2009 one of Sweden's largest daily newspapers wrote: "A new photo museum to open in Stockholm." With several years' work experience and studies in photography, I immediately understood that this was going to be big. A quick e-mail to Jan and Per Broman led to a meeting in the old brick building at Slussen. A couple of months later, there were four of us, the brothers included, in the building that was about to become Fotografiska. Our shoes were white with construction dust a couple of months before the opening, and I had received a permanent contract as assistant to Jan Broman. It was rather doubtful whether Jan really needed an assistant, and I was not a very good one, as I was more interested in working with exhibitions, but we shared a fundamental love of the photographic image.

Eight years after the inauguration I am still in the brick building at Slussen: today I am responsible for Fotografiska's exhibition department. With more than 140 exhibitions under our belt, it humbles me to think of the journey we have undertaken in the company of the hundreds of thousands of guests who have visited us over the years. We are often asked how we select the photographers and artists we exhibit at Fotografiska. The answer is as simple as it is elementary: we exhibit photography that affects us. Images that speak of everything from happiness to sorrow, of human beauty and complexity, the desire for community or solitude, life before birth and after death. Truth and fiction, brutal reality or staged landscapes, escapism or beauty.

In addition to the extensive planning period prior to the opening of an exhibition—the curatorial, budgetary, design, and installation work—the production can throw up various challenges. Like when I was asked to find 300 rectangular straw bales for Eleanor Coppola's installation, *Circle of Memory*, or to transform a vast white gallery to a darkened installation of Isaac Julien's *Ten Thousand Waves*, or locate a new site for Inez & Vinoodh's several hundred kilograms' heavy iron sculpture that turned out to be two centimeters too tall for the gallery. Or when David LaChapelle's exhibition *Burning Beauty*, which filled the entire building at the end of 2012, was to be uninstalled, all the galleries repainted, and three new exhibitions installed—in five days.

However, the most powerful and beautiful memories are those from our meetings with the artists and the photographers. When we sat down with Bettina Rheims in her studio and she grabbed hold of the microphone and described her life for the recording device. Elliott Erwitt's apartment in New York, Anton Corbijn's studio in The Hague, and the Walther Collection's subterranean gallery in a residential area in Neu-Ulm, Germany. Our conversations with Paul Hansen about the conflicts in the world. Ren Hang's laughter when he visited us for the opening, just a few days before he passed away. Sarah Moon's voice as she vividly described her pictorial world: "I like it when the party's over." All those who have devoted their lives to photography. When I look at the images and scenes they have created, I am constantly struck by the unique ability of photography: a small piece of frozen time.

PAULINE BENTHEDE
Exhibition Manager, Fotografiska International

A Universal Voice

Photography as a unique medium. A language with multiple layers. It can describe events, tell stories, convey emotions, and change us profoundly. It is a language we all understand and a place where we can meet.

Such a meeting place is Fotografiska, and in particular our initiative Fotografiska for Life, a forum and platform that highlights important social issues and problems, providing vulnerable people with an arena where they can make their voices heard. In exhibitions, discussion forums, and campaigns, Fotografiska for Life acts as a catalyst to disseminate knowledge and stories from all corners of the world and include people who are rarely allowed to be seen.

In the exhibition *Where the Children Sleep*, award-winning photographer Magnus Wennman followed refugees fleeing from the wars in the Middle East in 2015. He portrayed children on the run in environments where they spent their nights. It was an incredibly powerful and moving portrait of the horrors of war, from a perspective we seldom experience—that of the children. Wennman's images had such a profound impact on us that, in just two weeks, we planned, curated, and produced an exhibition that made waves internationally and has toured both Europe and the United States and has been presented at, among others, the U.N. Headquarters in New York and Capitol Hill in Washington, D.C.

To be an arena for photography means presenting the entire beautiful spectrum that is photography, from daguerreotypes to 3D-mapped video art. The fact that we embrace all facets of photography enables us to mount exhibitions and experiences that inform, inspire, and challenge. From the Old Masters' vivid depictions of life at the previous turn of the century, to how contemporary artists and creators employ the medium of photography to create new worlds and narratives, both physical and virtual. The power of photography as a visual communicator to convey knowledge and information plays an ever more important role in our digital world that has to be shared by an increasing number of people. Speed is of the essence and in the brief lifetime of a quick scroll through social media, a picture is often worth more than a thousand words.

Another of our Fotografiska for Life projects that means a lot to me is *Icons*. We created the exhibition in collaboration with the Glada Hudik Theatre and photographer Emma Svensson to provide a place where men and women with Down syndrome could be seen and heard. In a series of compelling portraits, models with Down syndrome infused life into historical and societal archetypes, based on what they dream of becoming: ballerinas, superheroes, presidents, or queens. The images were accompanied by films, stories, and the experience of living with and close to Down syndrome, showing how people with Down syndrome are treated and received in society. In conjunction with the opening of the exhibition, "Down syndrome" was the third most googled phrase in Sweden.

Photography is not just a representation or a frozen moment in time. It is a language and a tool that brings us closer to one another and provides us with a universal voice with which to communicate.

JOHAN VIKNER
Exhibition Manager, Fotografiska

Take a great image. Put it next to another. Let them talk. The paring might seem simple, funny, even banal. A matching pattern, a similar theme, a stark contrast. Look deeper. Tune into the wordless dialogue of images. Unintended beauty may arise, secrets may be revealed. It could get ugly, provocative, even obscene. Those who seek conflict will find fuel in this volume. Sexism, racism, class, gender roles, and world order will be addressed. There are photog-

raphers represented who dedicate their talent and rage to exposing injustice, others risk their life on the battlefield, some make fortunes portraying power and fame. We have the fashion phantoms, the artsy giants, and the forces of nature. Some swear by the documentary truth. Others seek truth through manipulation. They have lent us their eyes. Now you can see for yourself. Enjoy. Engage.

JOHAN LINDSKOG
Curator and Creative Director, The Eye

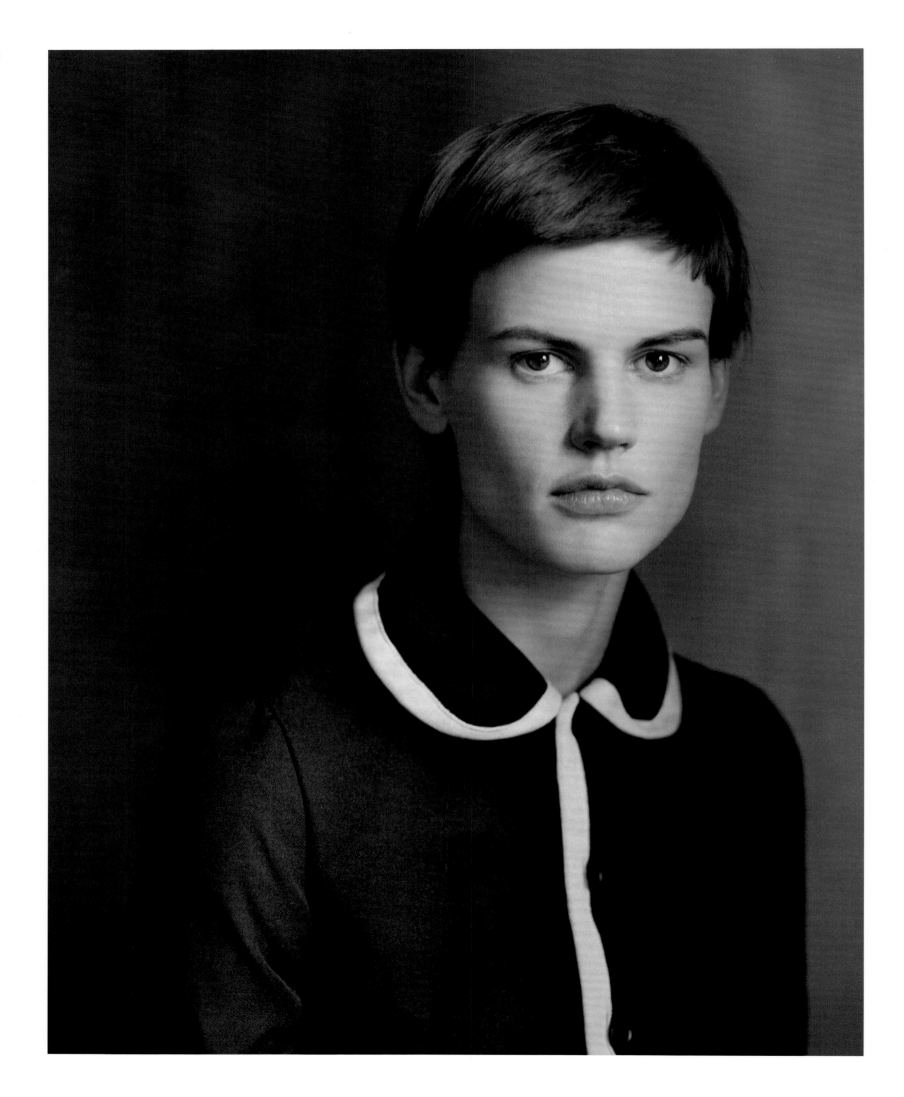

PAOLO ROVERSI

Saskia, Paris, 2013

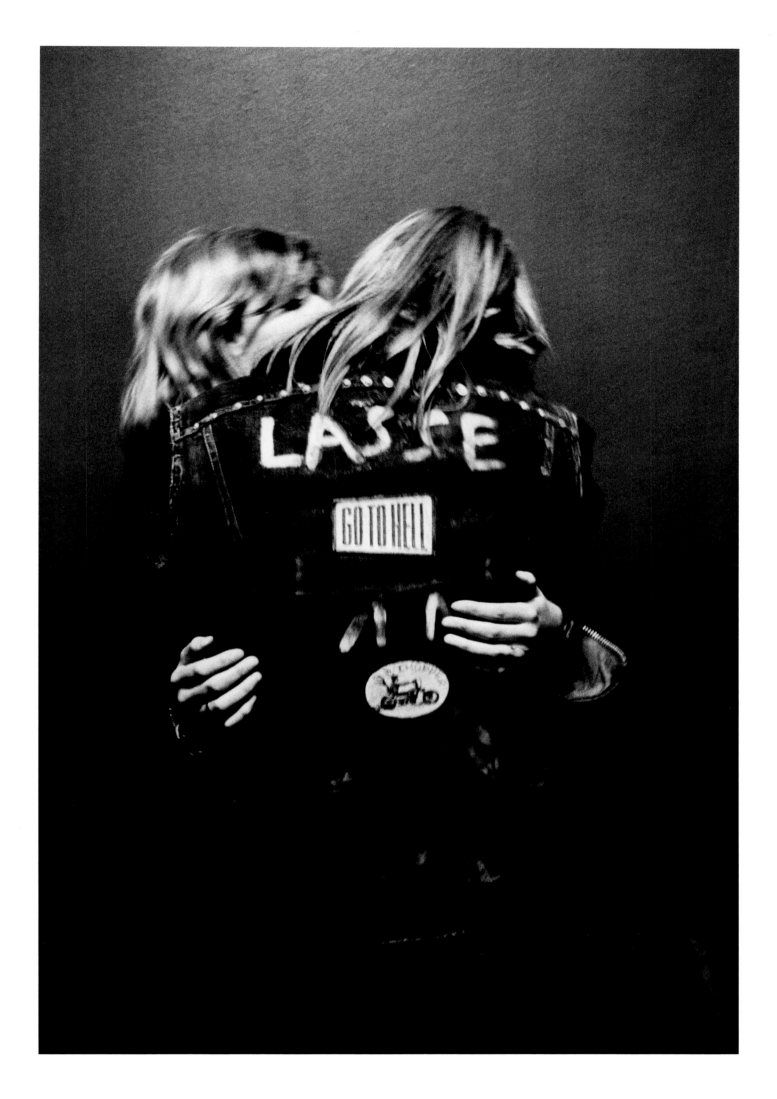

ANDERS PETERSEN

Untitled, from the series *Gröna Lund*, 1973

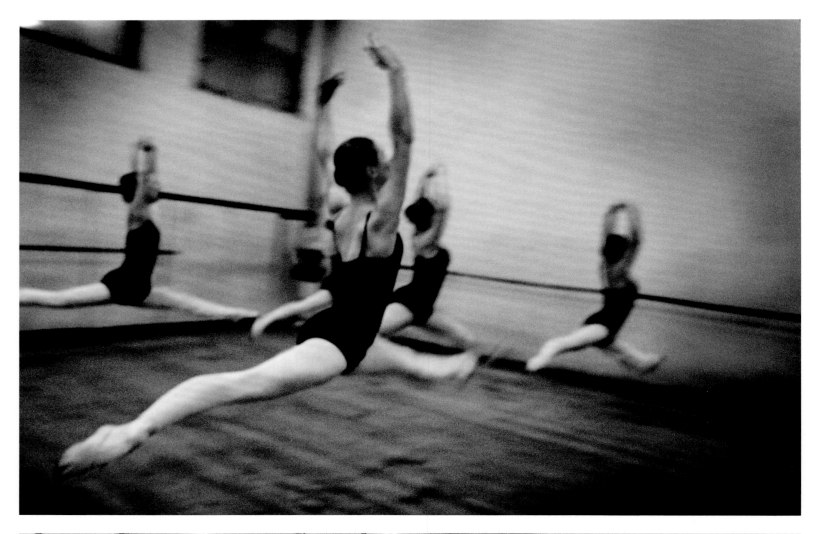

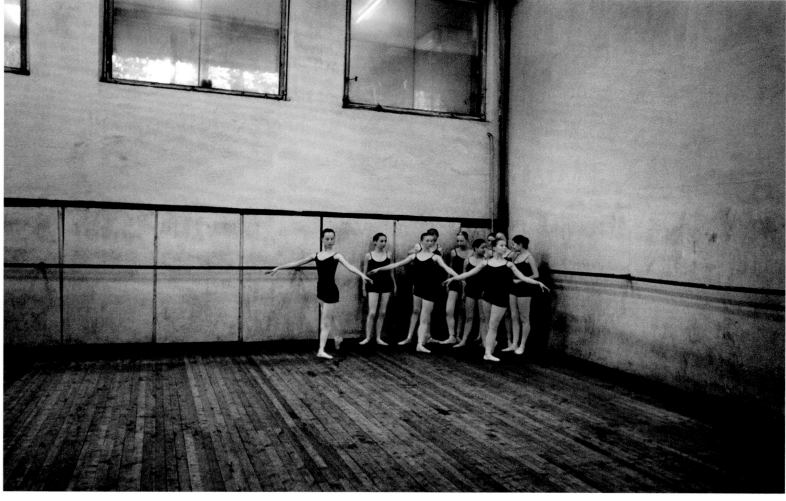

ÅSA SJÖSTRÖM
Moldova Ballet, 2005. Moldova Ballet, 2005

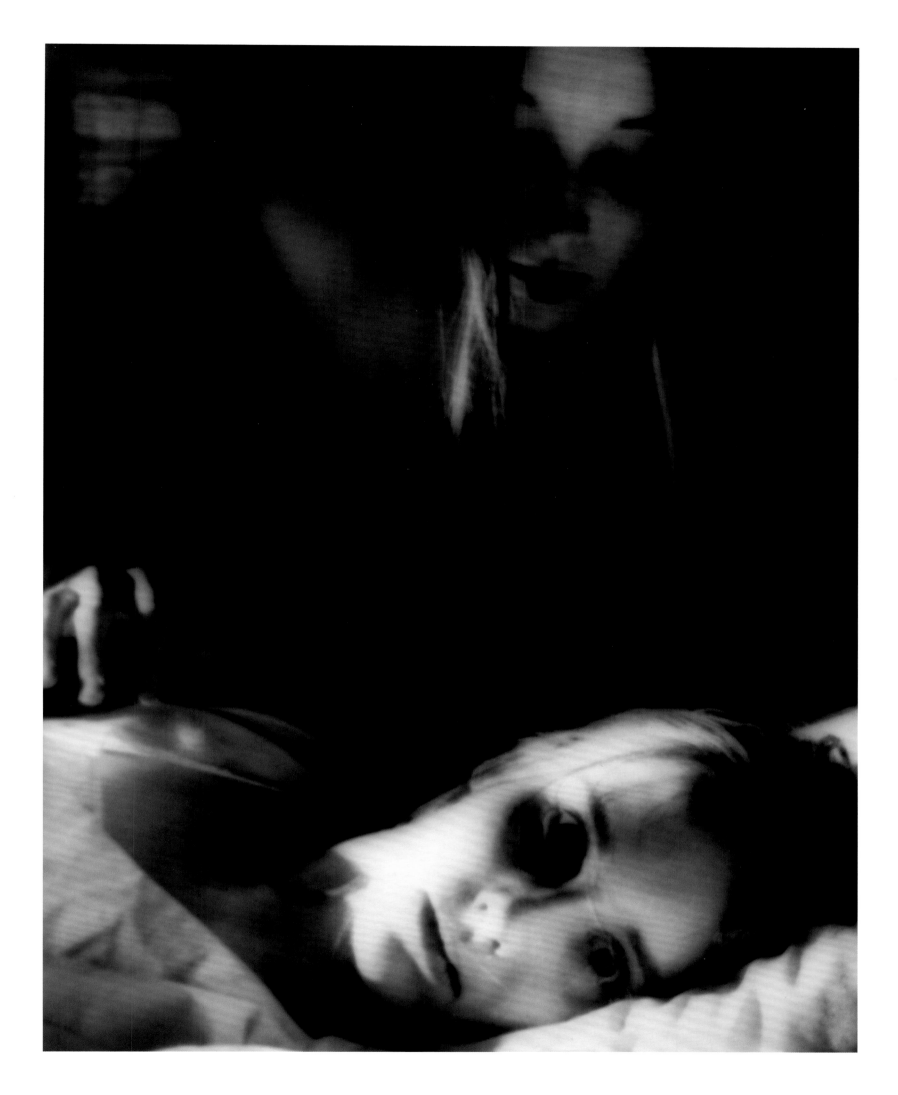

SALLY MANN

Untitled, 1971

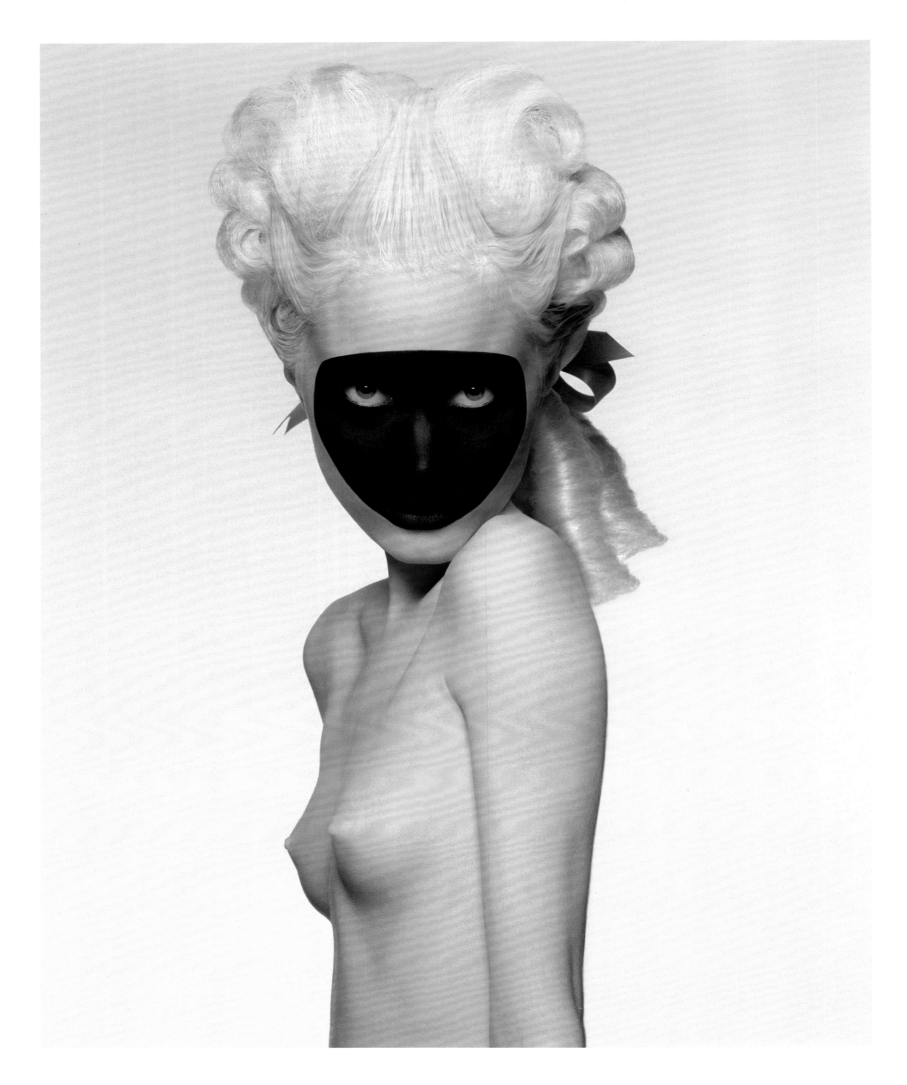

INEZ & VINOODH

Anastasia, 1994

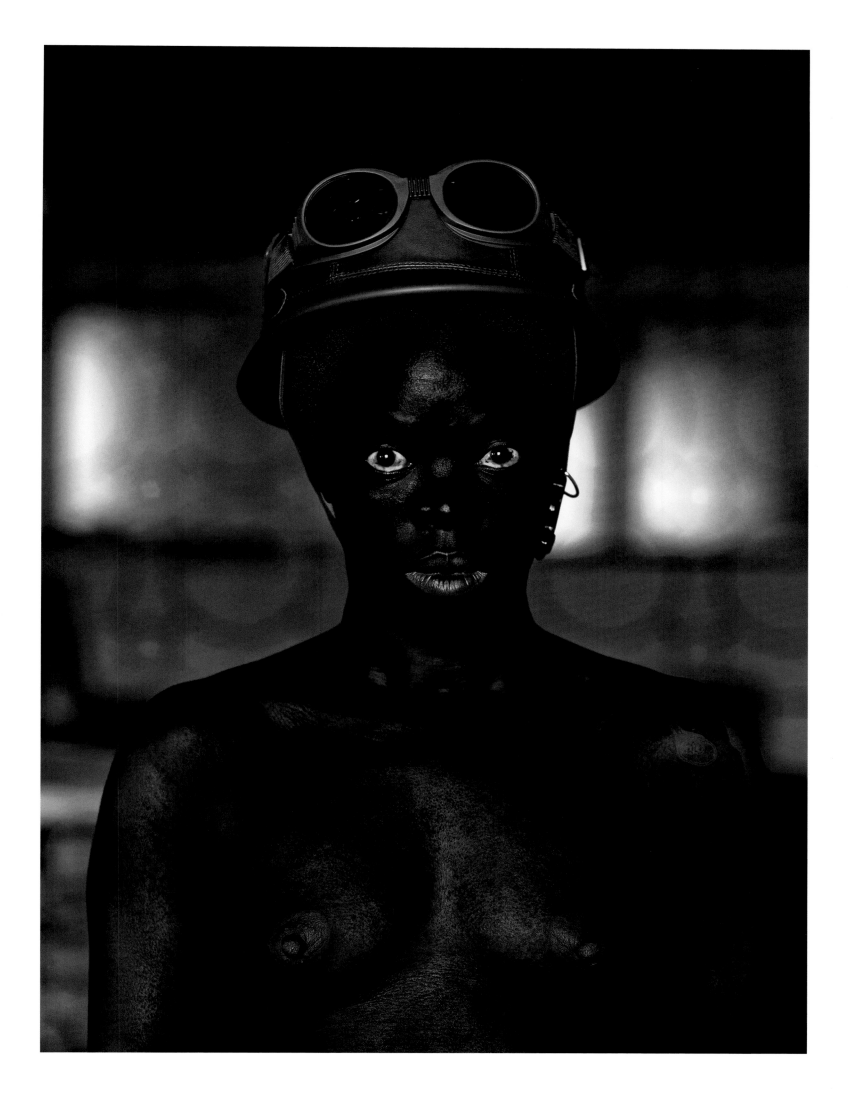

ZANELE MUHOLI
Thulani II, Parktown, 2015

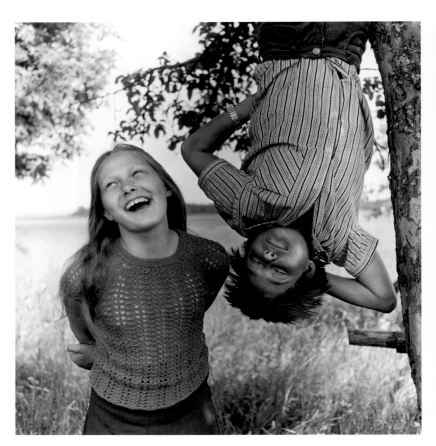
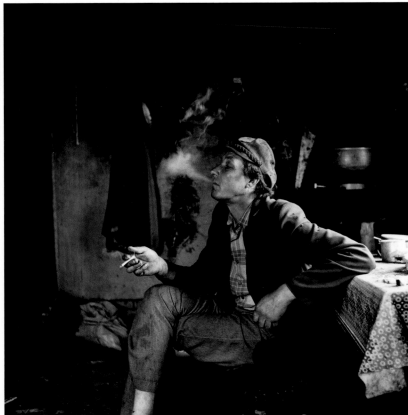
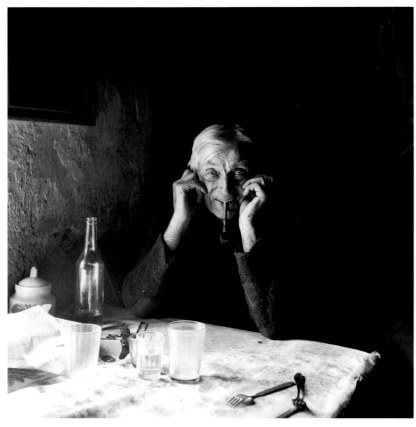
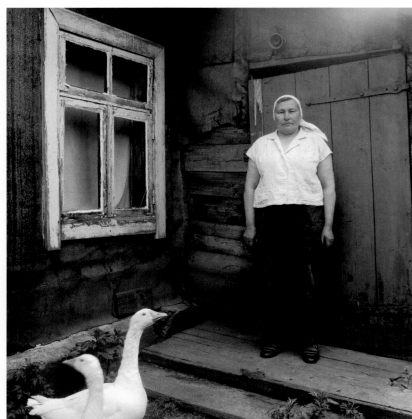

INTA RUKA

Ineta Mača, Aigars Mačs, 1985. Jānis Mačs, 1984. Donats Studers, 1984. Anna Priedeslaipa, 1987

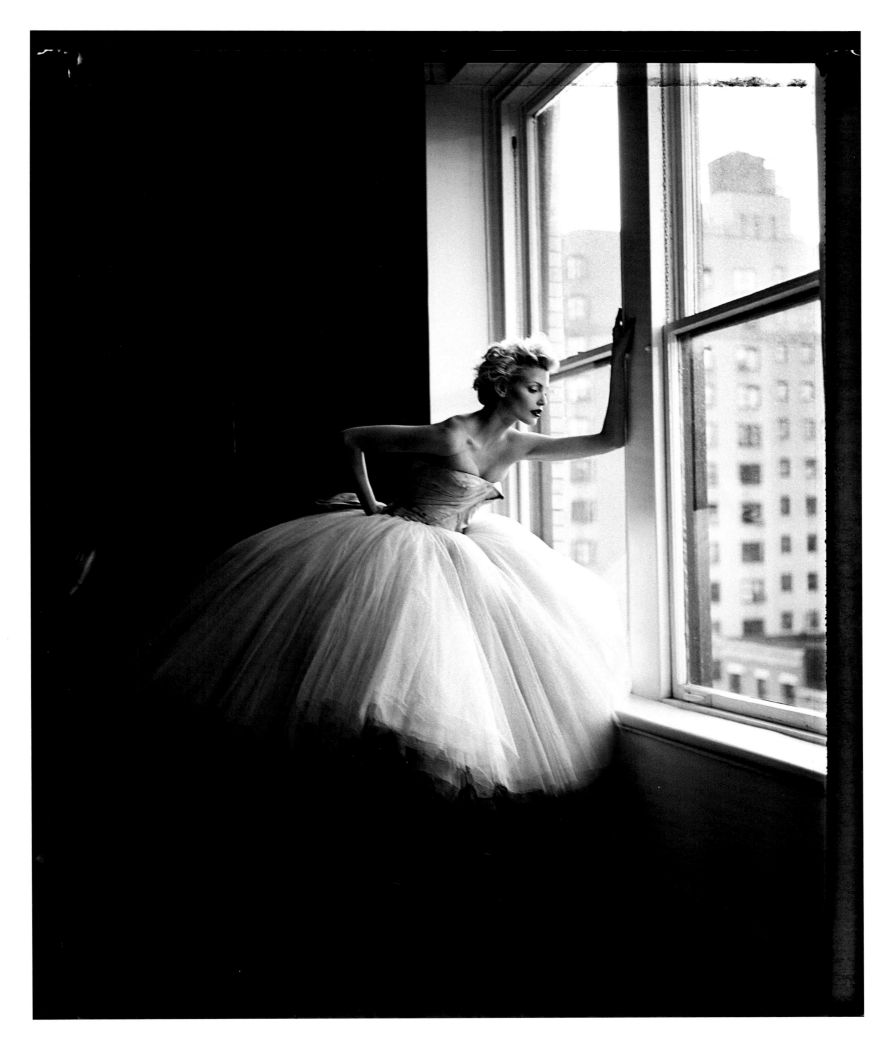

PATRICK DEMARCHELIER

Nadja Auermann, New York, 1995

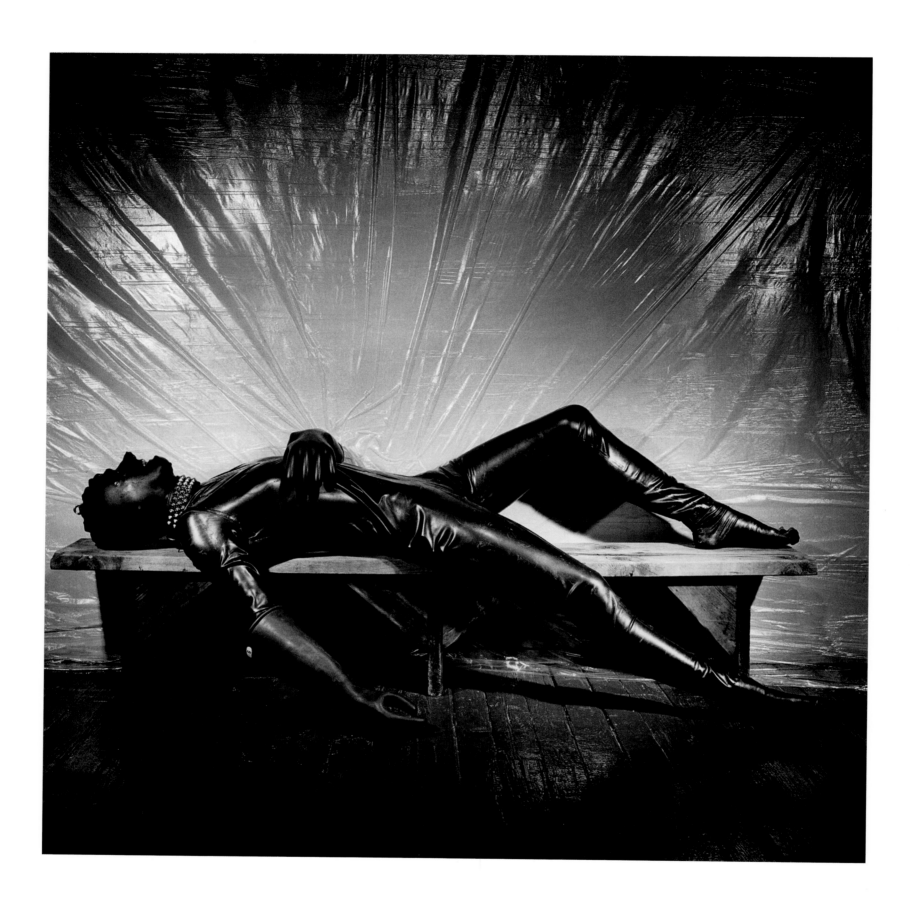

ROBERT MAPPLETHORPE

Joe/Rubberman, 1978

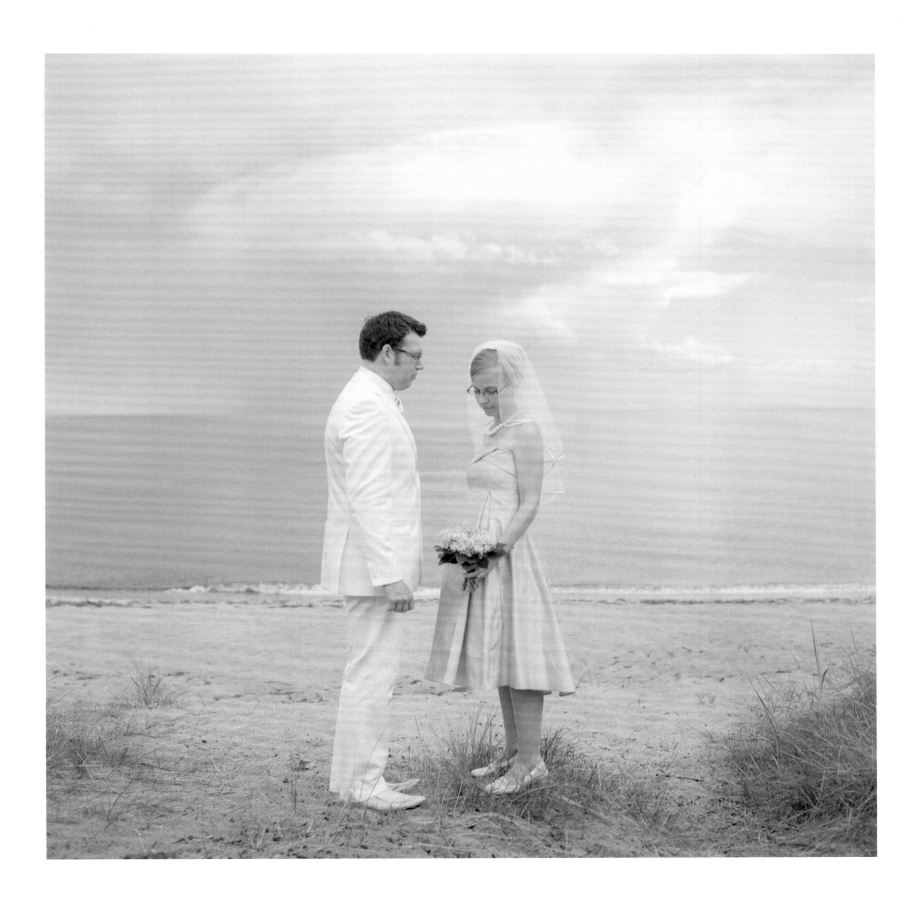

ANNA CLARÉN

From the series *Close to Home*, 2013

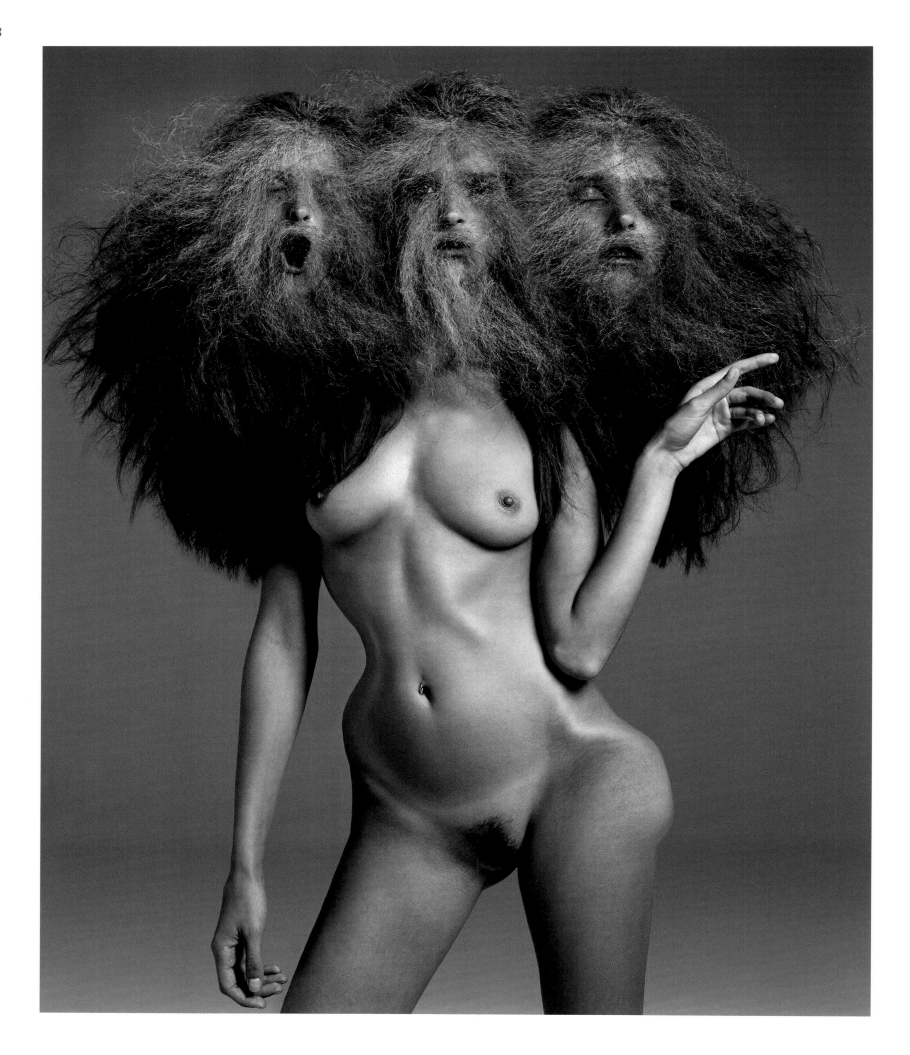

INEZ & VINOODH

Lucy Fer, *Visionaire*, 2011

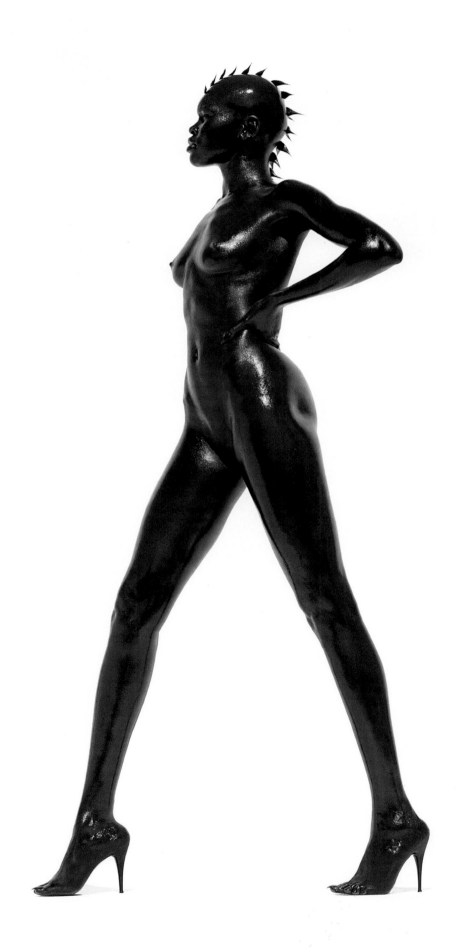

HERB RITTS

Alek Wek, Los Angeles, 1998

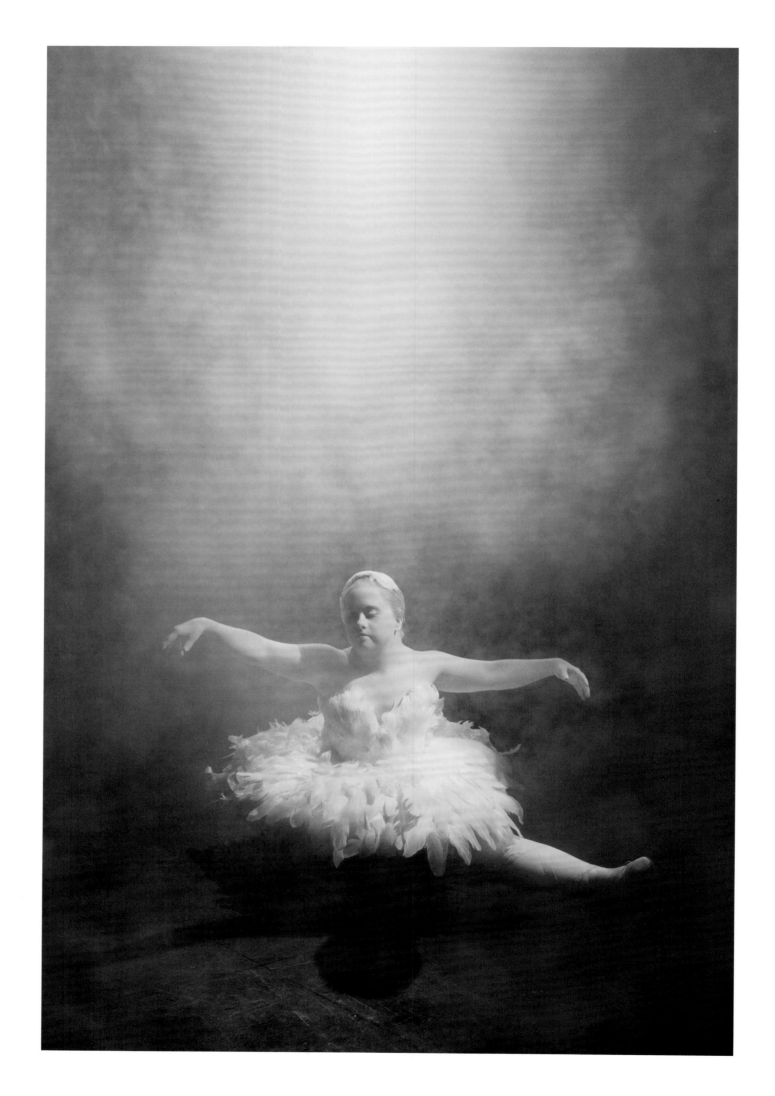

EMMA SVENSSON

Ballerina, 2016

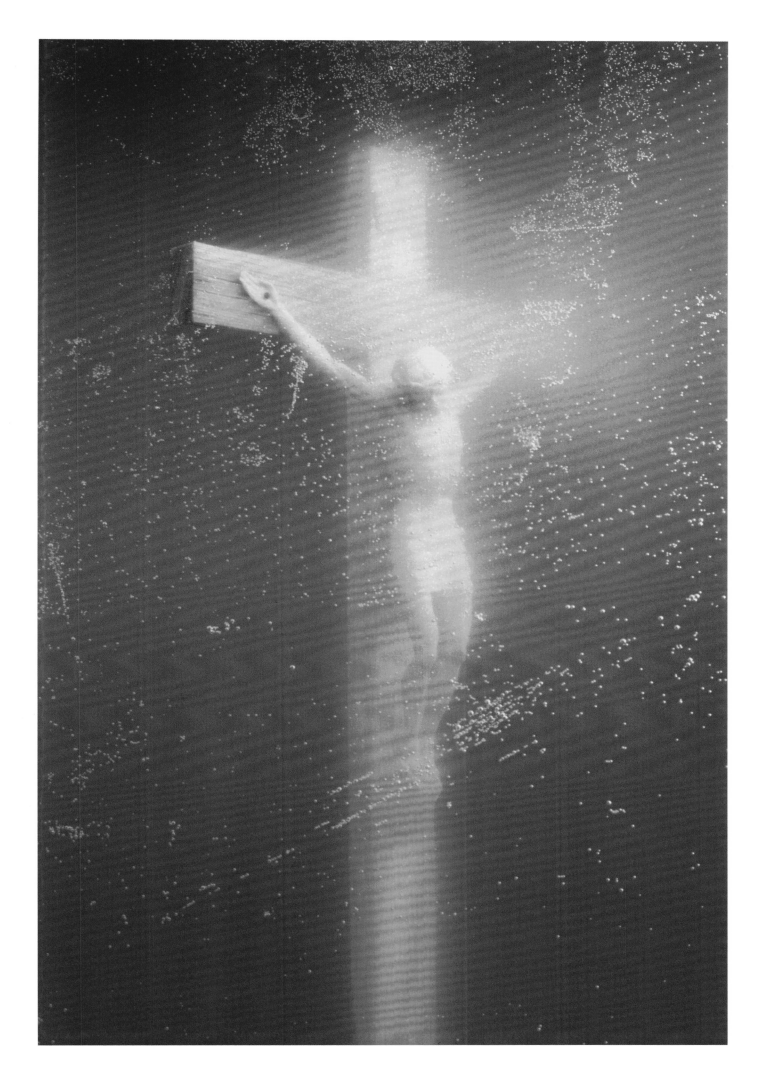

ANDRES SERRANO

Piss Christ, 1987

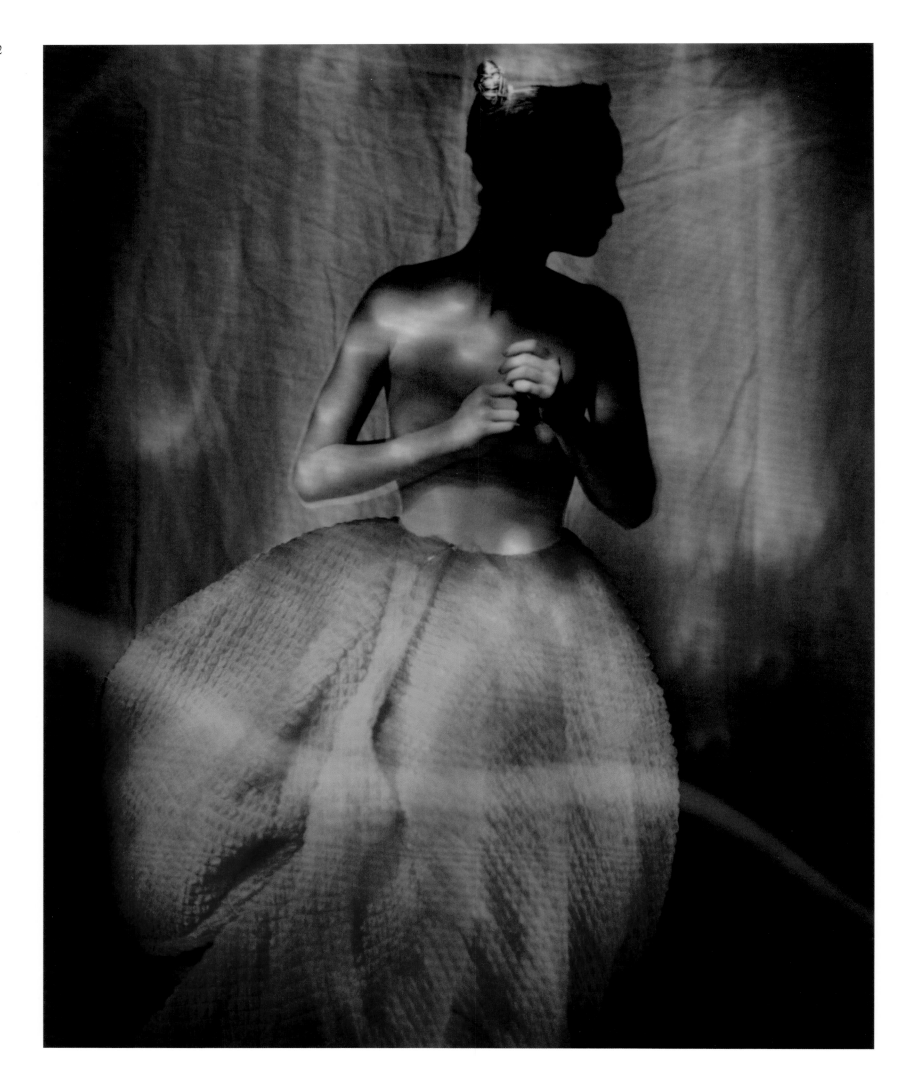

PAOLO ROVERSI

Audrey, Paris, 1996

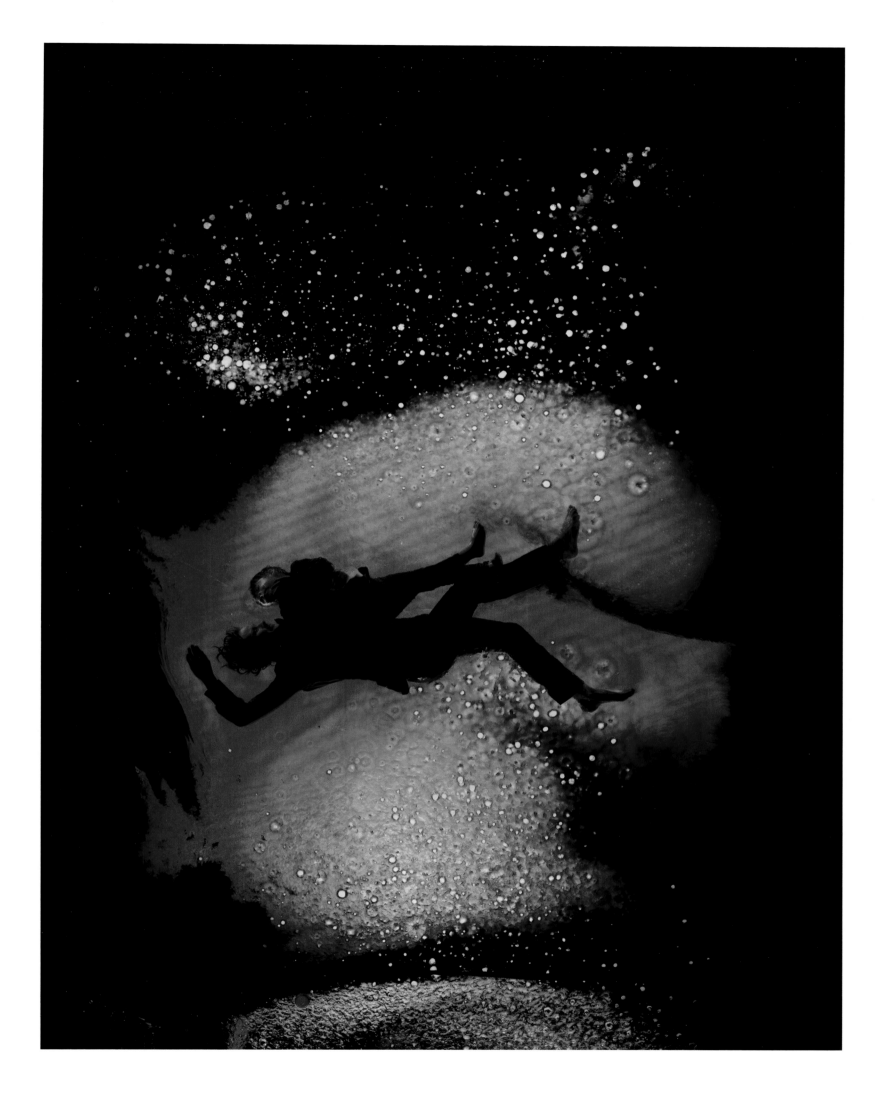

MARIA FRIBERG

Painting Series, No. 2, 2011

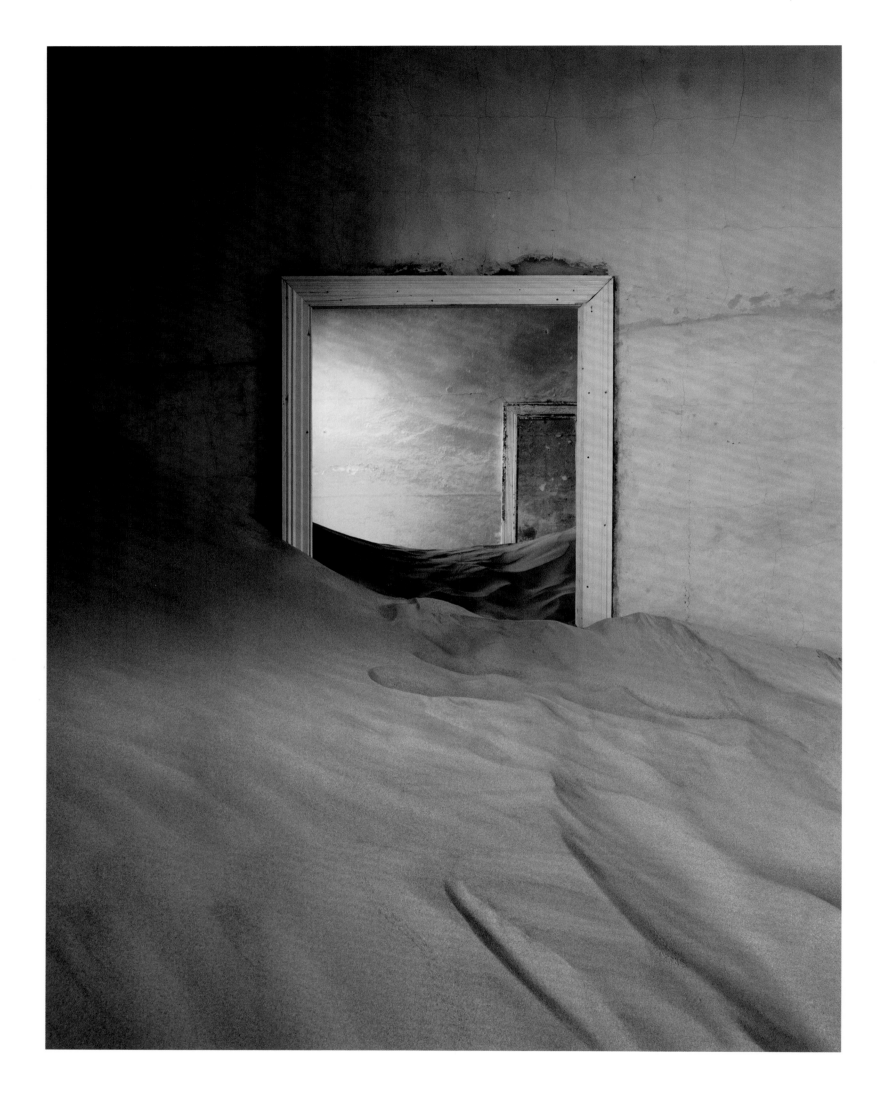

HELENE SCHMITZ
The Green Room, 2015

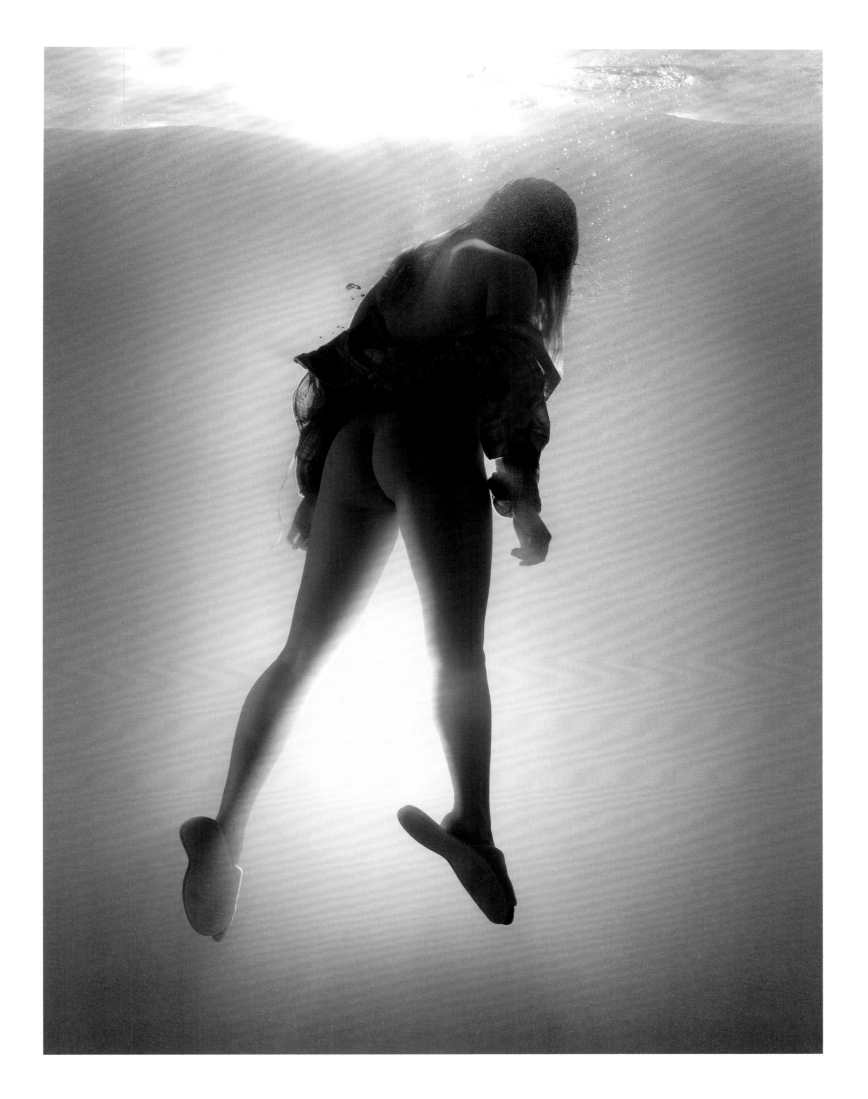

DAVID LACHAPELLE
Sarah, 2007

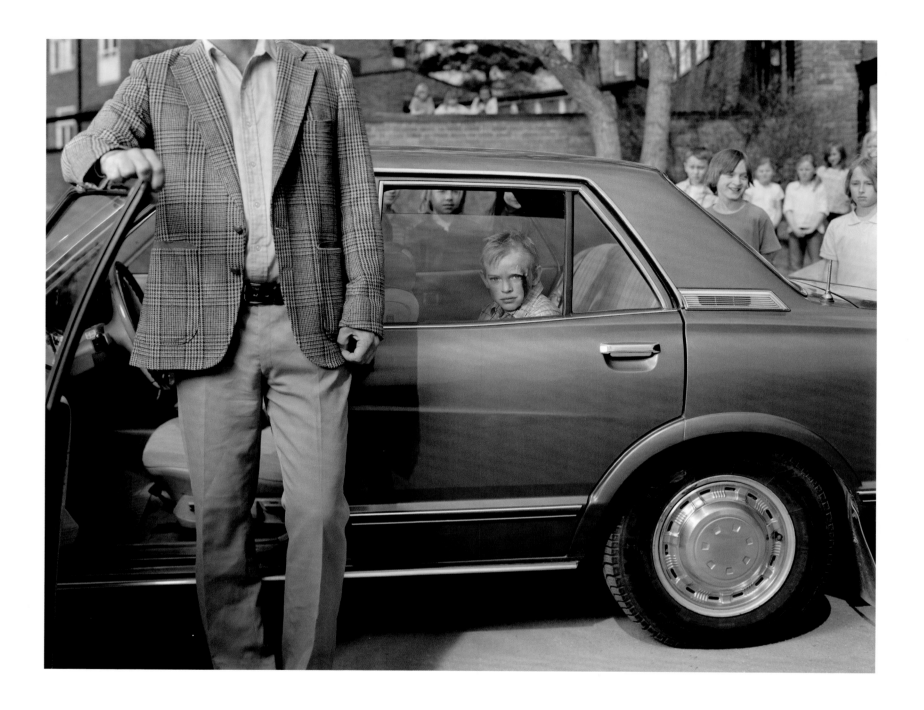

JOHAN WILLNER

Die Ordnung, 2006

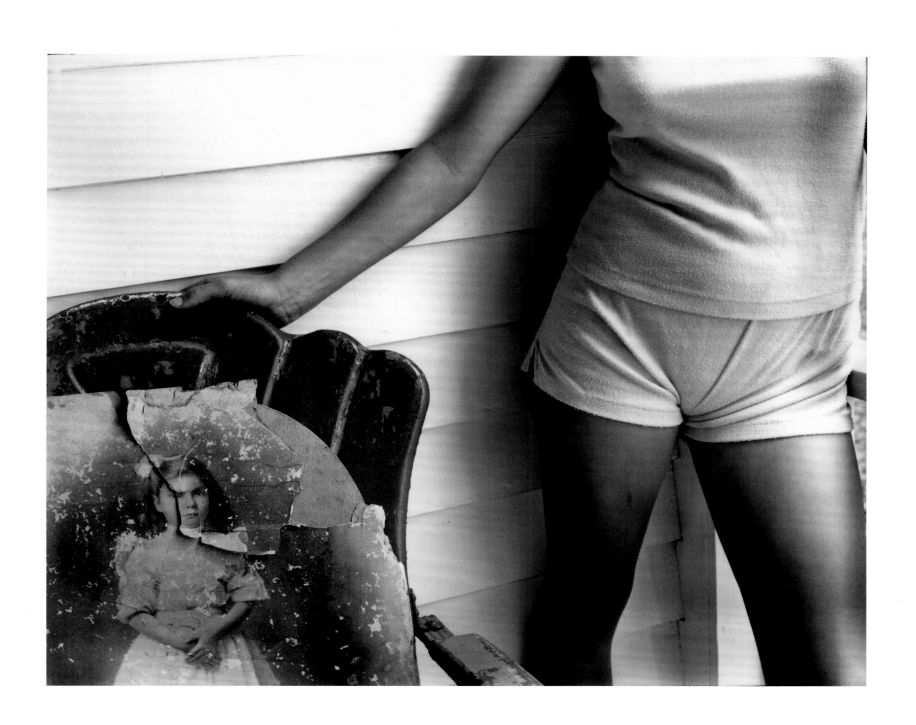

SALLY MANN

Sherry and Granny, 1983–1985

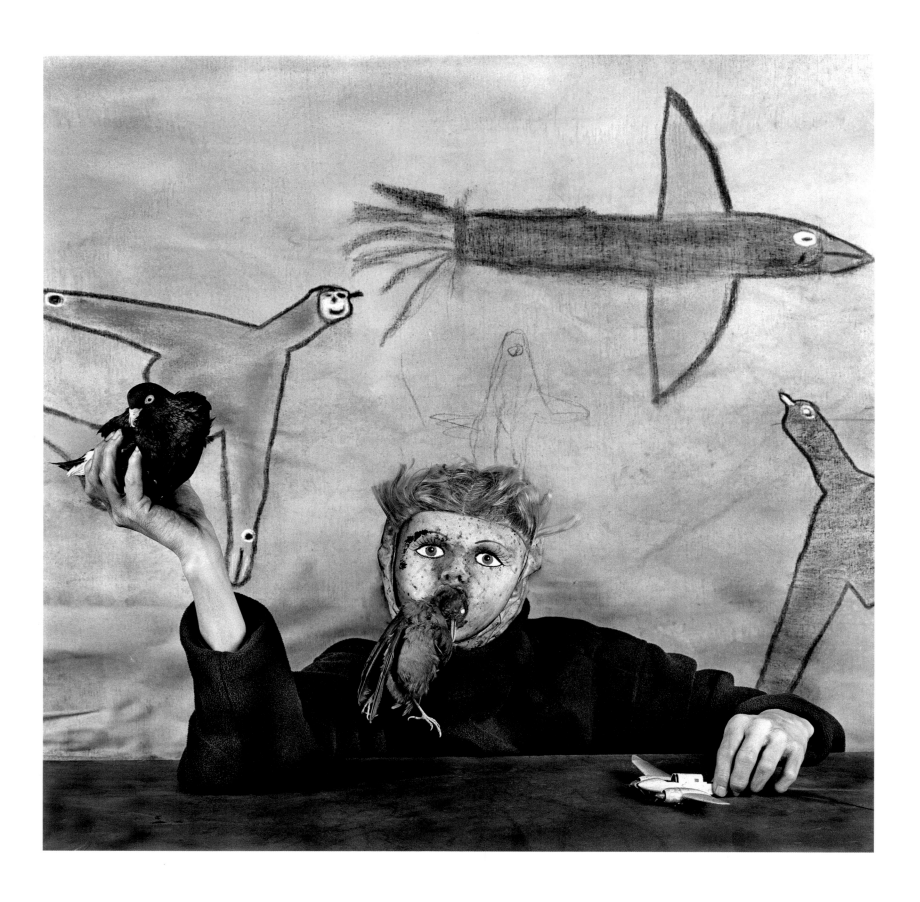

ROGER BALLEN
Take Off, 2012

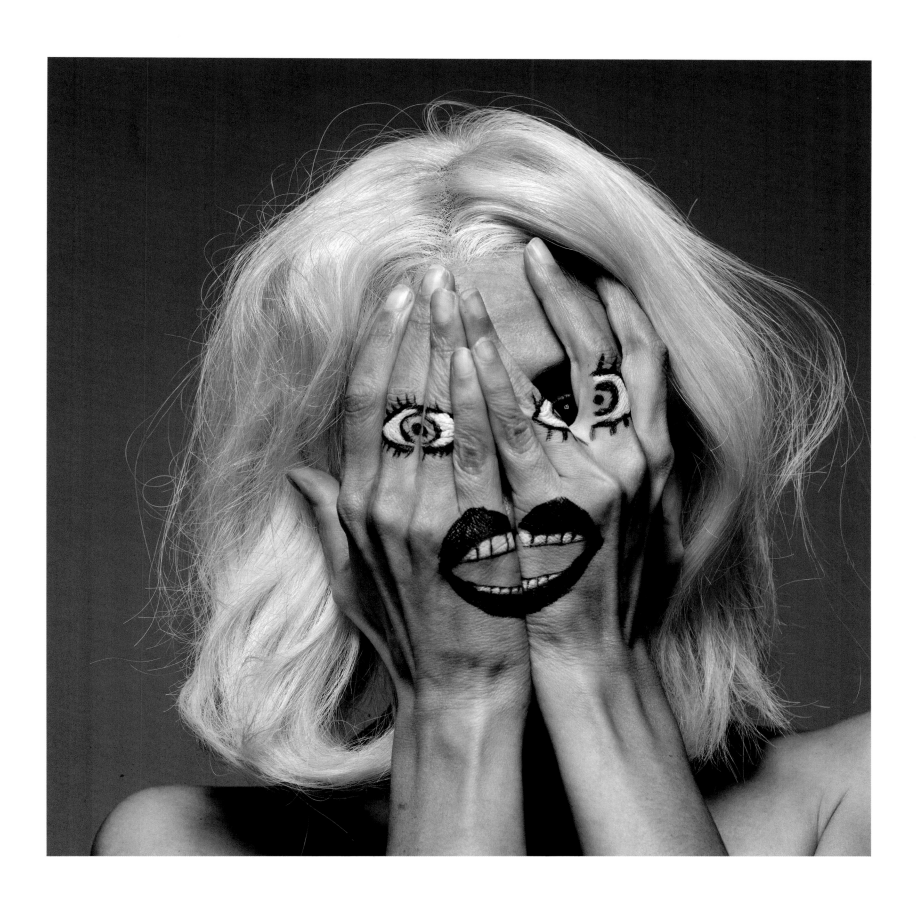

INEZ & VINOODH

Joan via Inez, Theatergroep Mugmetdegoudentand, 2005

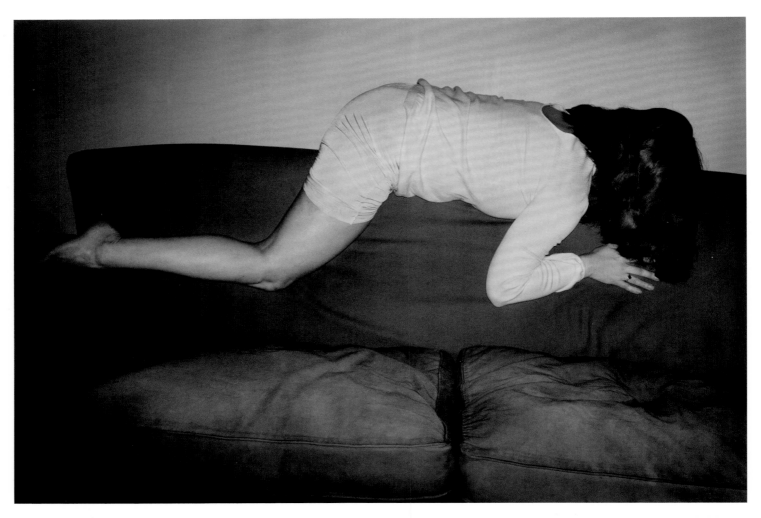

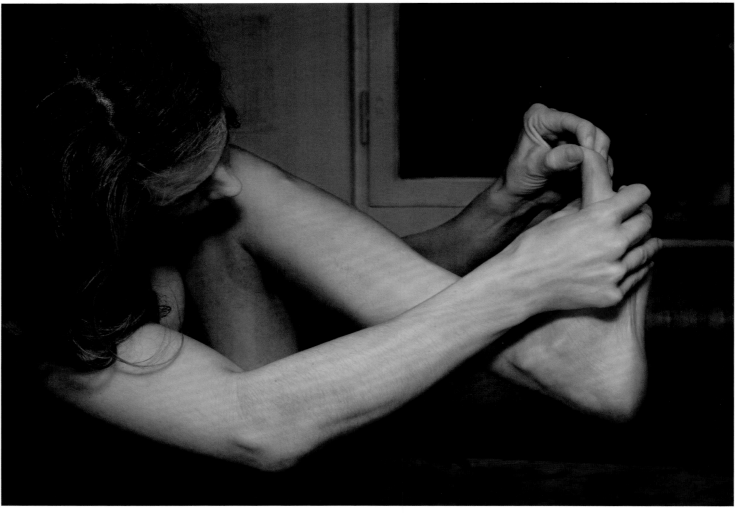

MONIKA MACDONALD

Untitled, from the series *In Absence*, 2015. Untitled, from the series *In Absence*, 2015

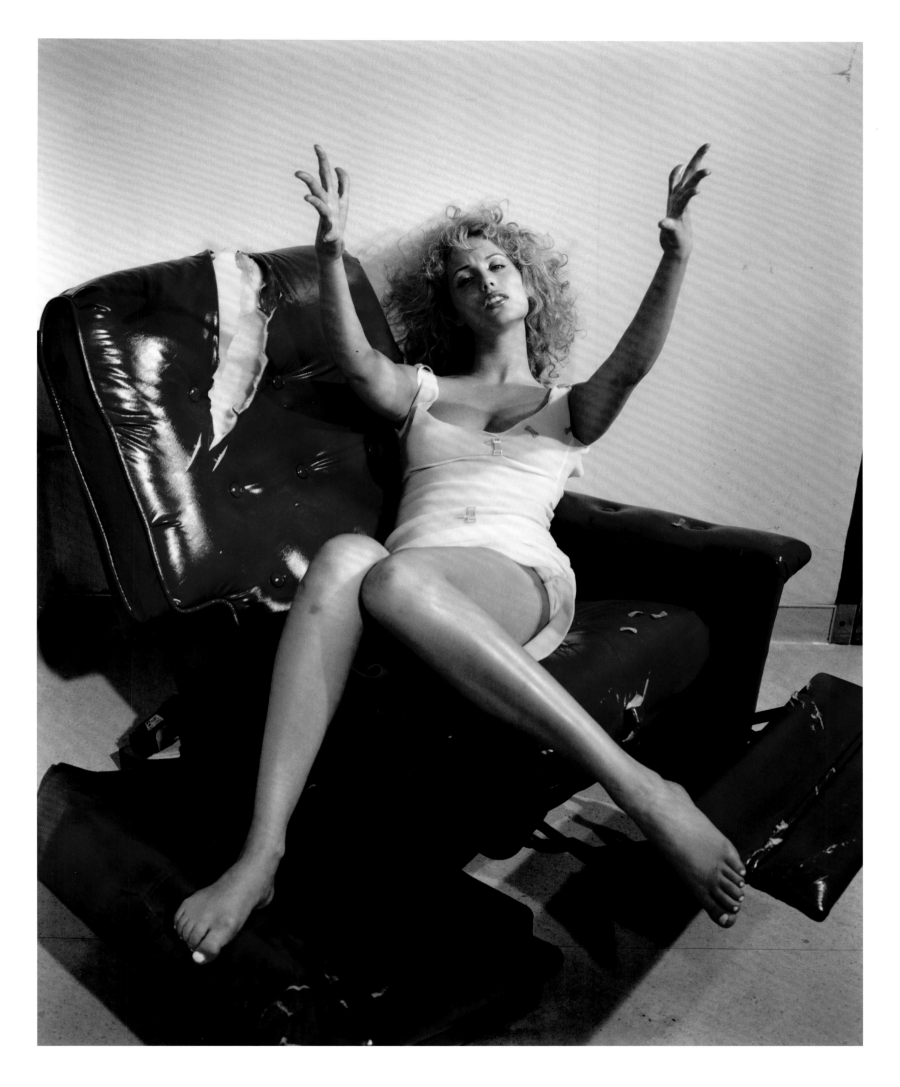

BETTINA RHEIMS
"Pourquoi m'as tu abandonnée?", Elizabeth Berkley in a Coucou's Nest, Los Angeles, February 1996

VIVIANE SASSEN

Red Leg Totem, from the series *Umbra*, 2014

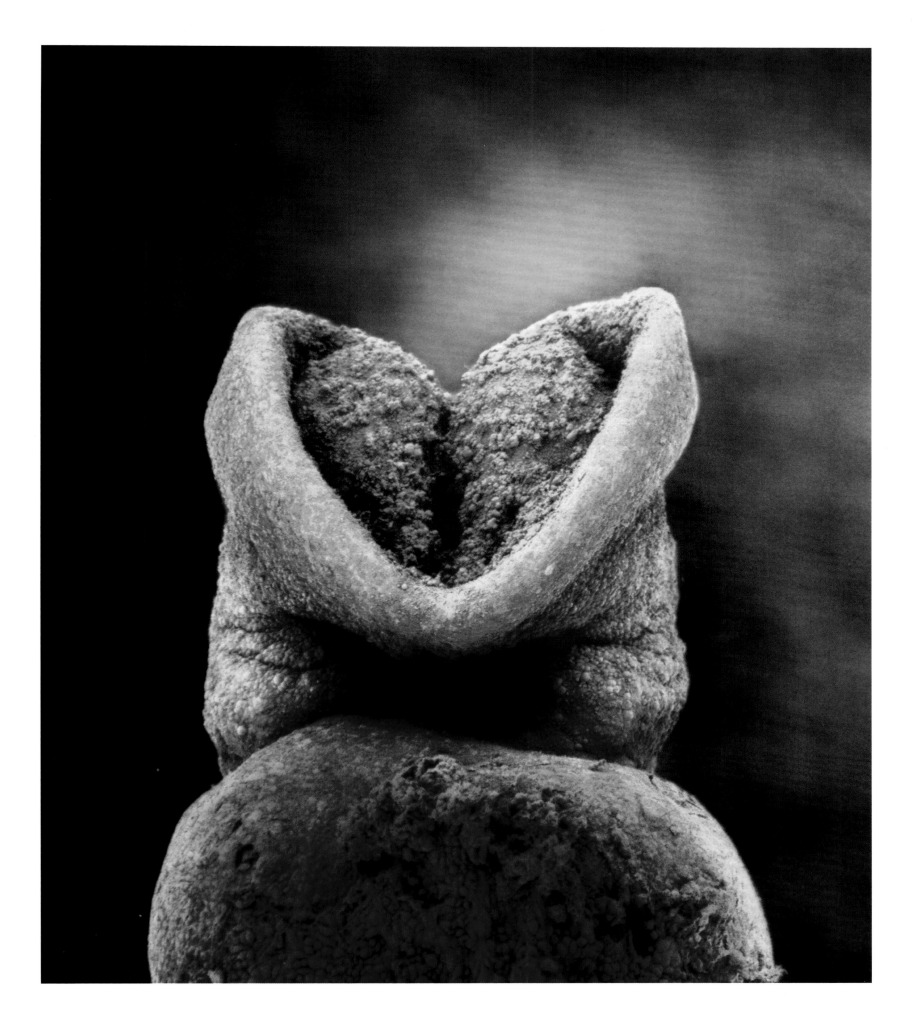

LENNART NILSSON

22 Days, The Brain of an Embryo

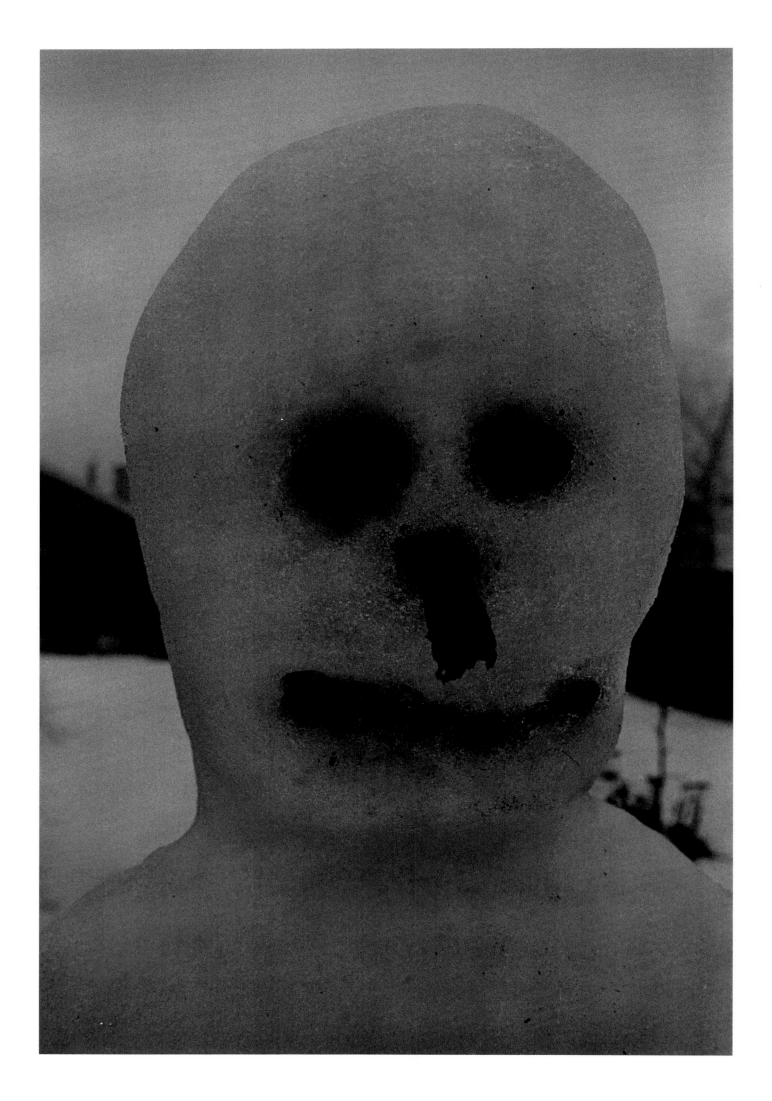

ANDERS PETERSEN

Untitled, from the series *City Diary*, 2012

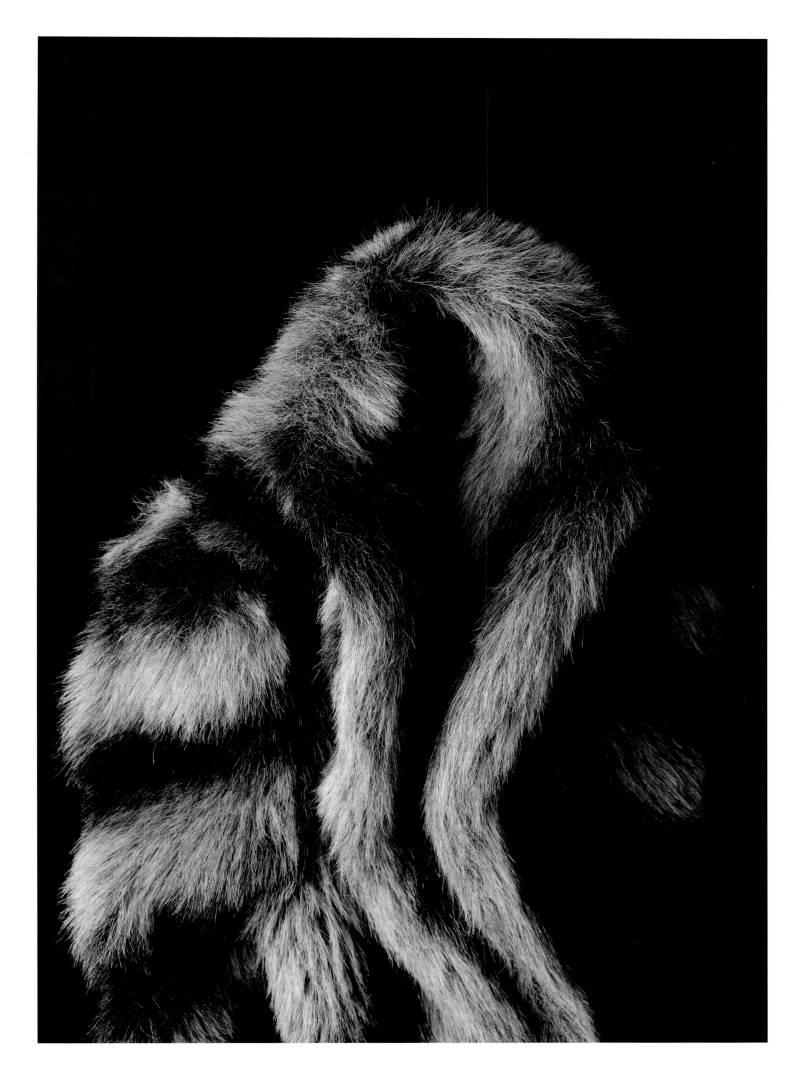

VÉRONIQUE DUCHARME

Armour V, 2010

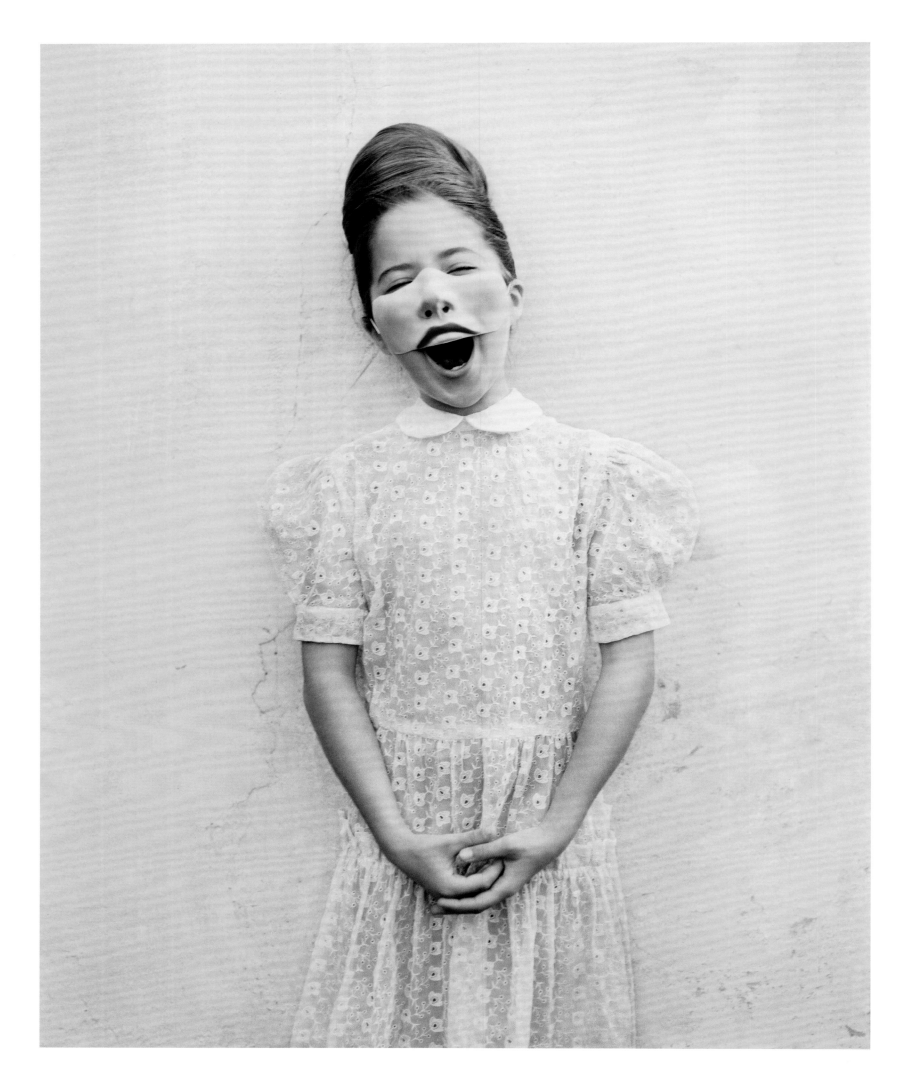

VEE SPEERS

Untitled No. 1, from the series *The Birthday Party*, 2007

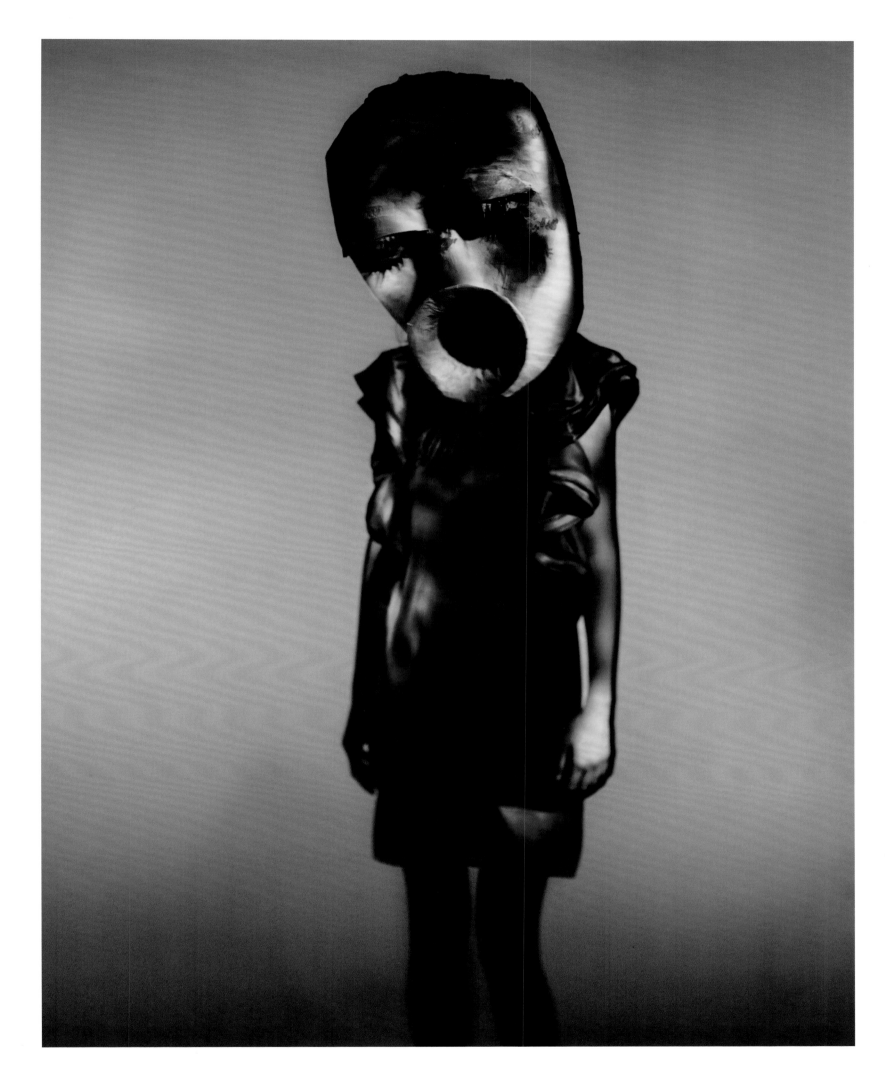

PAOLO ROVERSI
Kasia, Paris, 2007

"I create situations that do not exist. I seek the truth from fiction."

SARAH MOON

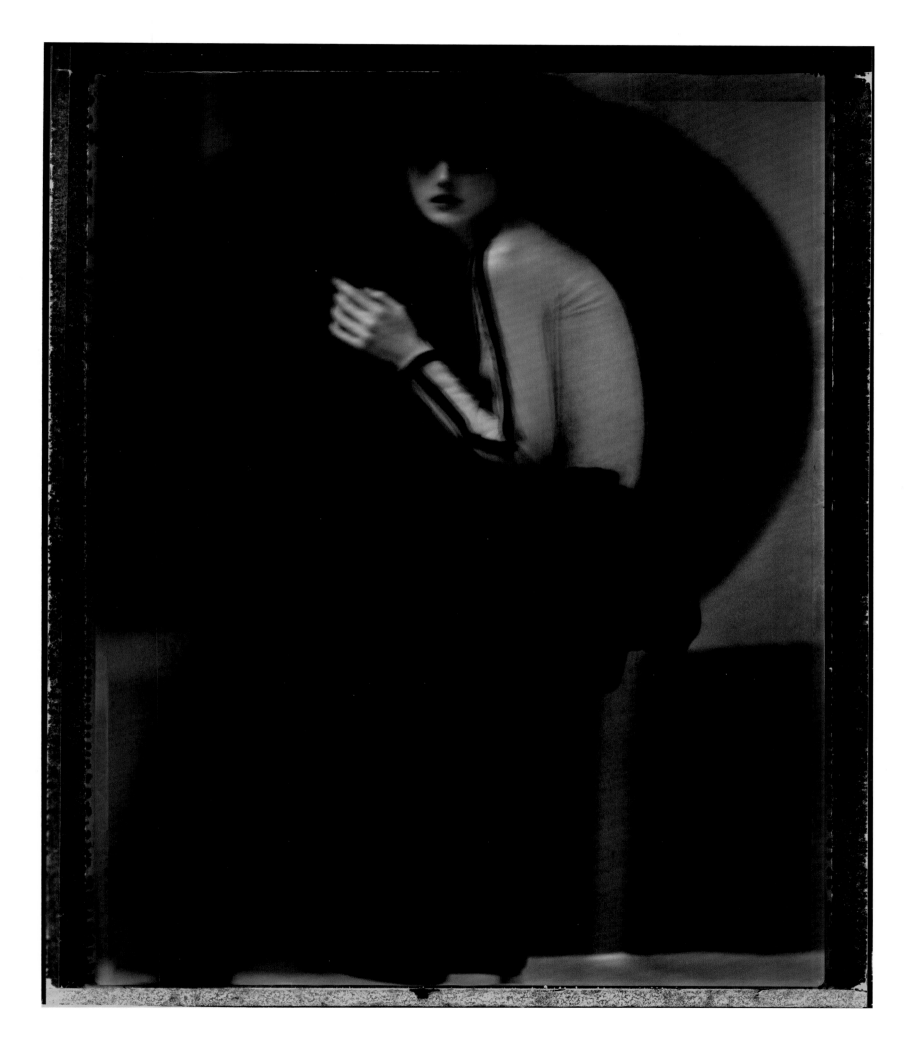

SARAH MOON
Christina, 2008

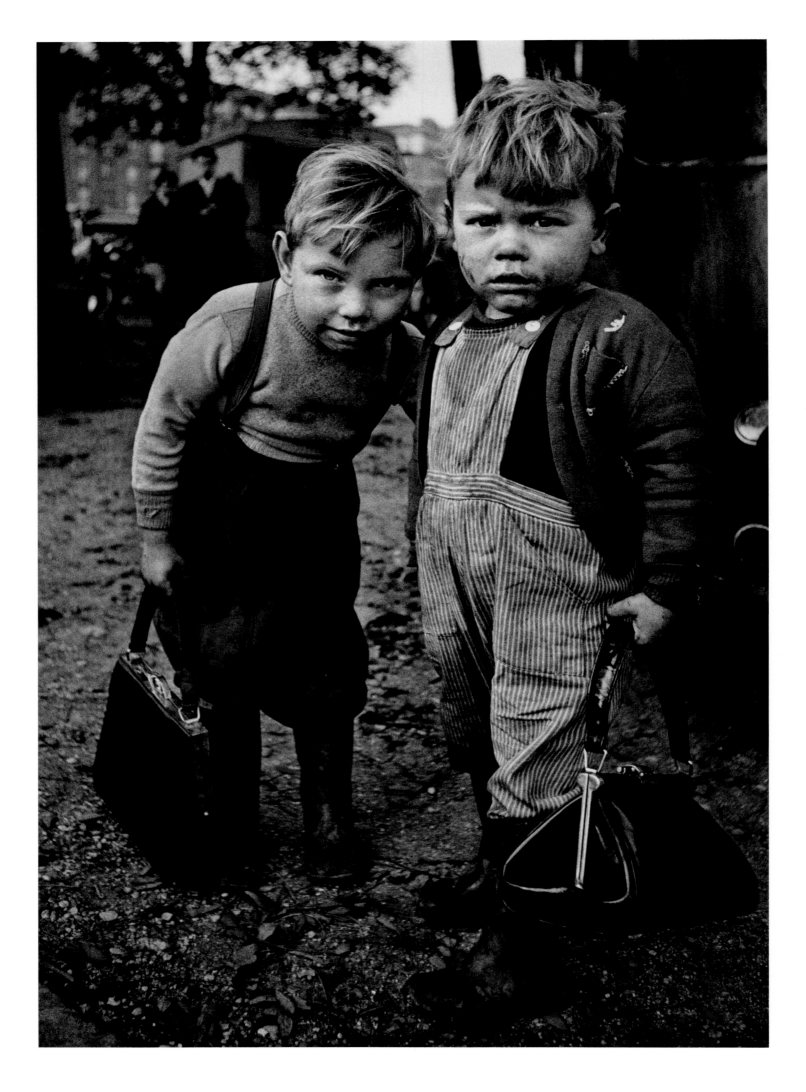

CHRISTER STRÖMHOLM
Montreuil, Paris, 1962

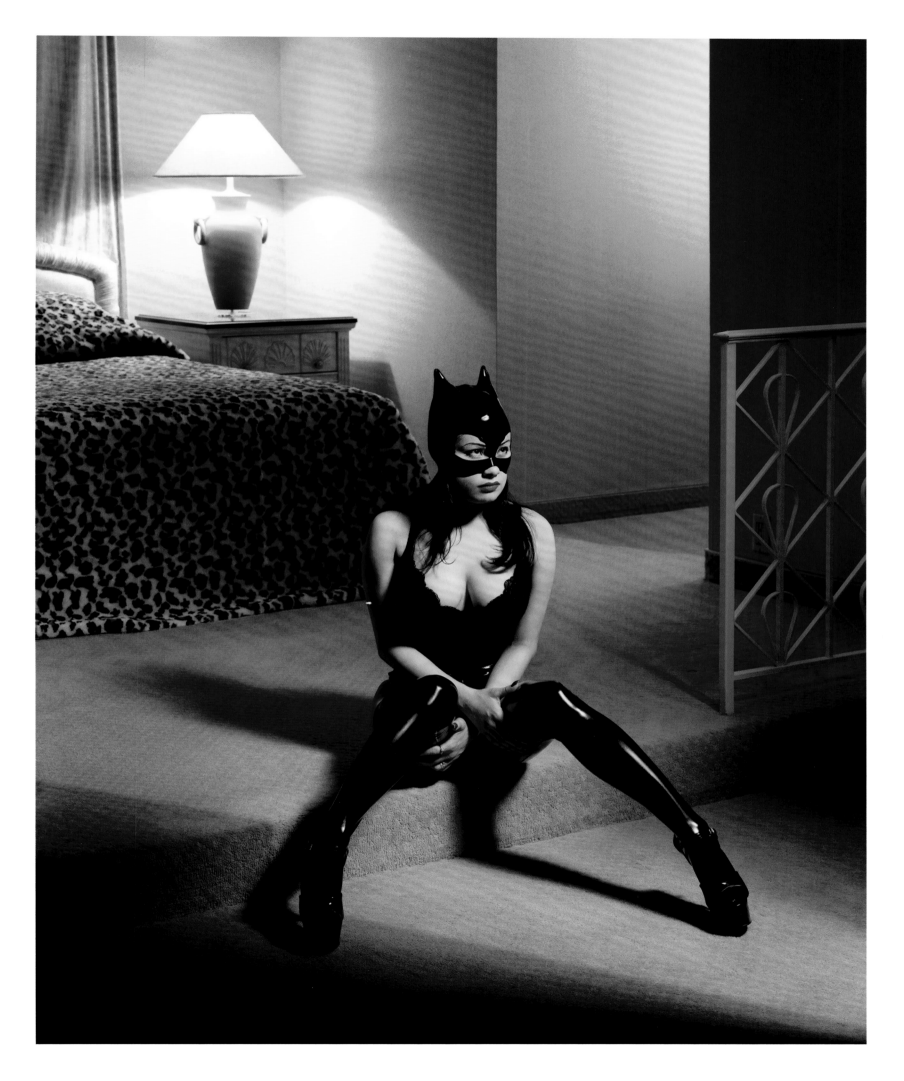

ALBERT WATSON

Breaunna in Cat Mask, Las Vegas Hilton, 2001

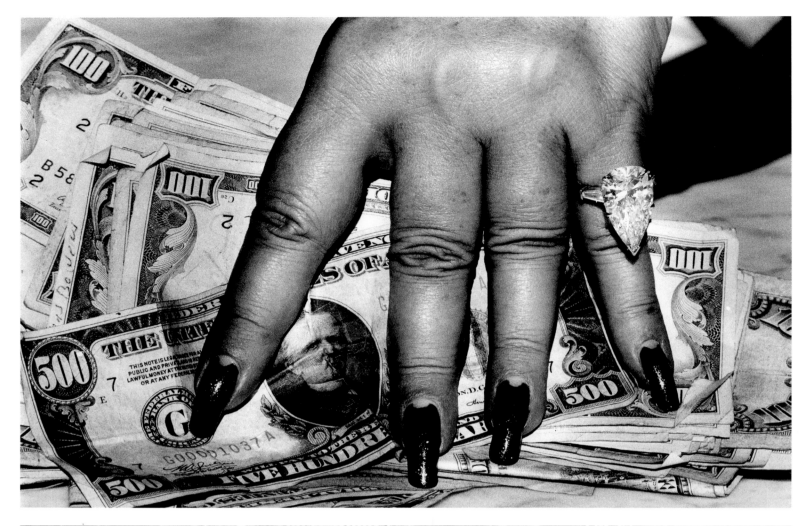

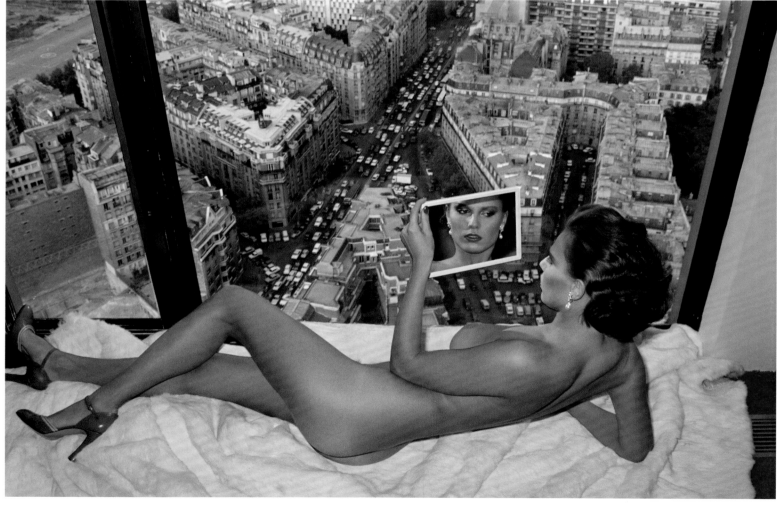

HELMUT NEWTON

Fat Hand with Dollars, Monte Carlo, 1986. Bergstrom over Paris, 1976

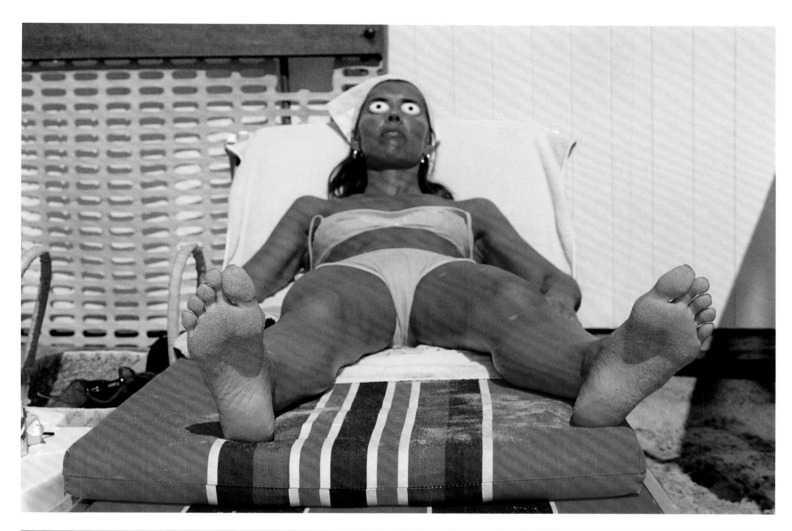

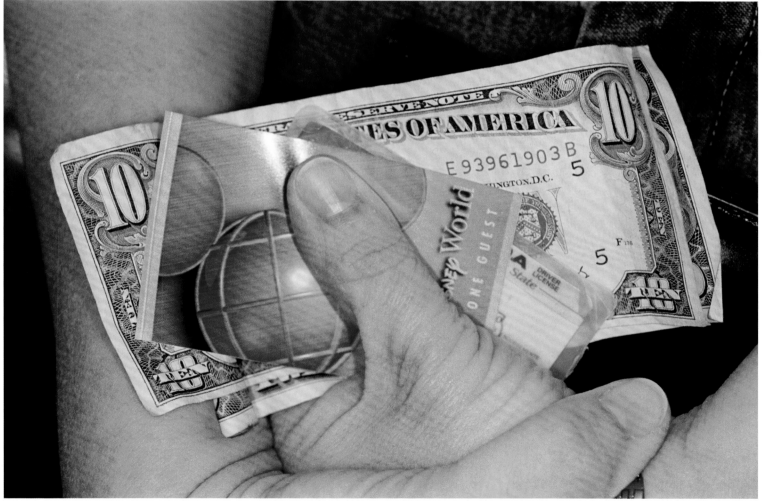

MARTIN PARR

Knokke, Belgium, 2001. Florida, USA, 1998

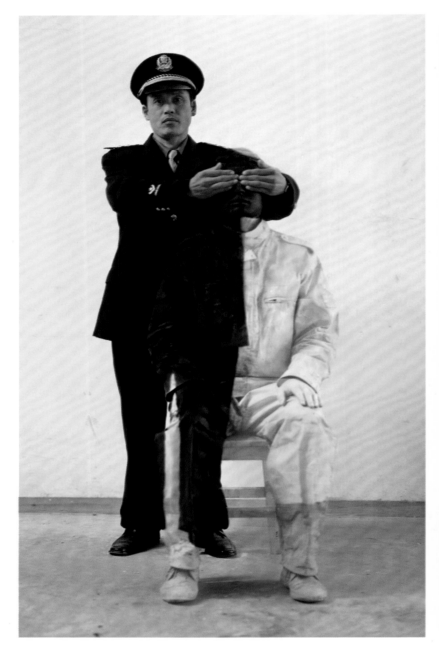 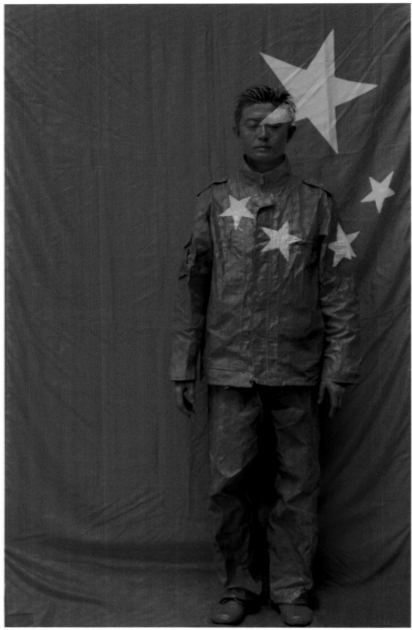

LIU BOLIN

Hiding in the City No. 17, Civilian and Policeman No. 2, 2006. Hiding in the City No. 26, In Front of the Red Flag, 2006

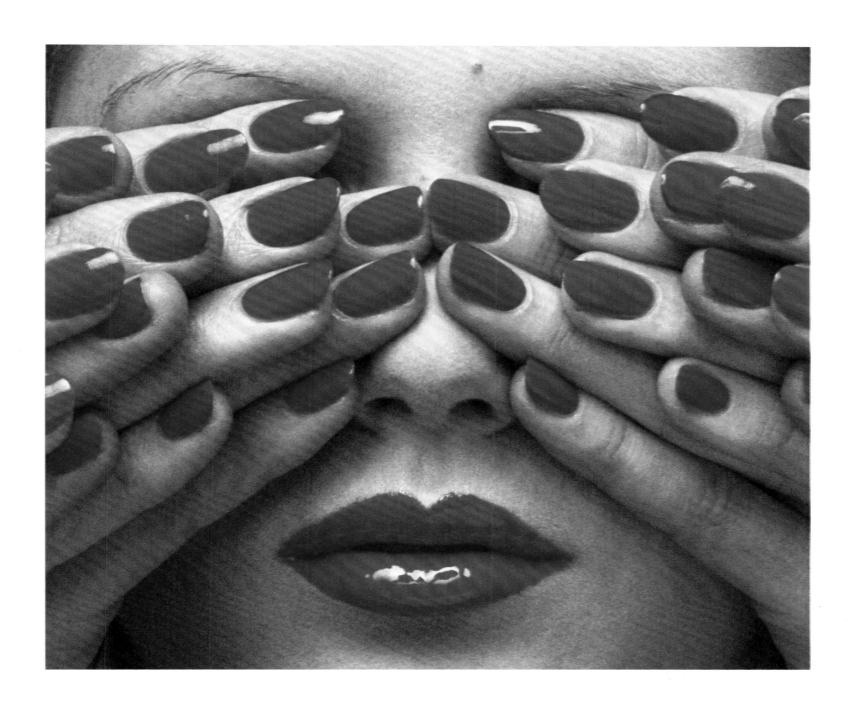

GUY BOURDIN

Vogue Paris, May 1970

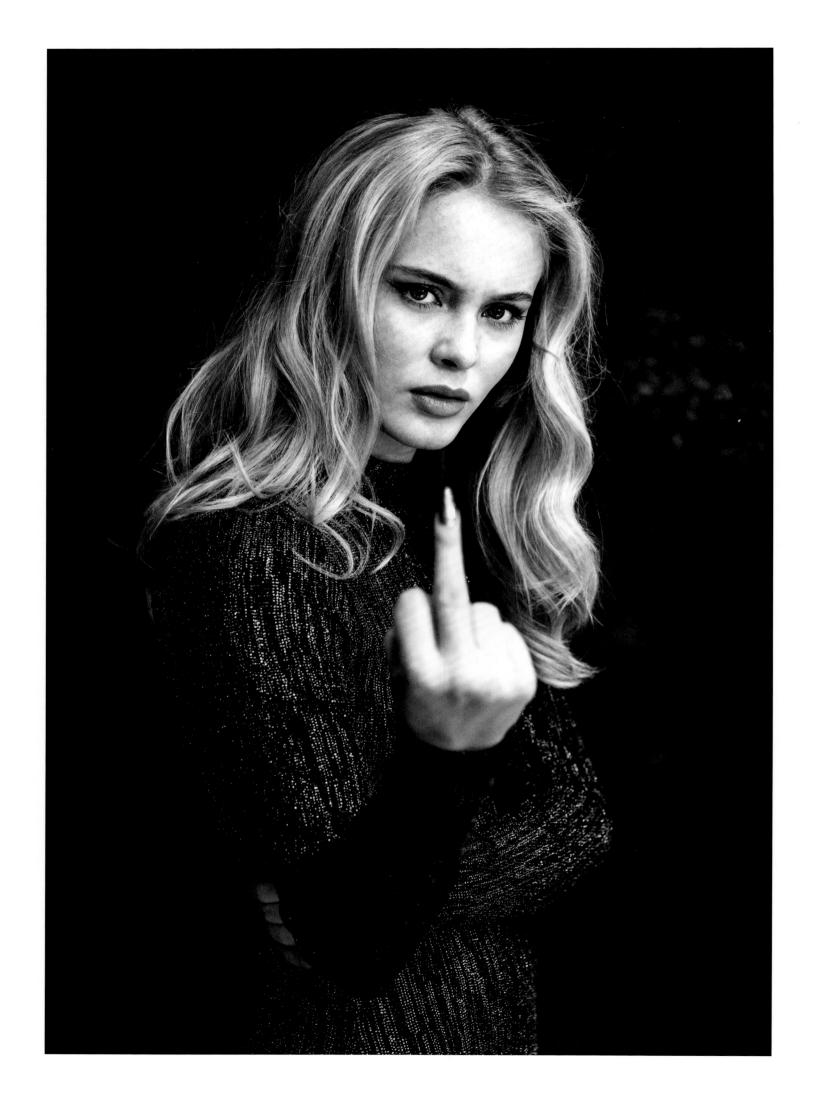

ALBERT WIKING

Zara Larsson, Women Power No. 1, 2015

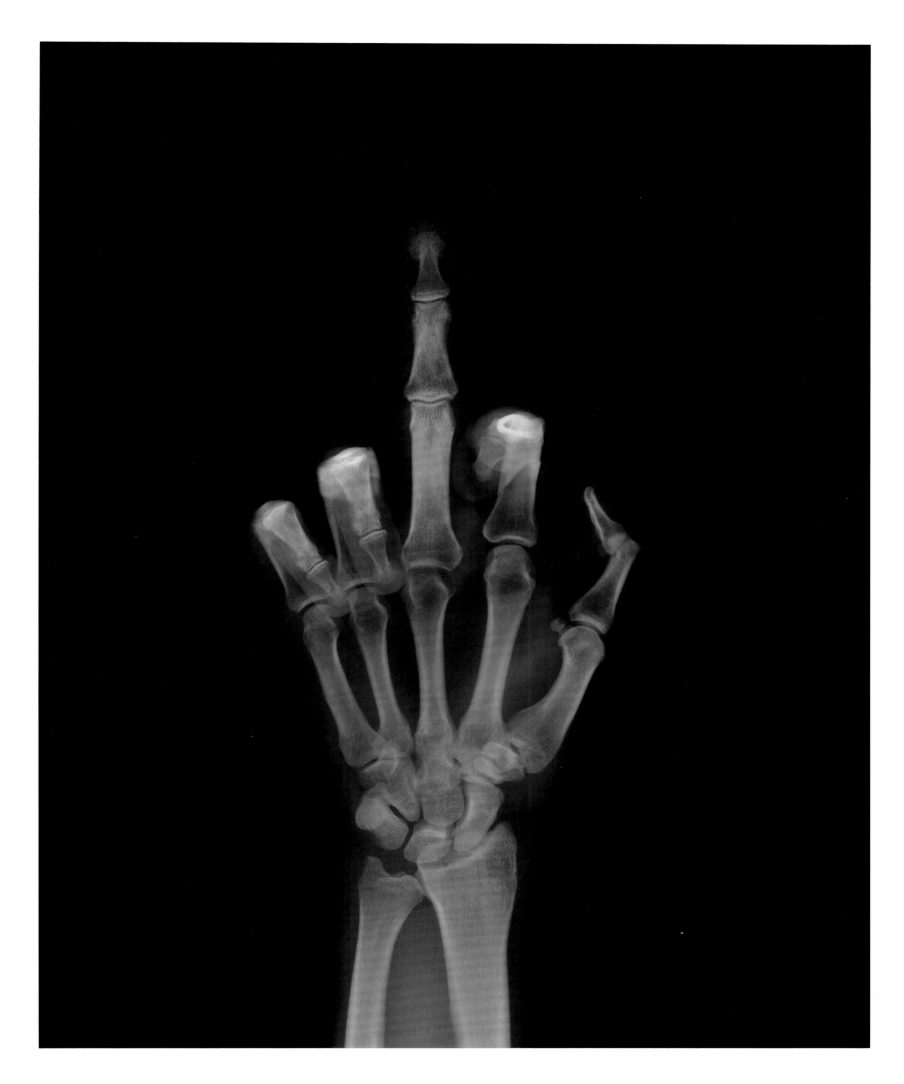

NICK VEASEY
The Finger, 2001

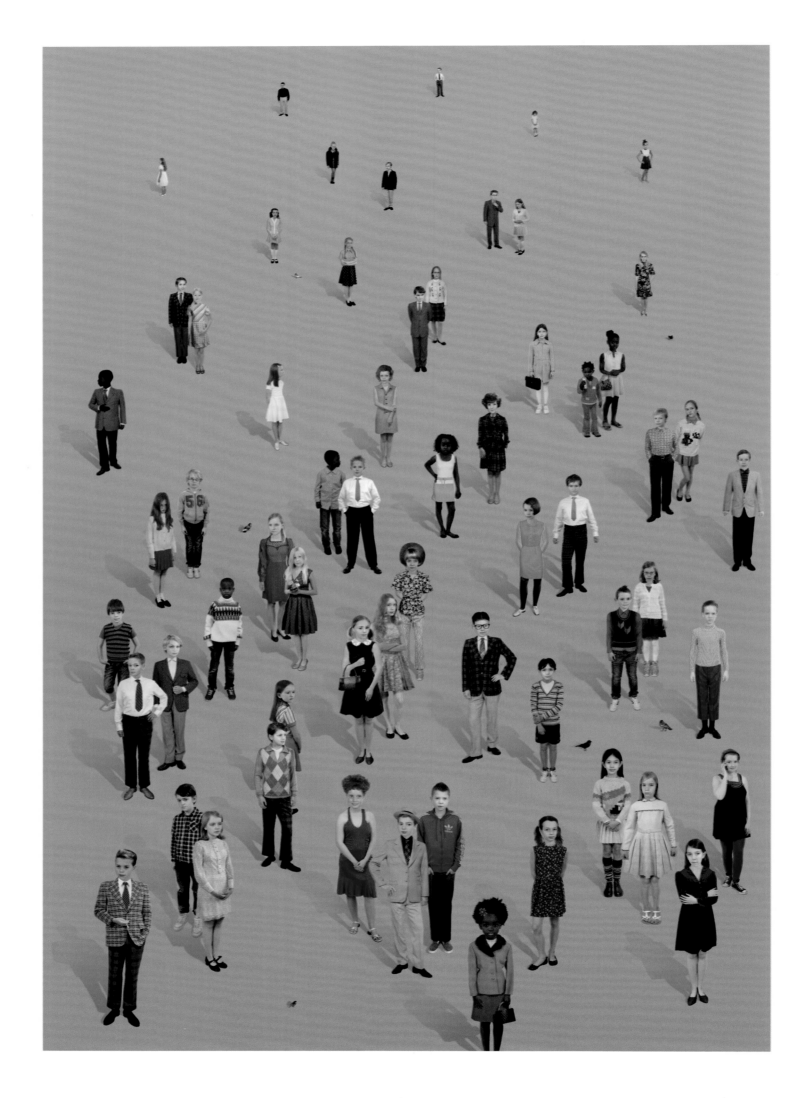

RUUD VAN EMPEL
Landscape No. 2, 2012

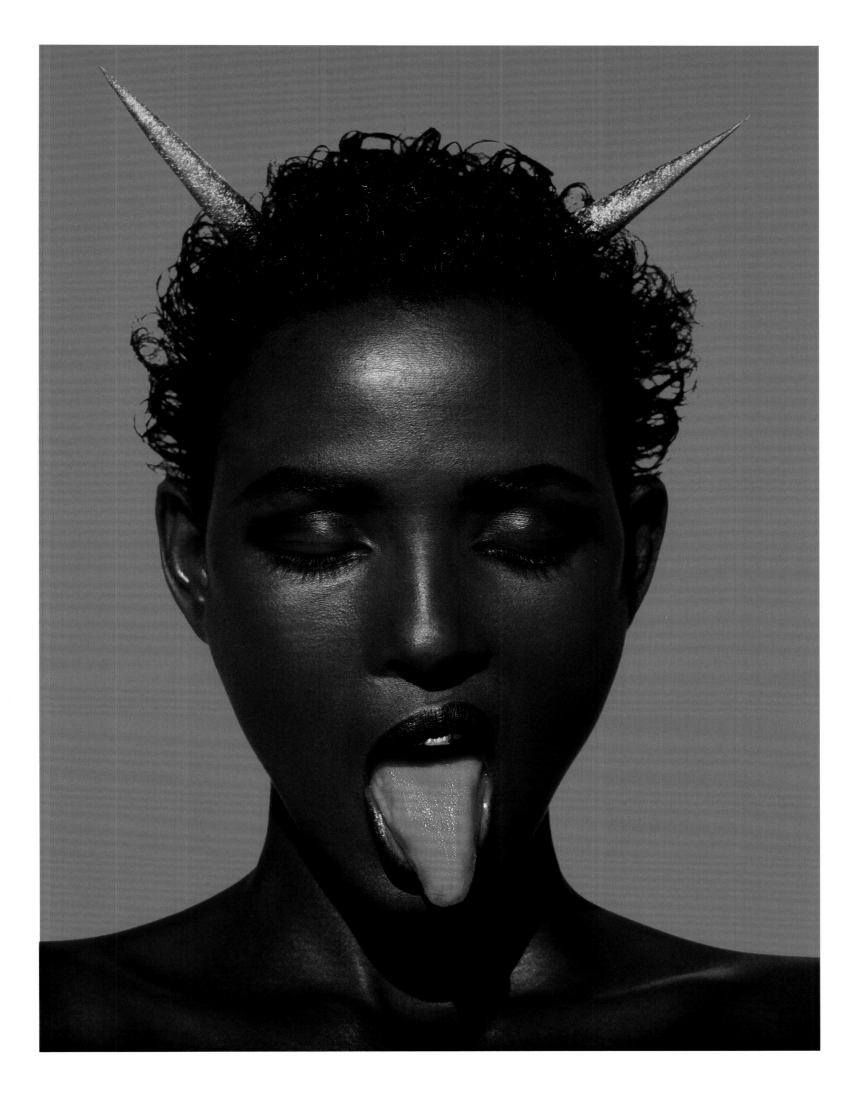

ALBERT WATSON

Waris, Quarzazate, Morocco, 1993

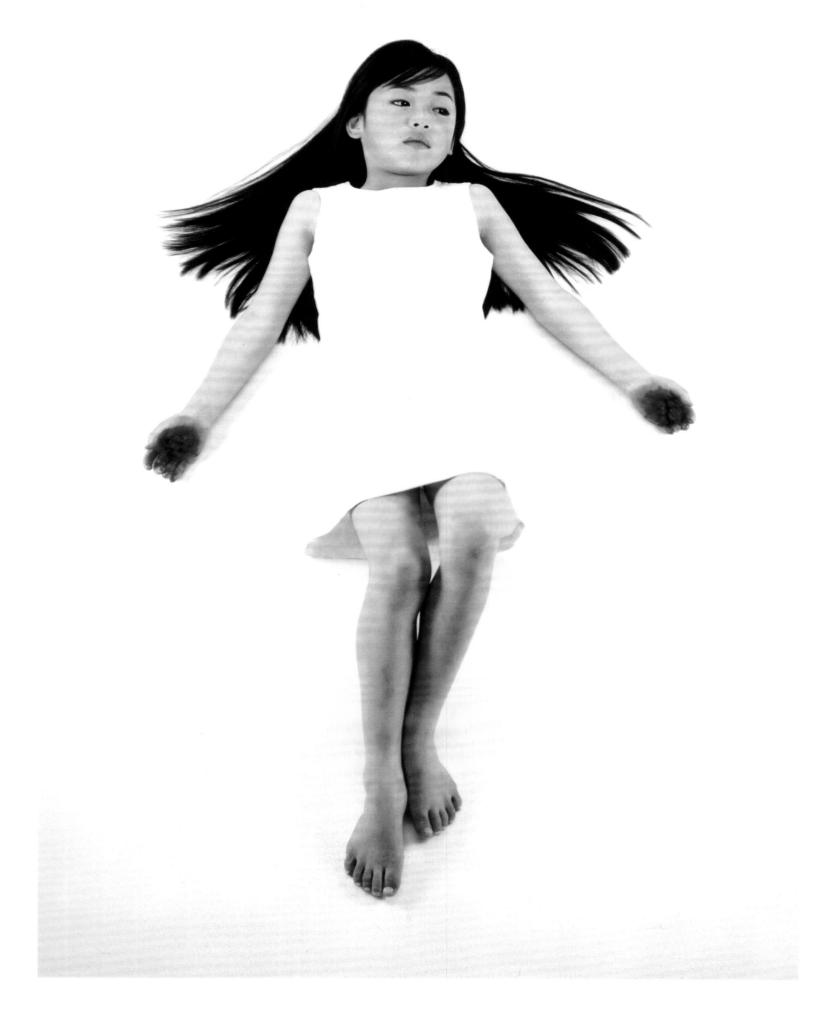

MOTOHIKO ODANI
Phantom Limb, 1997

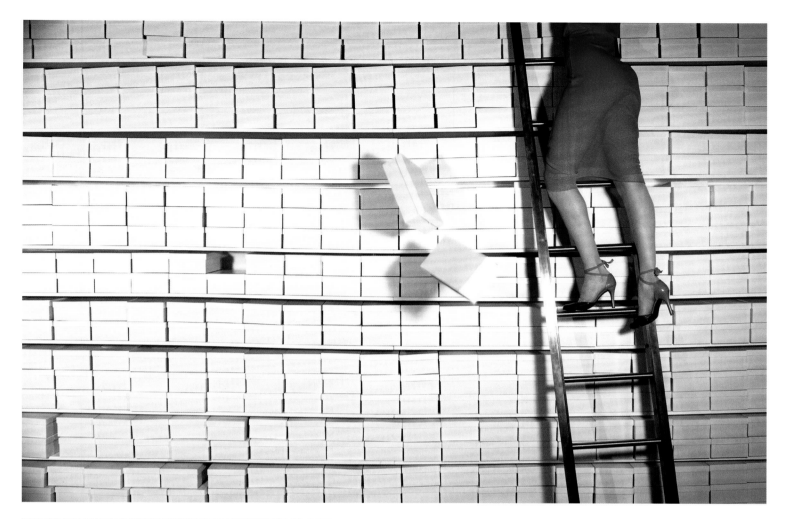

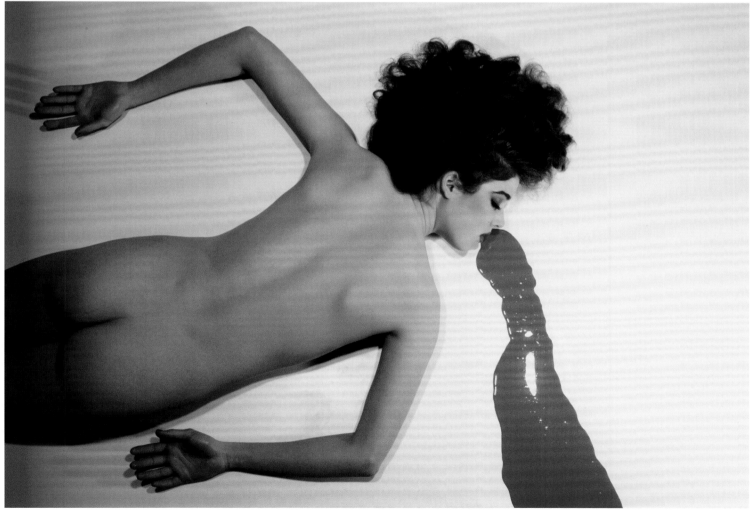

GUY BOURDIN

Charles Jourdan, Fall 1977. Pentax Calendar, 1980

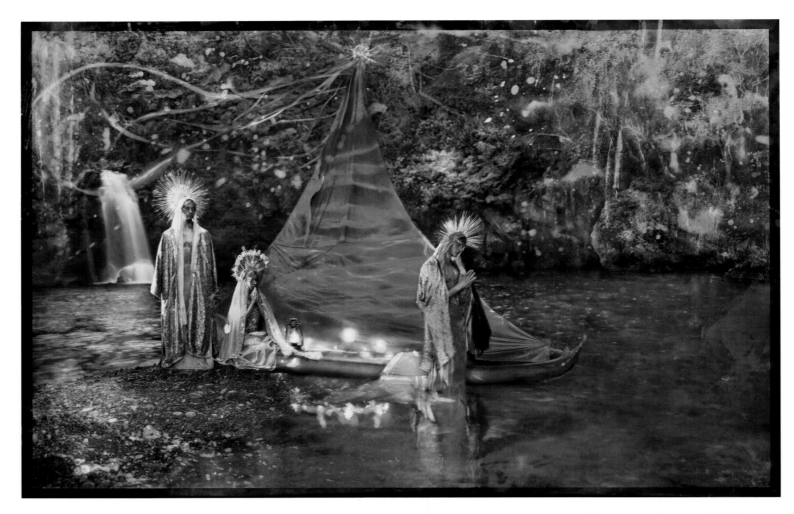

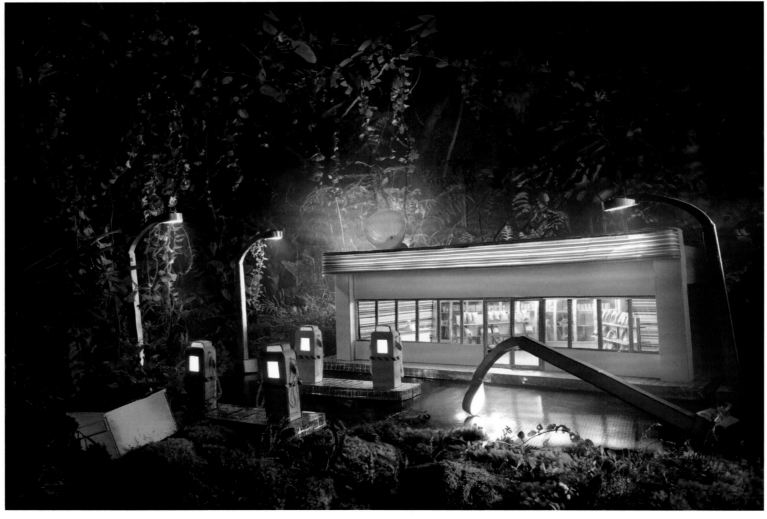

DAVID LACHAPELLE

A New World, 2017. Gas am pm, 2012

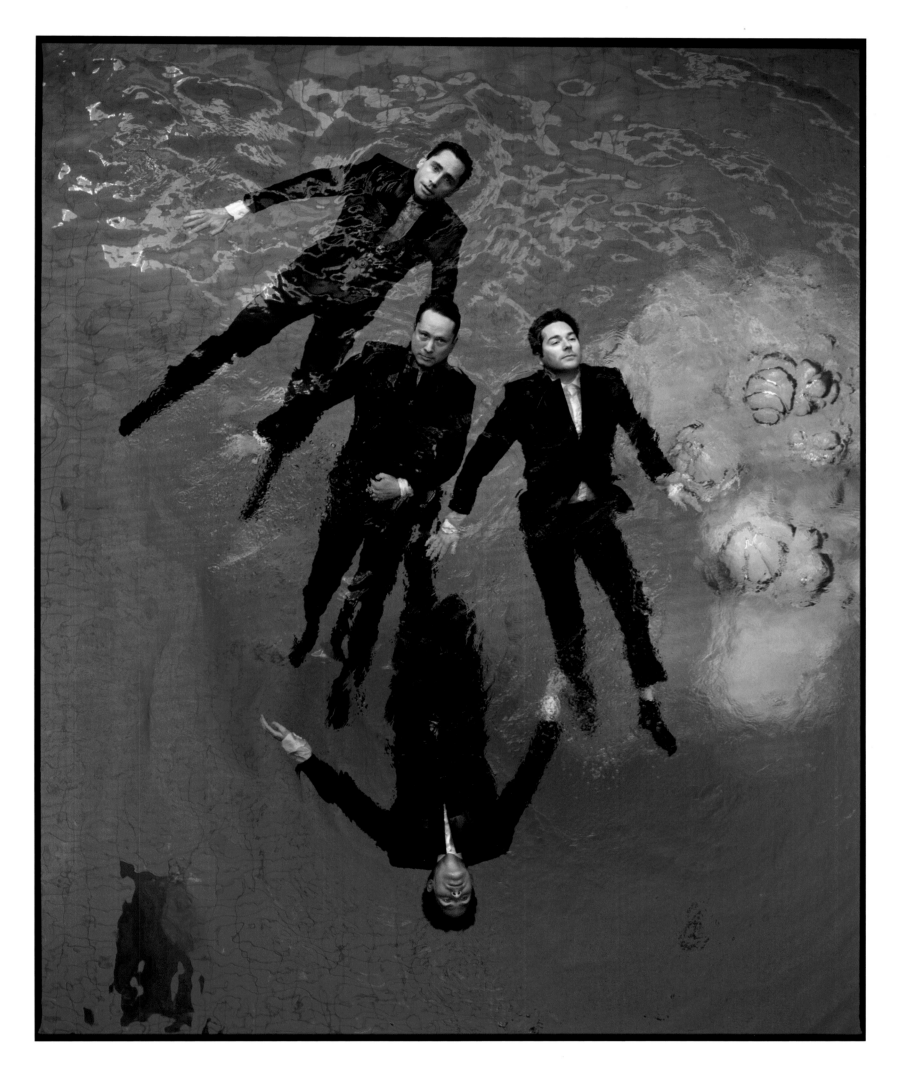

MARIA FRIBERG

Almost There 5, 2000

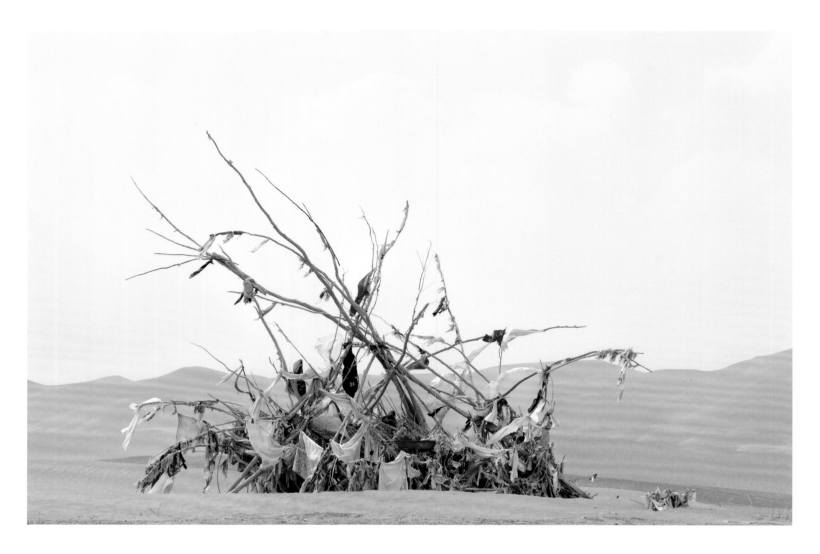

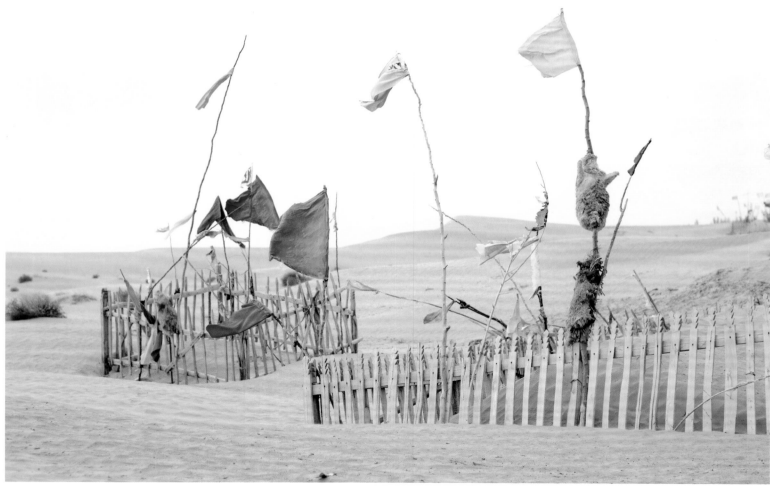

LISA ROSS
Unrevealed, Site 1 (Adorned), 2006. Unrevealed, Site 2 (Red Masthead), 2010

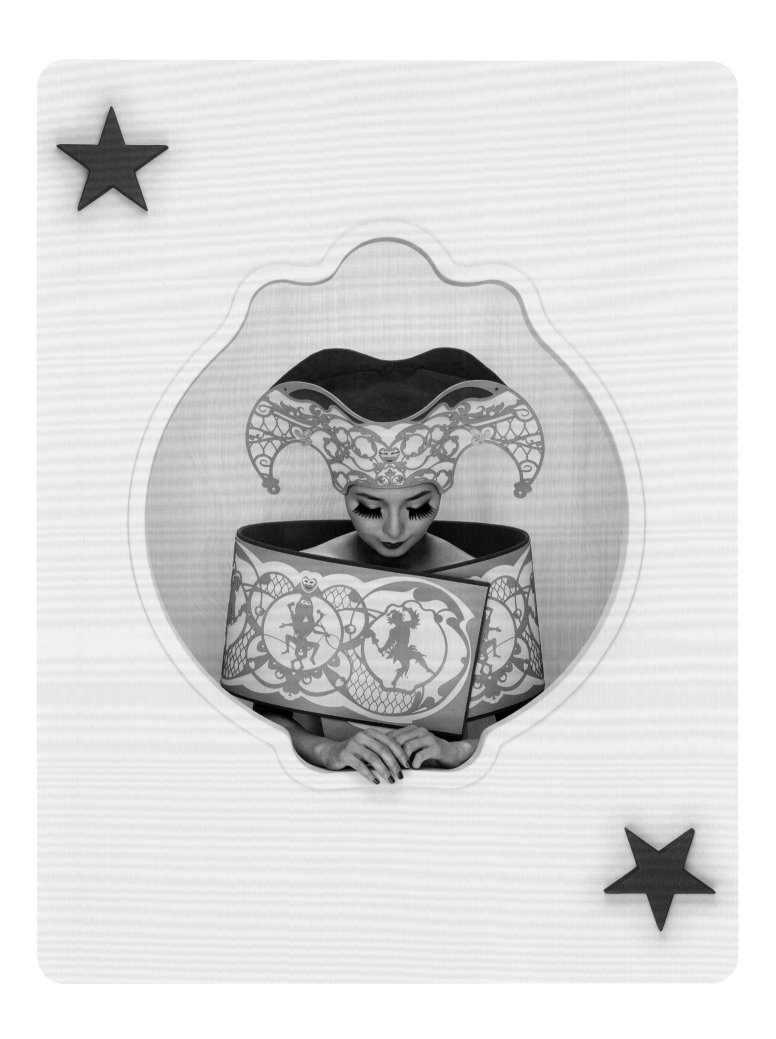

CHRISTIAN TAGLIAVINI
La Matta Rossa, 2012

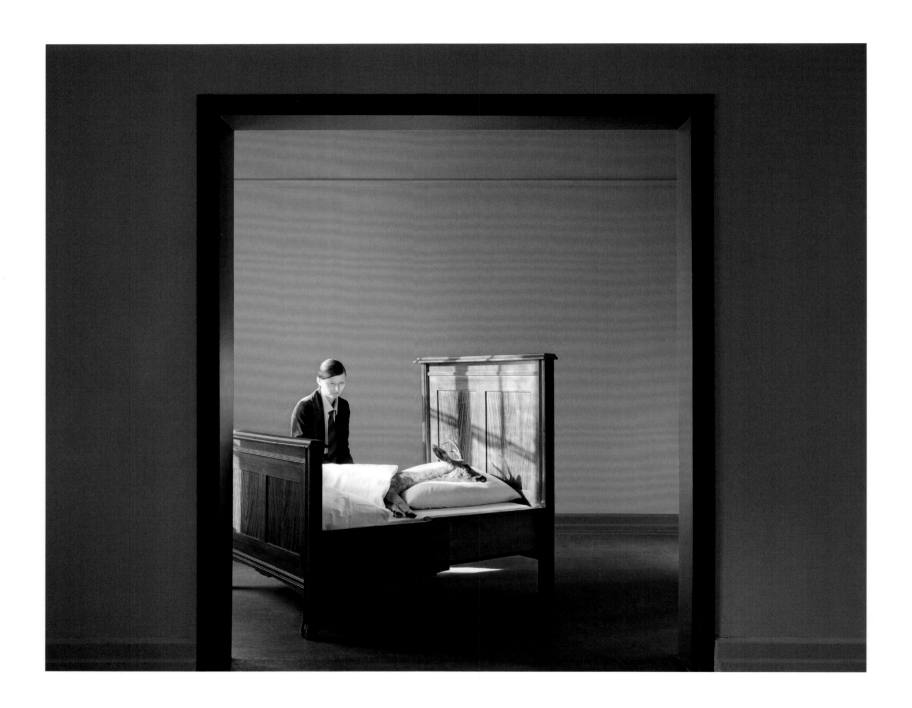

NYGÅRDS KARIN BENGTSSON

Deer Room, 2009

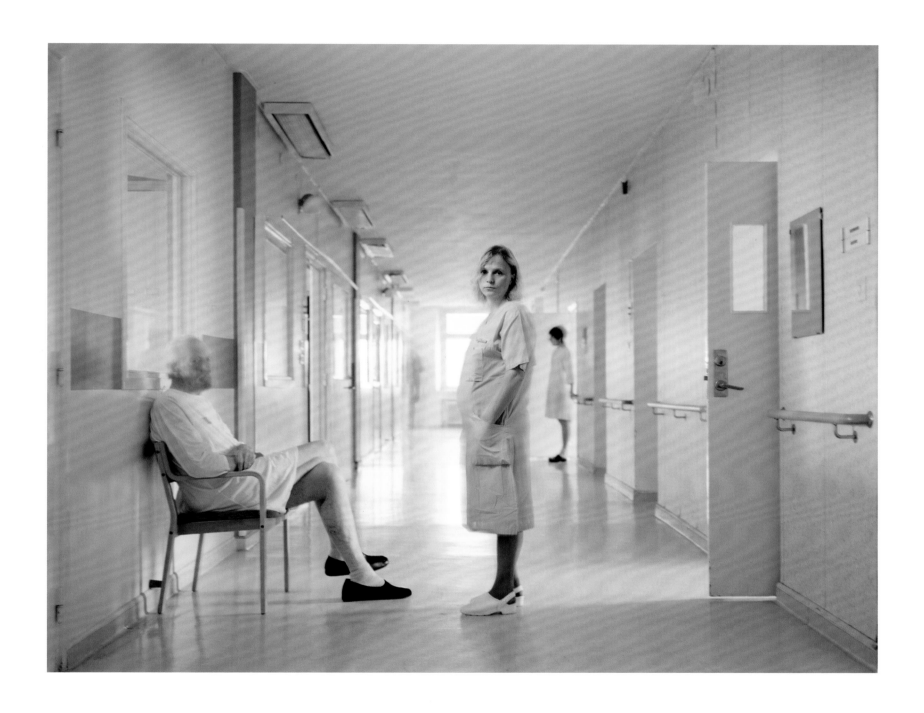

JOHAN WILLNER

Anticipation, 2009

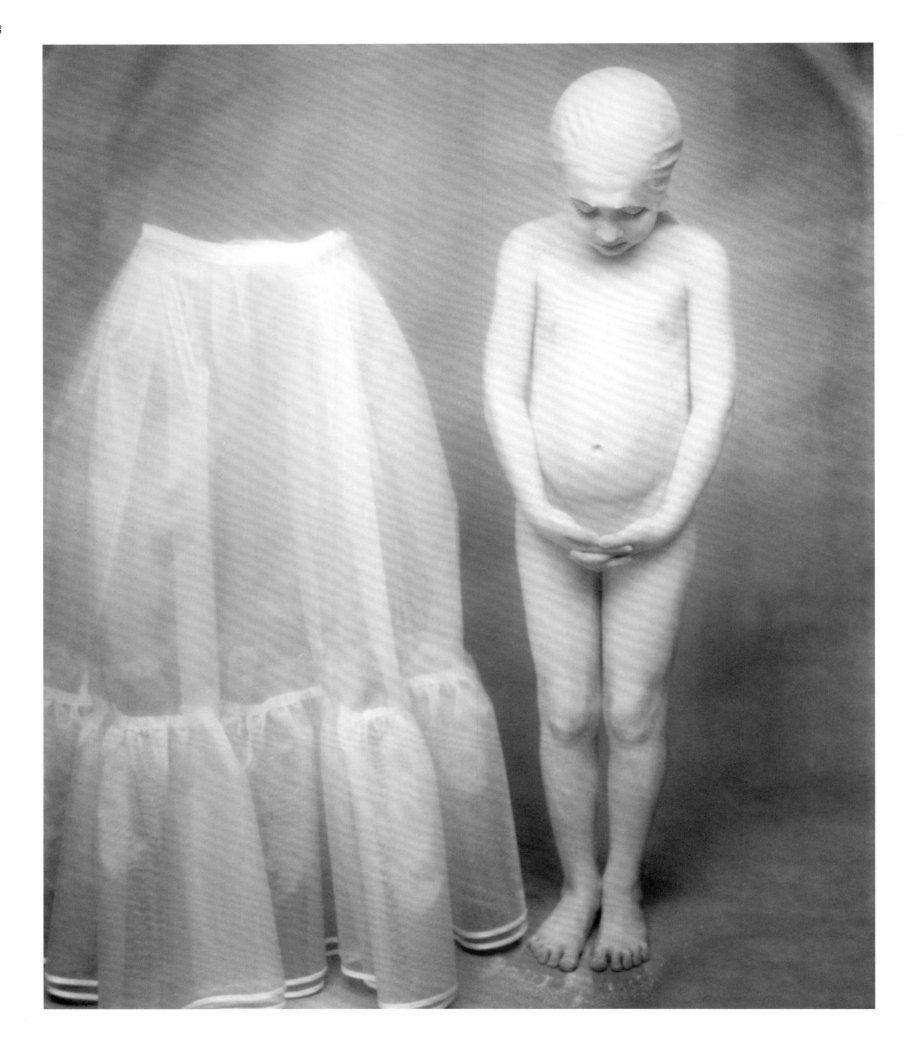

JOYCE TENNESON
Katy and Skirt, 1987

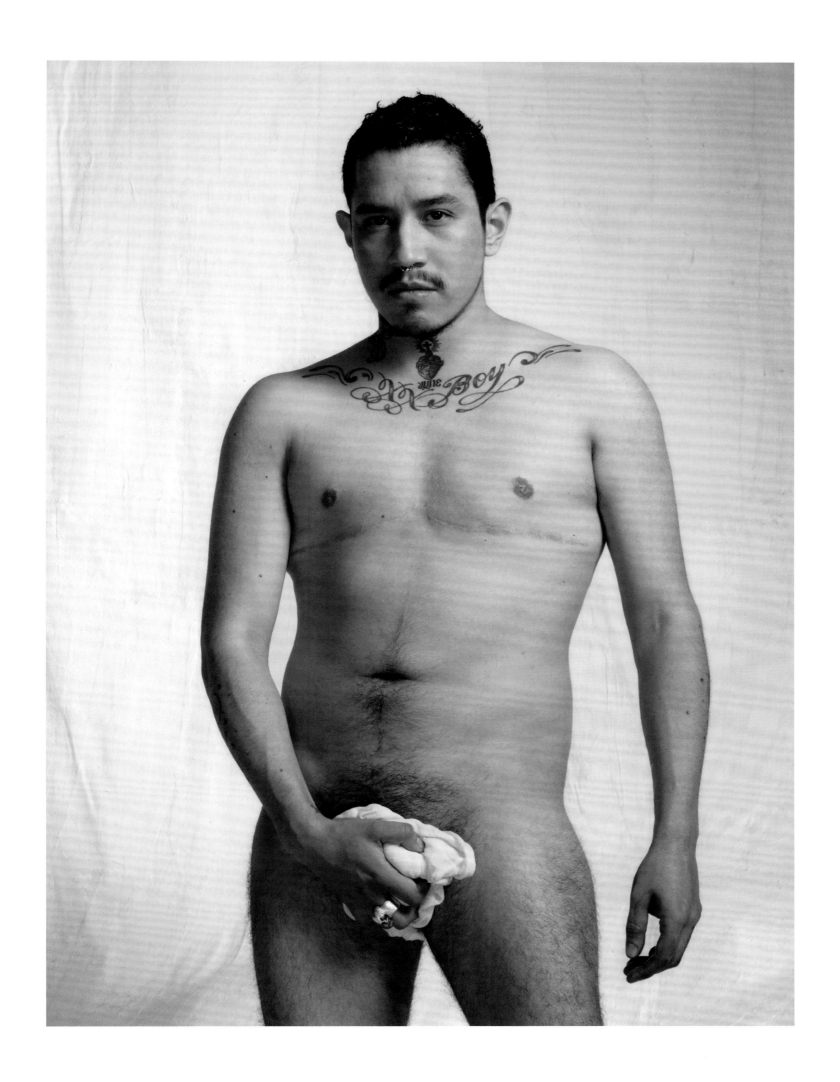

BETTINA RHEIMS

Kael T.B.I., from the series *Gender Studies*, Paris, June 2011

"I wanted my photographs to be as powerful as the last thing a person sees or remembers before death."

JOEL-PETER WITKIN

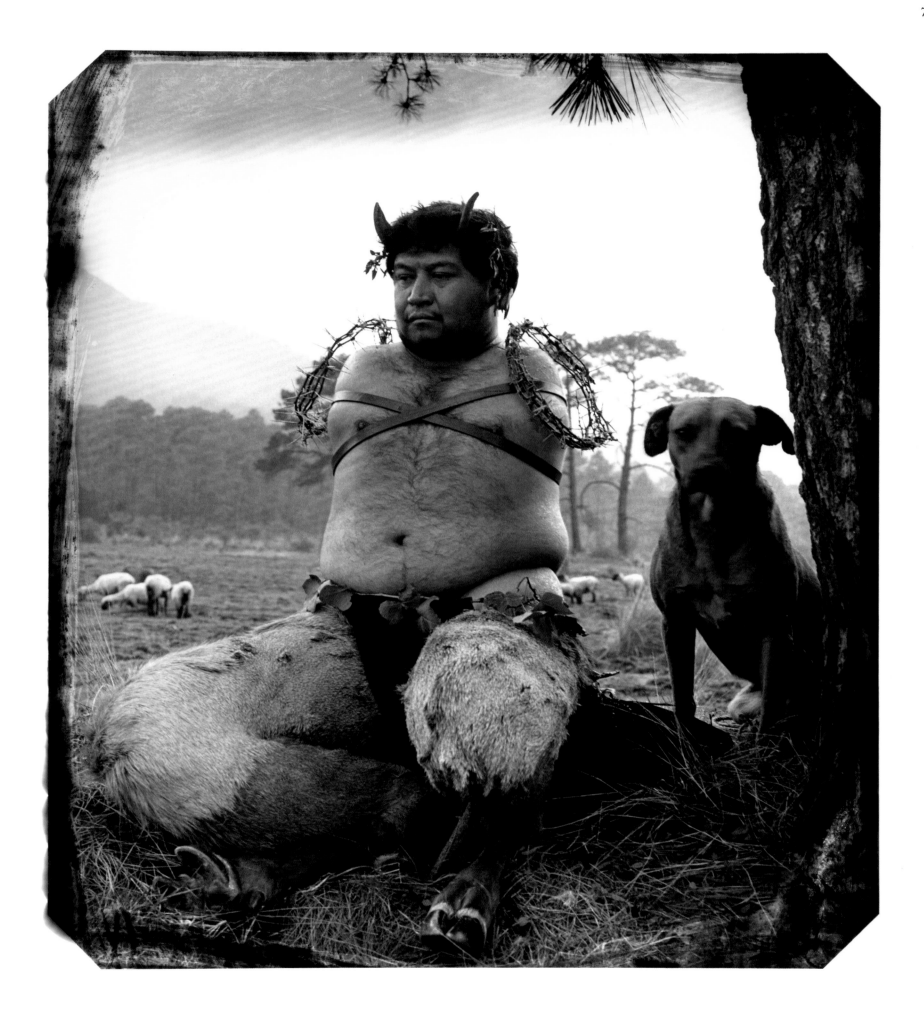

JOEL-PETER WITKIN

Satiro, Mexico, 1992

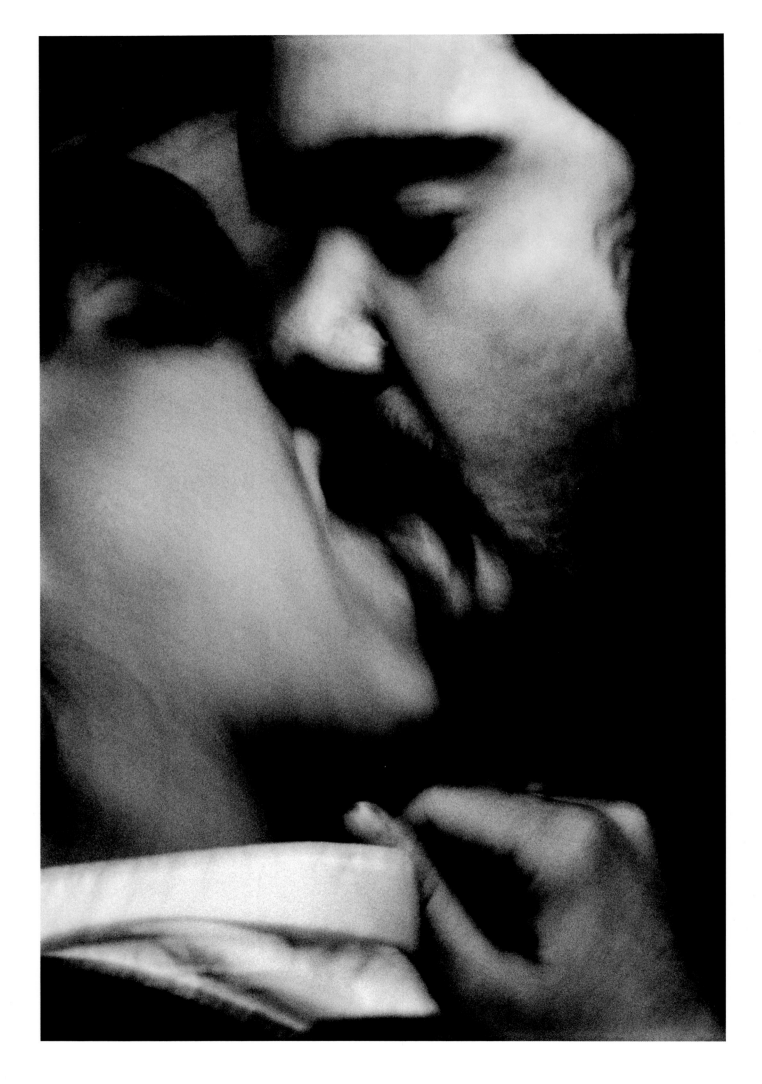

MARGARET M. DE LANGE

From the book *Surrounded by No One*, 2010

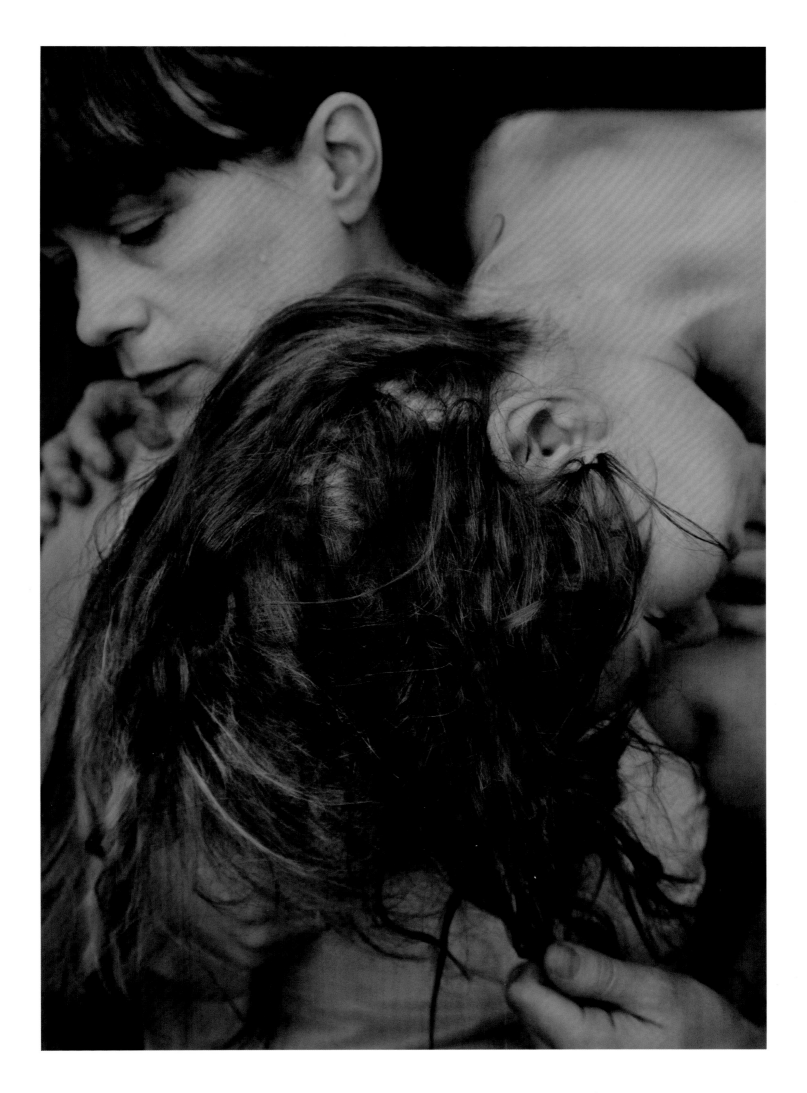

MONIKA MACDONALD

Untitled, from the series *In Absence*, 2015

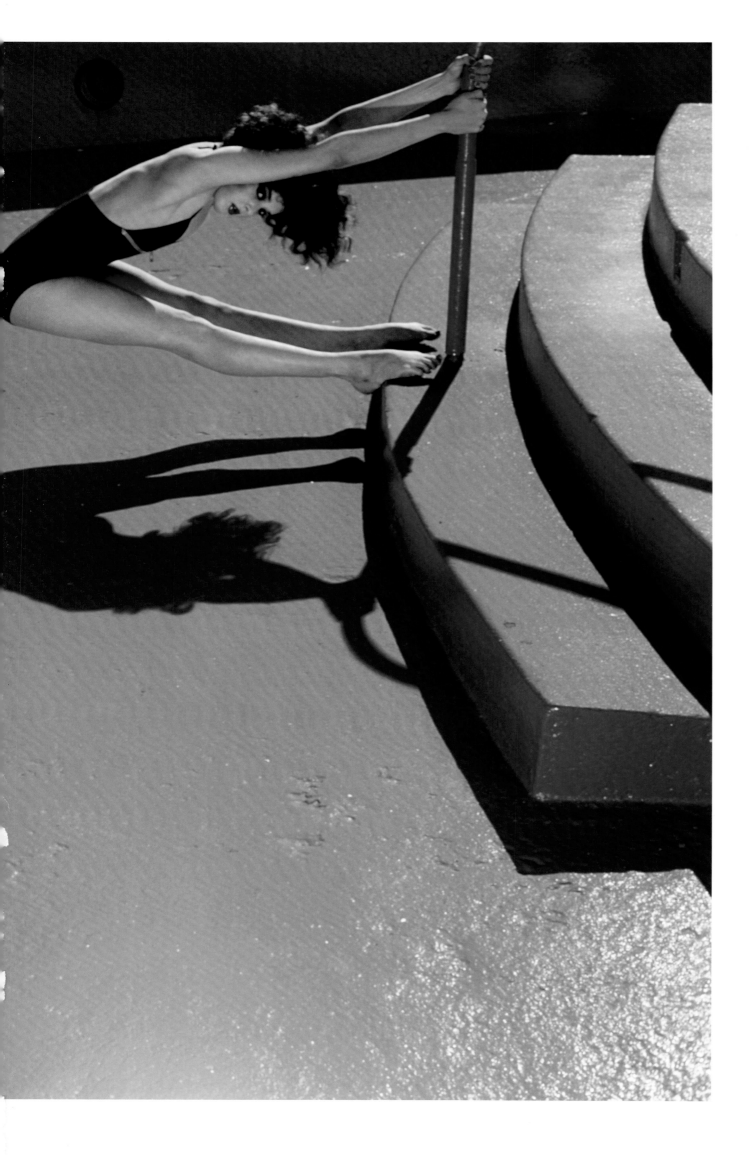

GUY BOURDIN
Guy Bourdin Archives, 1978

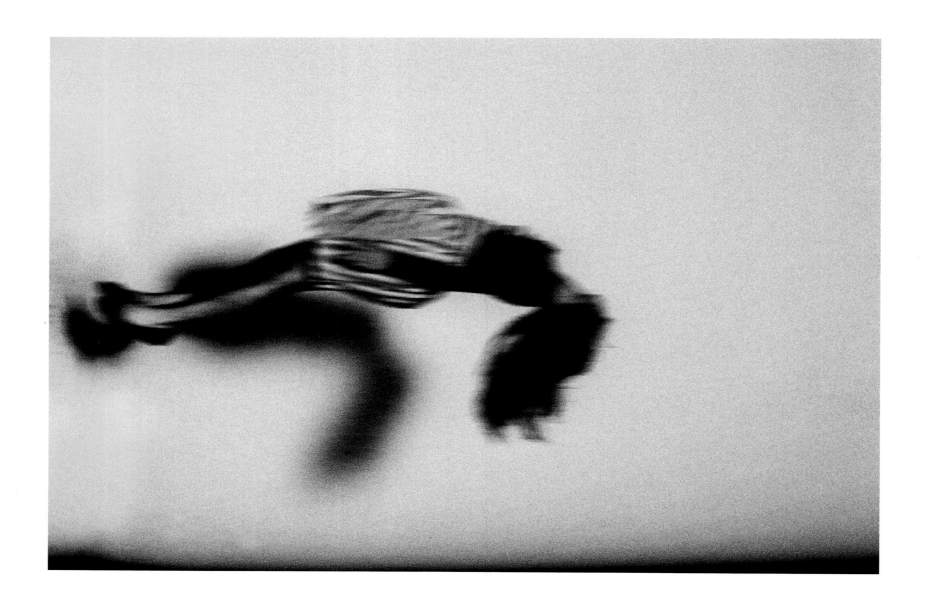

LU KOWSKI

Untitled

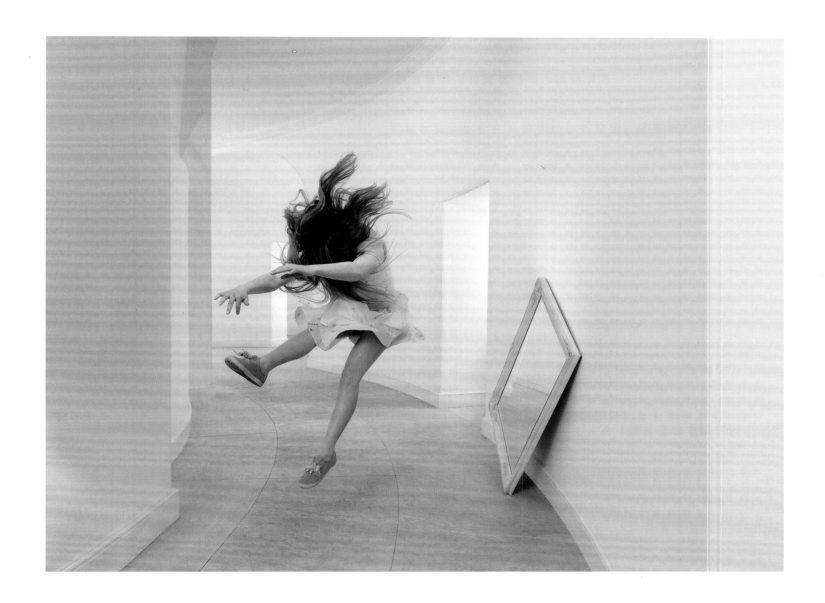

JULIA FULLERTON-BATTEN
Mirror, 2008

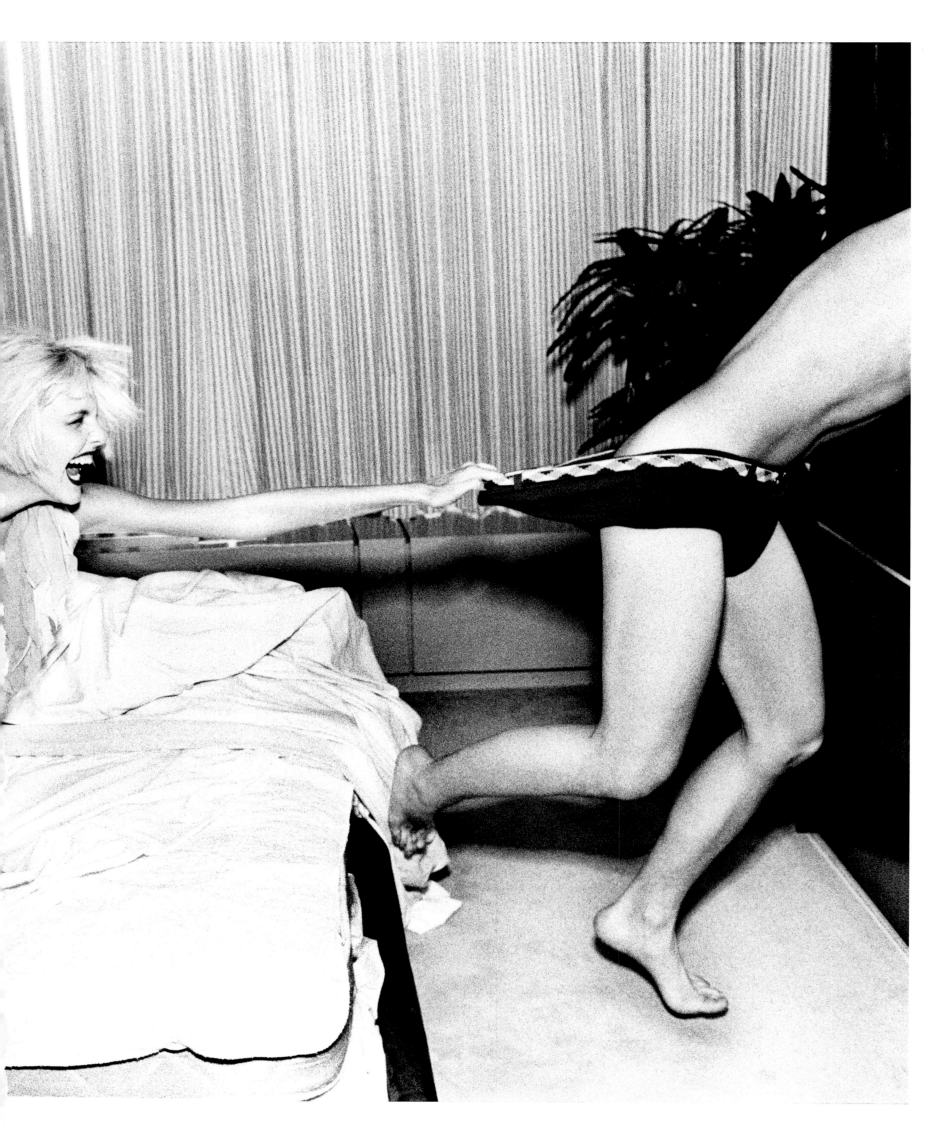

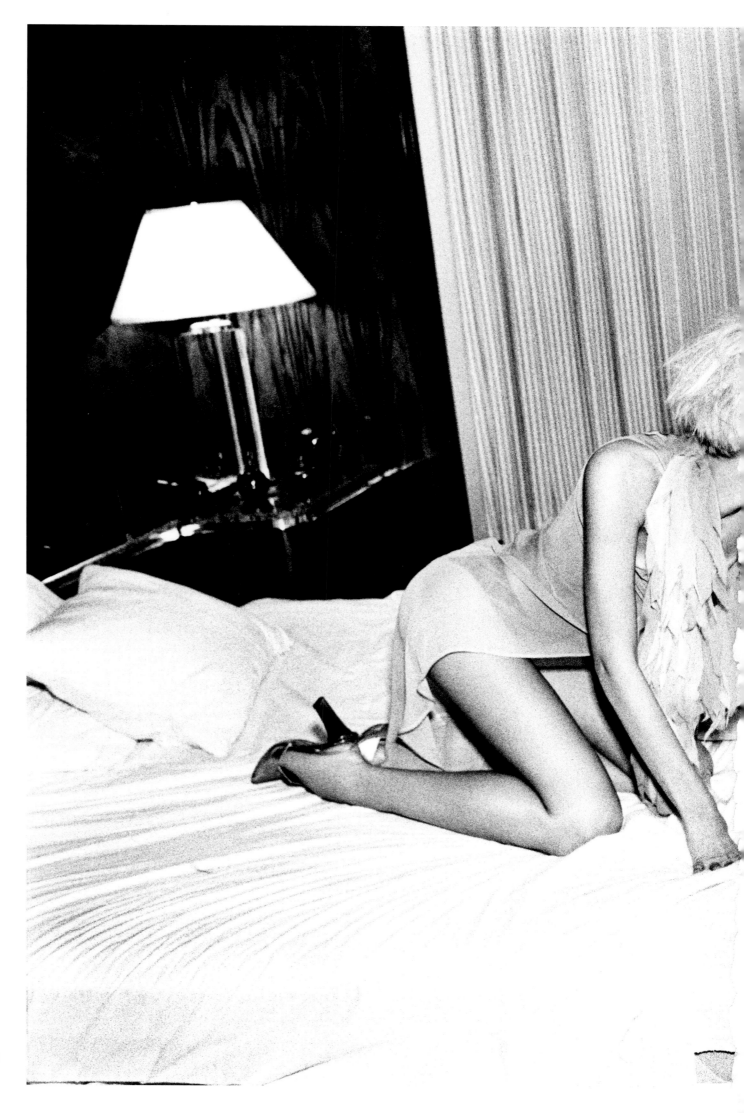

ELLEN VON UNWERTH
Again?, 1997

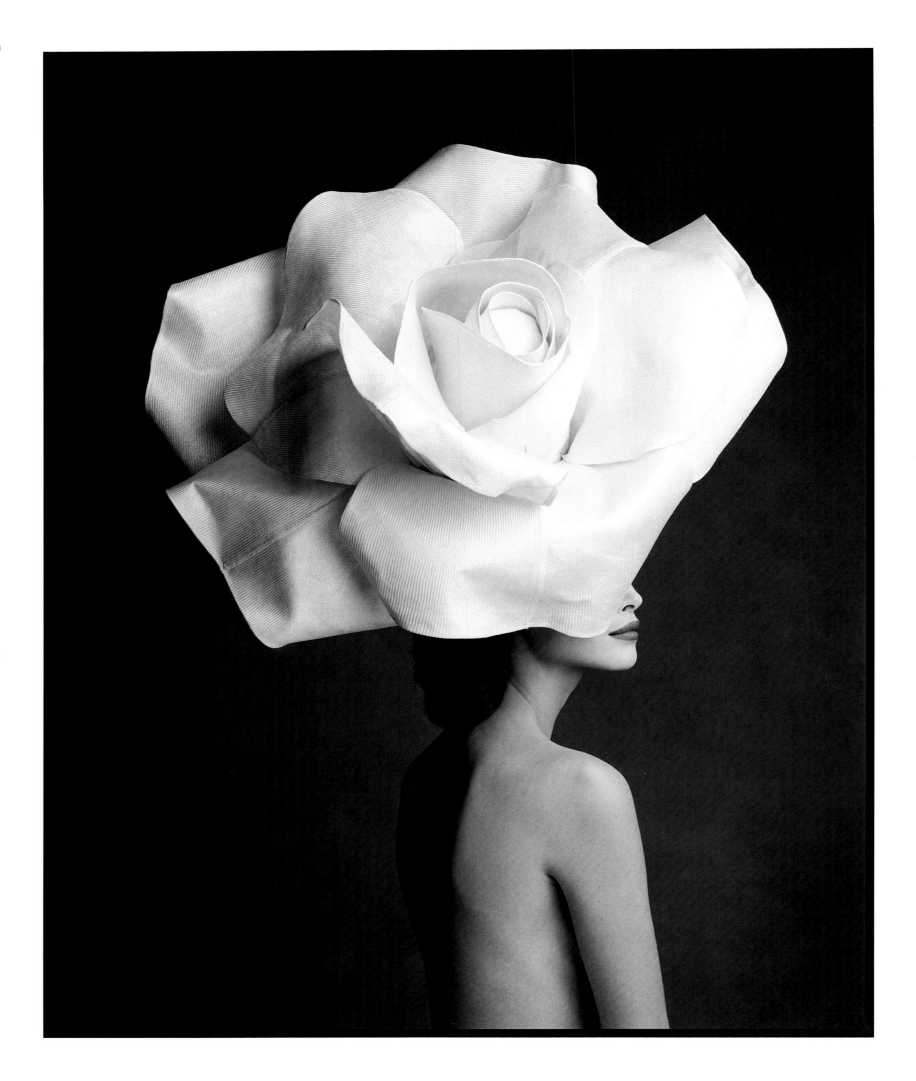

PATRICK DEMARCHELIER

Christy Turlington, New York, 1992

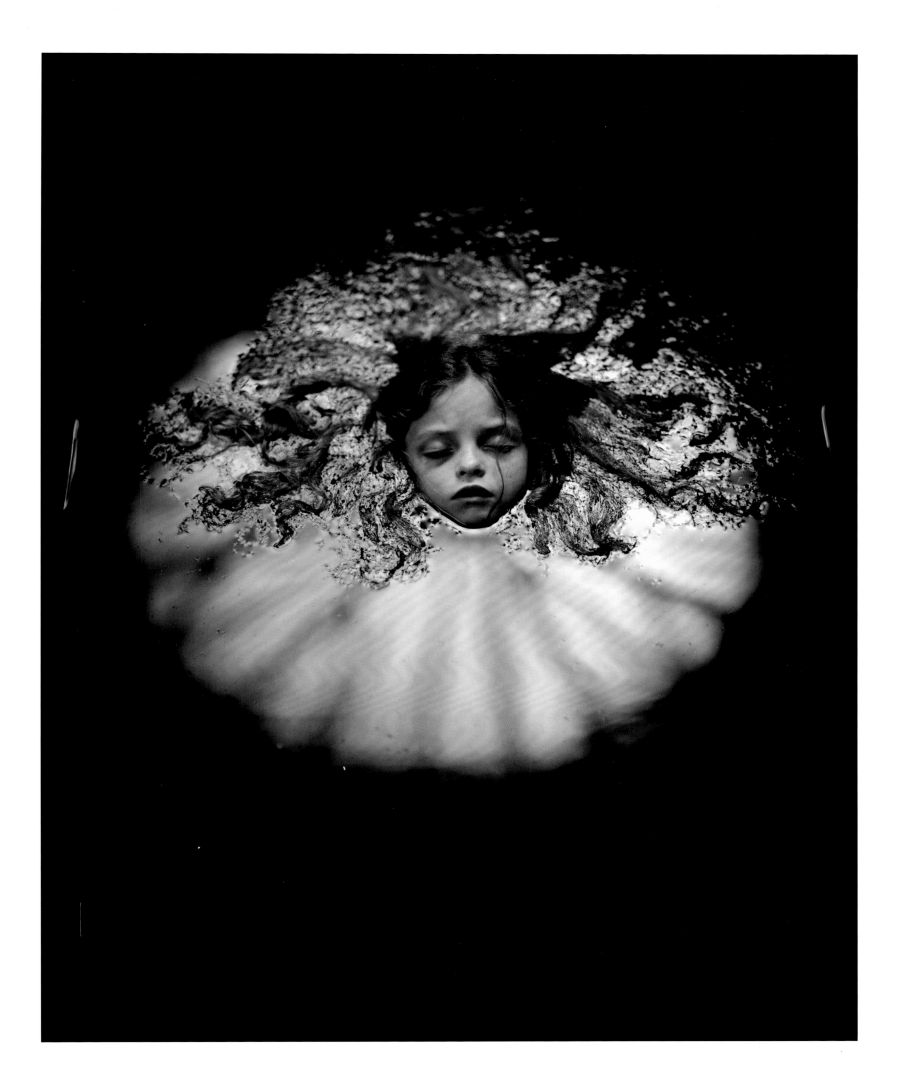

SALLY MANN

At Warm Springs, 1991

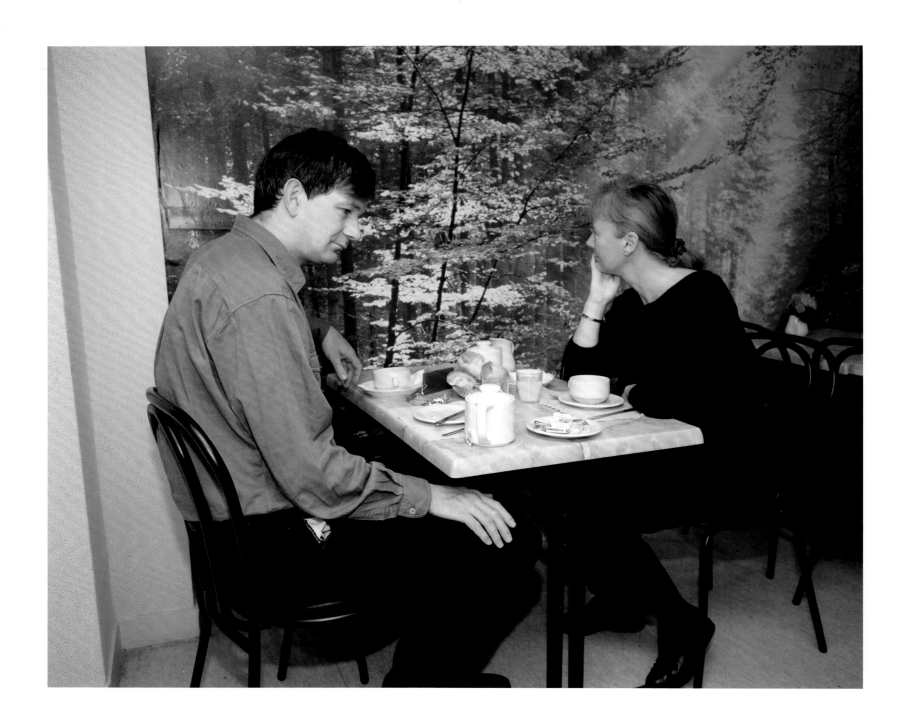

MARTIN PARR
Bored Couples, Paris, France, 1992

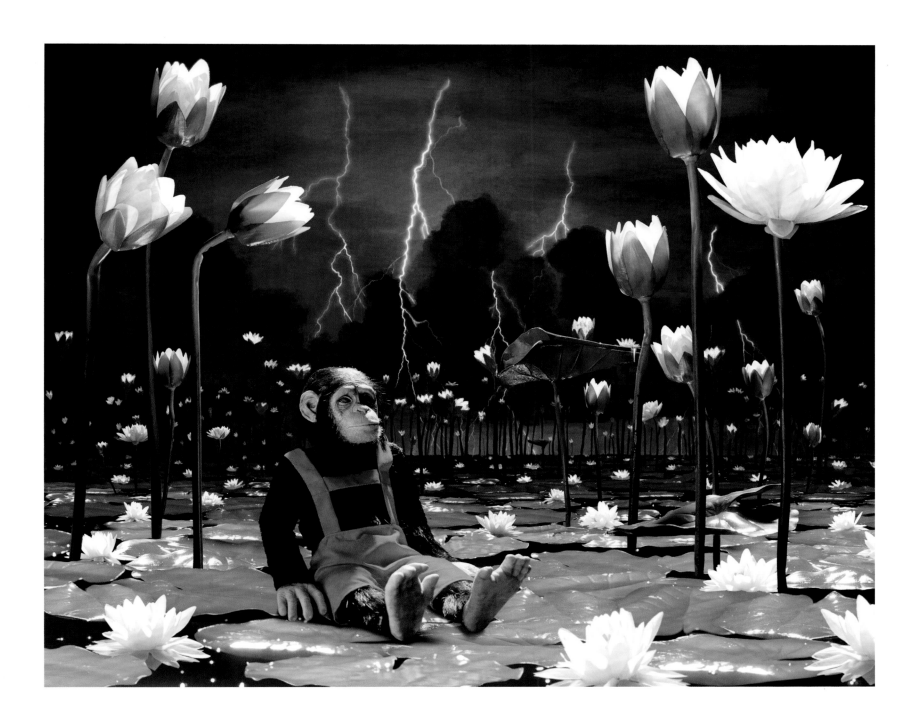

HELENA BLOMQVIST

Waterlilies, 2008

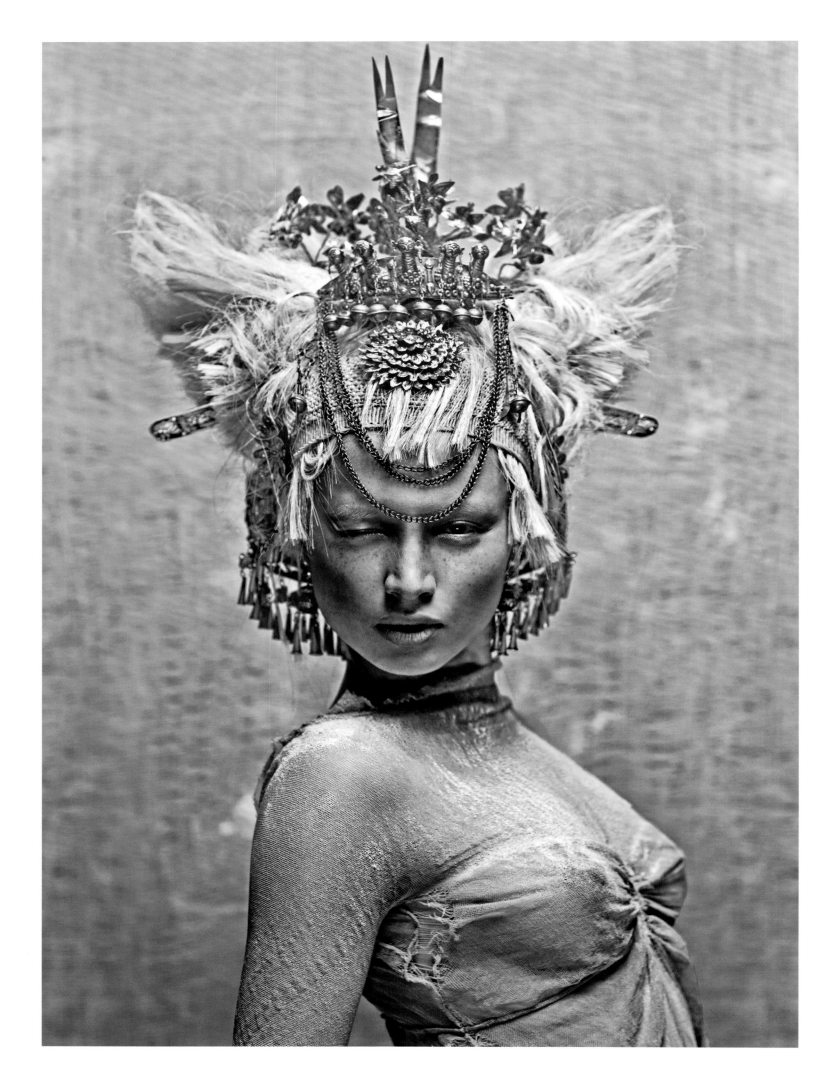

CHEN MAN
12 Chinese Colors, White, 2011

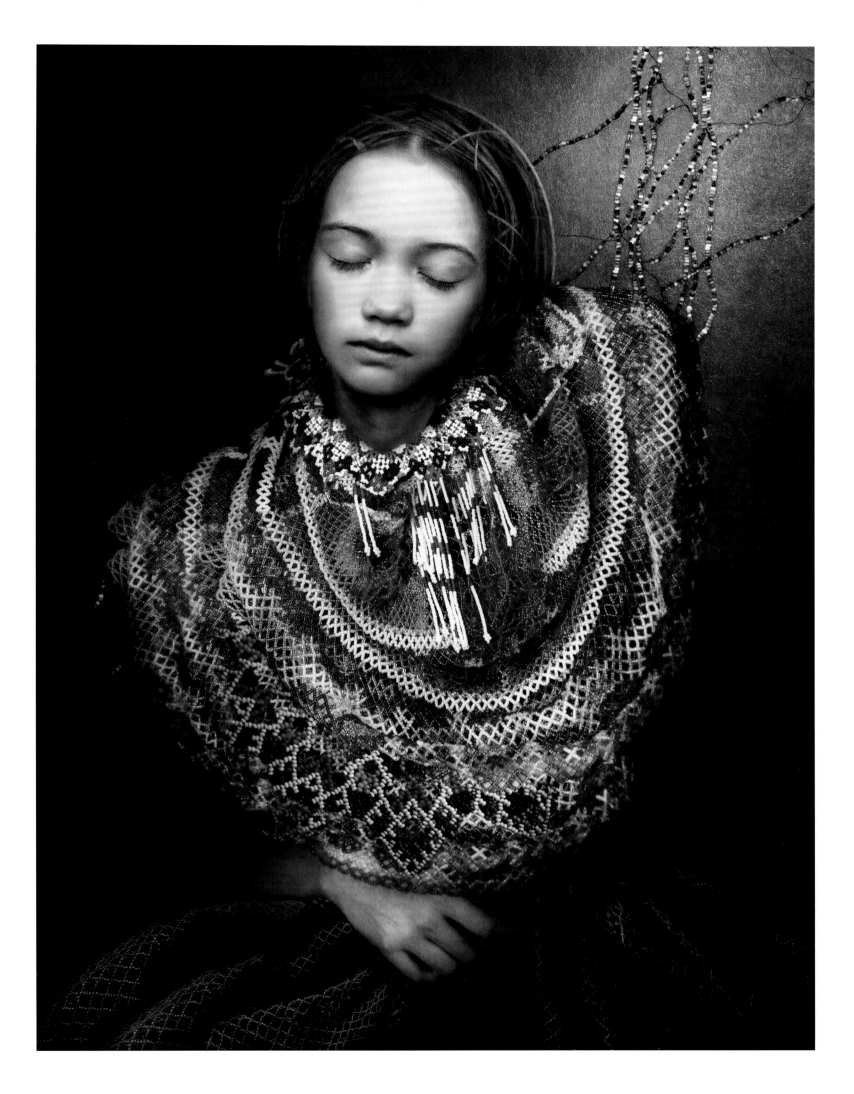

COOPER & GORFER

Ena with Eyes Shut, 2014

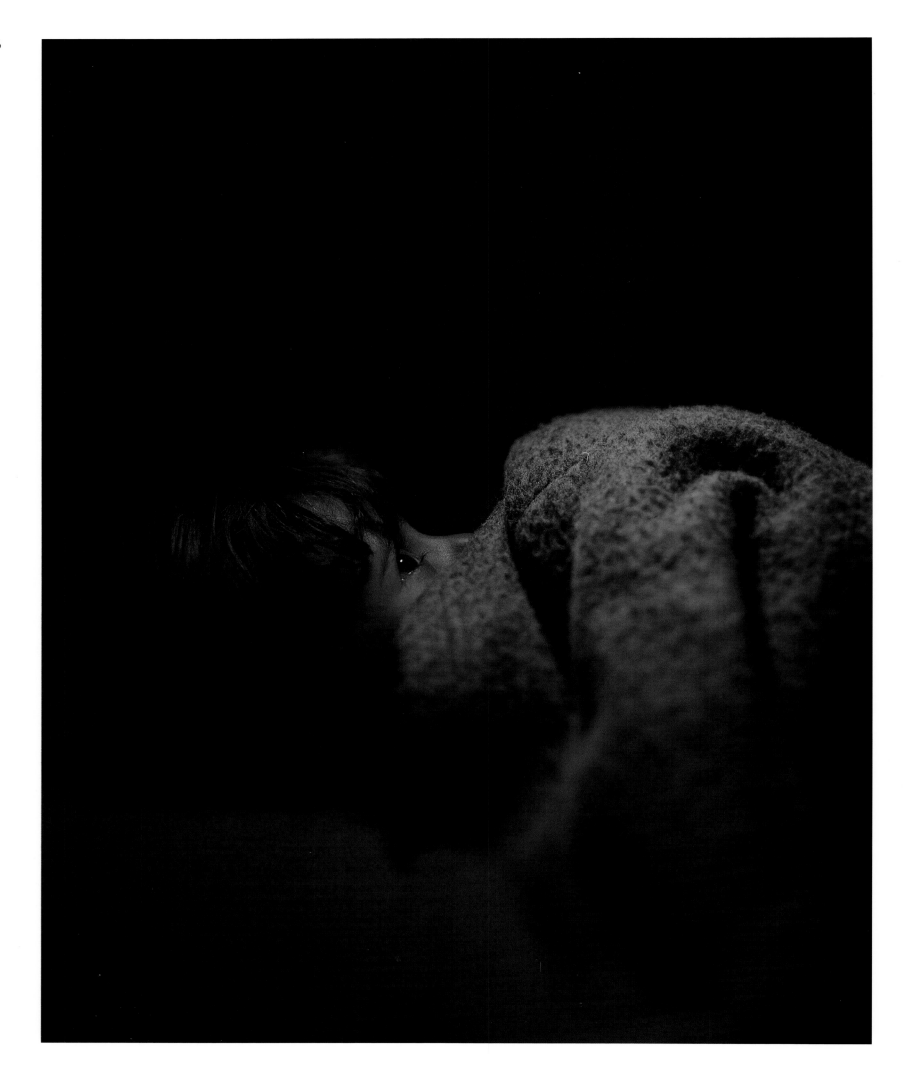

MAGNUS WENNMAN
Farah, 2 Years, 2015

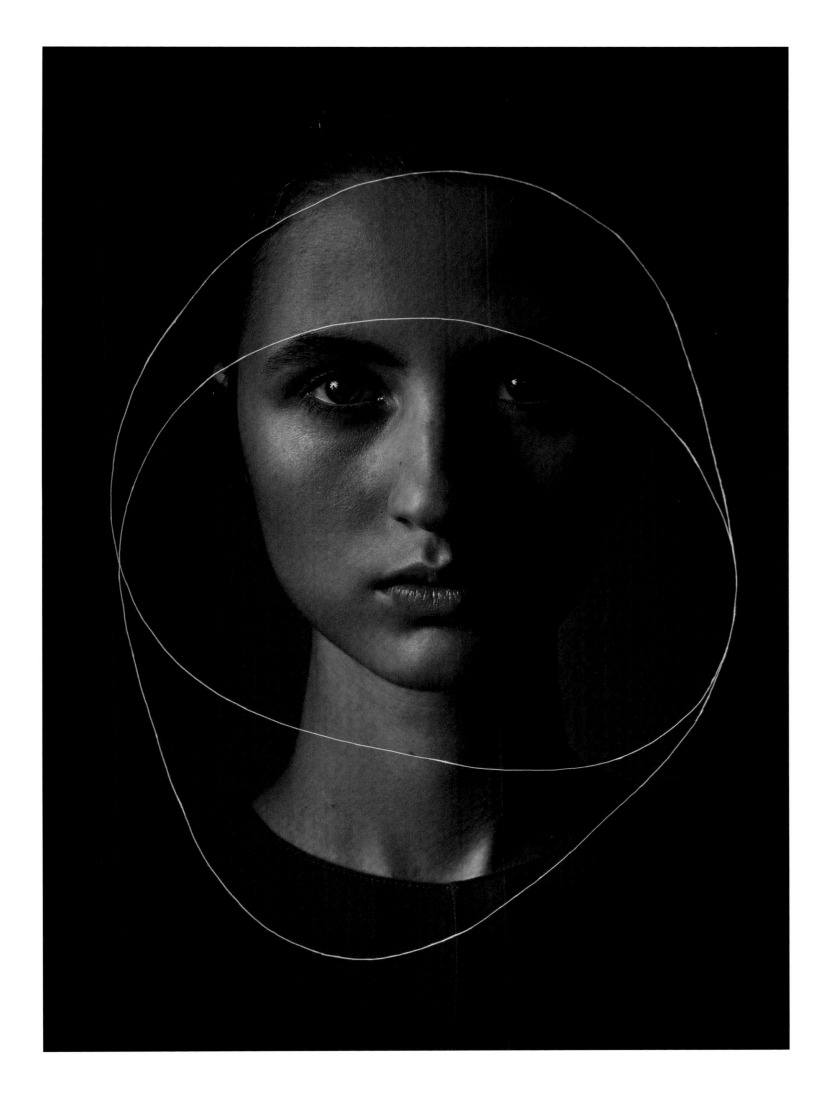

TINA BERNING & MICHELANGELO DI BATTISTA

Black Circle (Leila), 2017

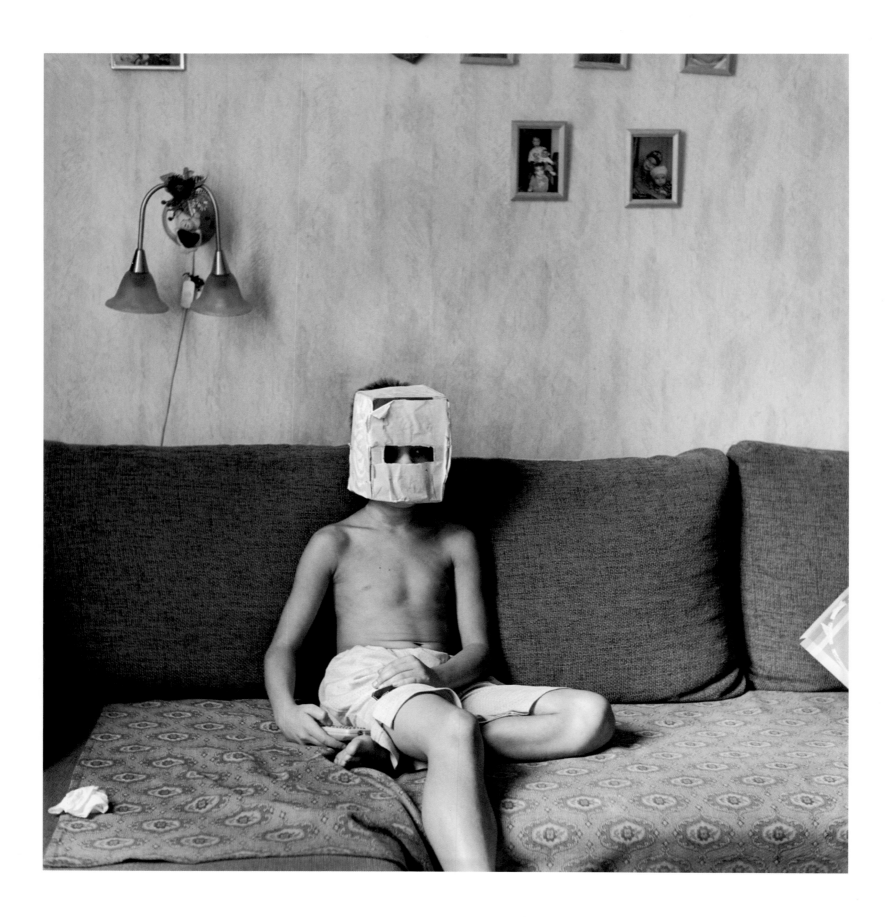

INTA RUKA
Rihards Štībelis, 2006

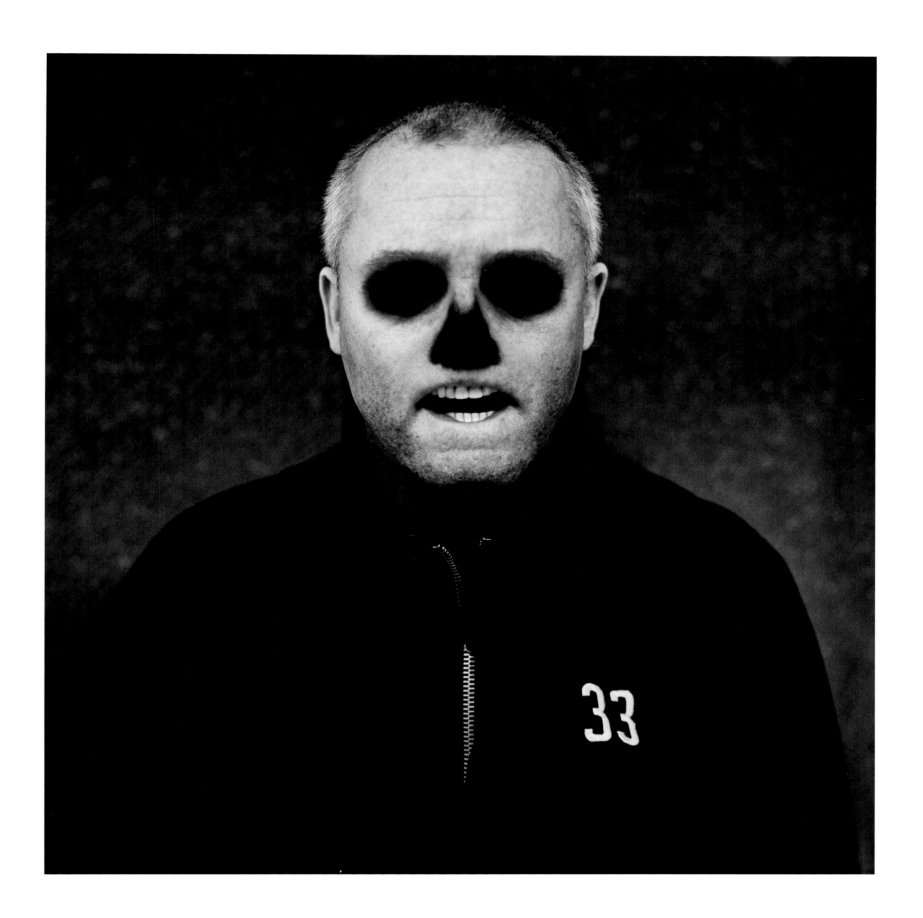

ANTON CORBIJN
Damien Hirst, 2011

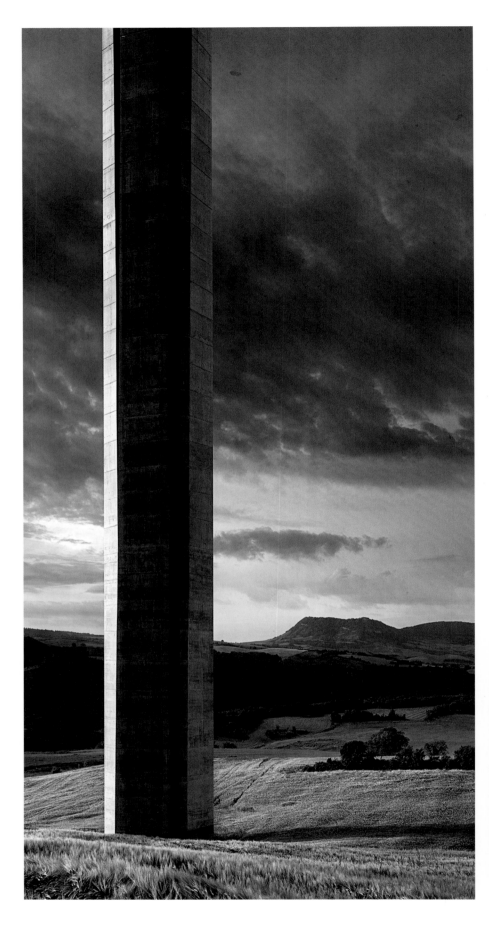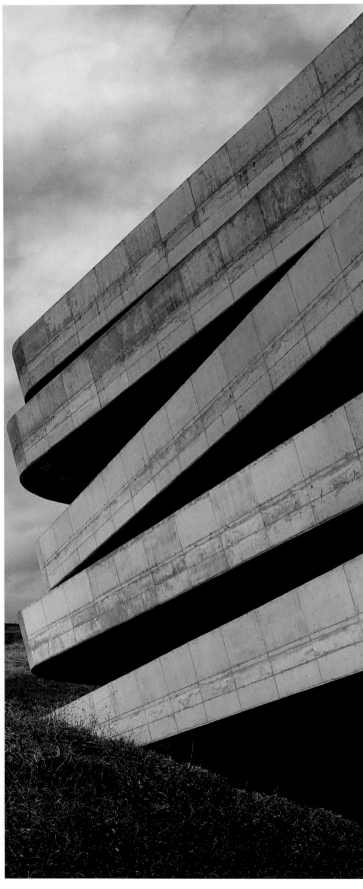

AITOR ORTIZ
Millau 003, 2008. Destructuras 105, 2011

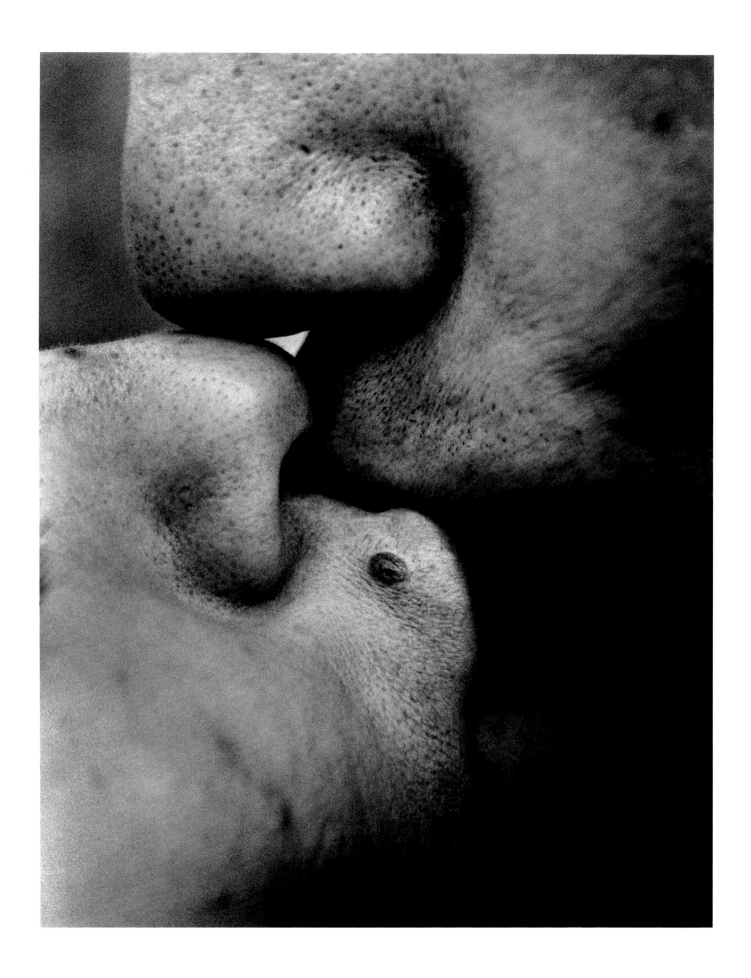

CHRISTER STRÖMHOLM
Kischka and Daniel, Paris, 1962

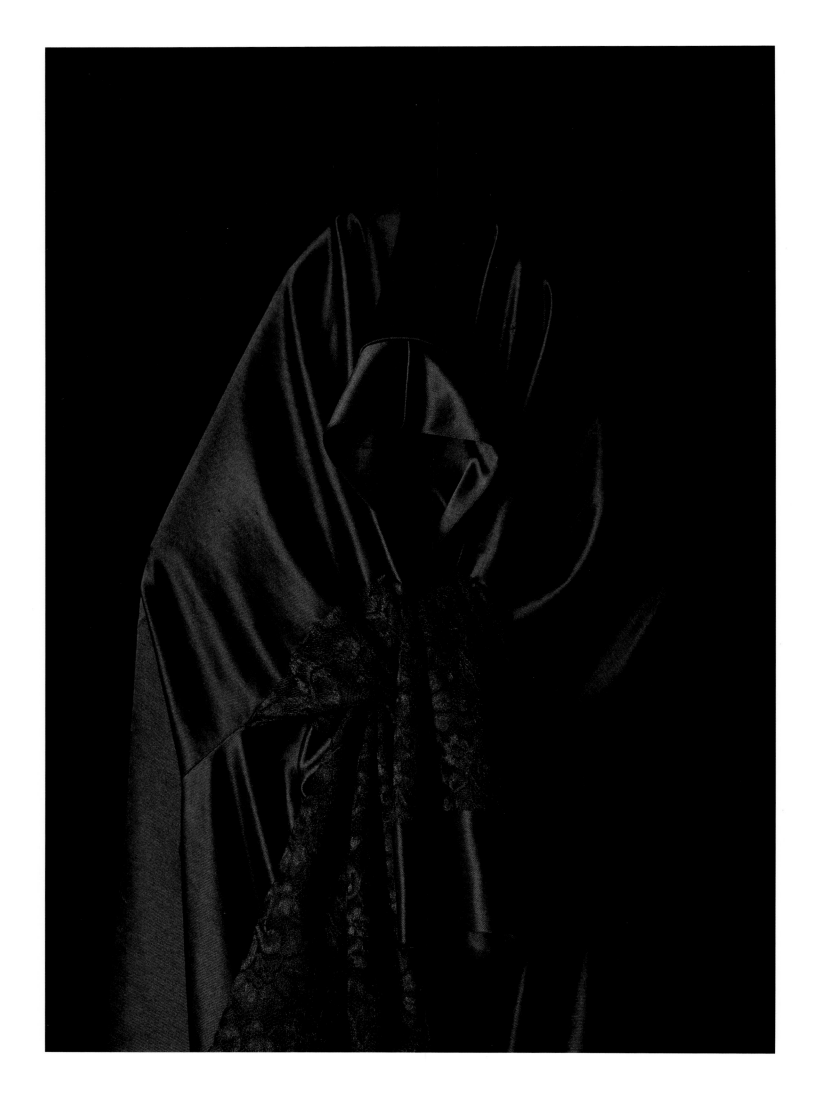

VÉRONIQUE DUCHARME

Armour I, 2010

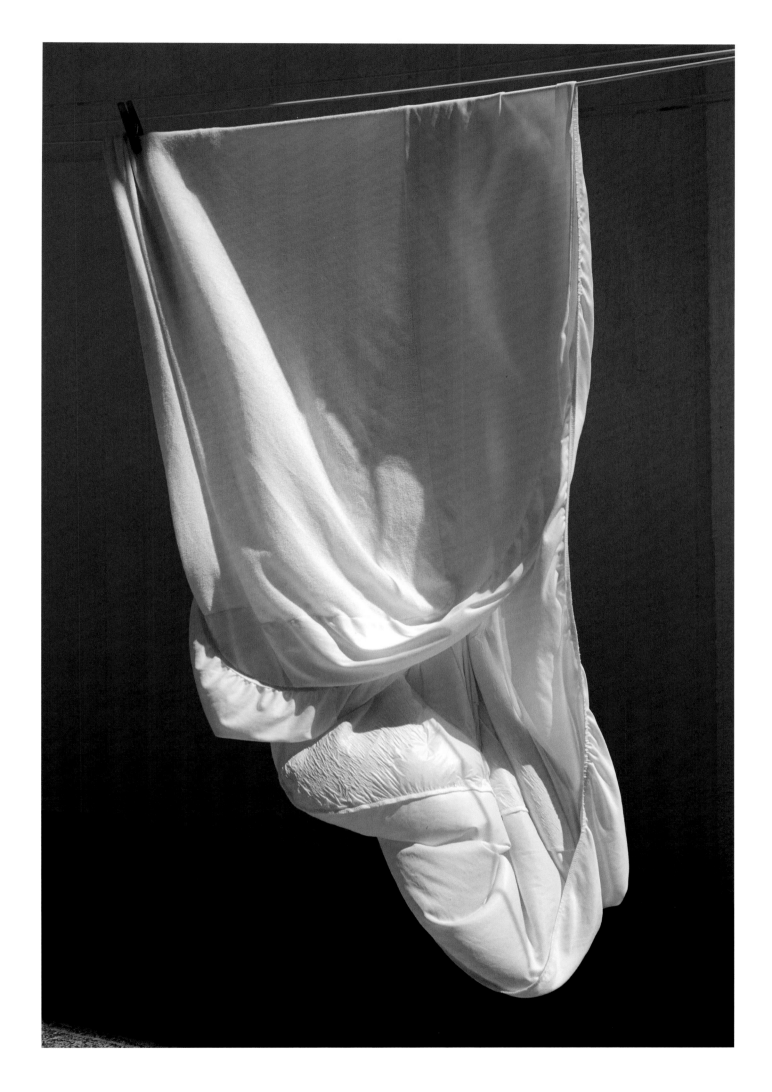

VIVIANE SASSEN

Sheet, Larvae, from the series *Umbra*, 2014

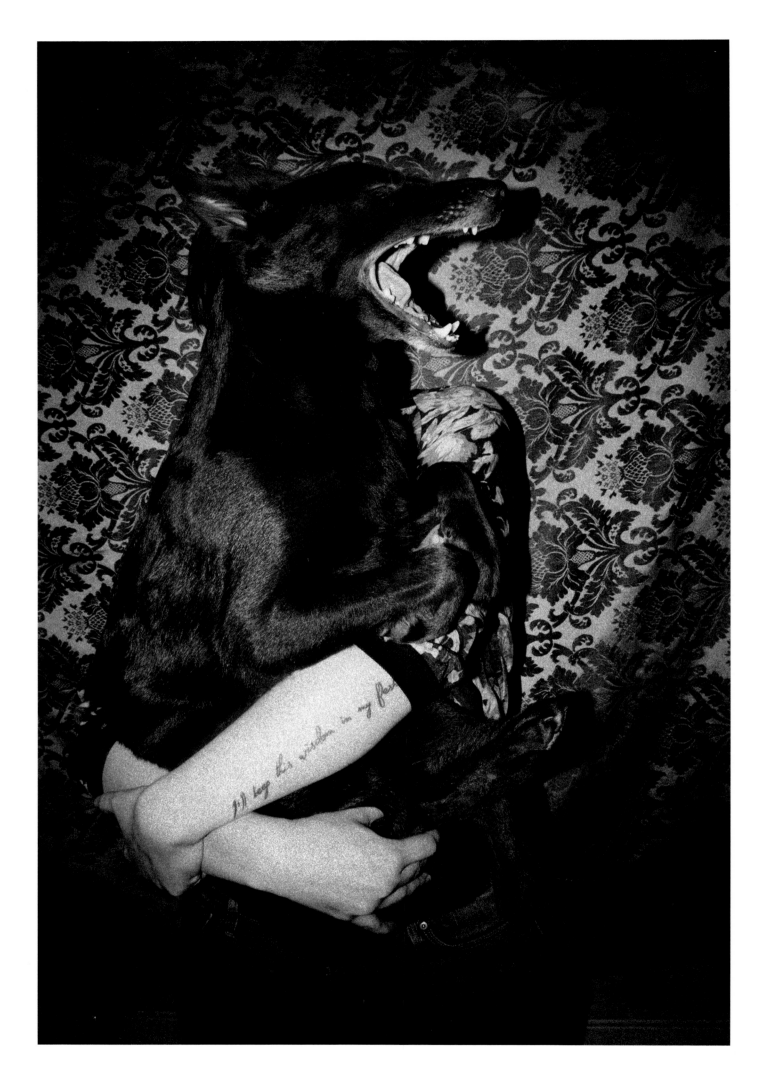

LU KOWSKI

Untitled

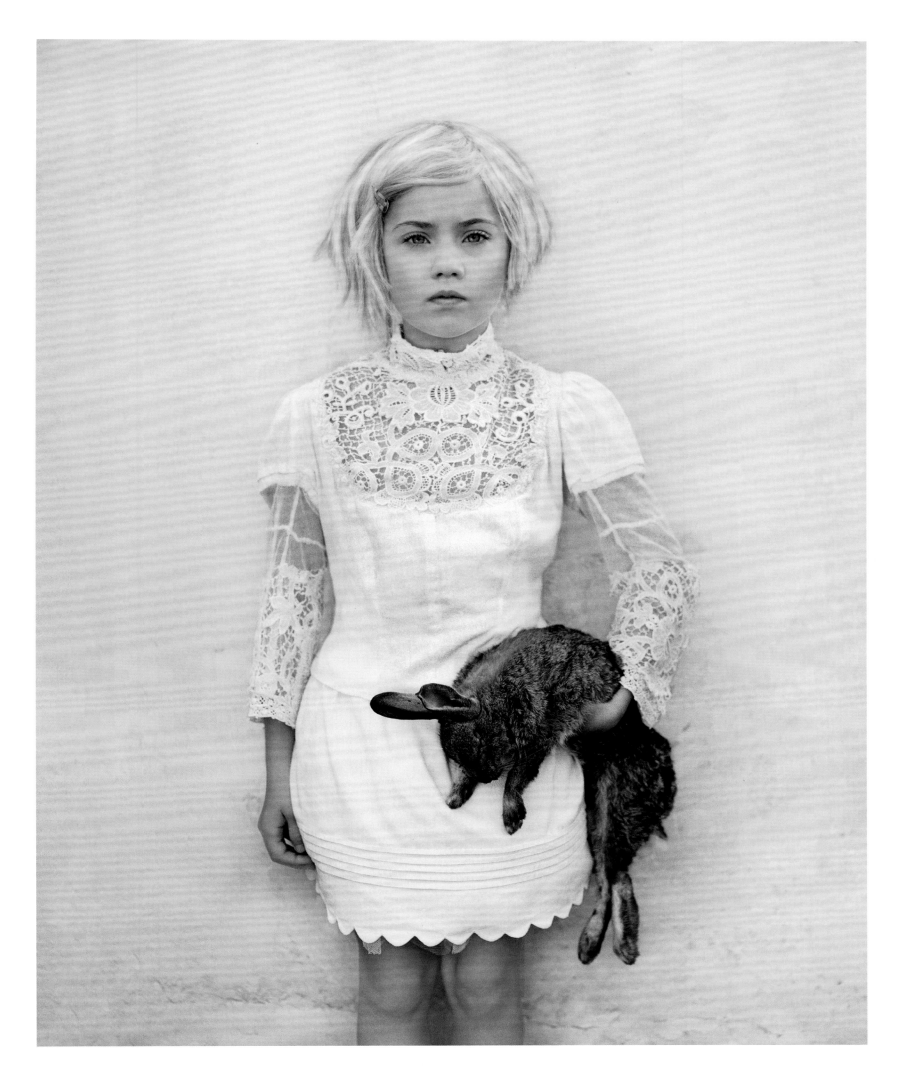

VEE SPEERS

Untitled No. 30, from the series *The Birthday Party*, 2007

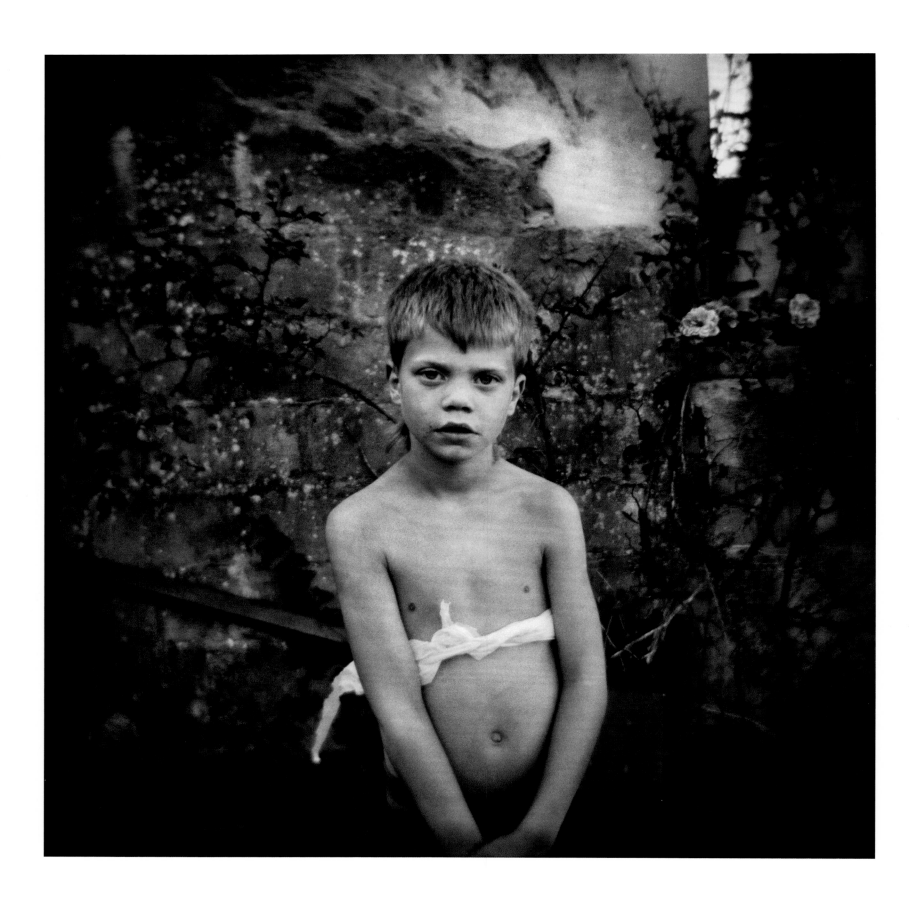

MARTIN BOGREN

Untitled

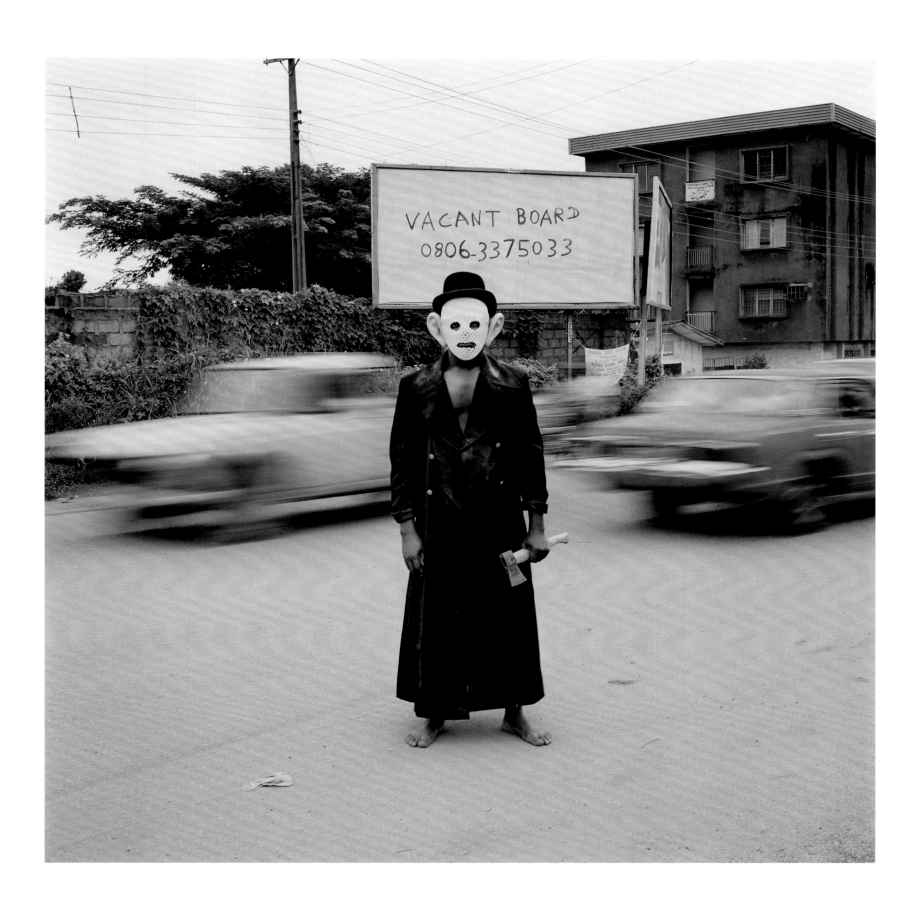

PIETER HUGO
Escort Kama, Enugu, Nigeria, 2008

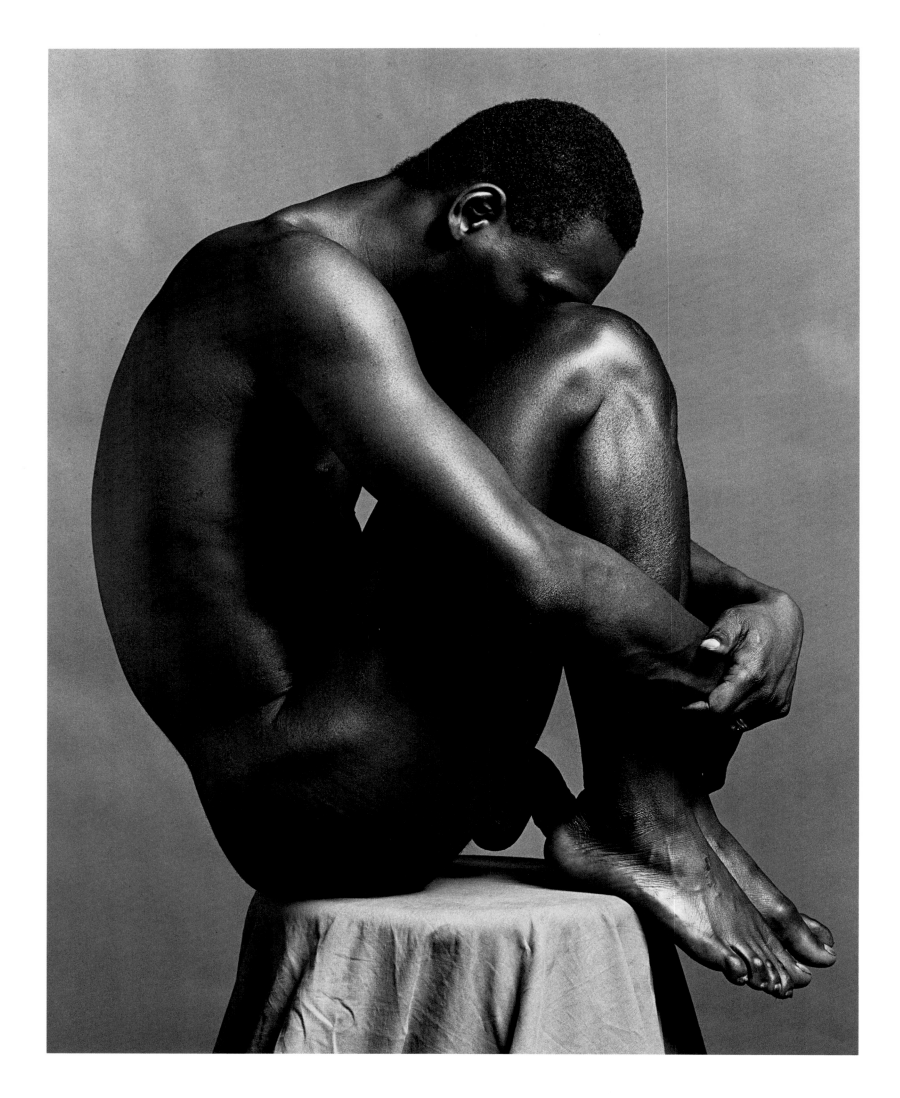

ROBERT MAPPLETHORPE

Ajitto, 1981

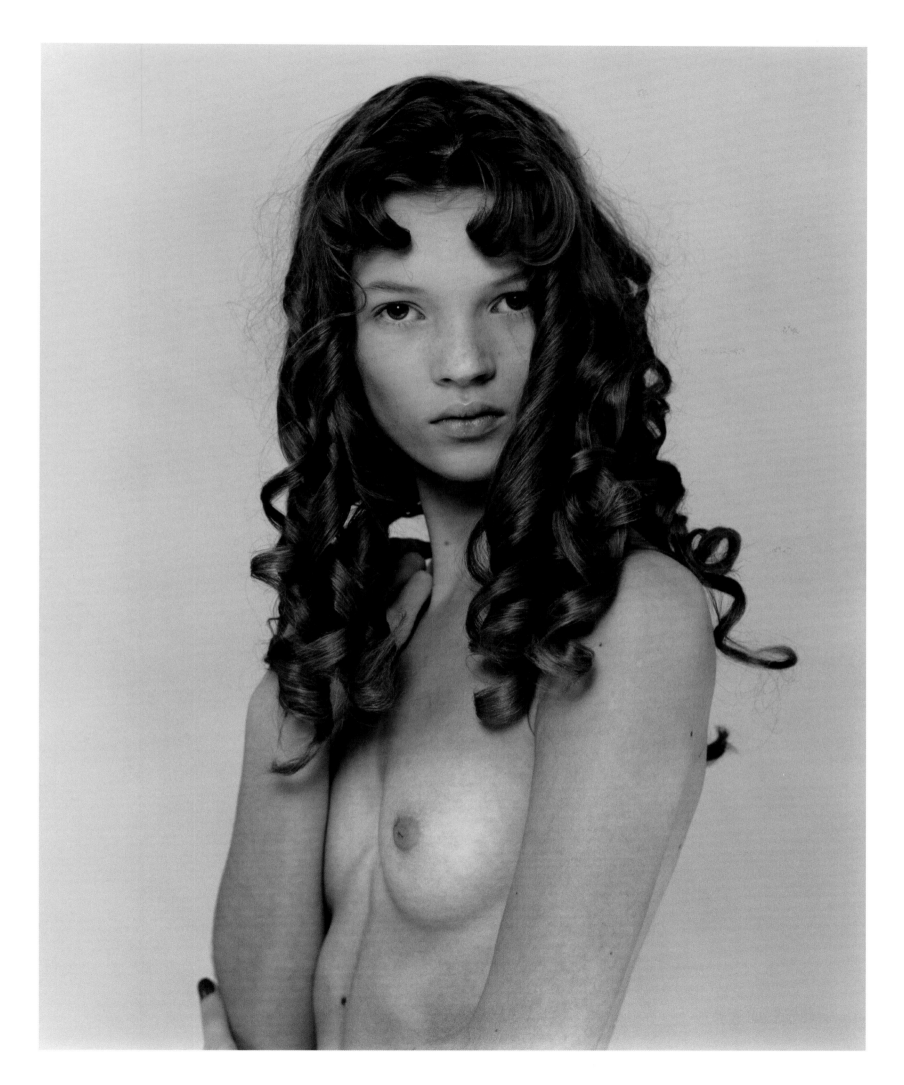

BETTINA RHEIMS

Kate, from the series *Modern Lovers*, London, December 1989

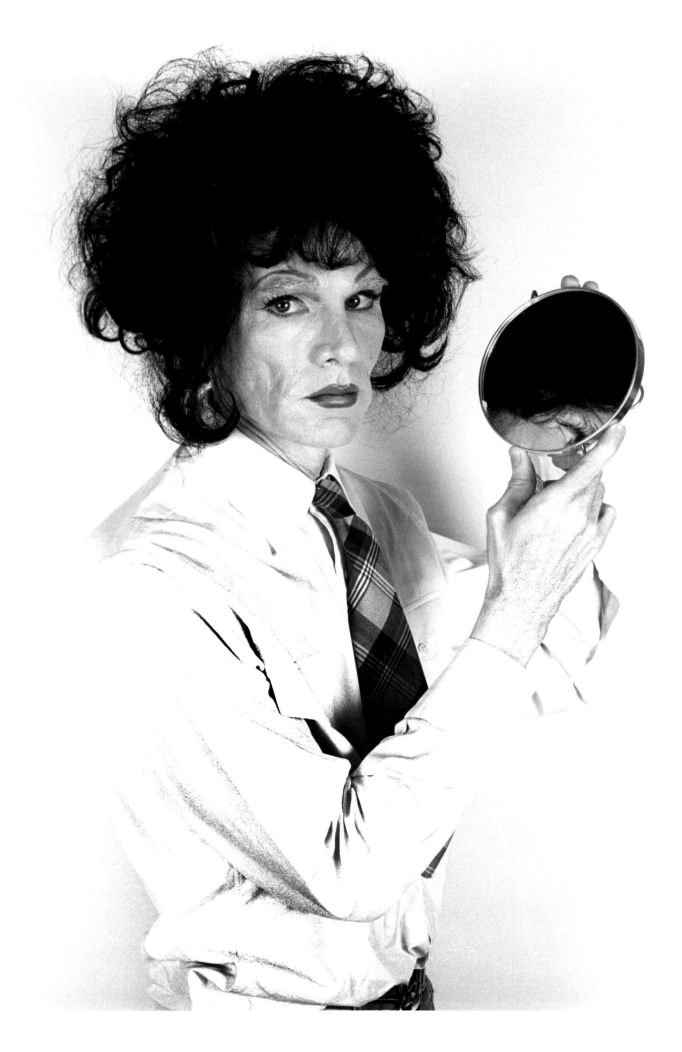

CHRISTOPHER MAKOS
Altered Image, Andy with Black Hair, Holding a Mirror, New York, 1981

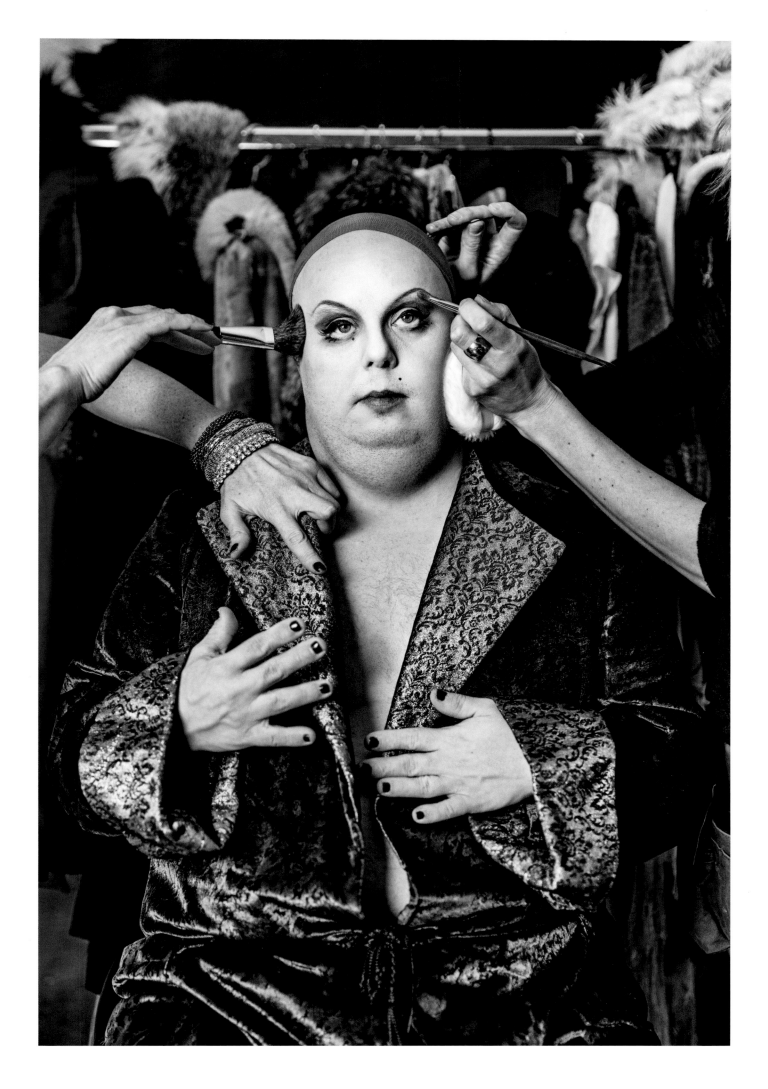

EMMA SVENSSON
Diva, 2016

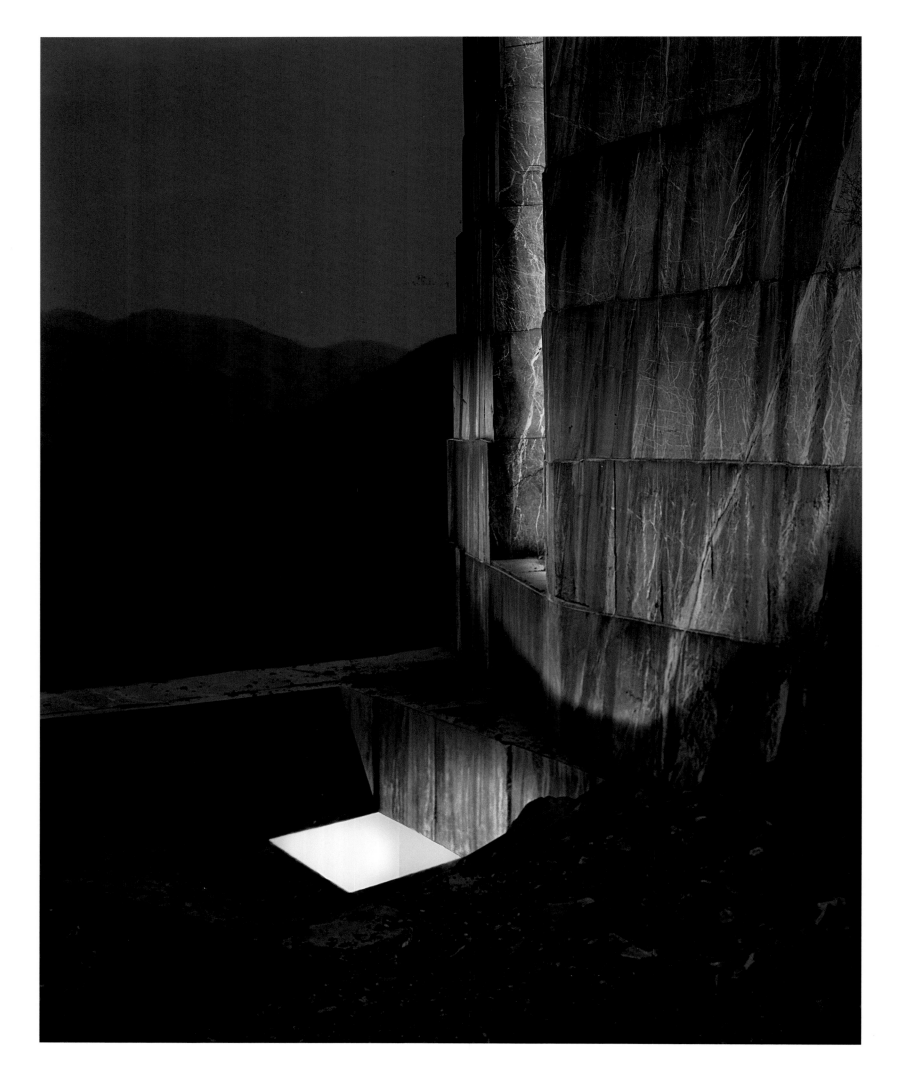

AITOR ORTIZ
Muros de Luz 015, 2005

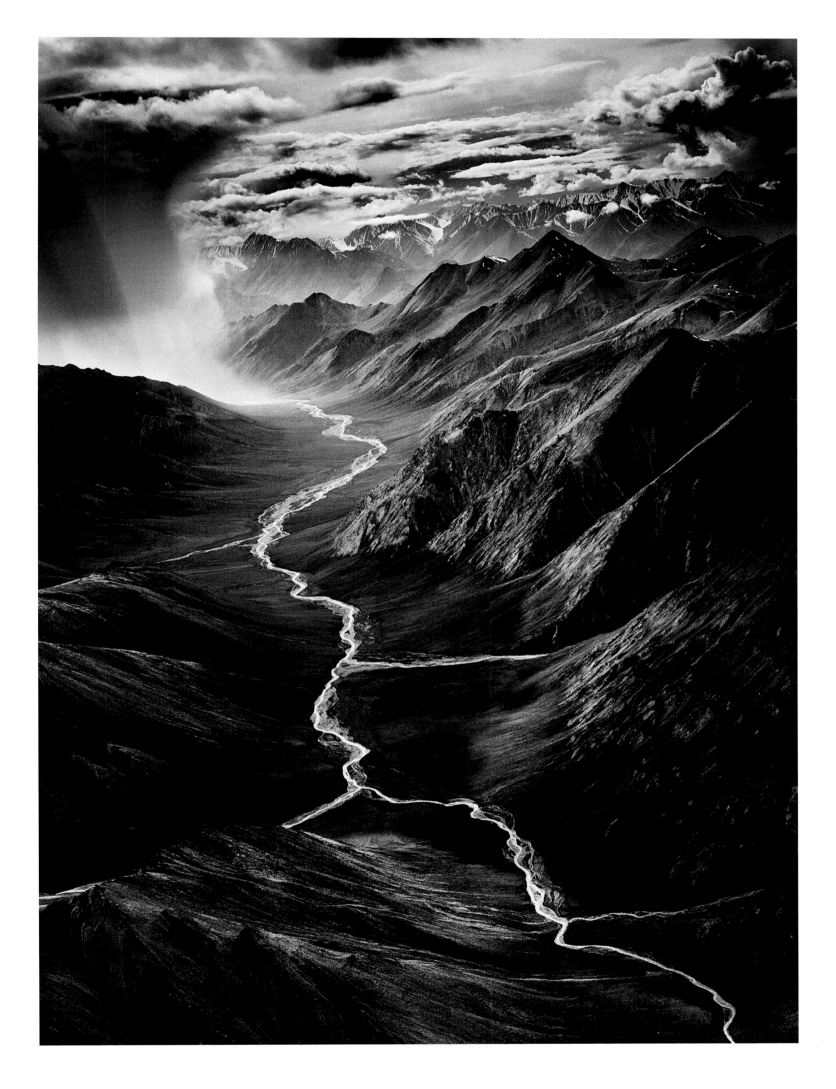

SEBASTIÃO SALGADO

Brooks Range, Arctic National Wildlife Refuge, Alaska, USA, 2009

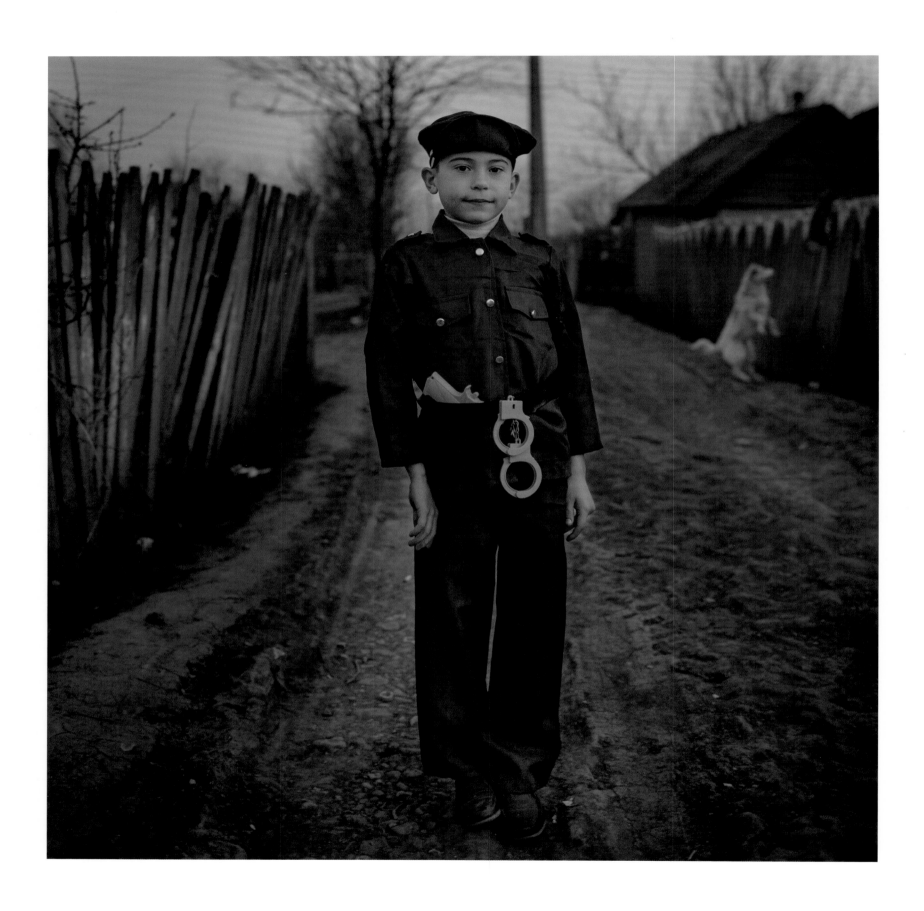

ÅSA SJÖSTRÖM
Hugh Jr., Baroncea, 2014

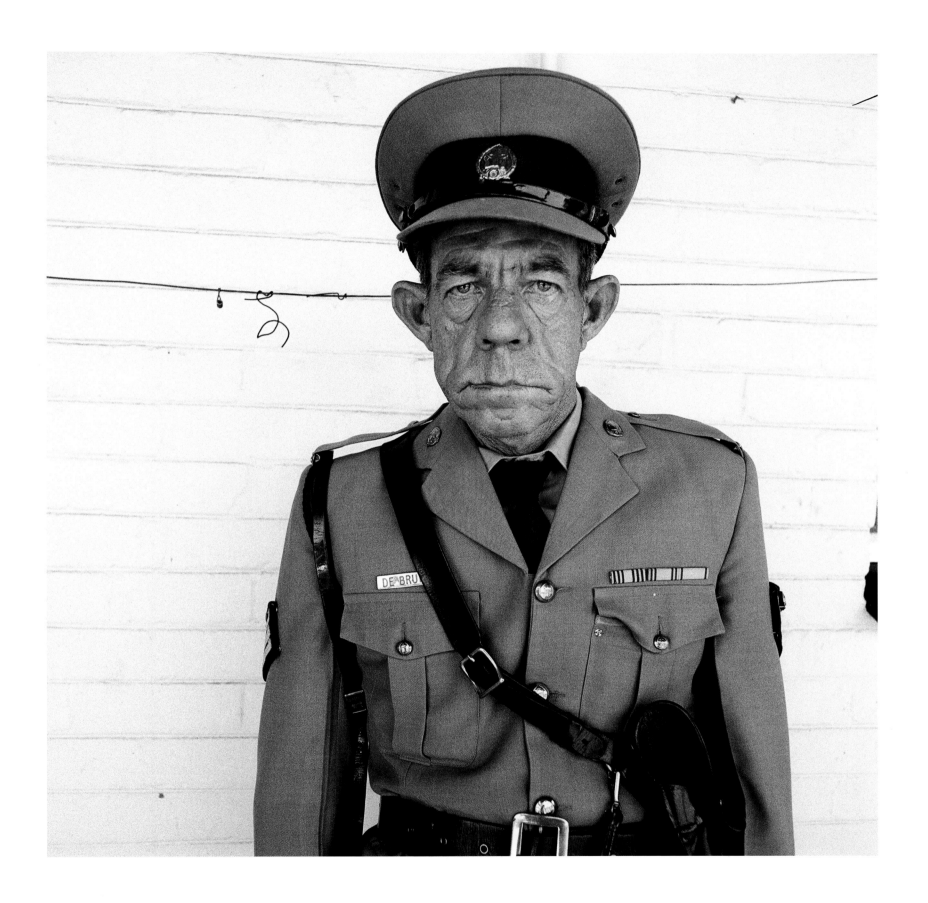

ROGER BALLEN

Sergeant F. de Bruin, Department of Prisons Employee, Orange Free State, 1992

"Shoot from the gut, edit with the brain."

ANDERS PETERSEN

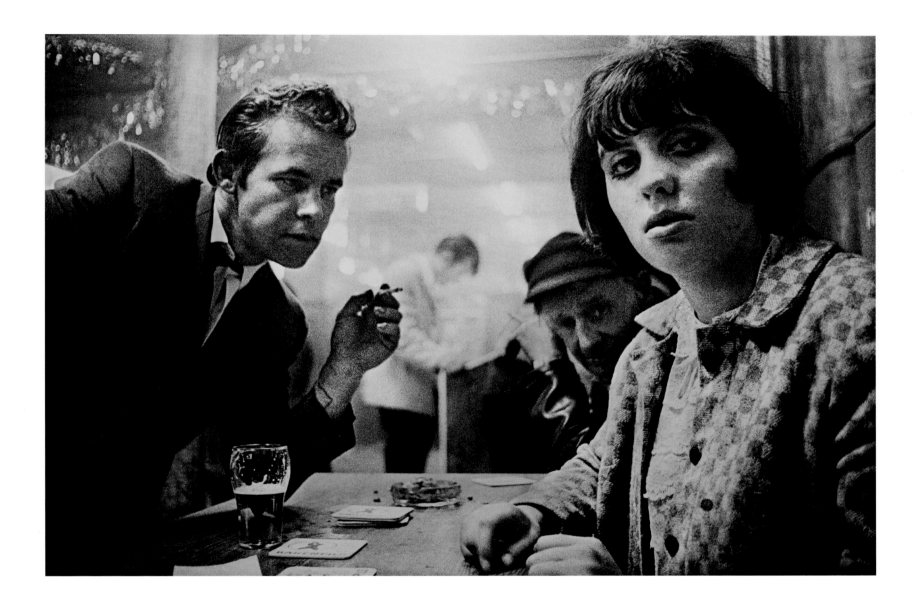

ANDERS PETERSEN

Untitled, from the series *Café Lehmitz*, 1967–1970

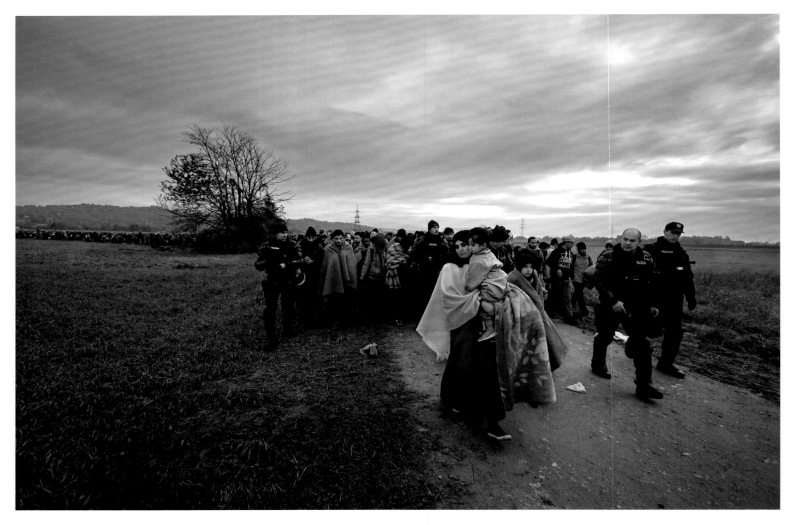

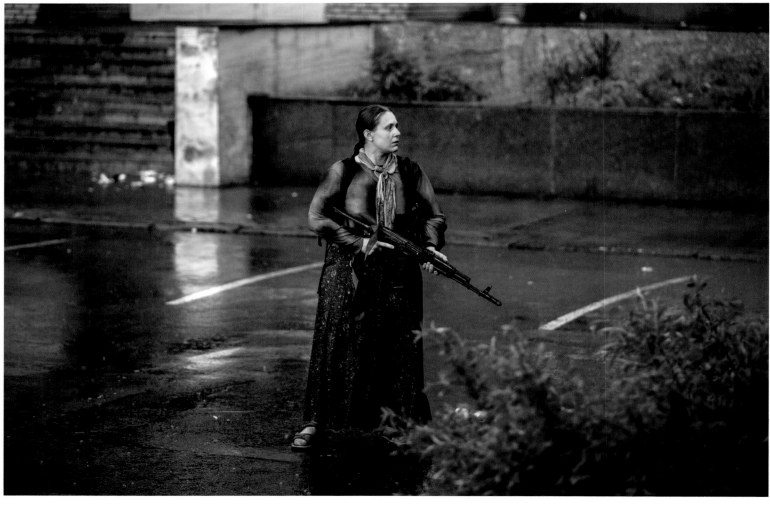

PAUL HANSEN

Escape to Nowhere, Rigonce, Slovenia, 2015. War by Proxy, Slavyansk, Ukraine, 2014

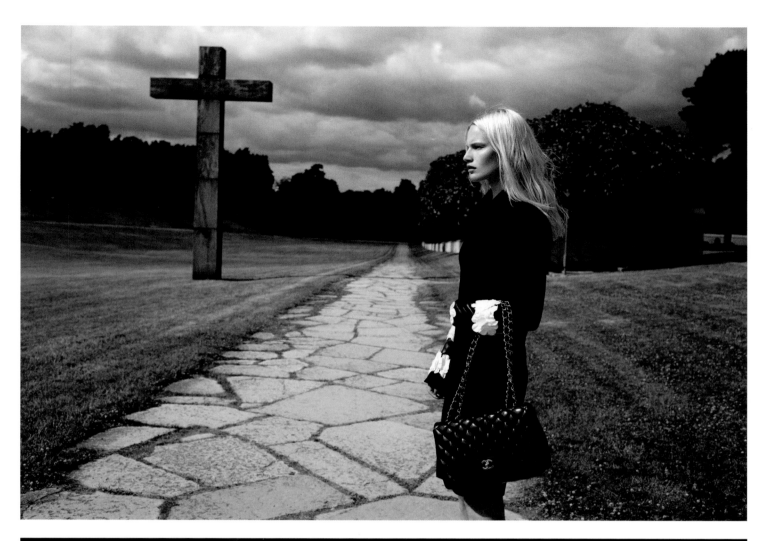

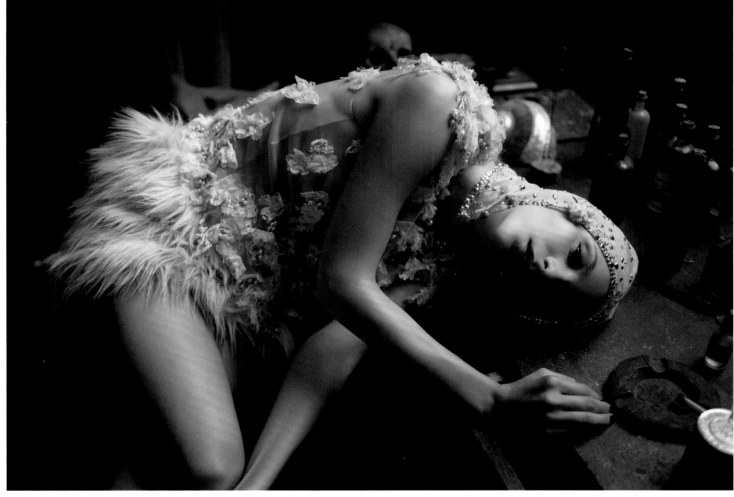

PETER FARAGO & INGELA KLEMETZ FARAGO

Vicky – Path. Dorothea – Still

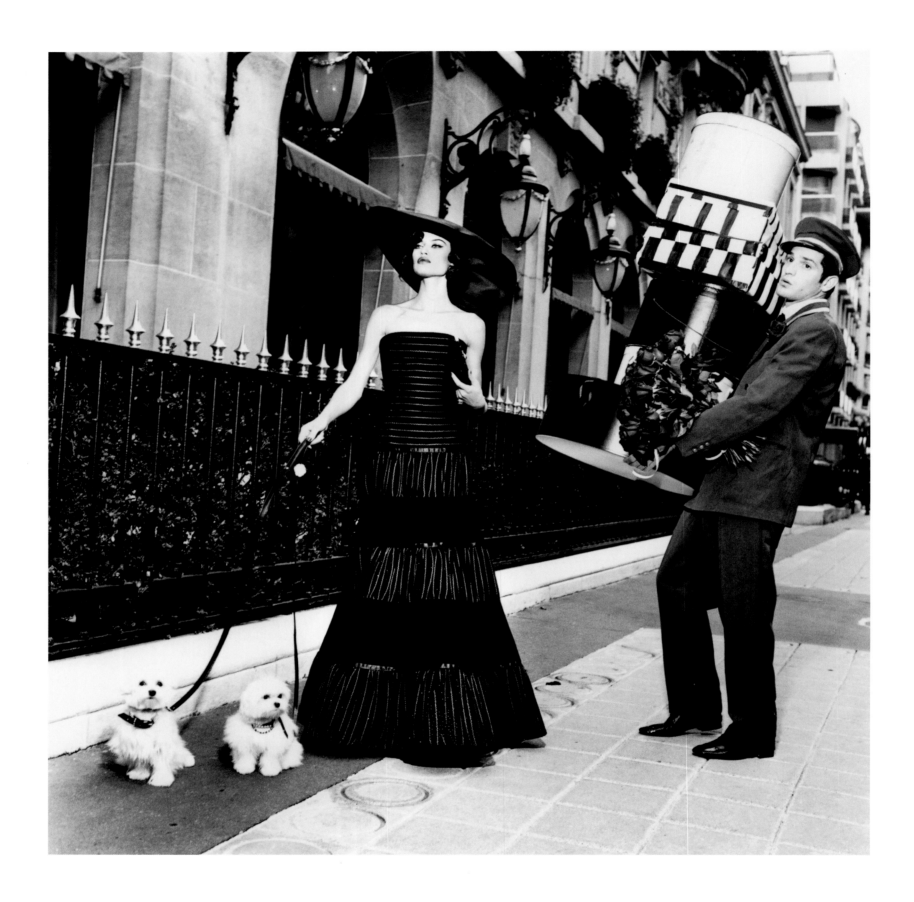

ELLEN VON UNWERTH

Rich Bitch, 2004

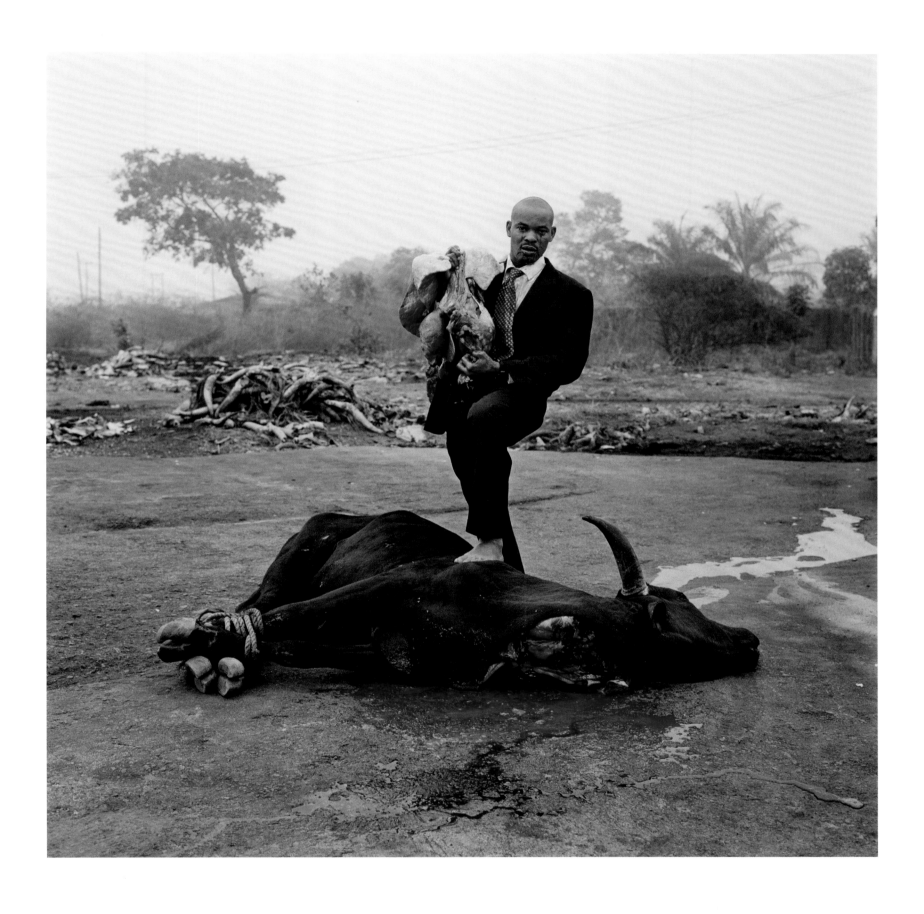

PIETER HUGO

Gabazzini Zuo, Enugu, Nigeria, 2008

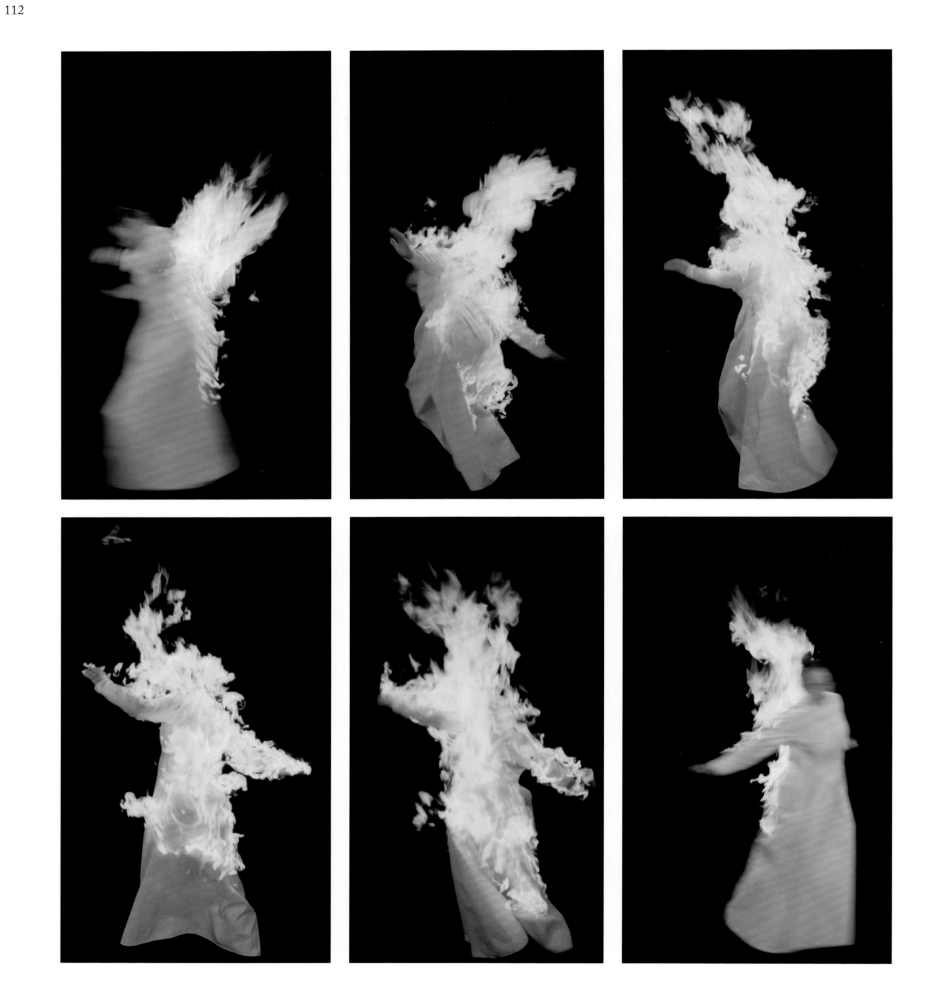

CHARLOTTE GYLLENHAMMAR
Night 1. Night 6. Night 3. Night 5. Night 4. Night 2, 2014

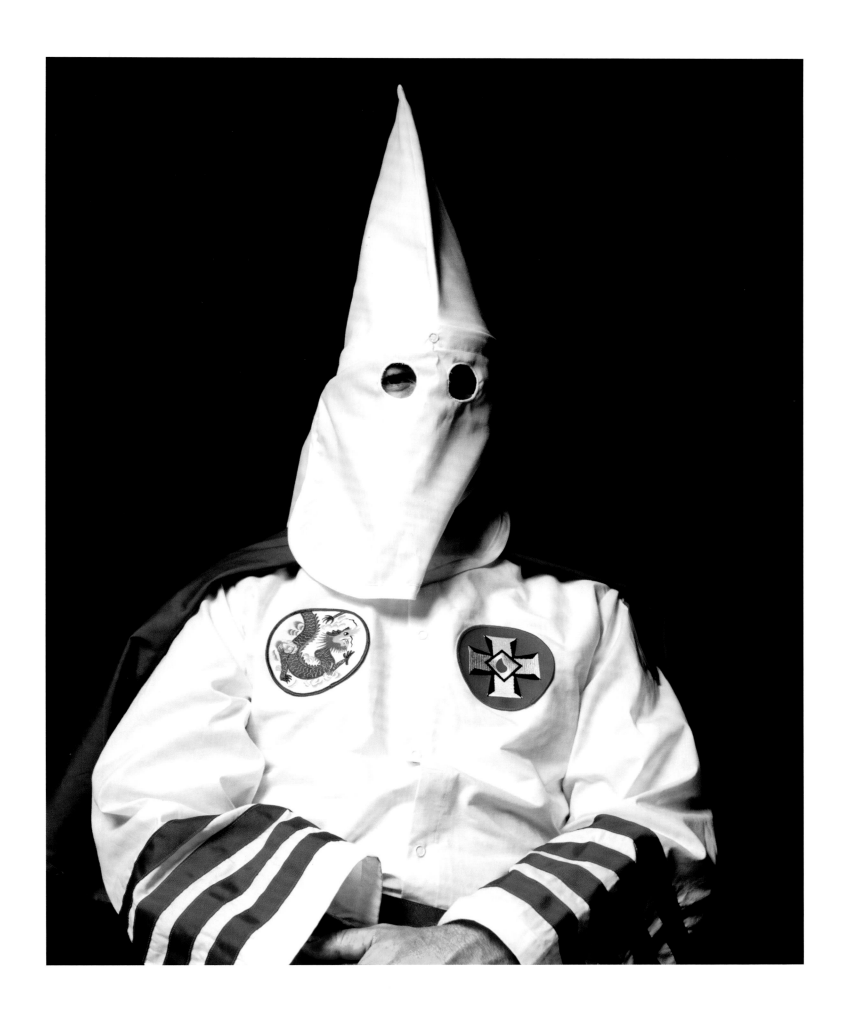

ANDRES SERRANO

Klansman (Grand Dragon), 1990

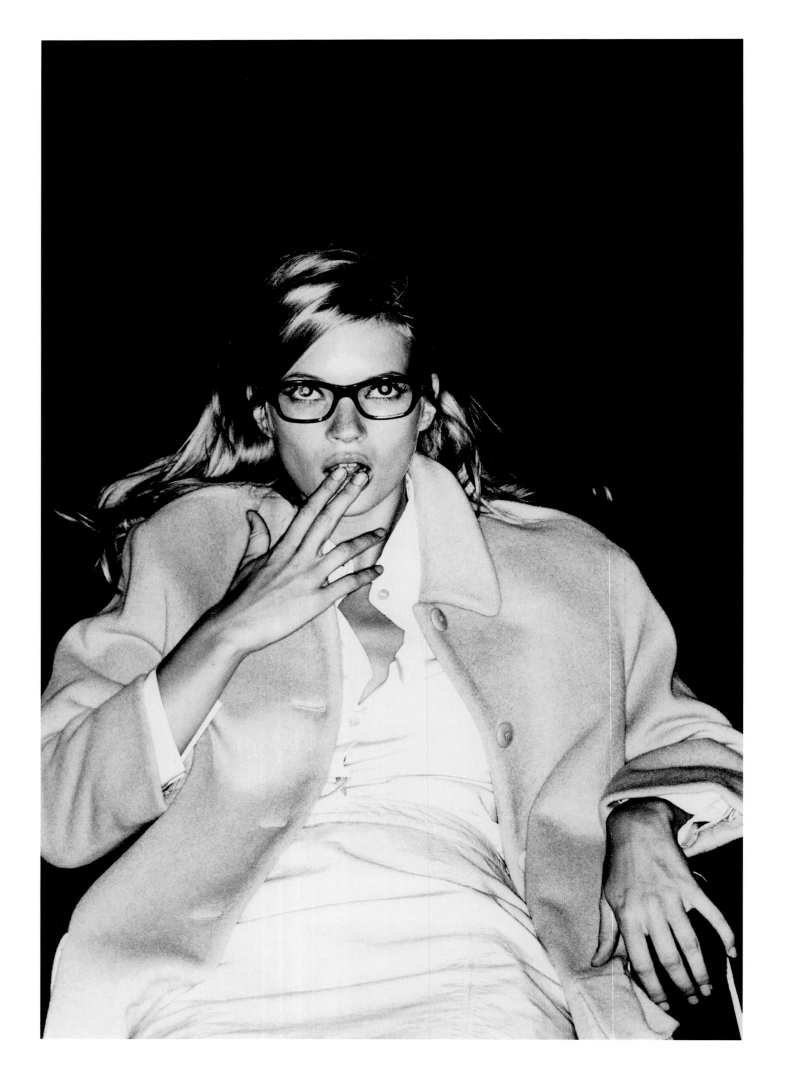

ELLEN VON UNWERTH

Kino, 1998

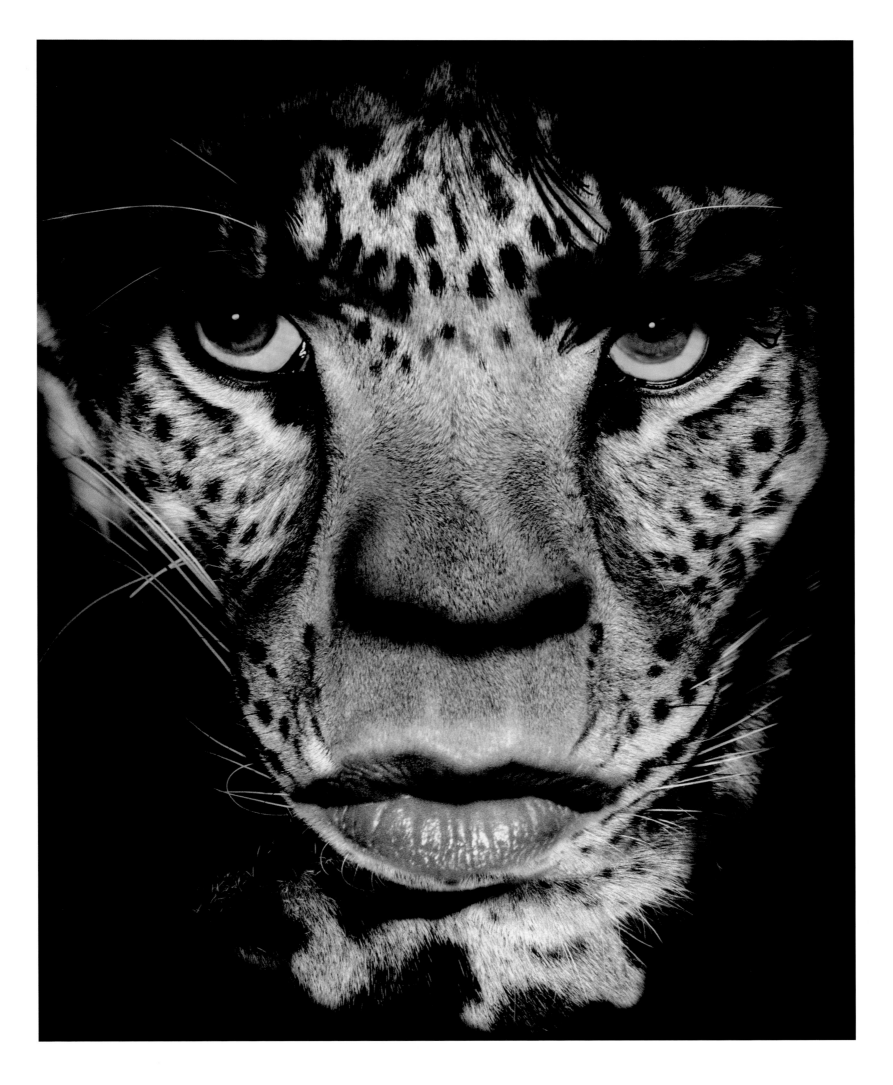

ALBERT WATSON

Mick Jagger, Los Angeles, 1992

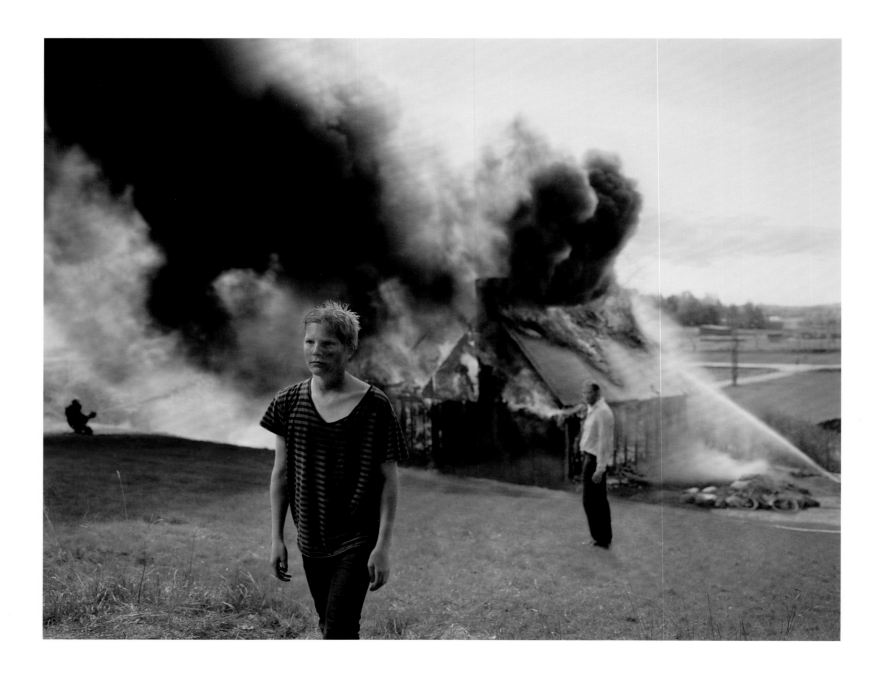

JOHAN WILLNER

Forward, 2009

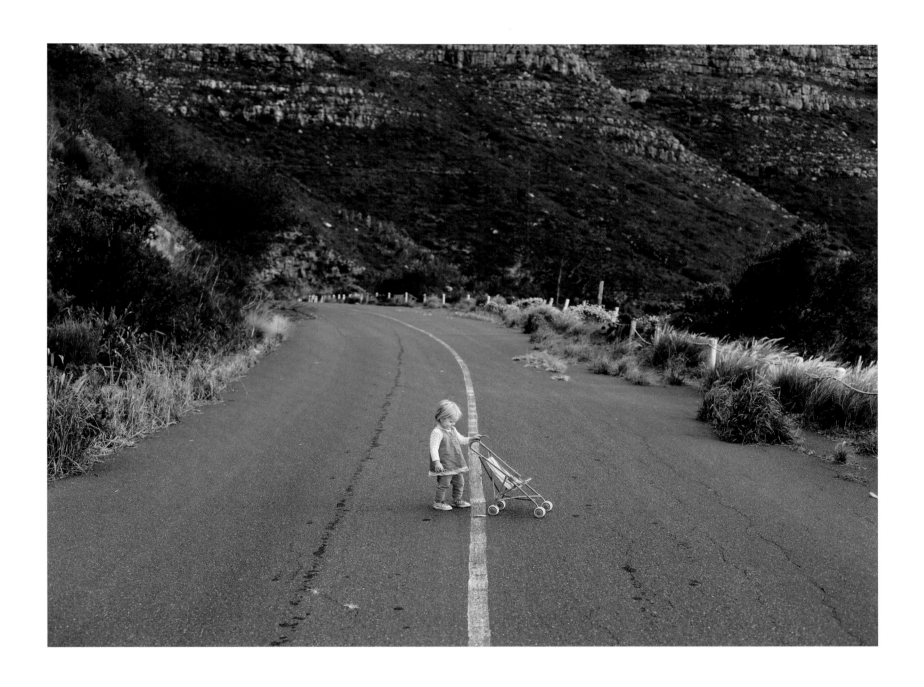

PIETER HUGO

Sophia Hugo on Table Mountain Road, Cape Town, 2011

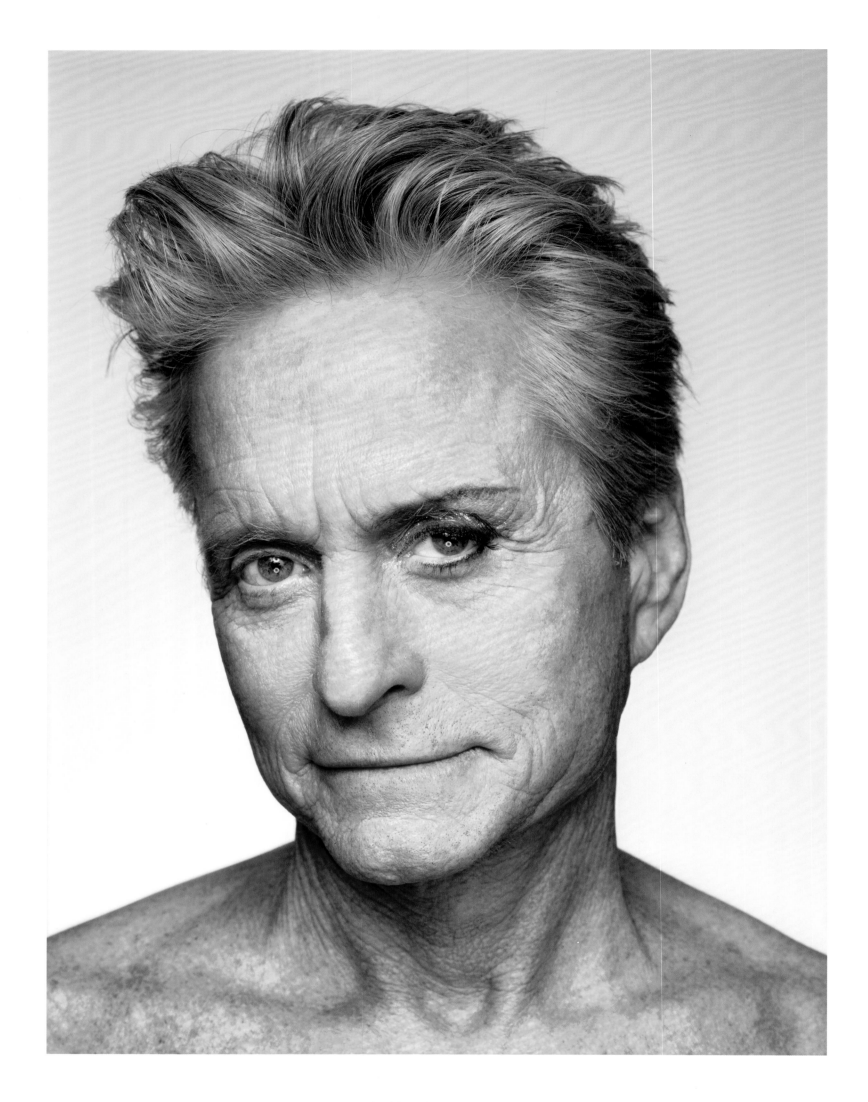

MARTIN SCHOELLER
Michael Douglas with Eyeshadow, New York, NY, 2013

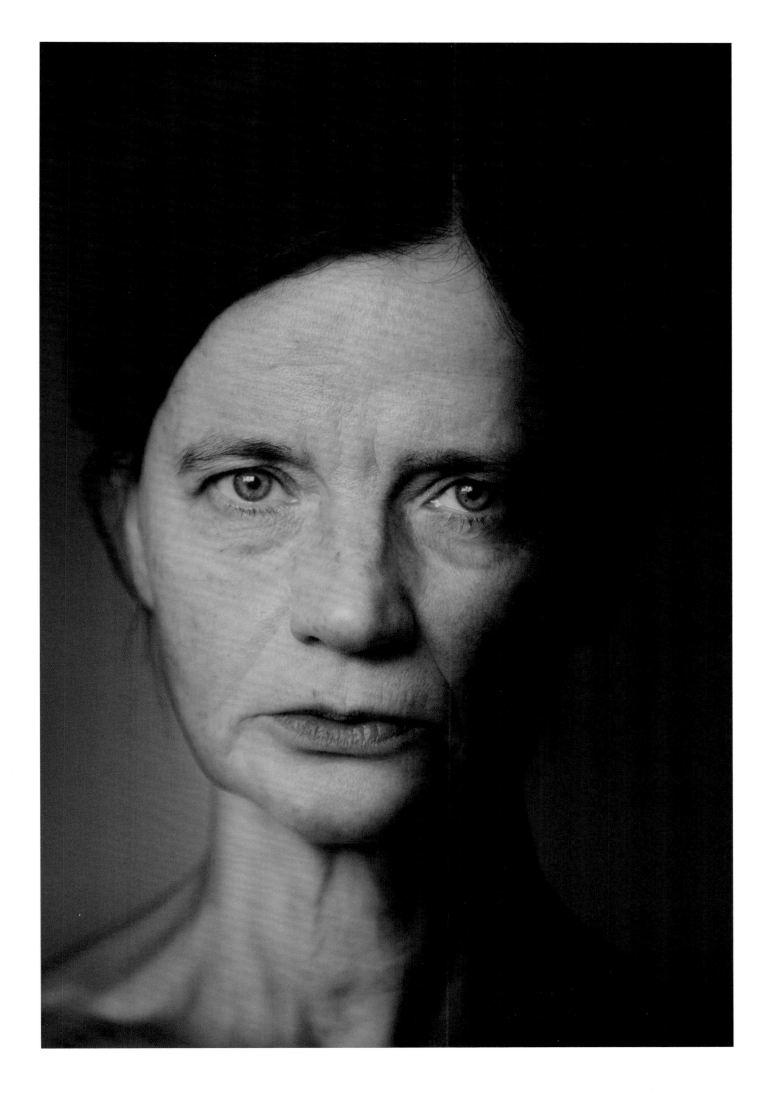

MONIKA MACDONALD

Untitled, from the series *In Absence*, 2015

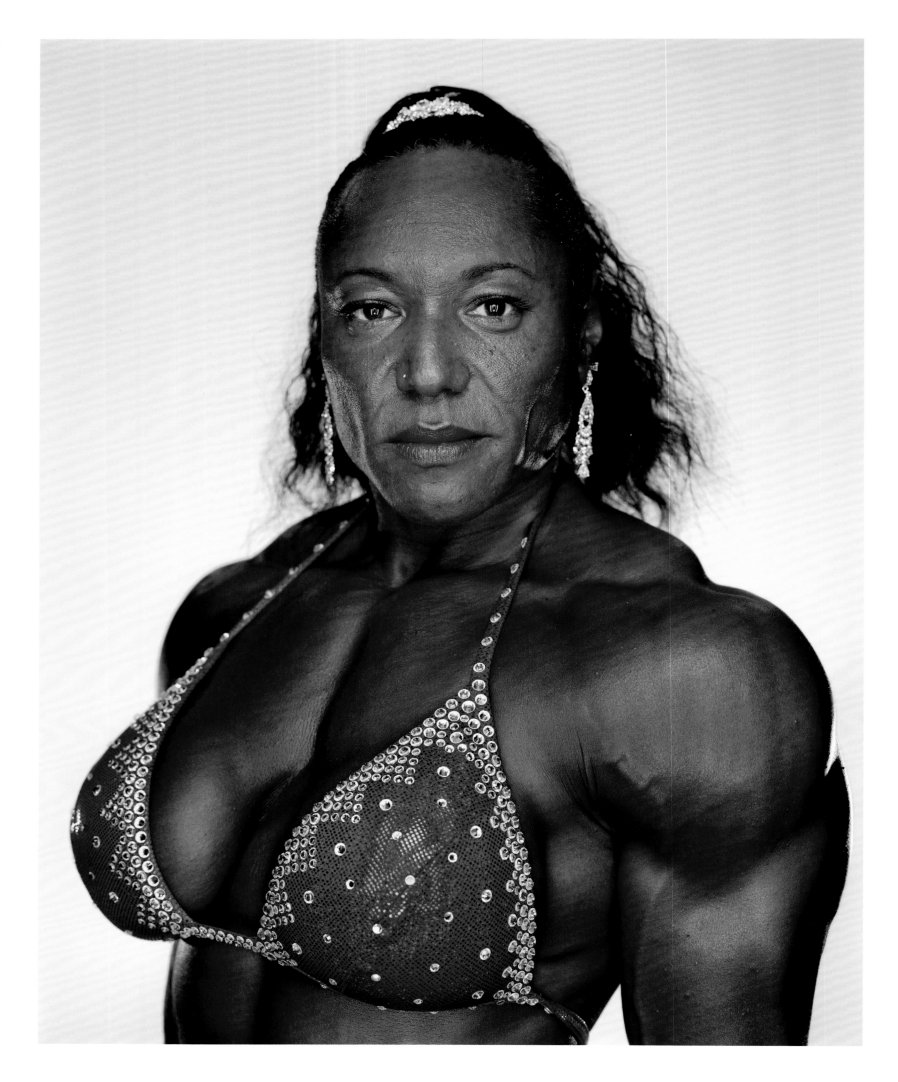

MARTIN SCHOELLER
Carmella Cureton, Atlantic City, NJ, 2007

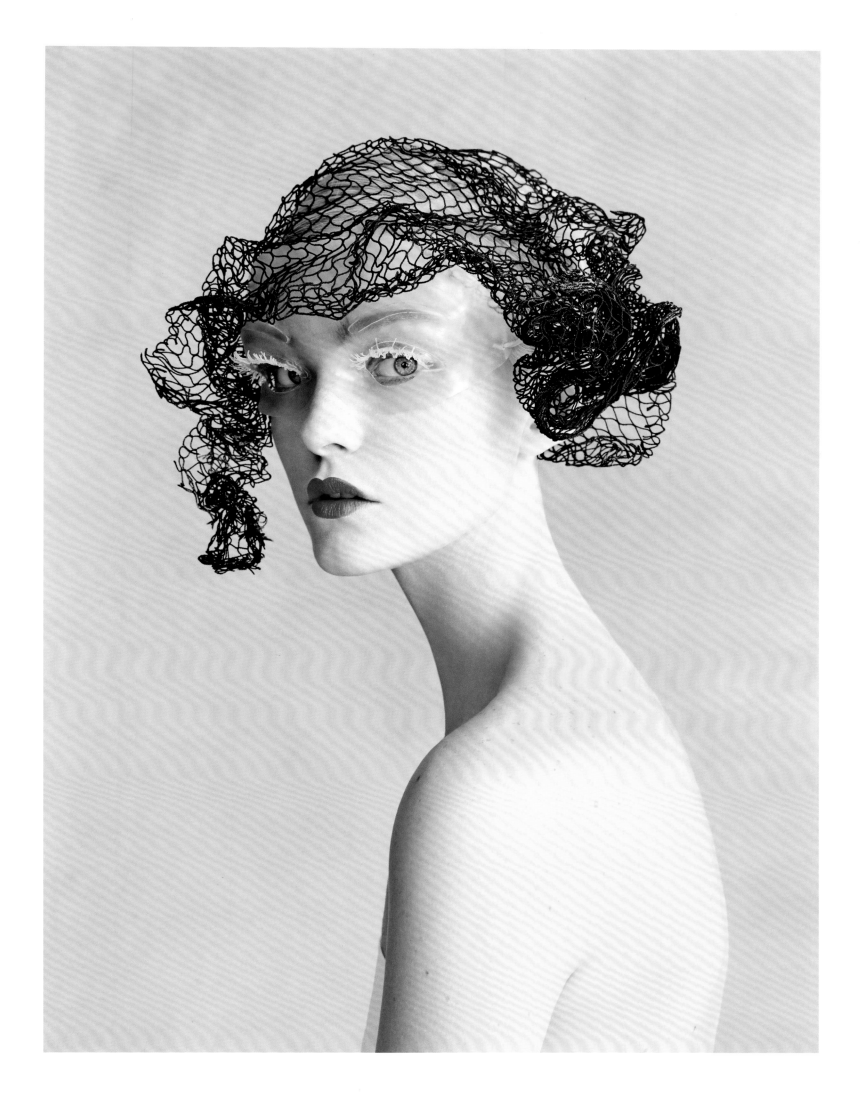

PATRICK DEMARCHELIER
Caroline Trentini, New York, 2015

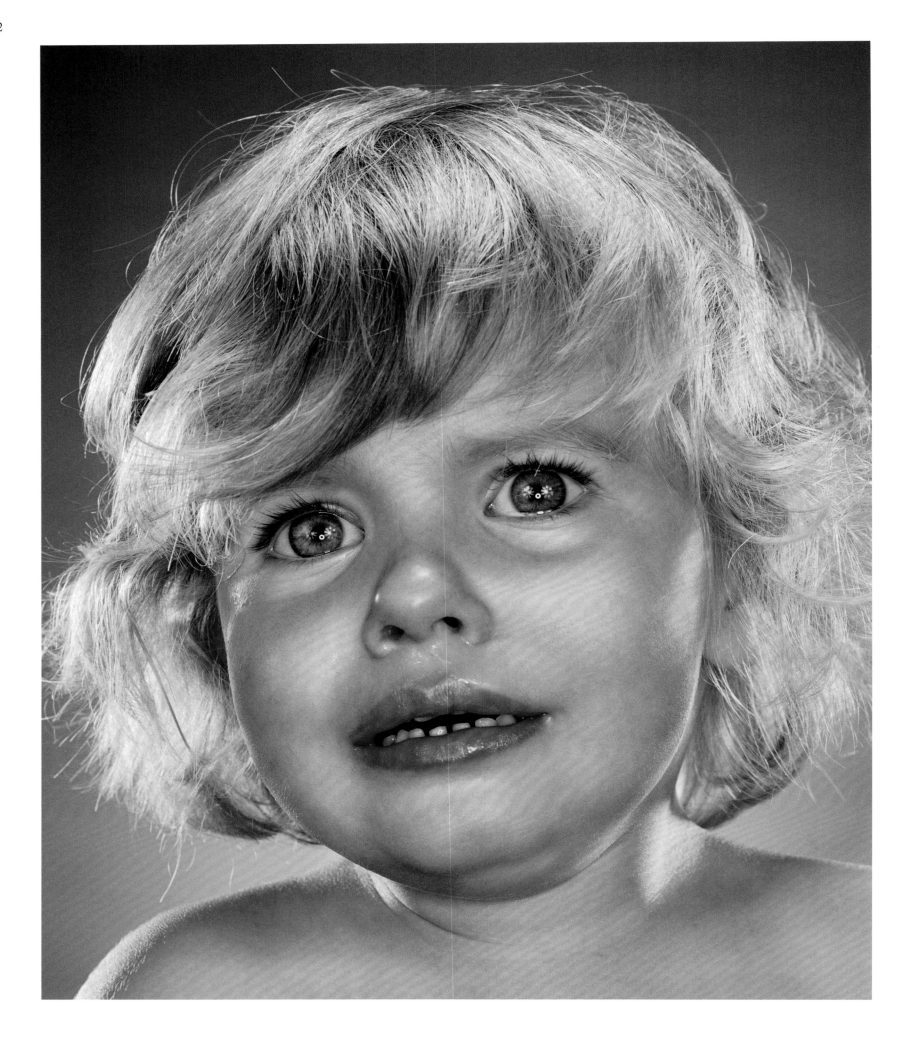

JILL GREENBERG
Apocalypse Now, 2005

"Crying is not evidence of pain or any suffering. It's really just the way children communicate."

JILL GREENBERG

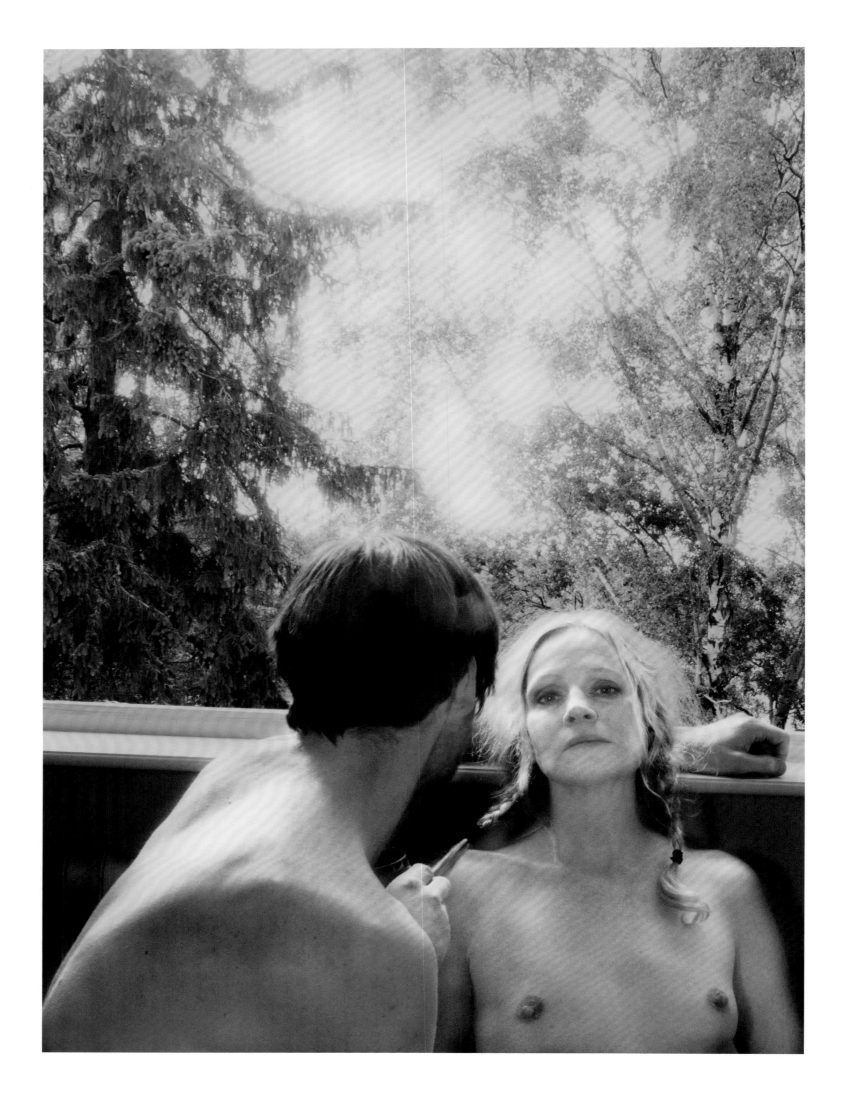

MONIKA MACDONALD

Untitled, from the series *In Absence*, 2015

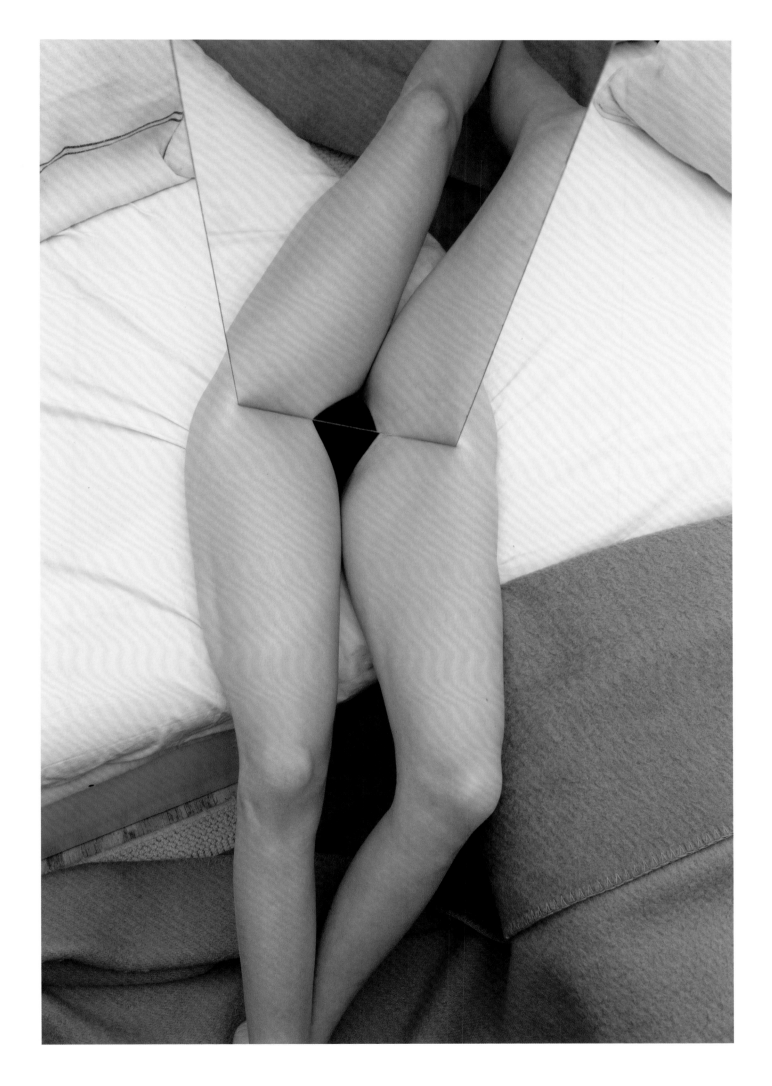

VIVIANE SASSEN
Marte No. 2, Larvae, from the series *Umbra*, 2014

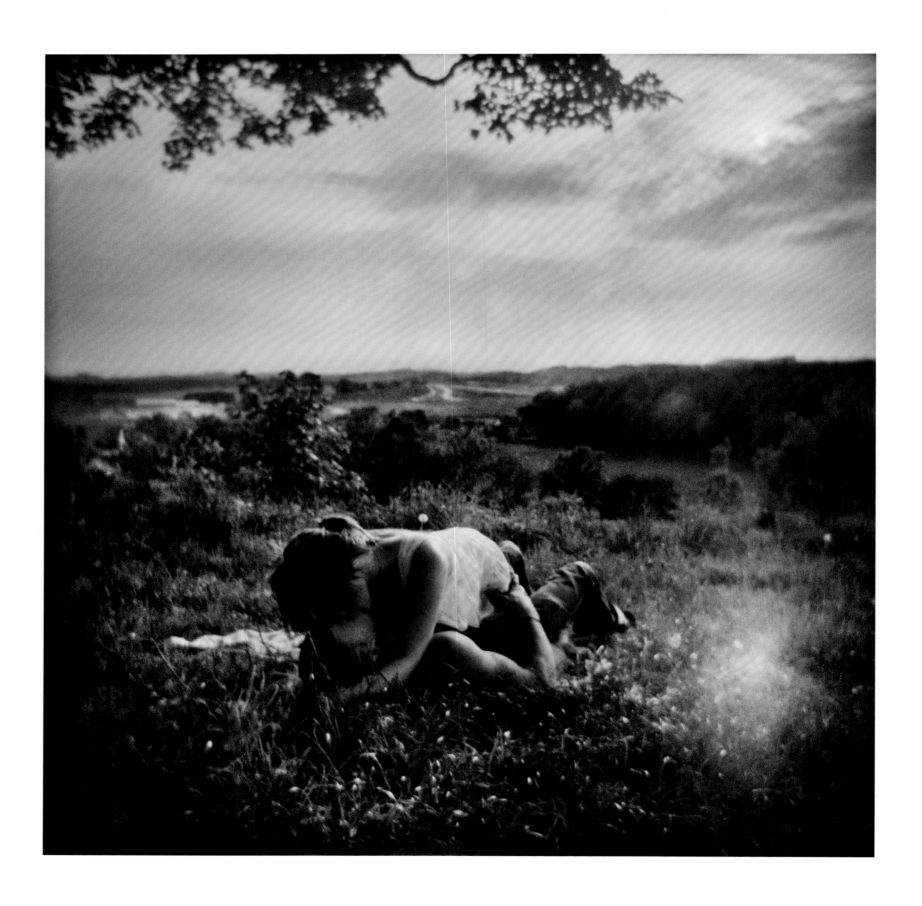

MARTIN BOGREN

Untitled

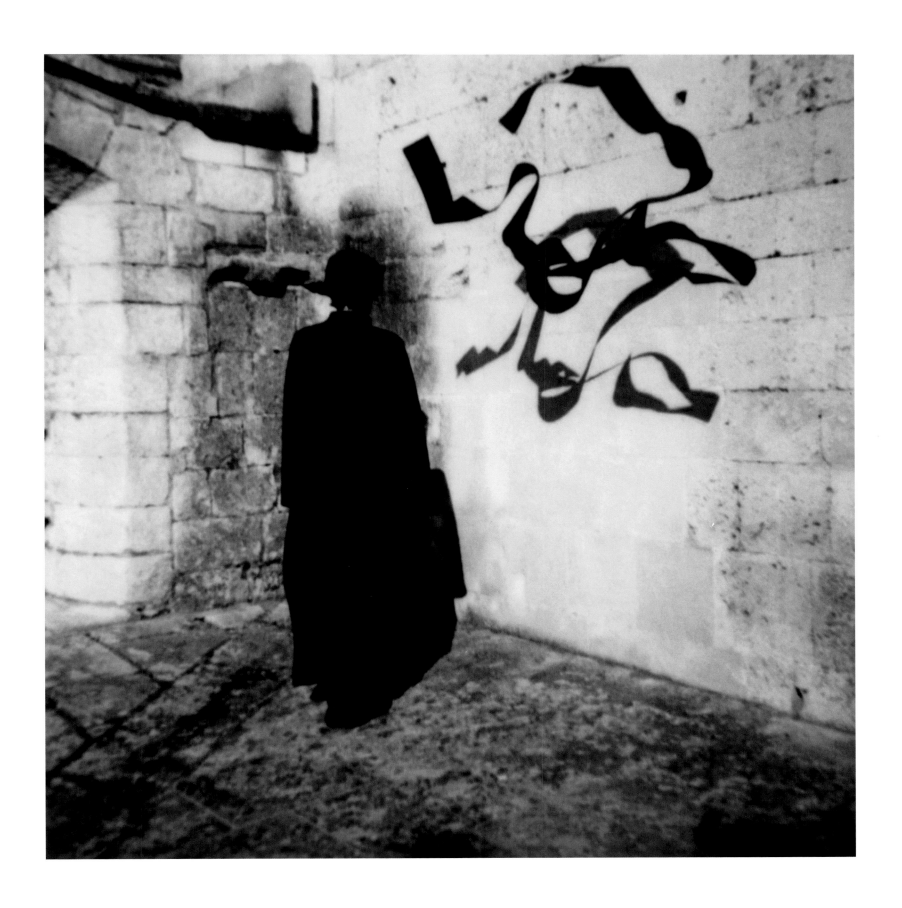

CORINNE MERCADIER
St. Trophime, La Suite d'Arles, 2003

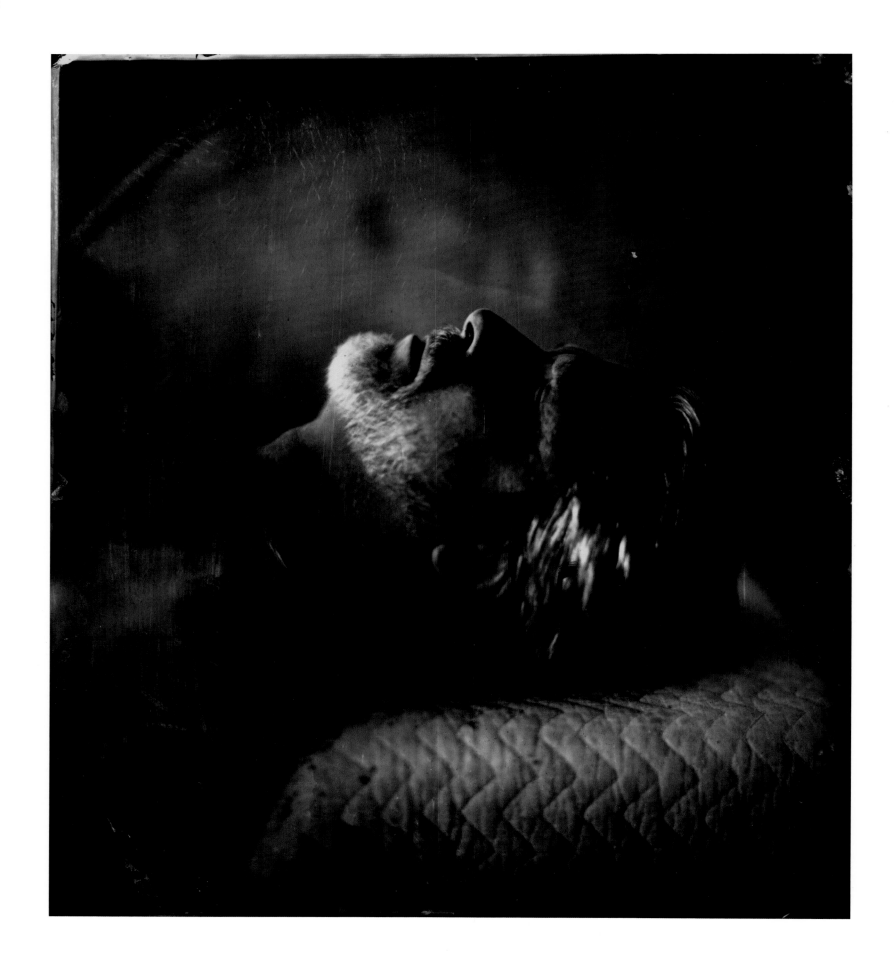

SALLY MANN
Was Ever Love, 2009

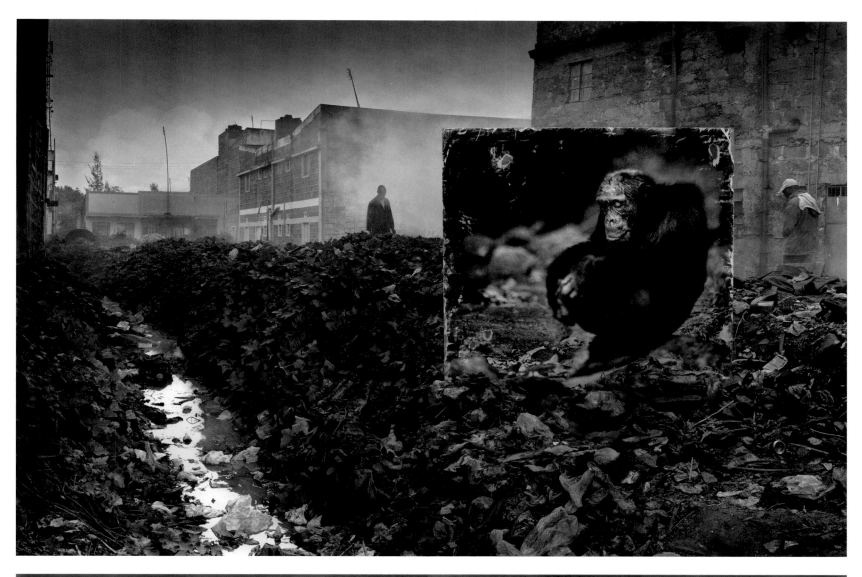

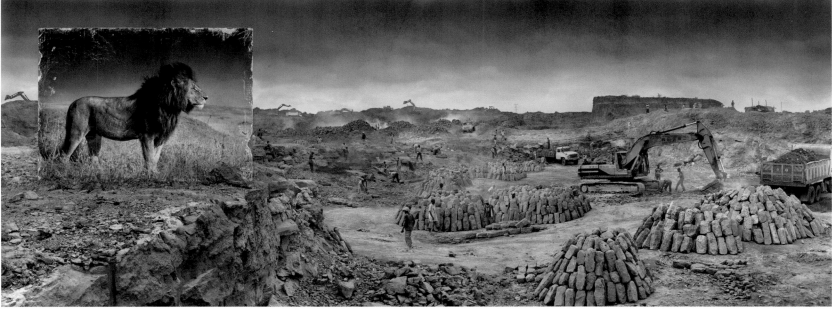

NICK BRANDT

Alleyway with Chimpanzee, 2014. Quarry with Lion, 2014

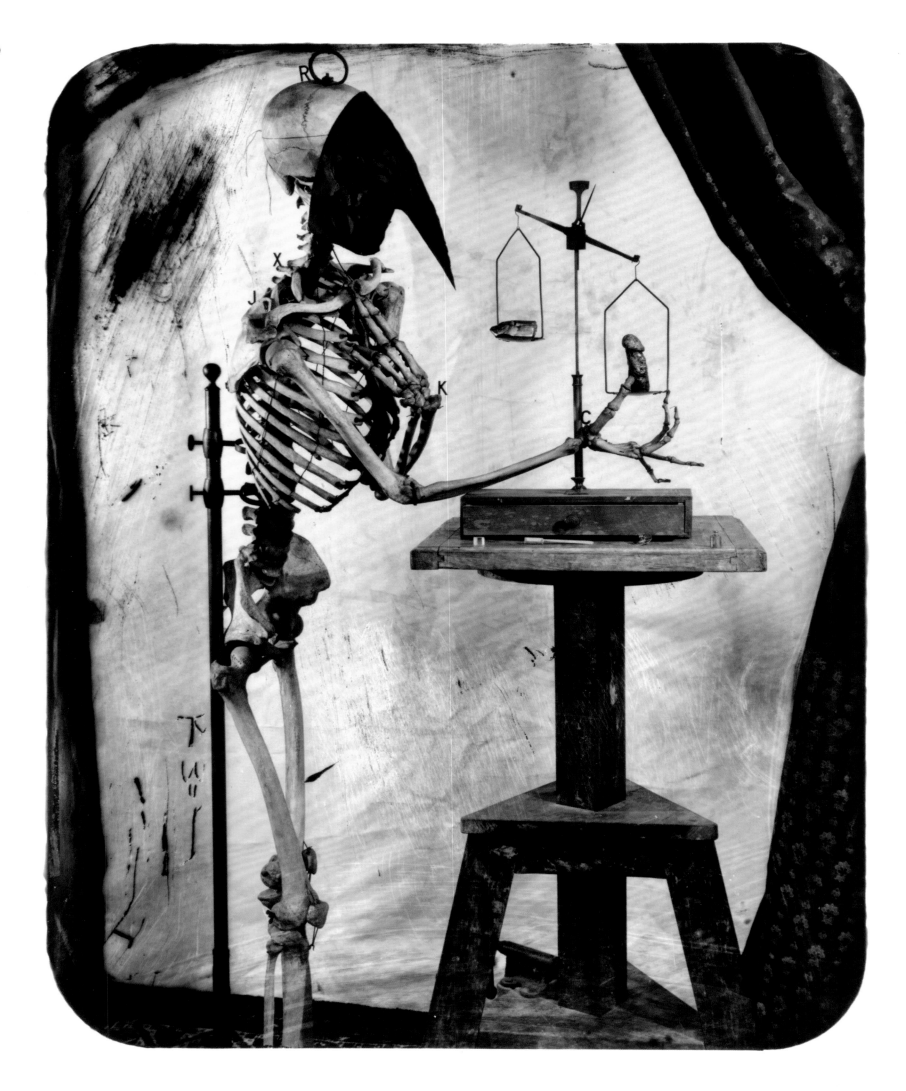

JOEL-PETER WITKIN
Who Naked Is, 1996

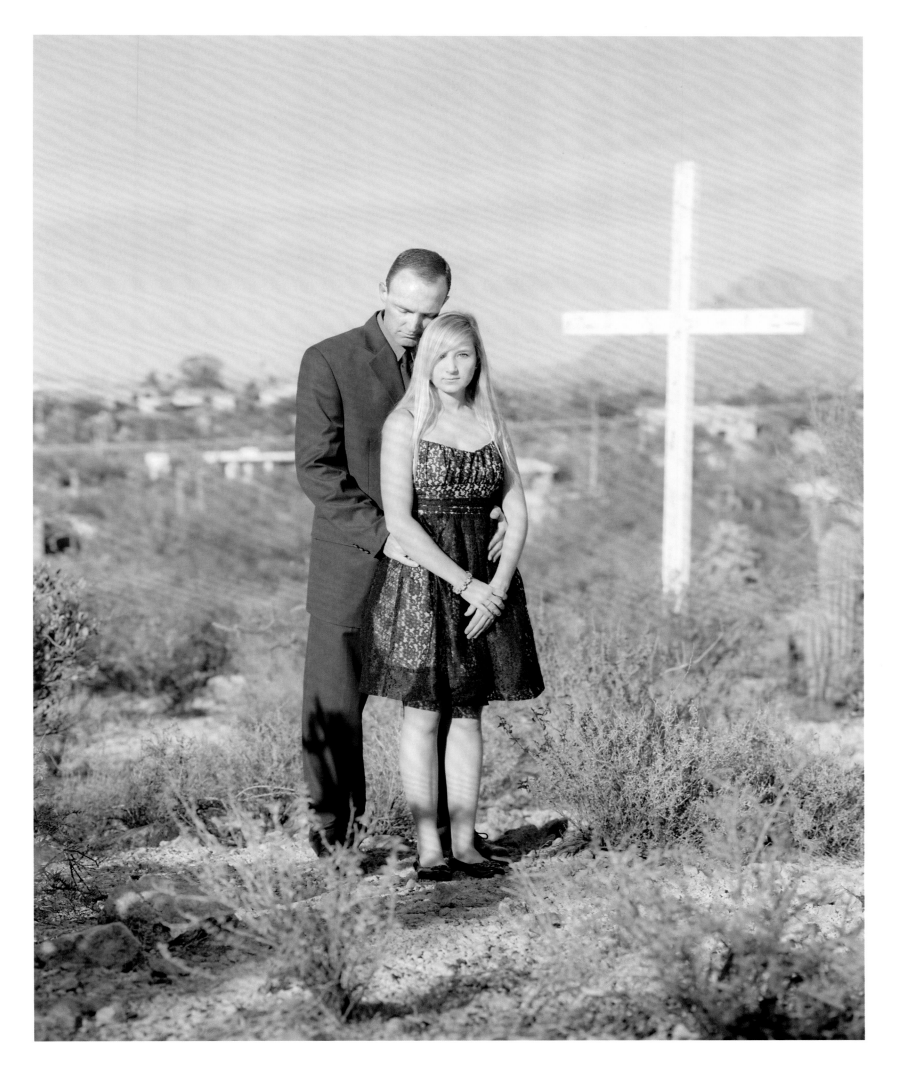

DAVID MAGNUSSON

Will & Nicole Roosma, Tucson, Arizona, 2011

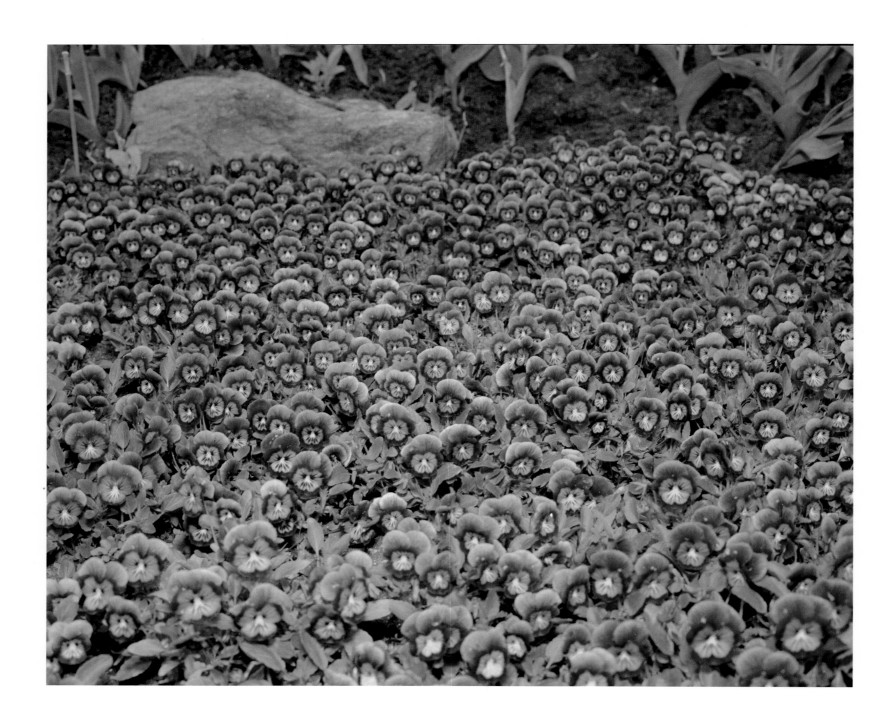

LARS TUNBJÖRK
Untitled

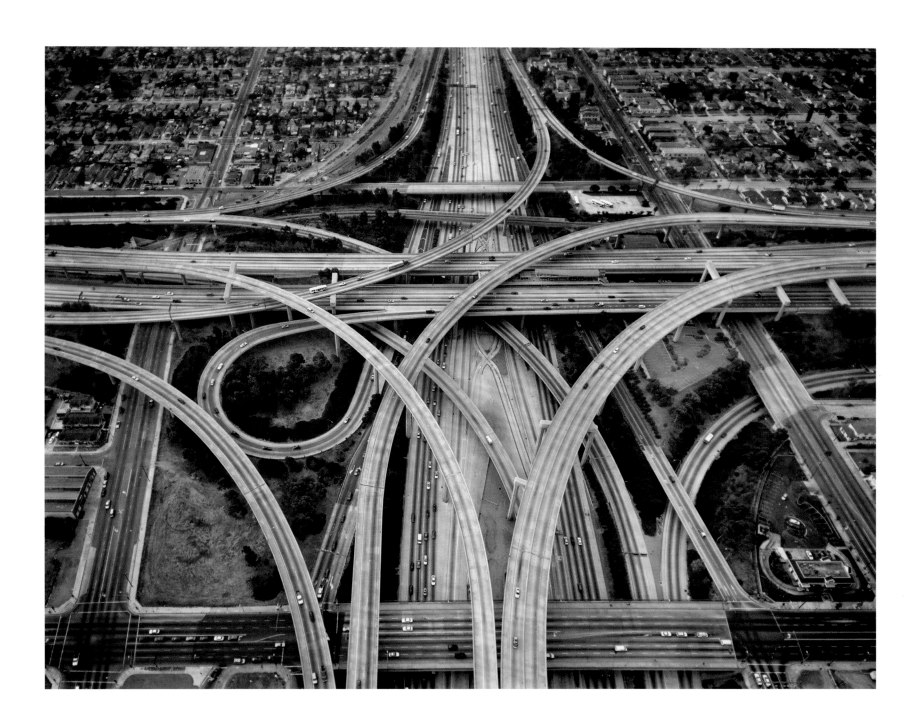

EDWARD BURTYNSKY
Highway No. 1, Intersection 105 & 110, Los Angeles, California, USA, 2003

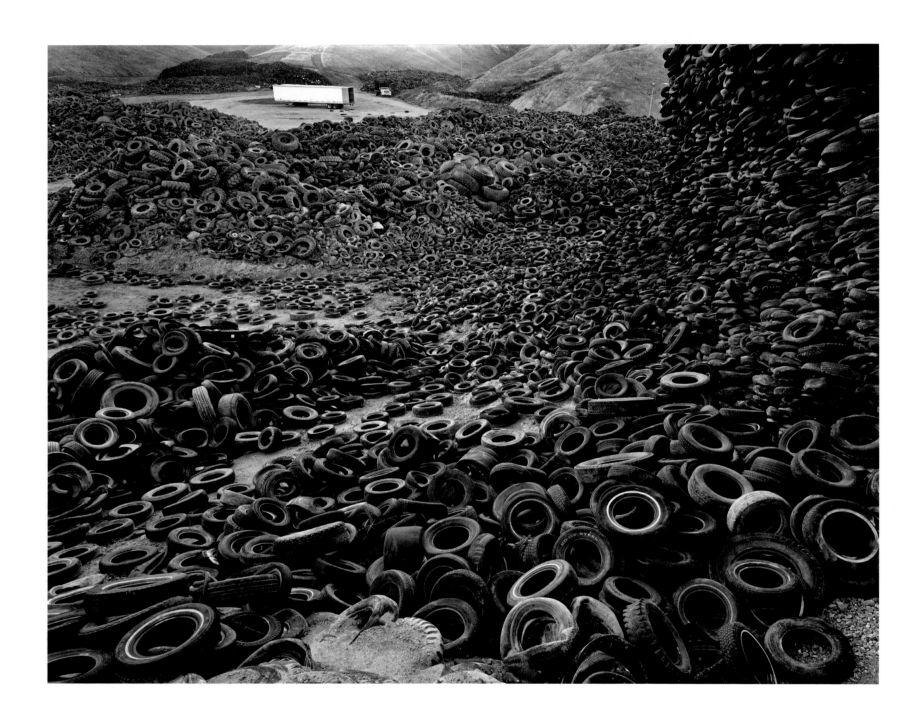

EDWARD BURTYNSKY

Oxford Tire Pile No. 1, Westley, California, USA, 1999

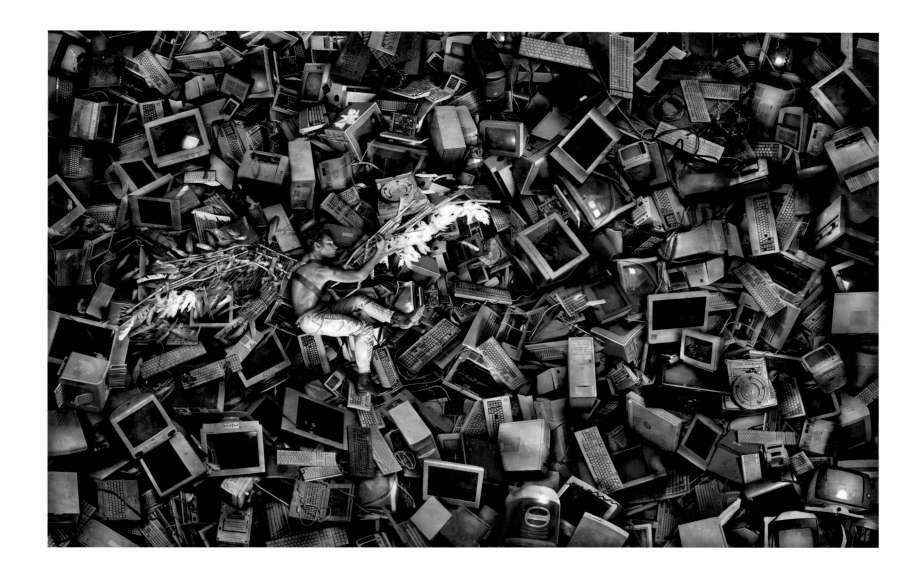

DAVID LACHAPELLE

Icarus, 2012

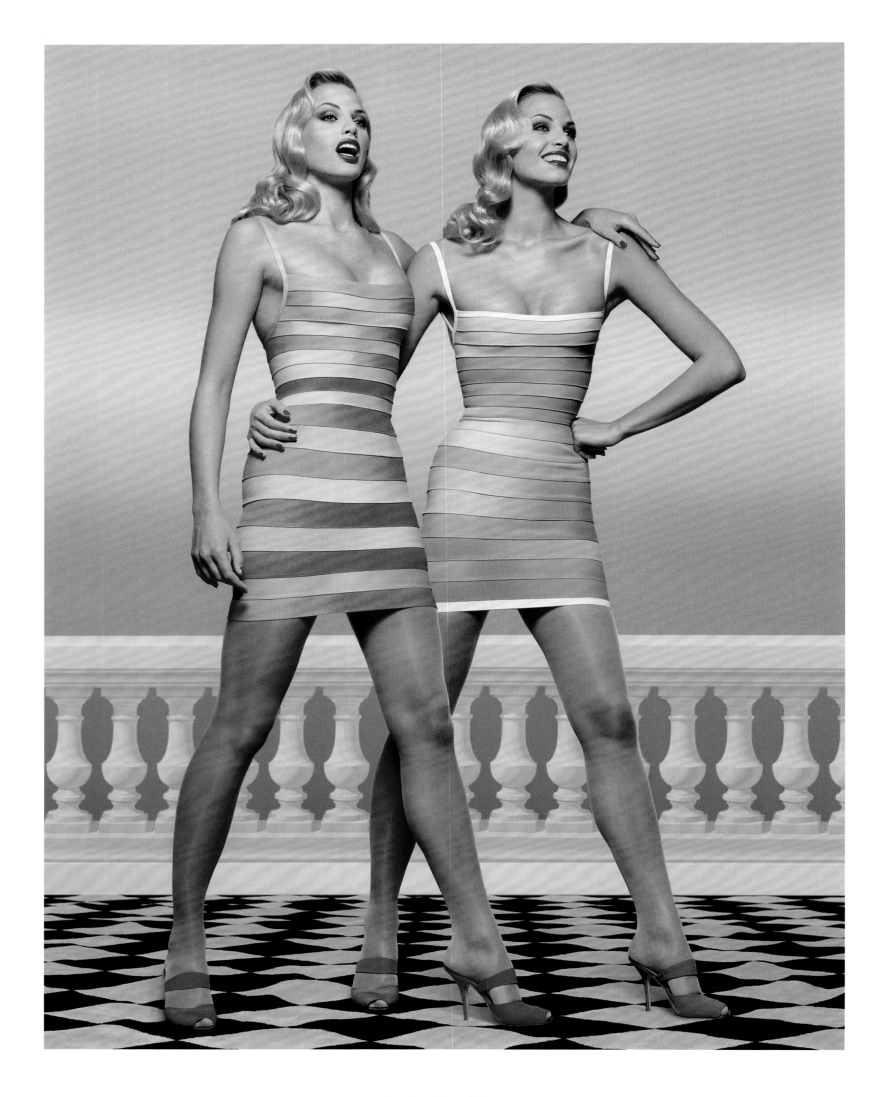

INEZ & VINOODH

Joanna, Herve Leger Campaign, 1995

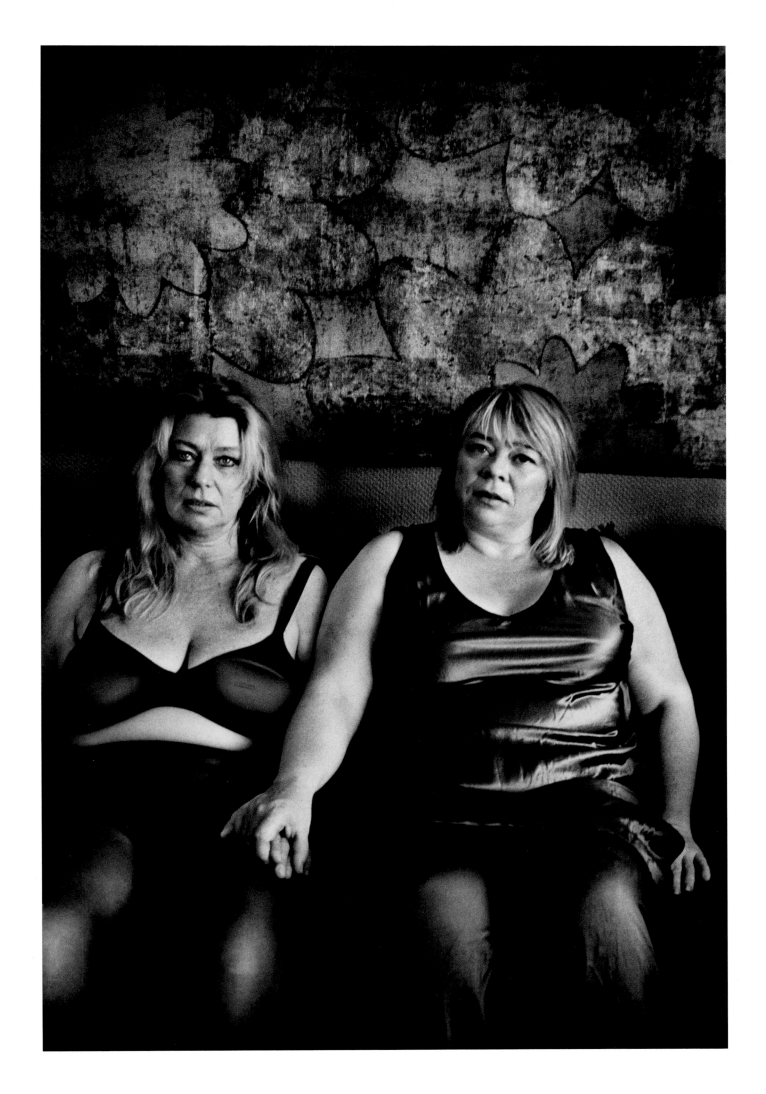

MARGARET M. DE LANGE

From the book *Surrounded by No One*, 2010

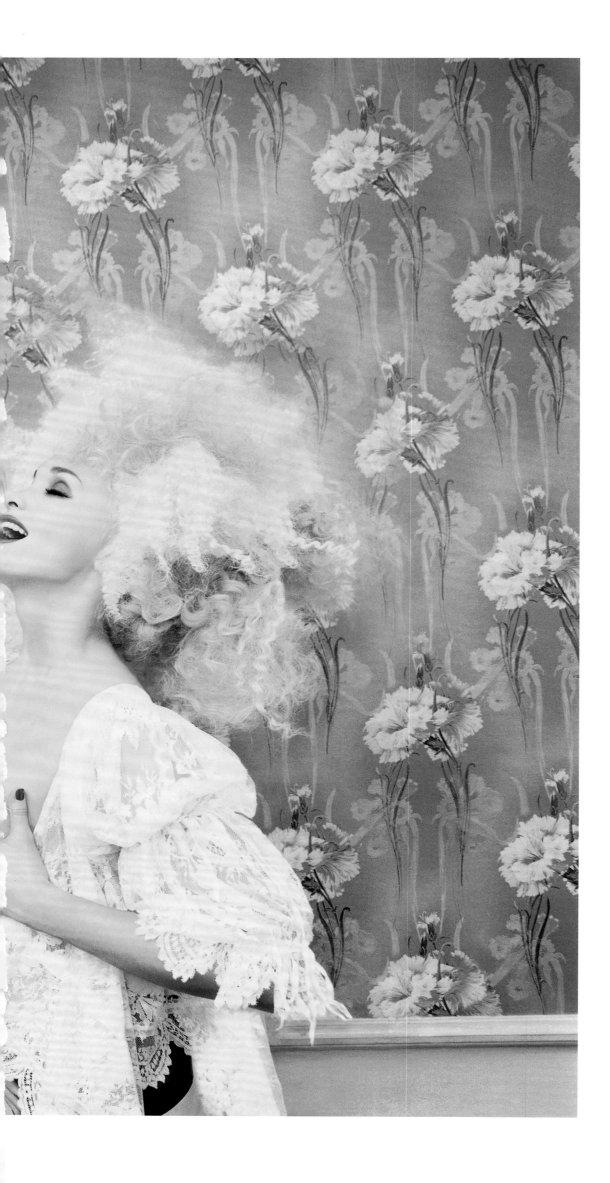

DAVID LACHAPELLE

Milk Maidens, 1996

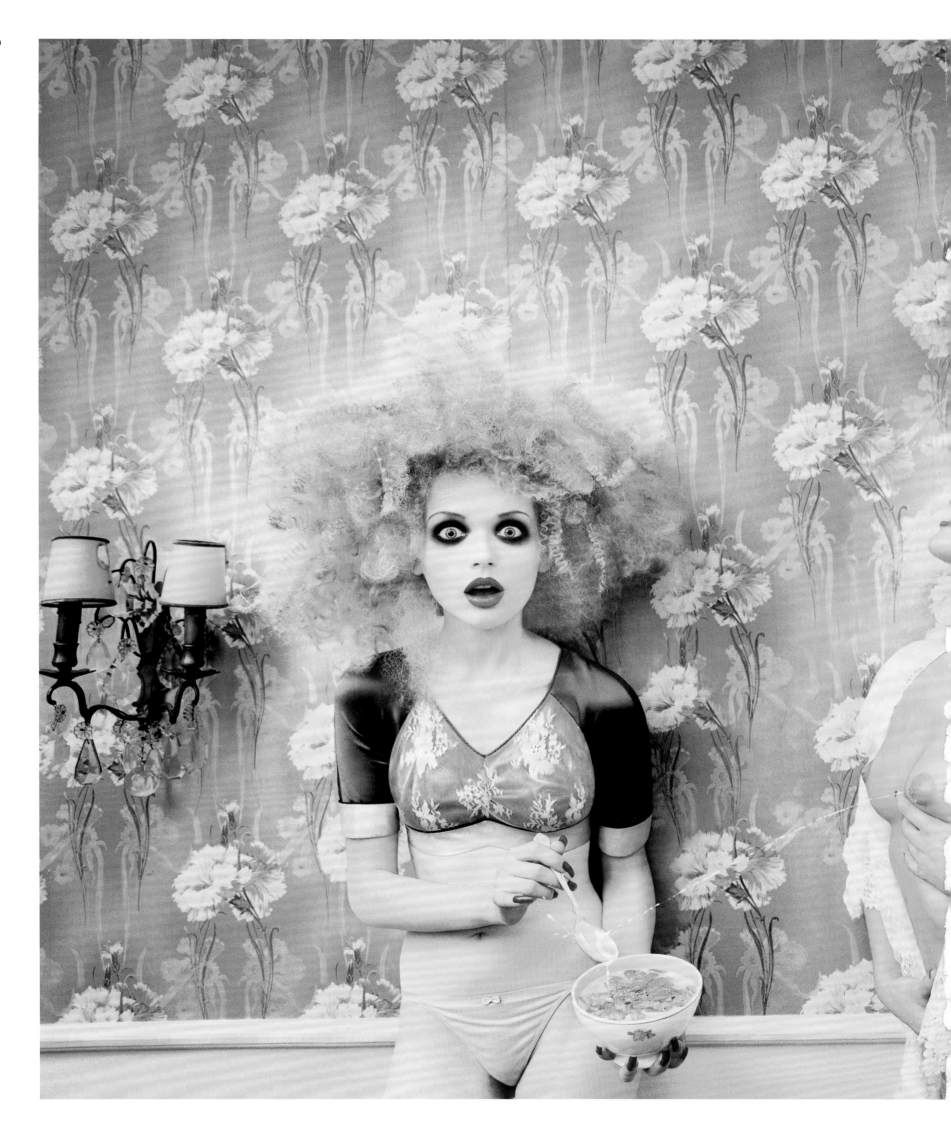

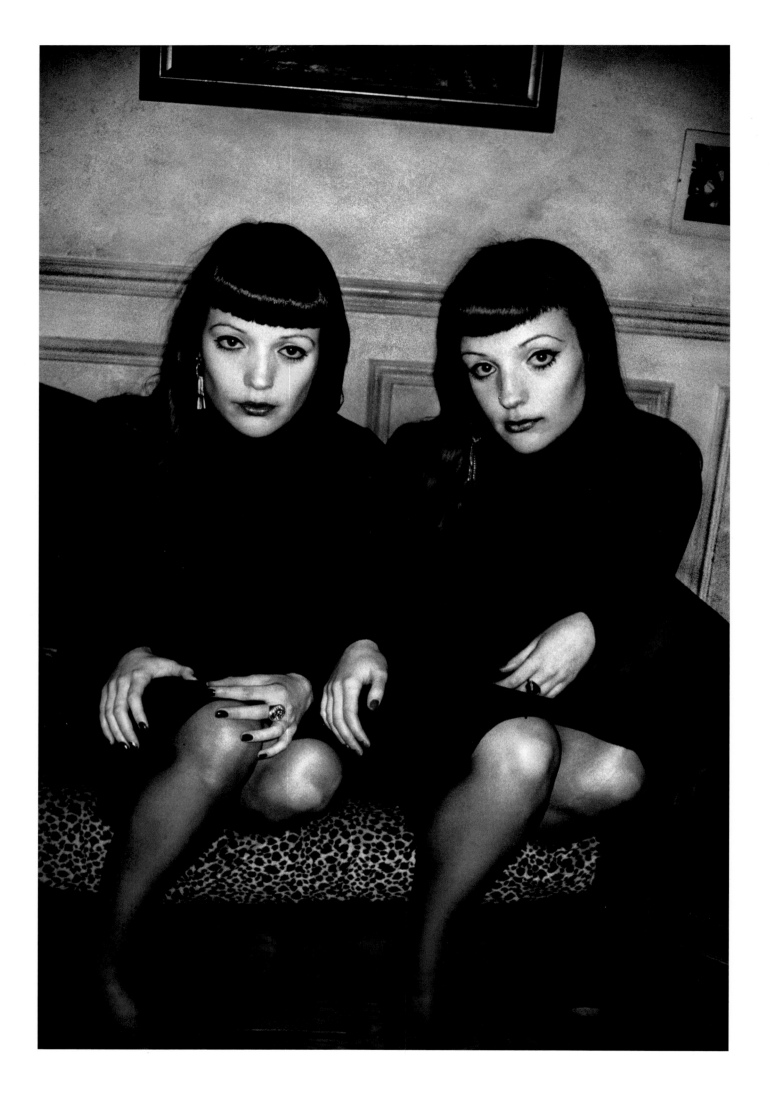

ANDERS PETERSEN
Untitled, Paris, 2006

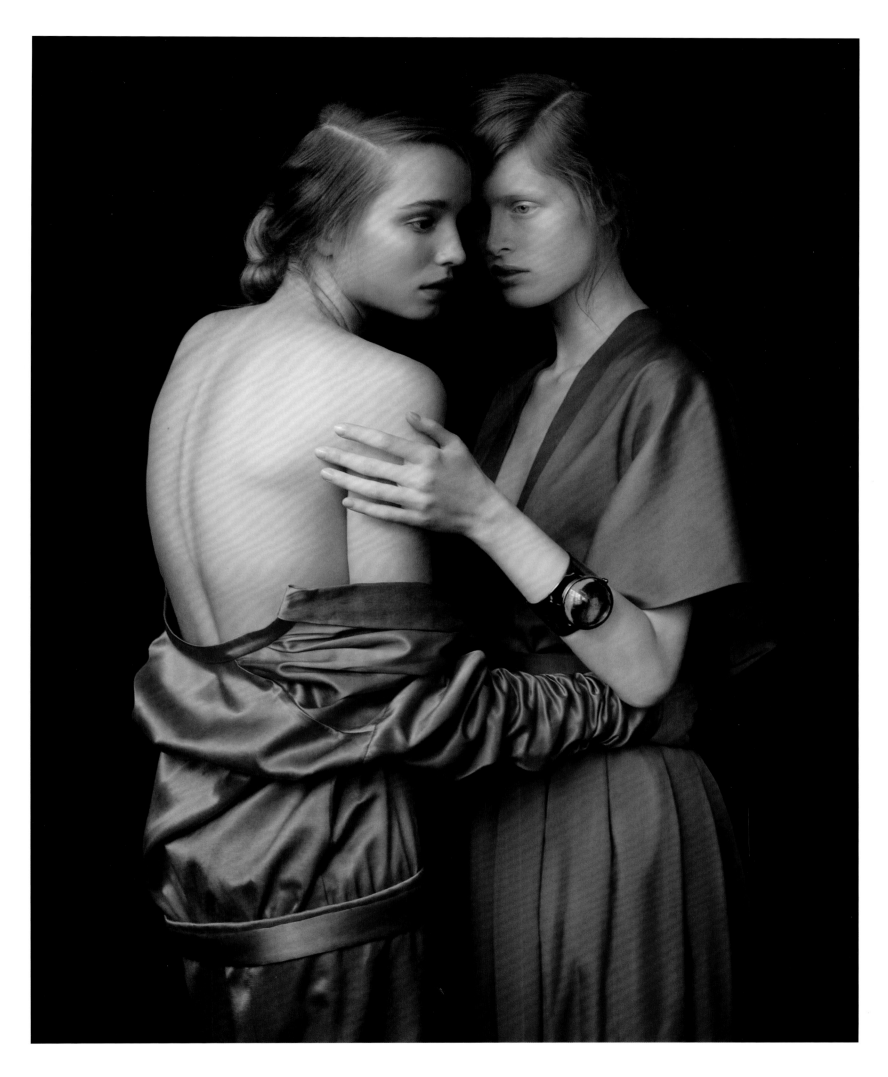

JULIA HETTA
Untitled, 2011

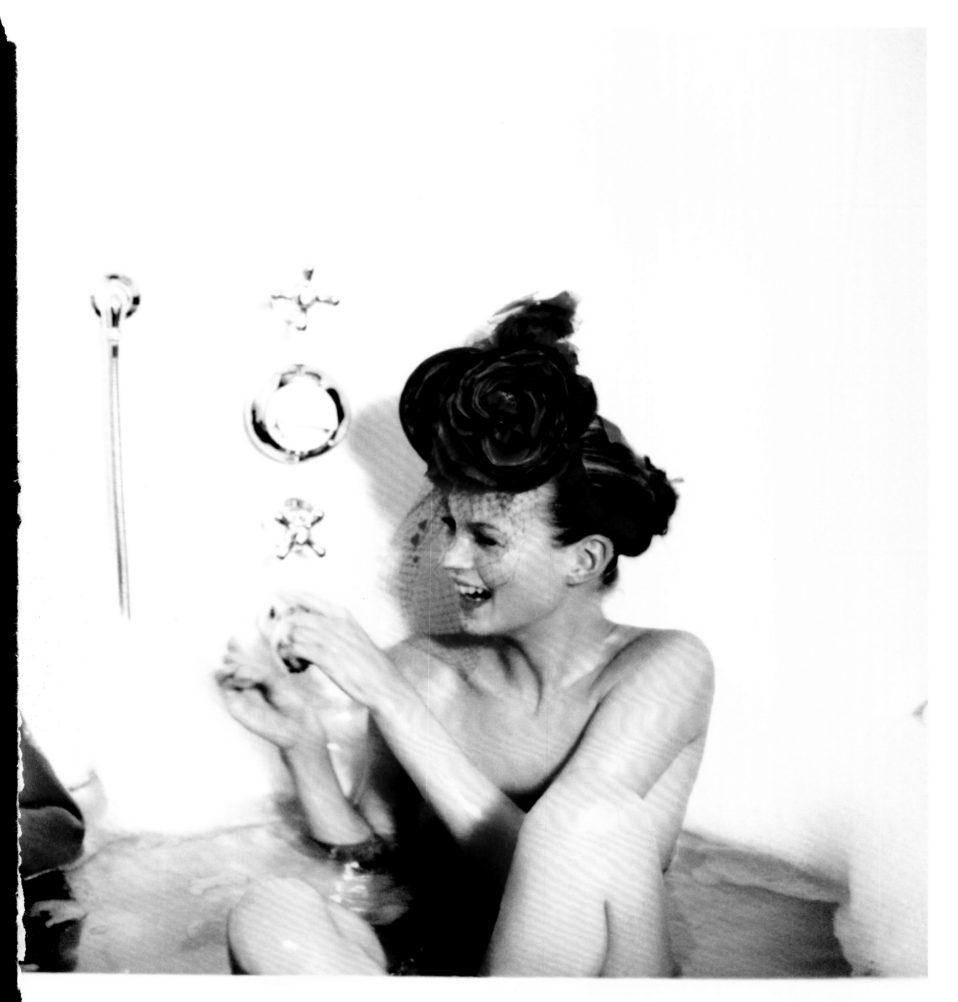

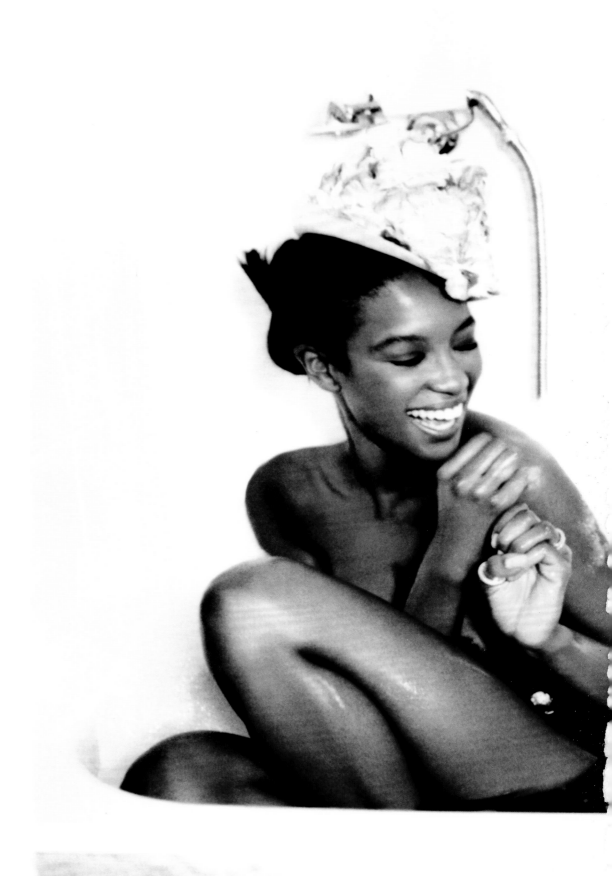

ELLEN VON UNWERTH
Bath Tub, 1996

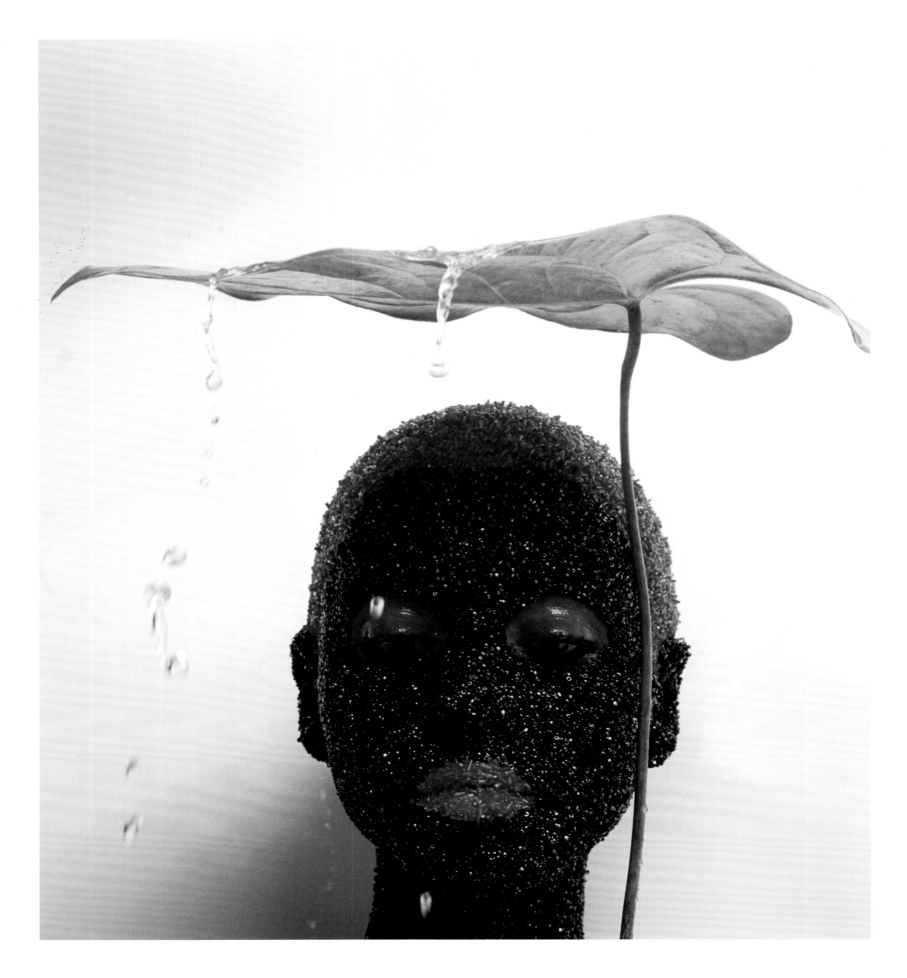

GUY BOURDIN

Vogue Paris, December–January 1969–1970

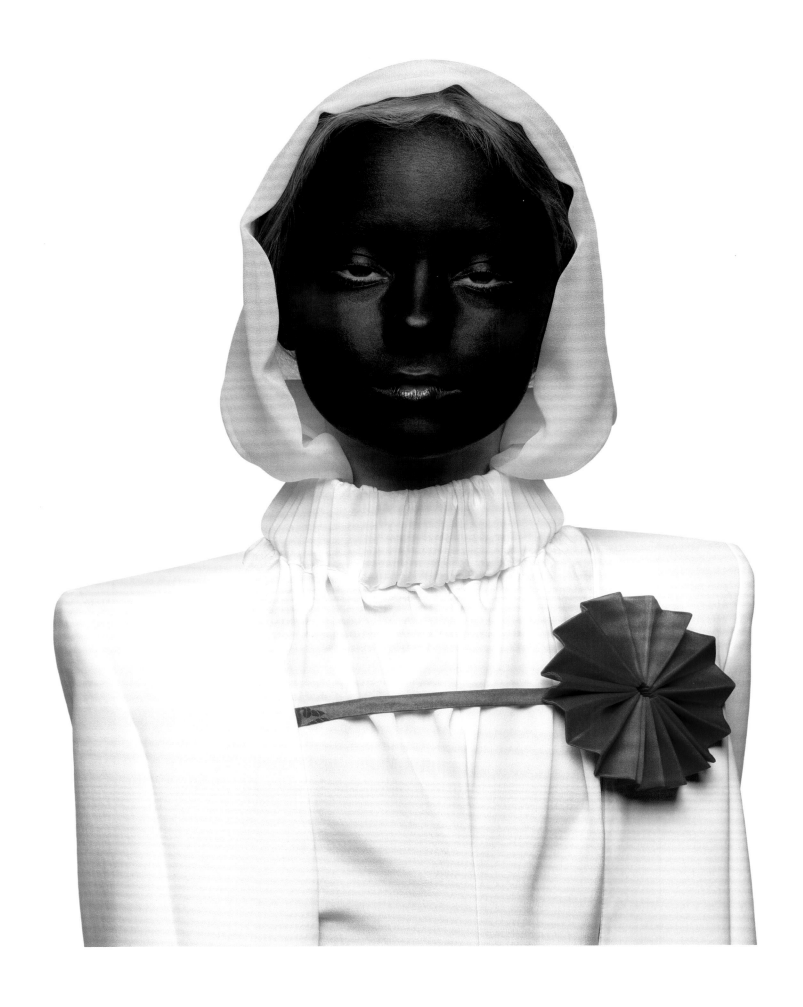

INEZ & VINOODH

The Widow (White), 1997

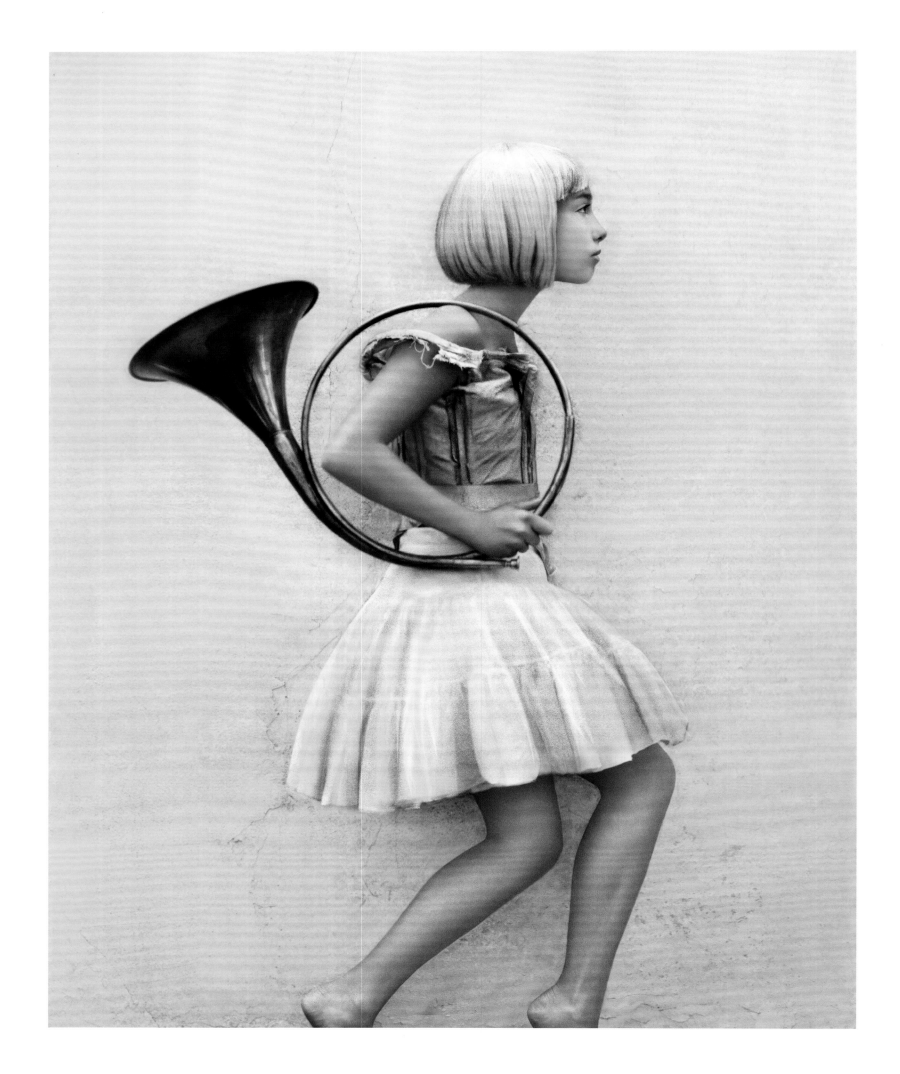

VEE SPEERS
Untitled No. 34, from the series *Bulletproof*, 2014

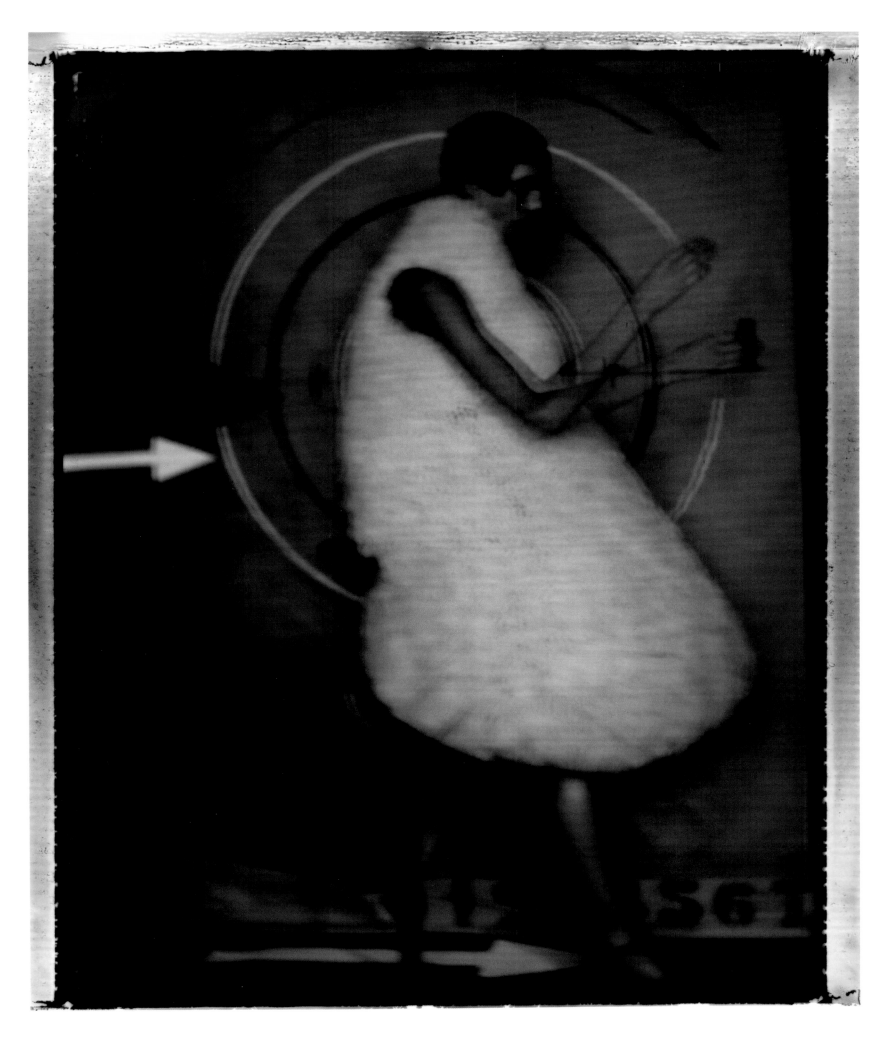

SARAH MOON
The Clock, 1999

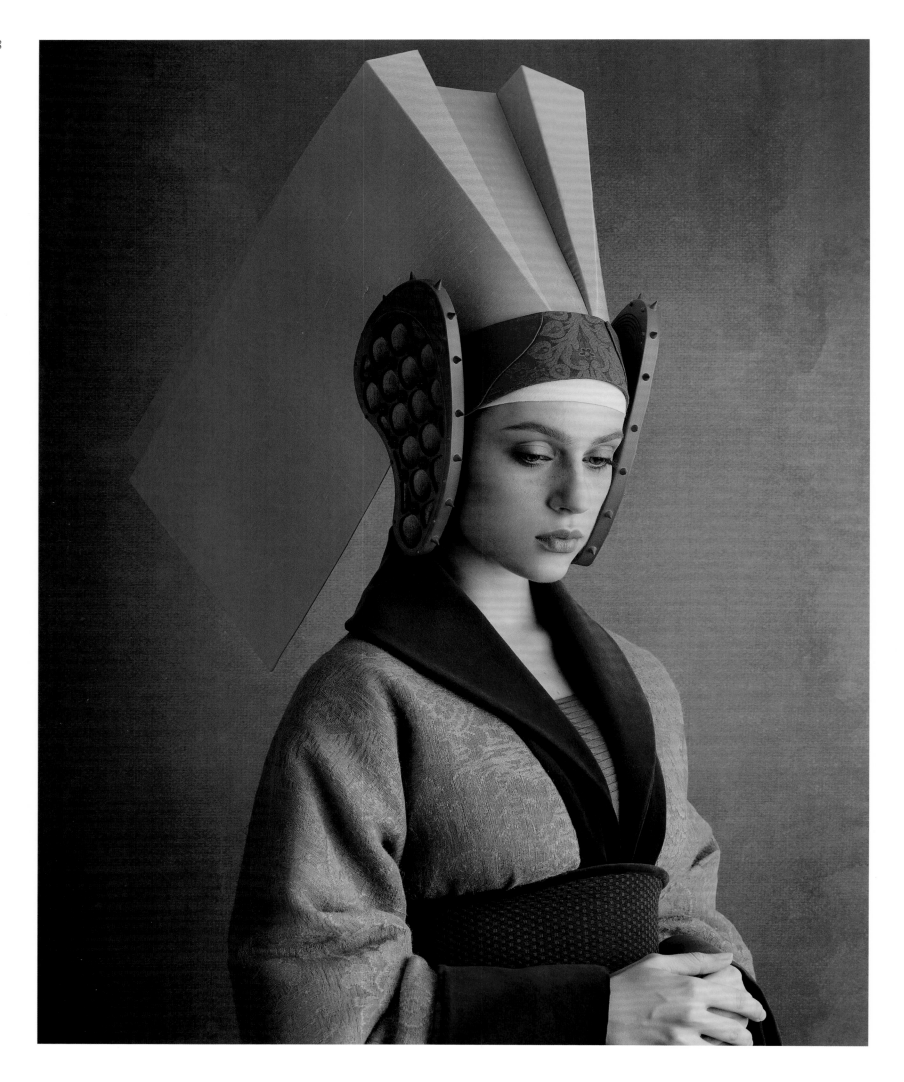

CHRISTIAN TAGLIAVINI
La Moglie dell'Orefice, 2017

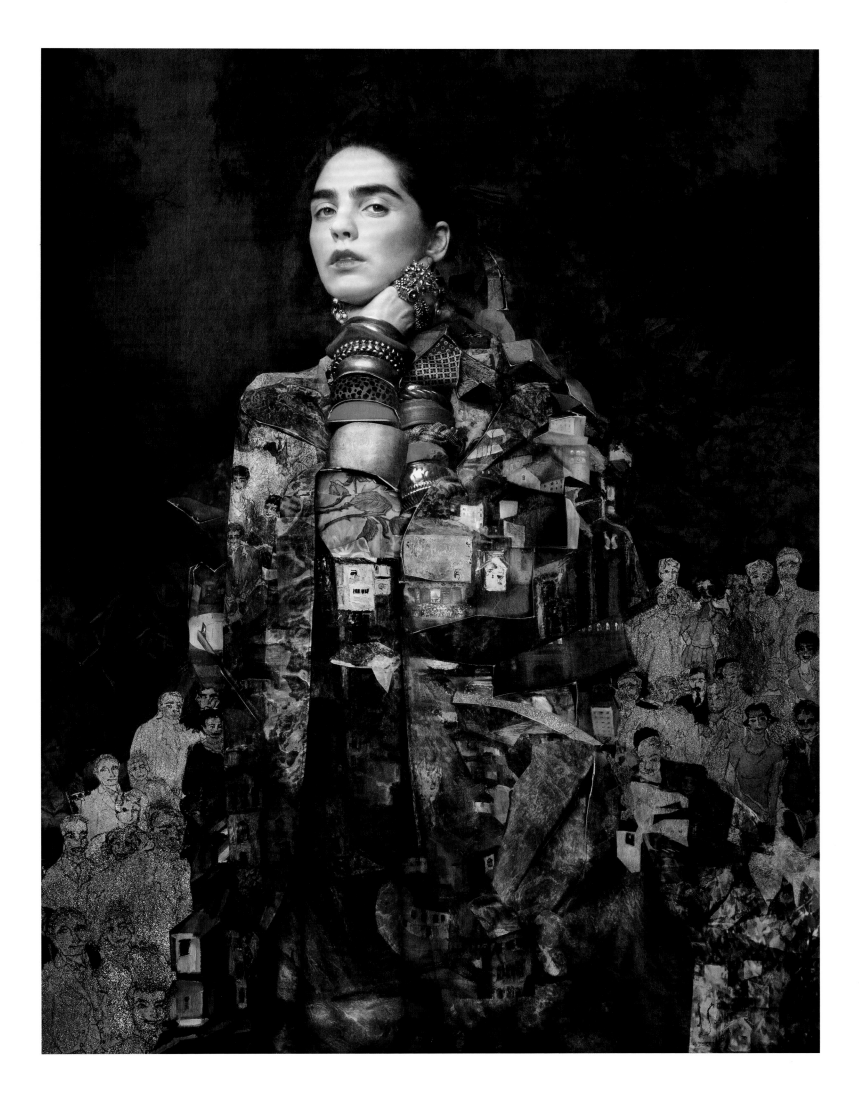

COOPER & GORFER
Amanda and the Painted People, 2017

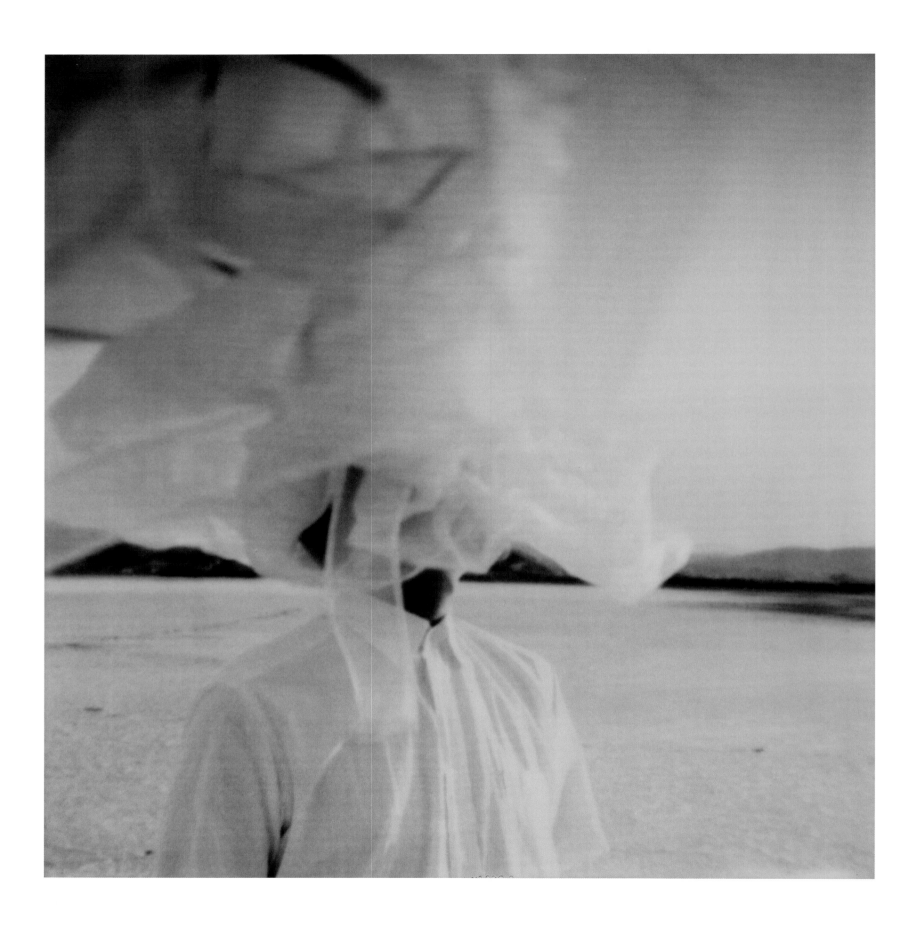

CORINNE MERCADIER

Une fois et pas plus 43, 2002

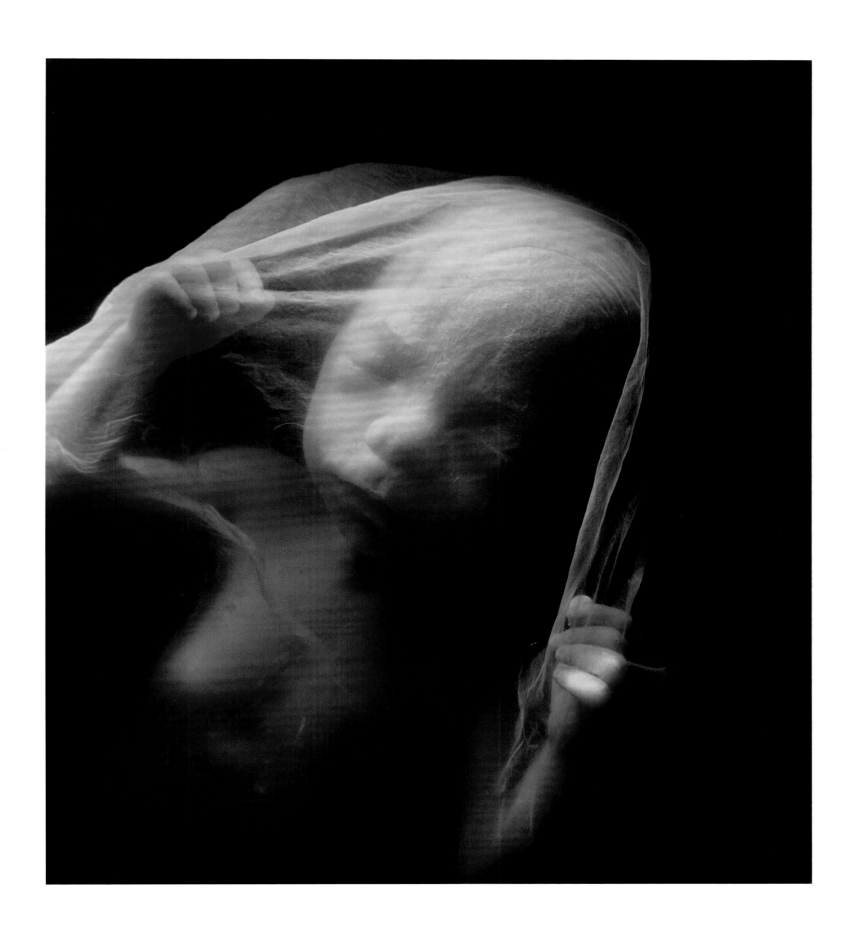

LENNART NILSSON

18 Weeks, Approximately 14 cm, The Fetus Can Now Perceive Sounds

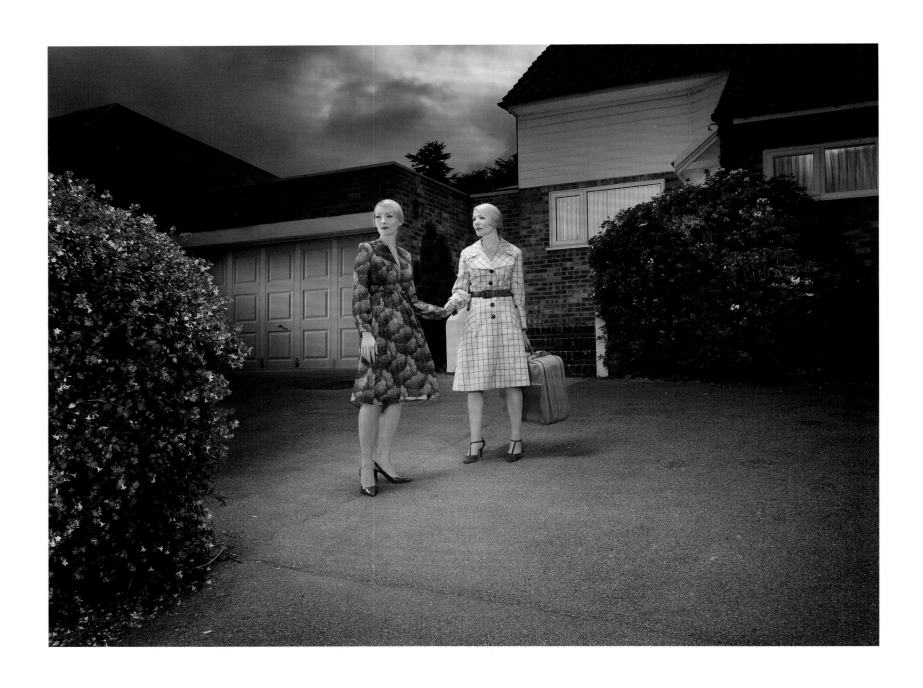

JULIA FULLERTON-BATTEN

Departure, 2012

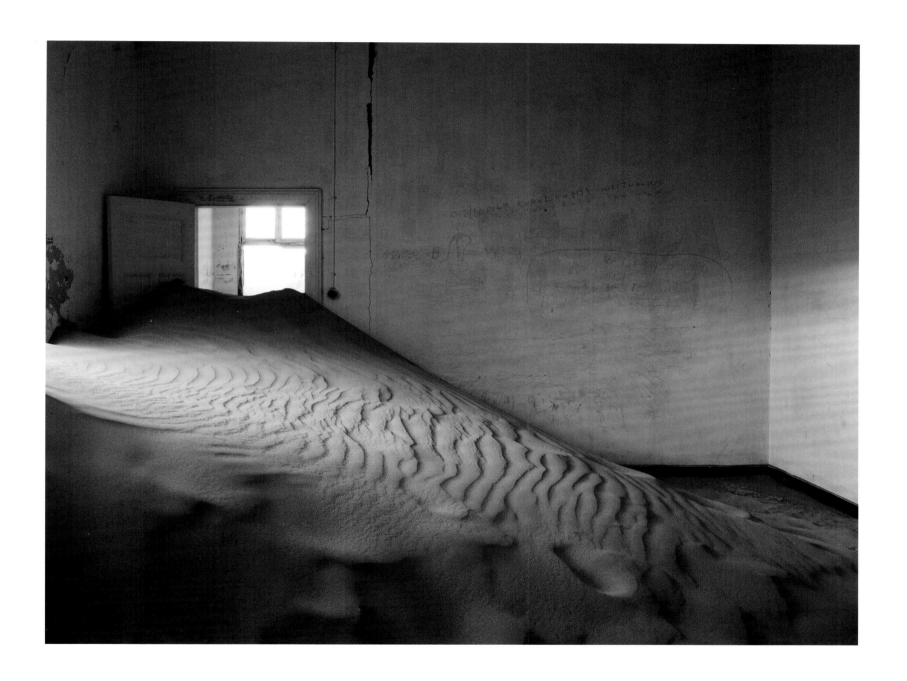

HELENE SCHMITZ

Interior, 2015

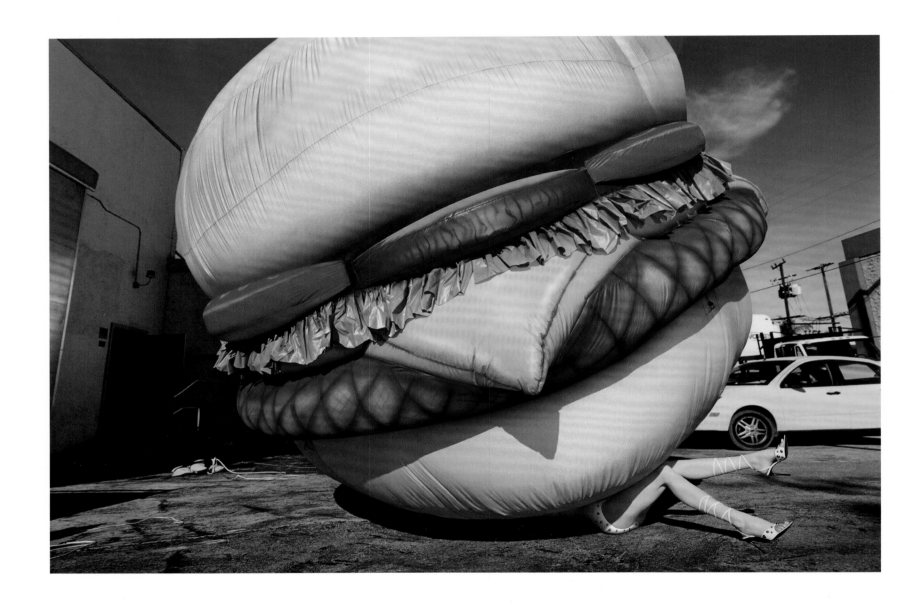

DAVID LACHAPELLE

Death by Hamburger, 2001

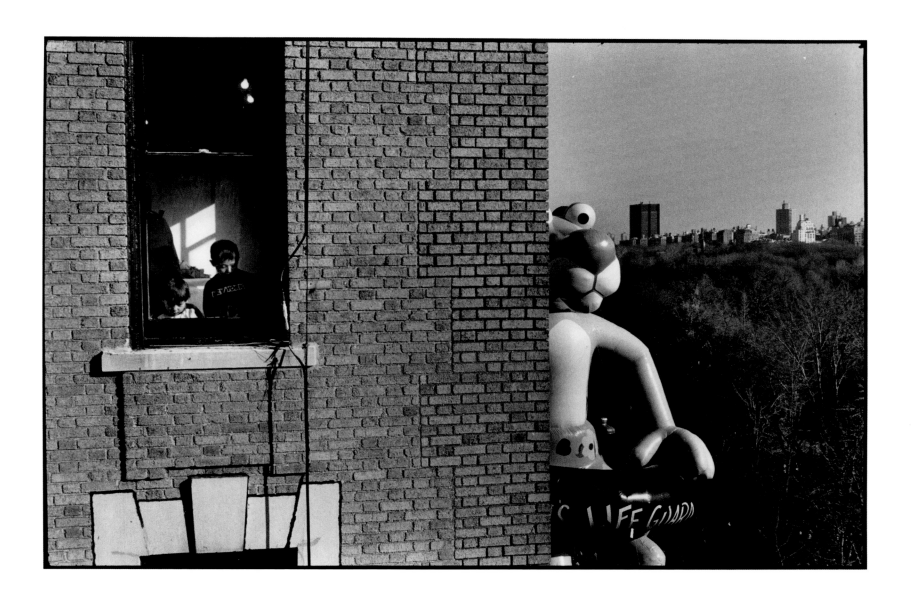

ELLIOTT ERWITT
USA, New York City, 1988

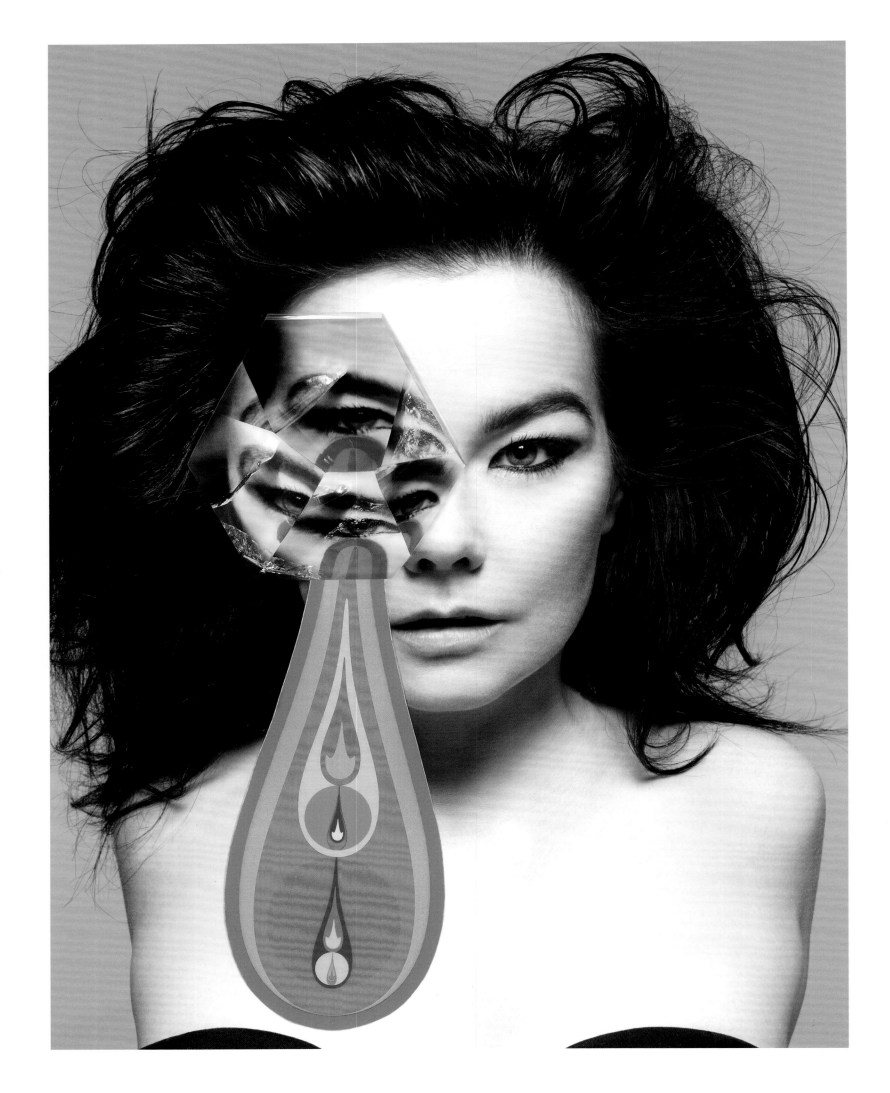

INEZ & VINOODH

Björk, *Interview* Magazine, with M/M (Paris), 2009

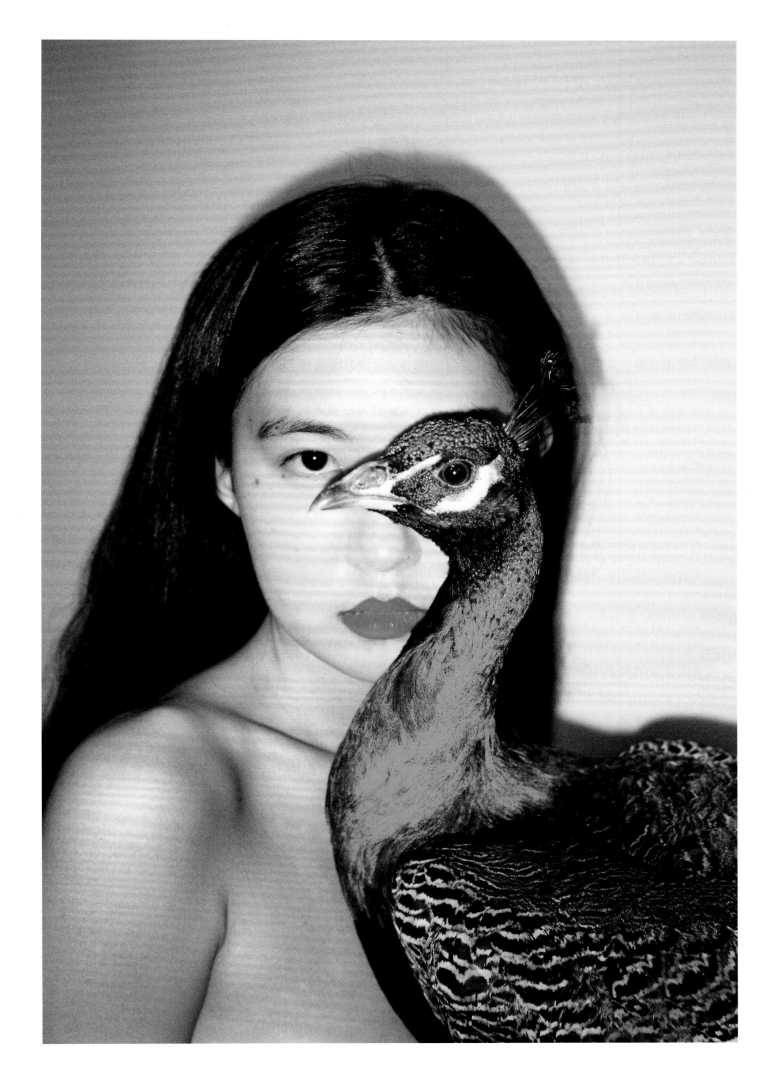

REN HANG

Untitled

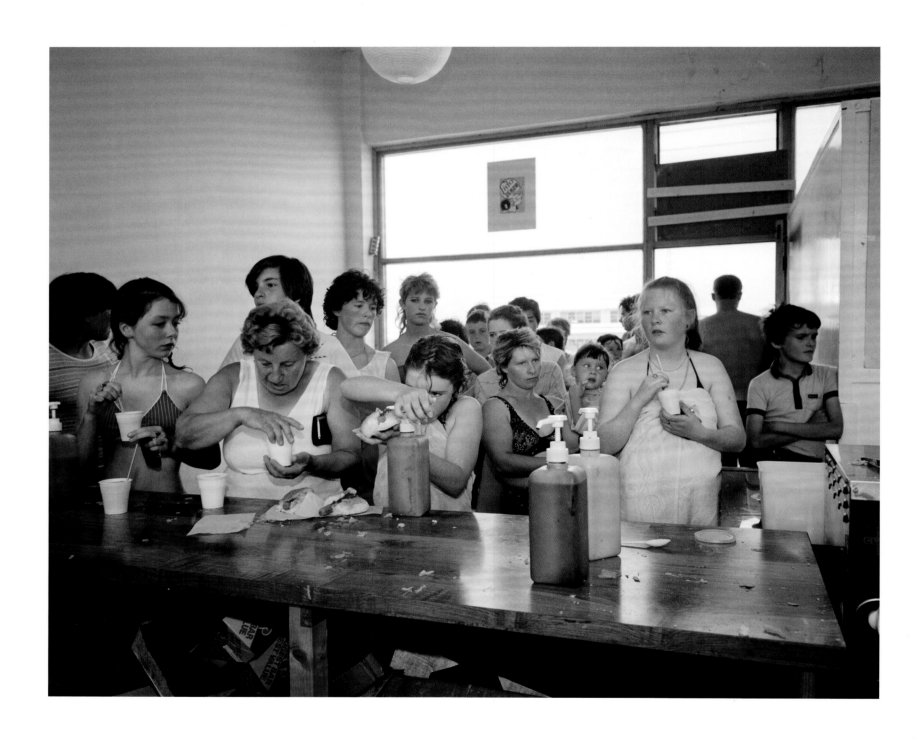

MARTIN PARR
New Brighton, England, GB, 1983–1985

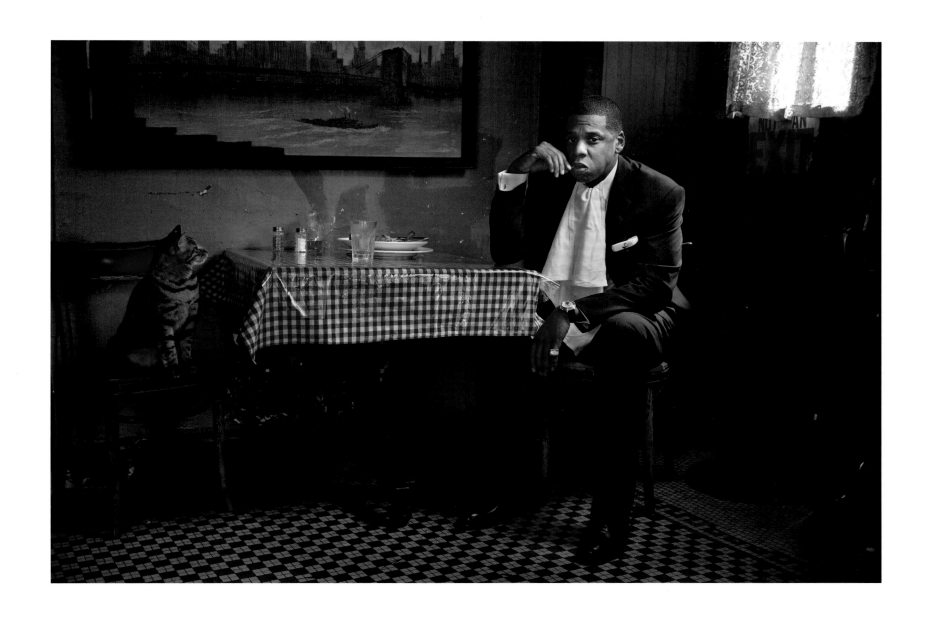

MARTIN SCHOELLER

Jay-Z with Cat, New York, NY, 2007

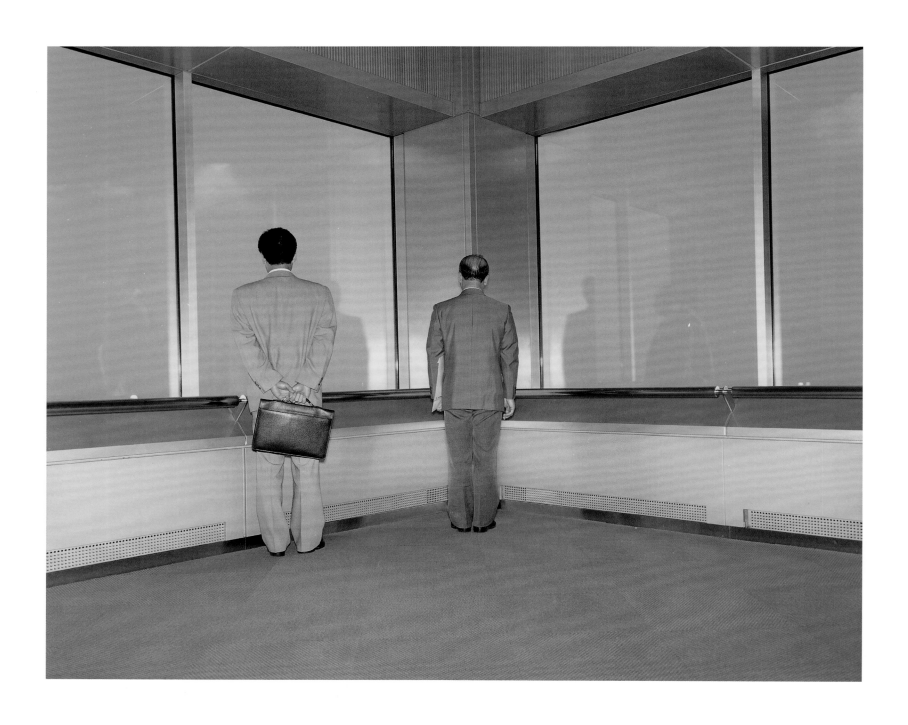

LARS TUNBJÖRK
Stadsförvaltning, from the series *Office*, Tokyo, 1996

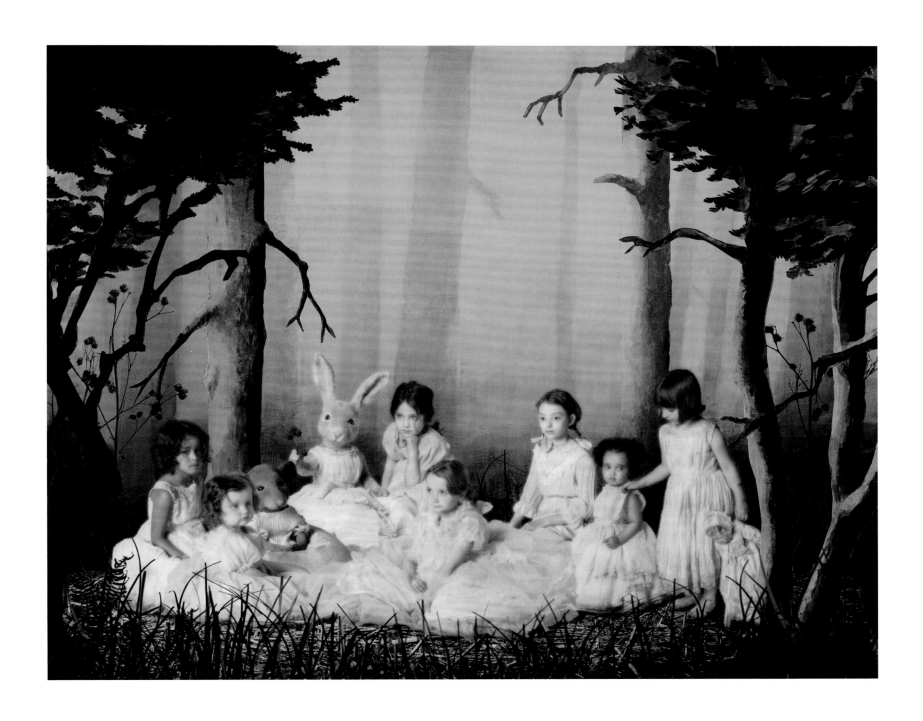

HELENA BLOMQVIST

Group Portrait in Forest, 2011

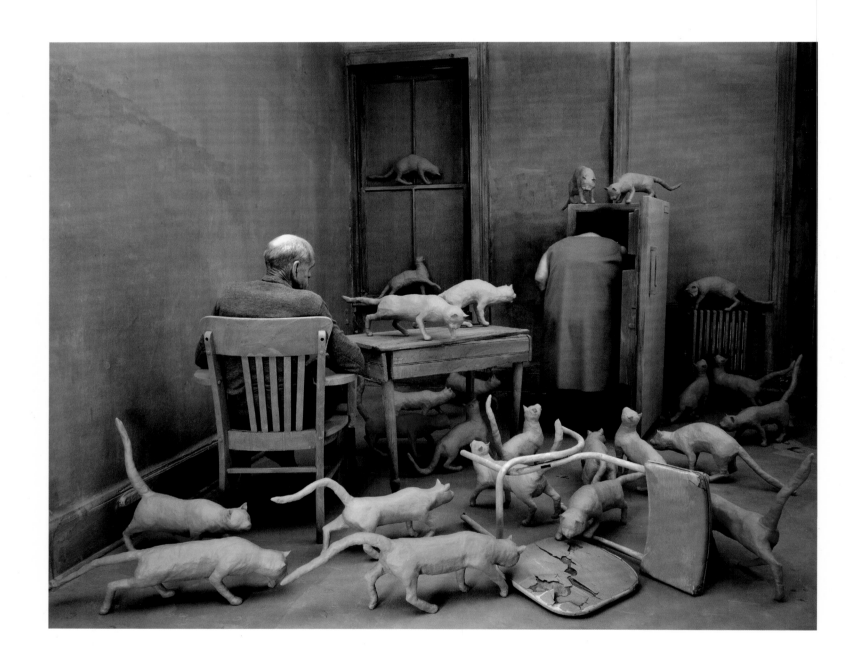

SANDY SKOGLUND

Radioactive Cats, 1980

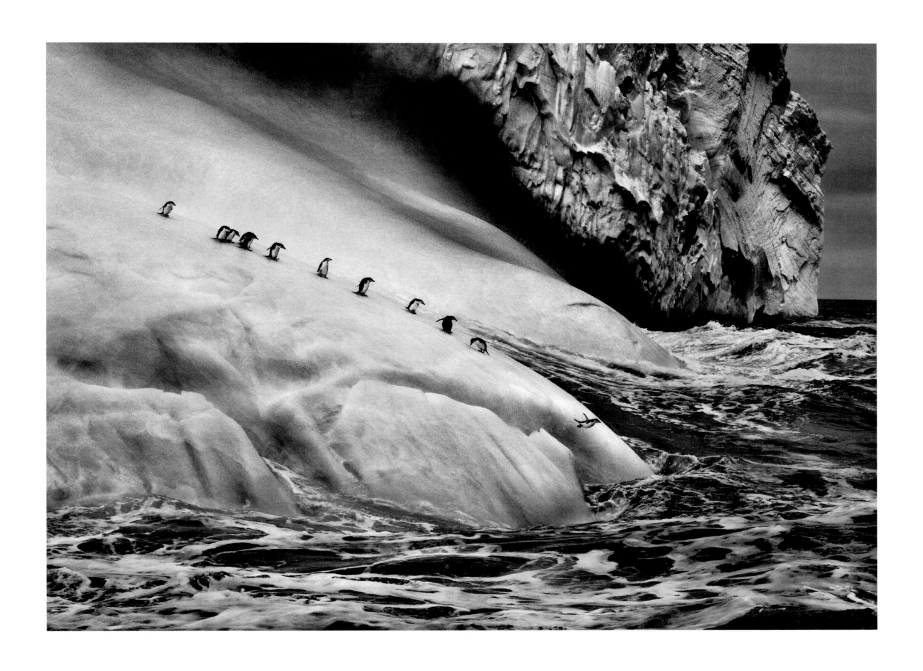

SEBASTIÃO SALGADO

Chinstrap Penguins, South Sandwich Islands, 2009

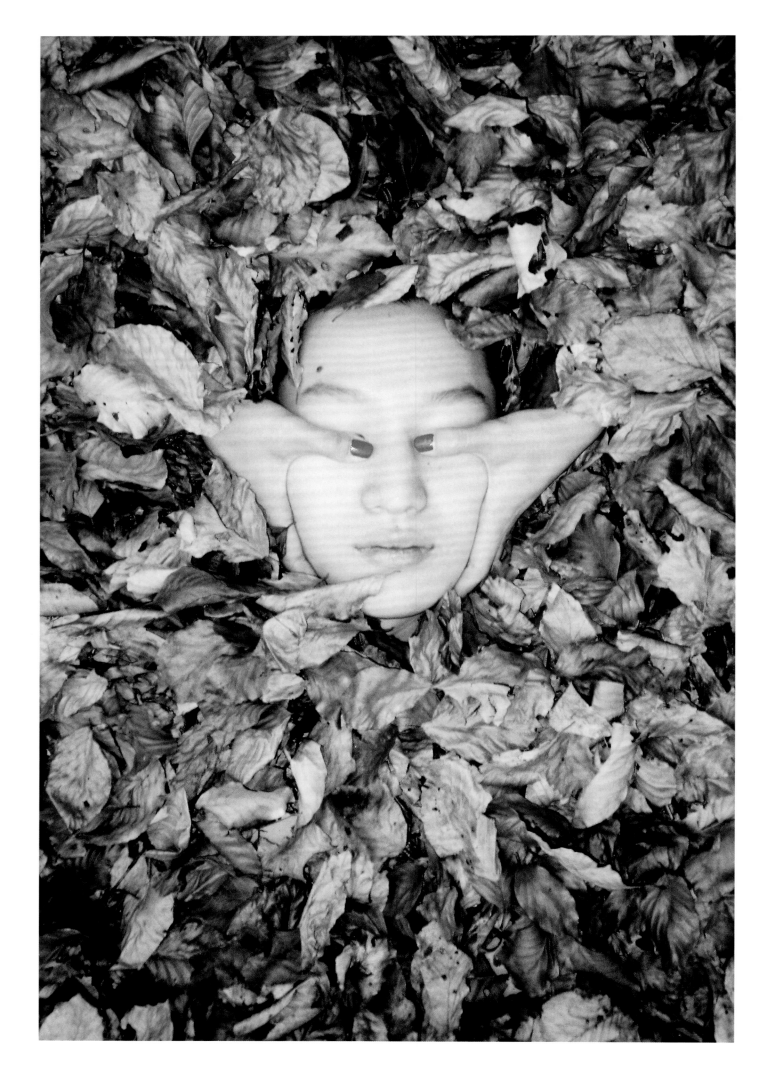

REN HANG
Untitled

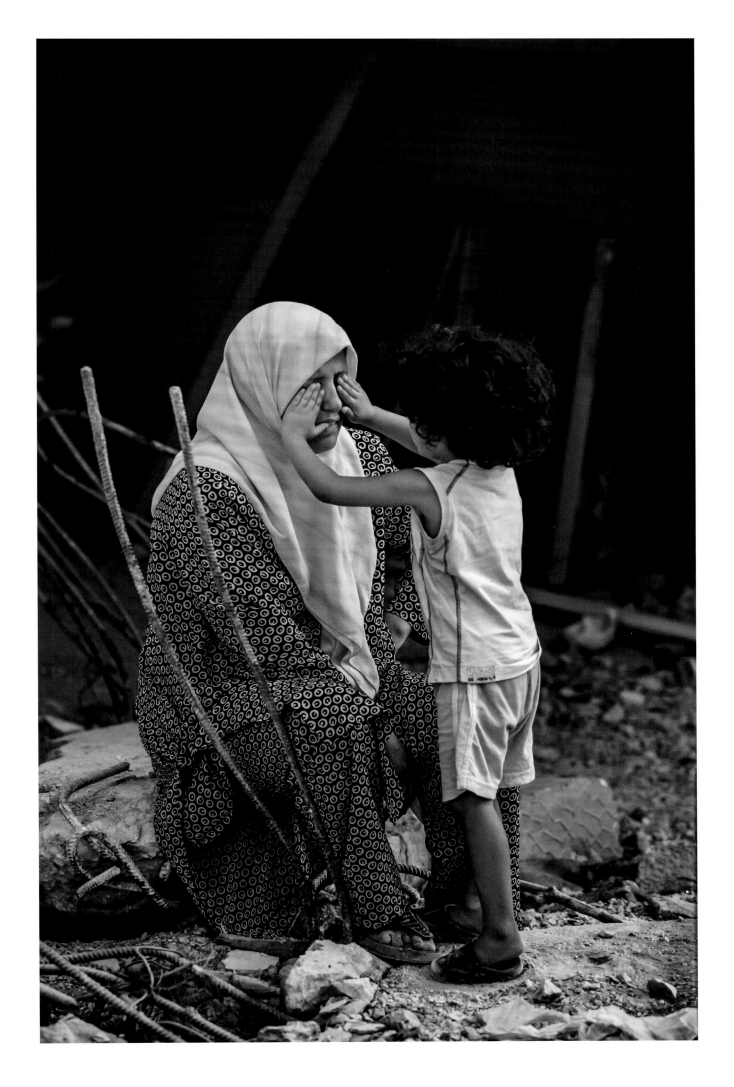

PAUL HANSEN

Stop Crying Mama, Qana, Lebanon, 2006

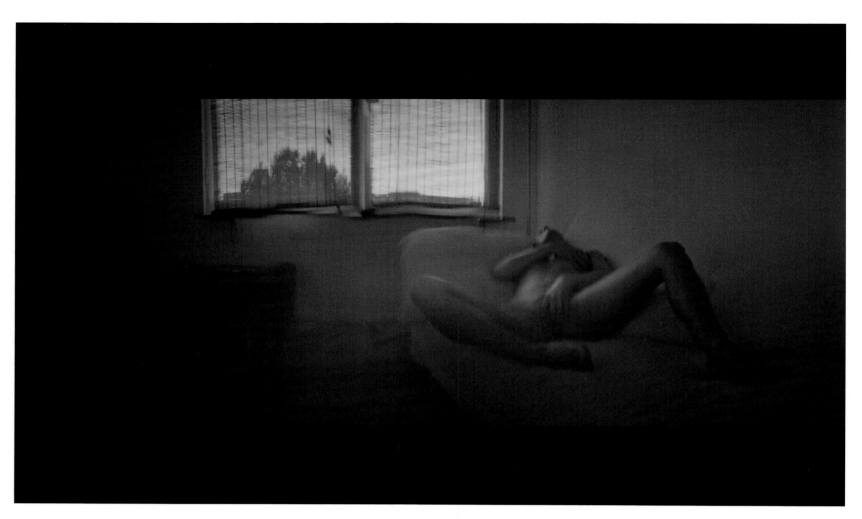

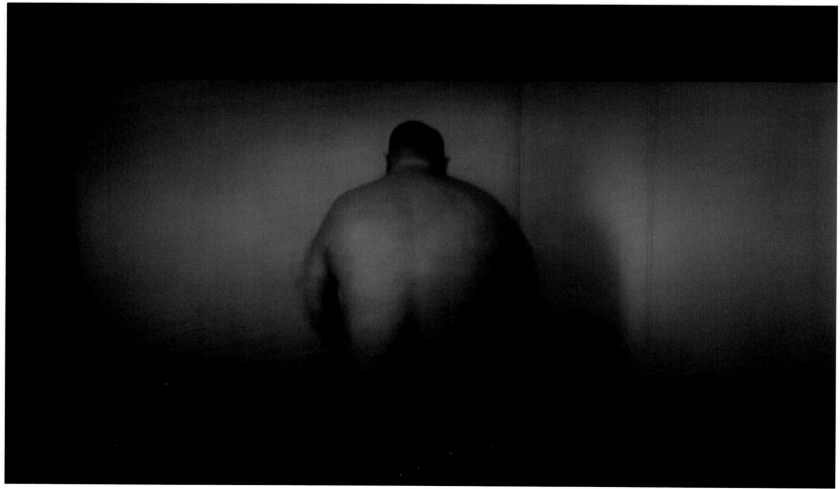

PIETER TEN HOOPEN

Untitled. Untitled

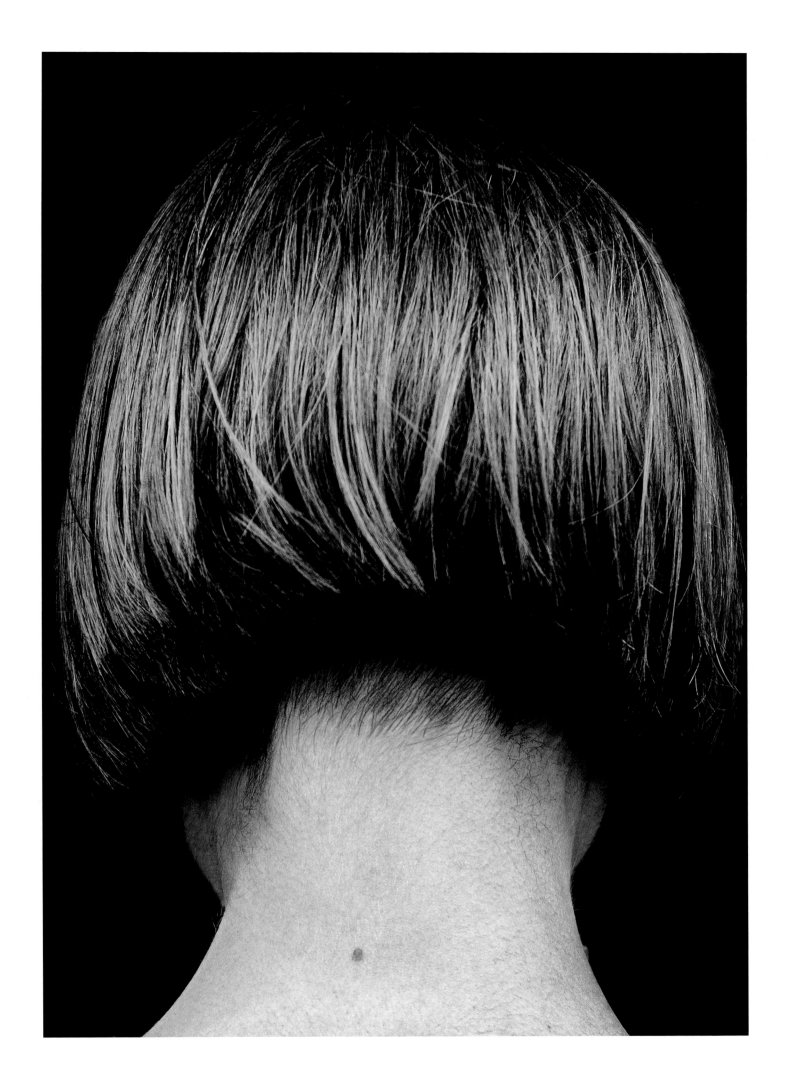

THOMAS WÅGSTRÖM

Necks, No. 37

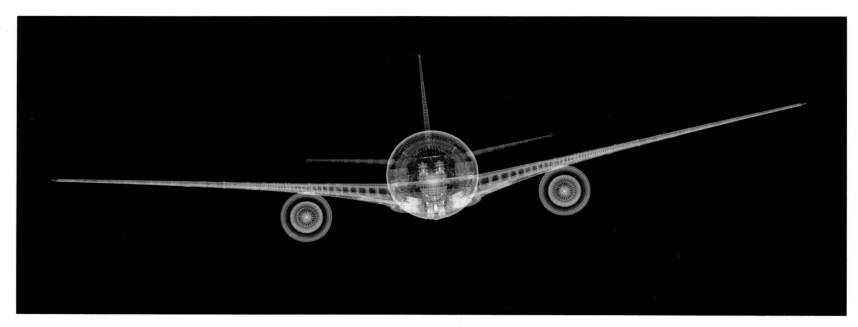

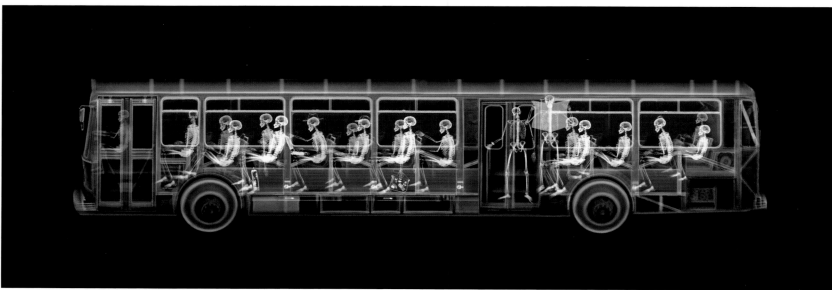

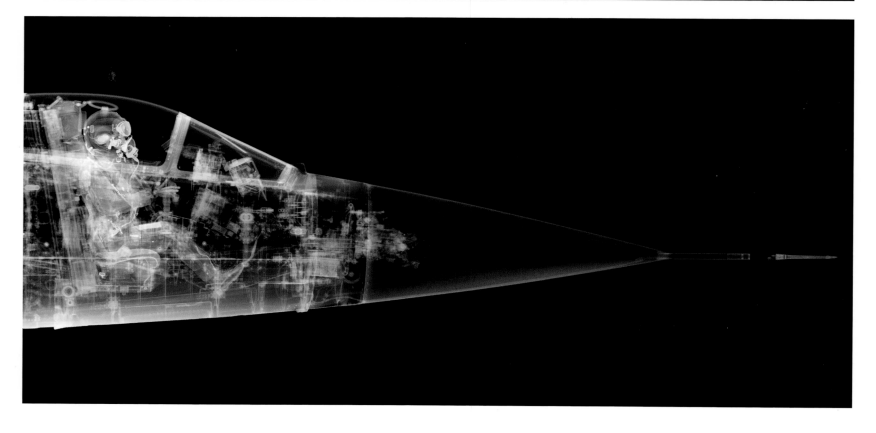

NICK VEASEY

Veasey Jet, 2013. Bus, 1998. F-104 Starfighter, 2016

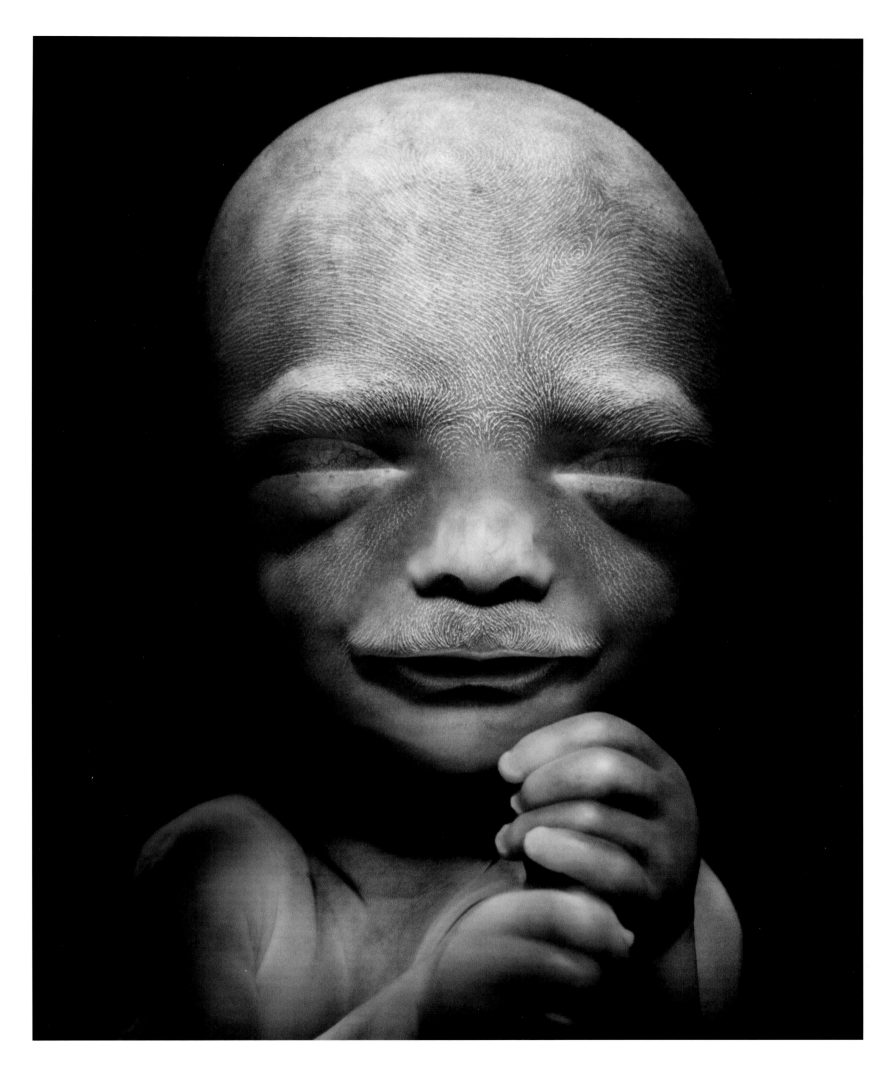

LENNART NILSSON

Fetus, 20 Weeks, Approximately 20 cm

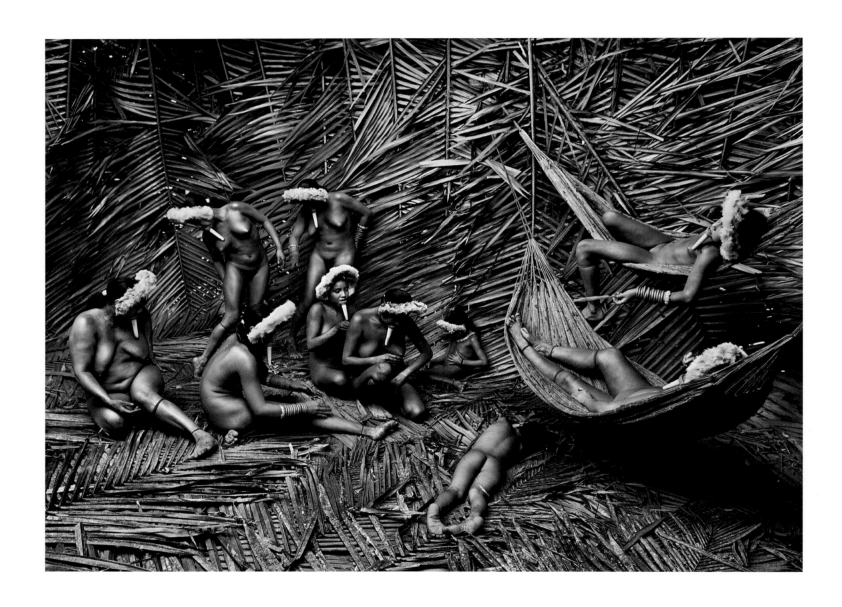

SEBASTIÃO SALGADO

Zo'é Village of Towari Ypy, Pará, Brazil, 2009

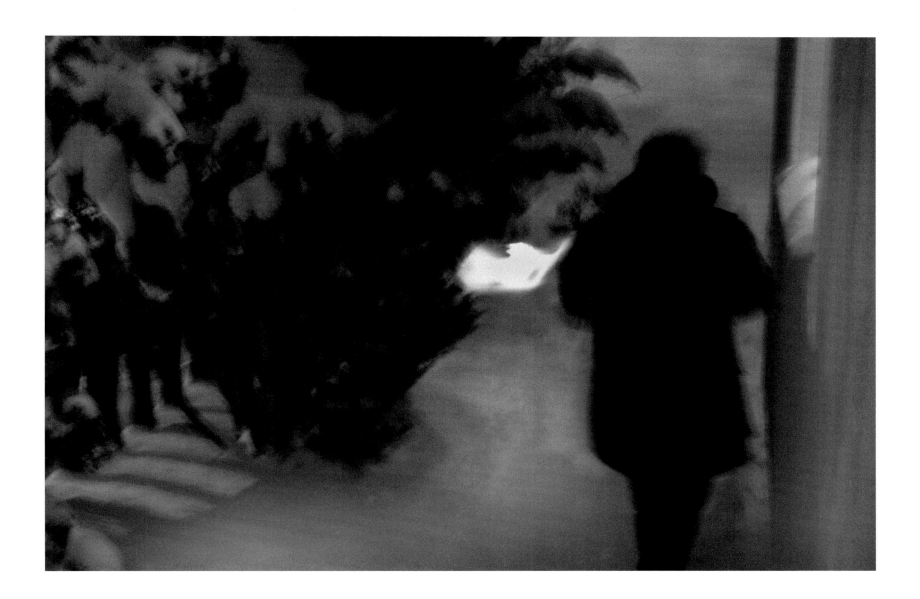

LU KOWSKI

Untitled

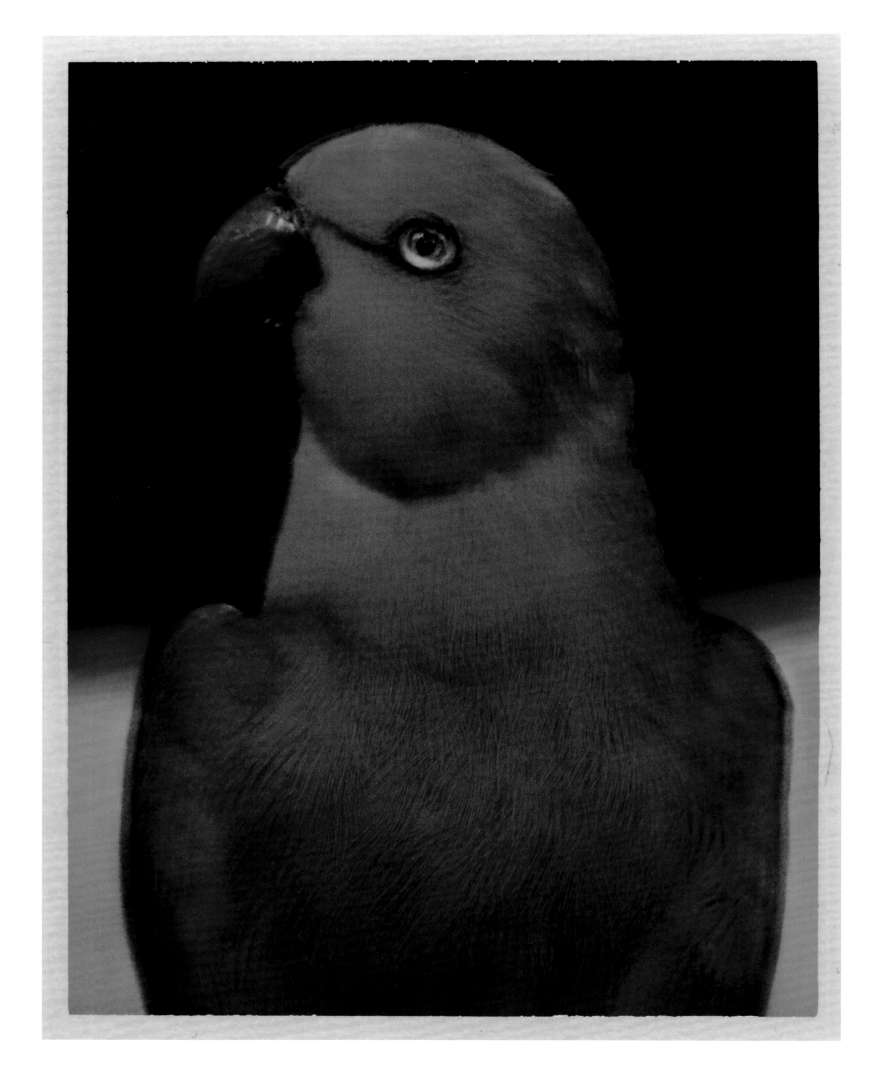

SARAH MOON

L'oiseau 1, 2000

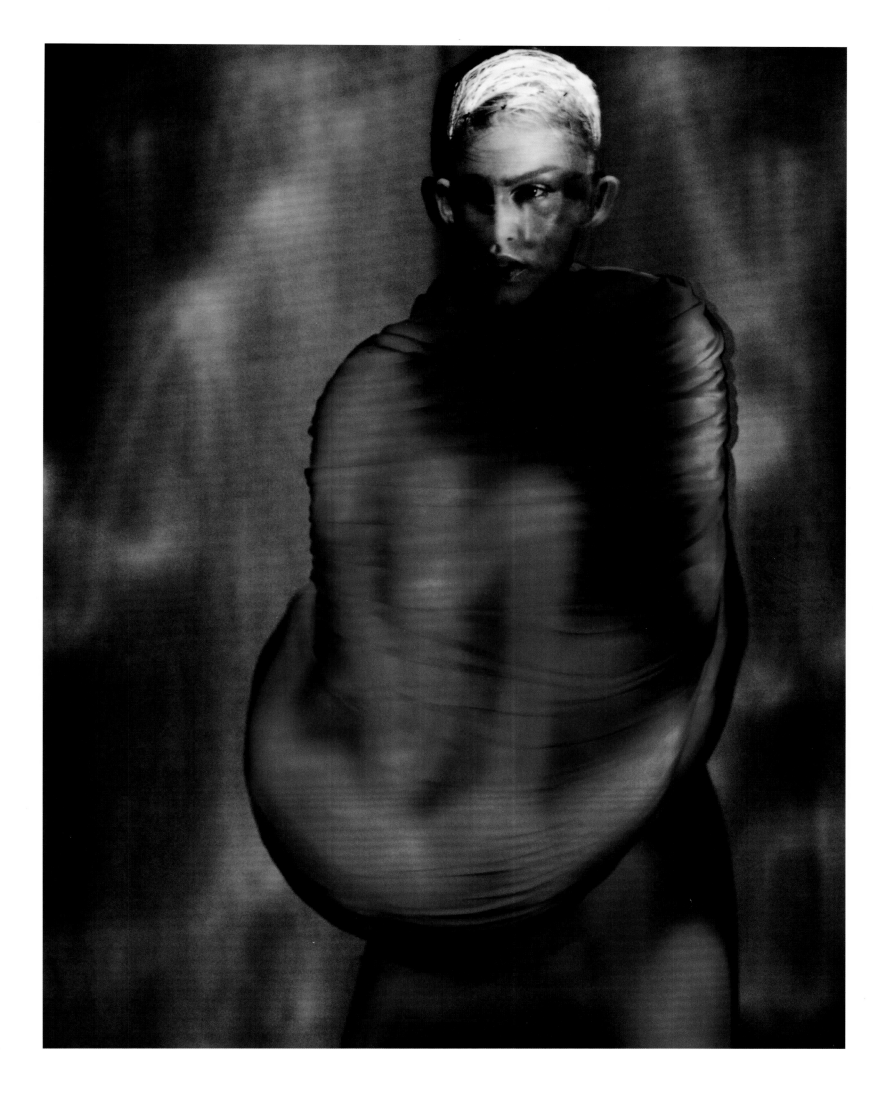

PAOLO ROVERSI

Sharon, Paris, 1996

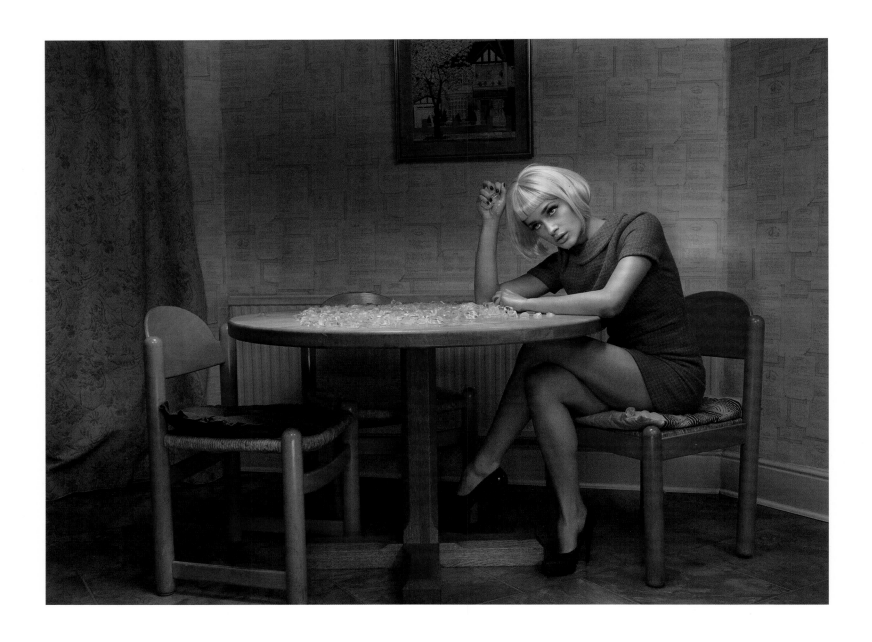

JULIA FULLERTON-BATTEN
The Waiting Game, 2013

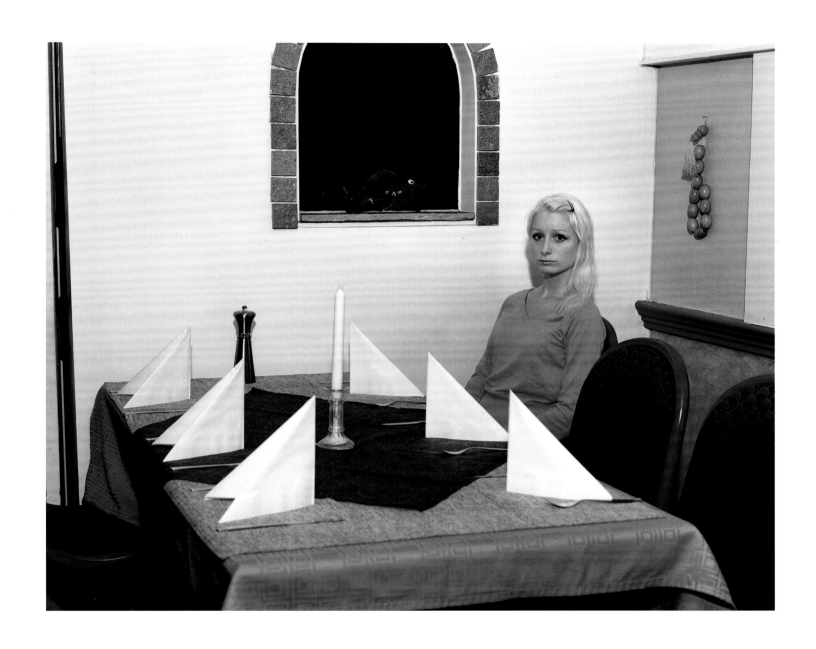

LARS TUNBJÖRK

Untitled, from the series *Winter*, Karlskrona, 2006

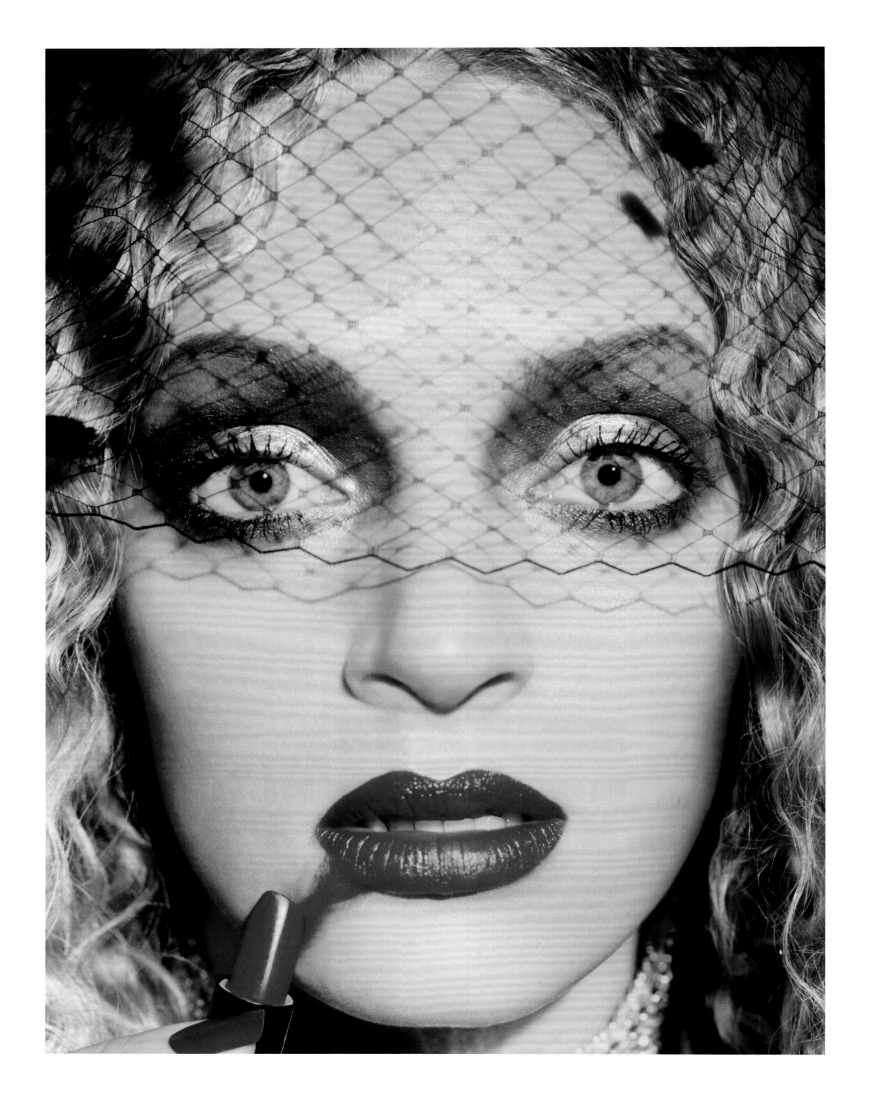

DAVID LACHAPELLE
Uma Thurman: Gossip, 1997

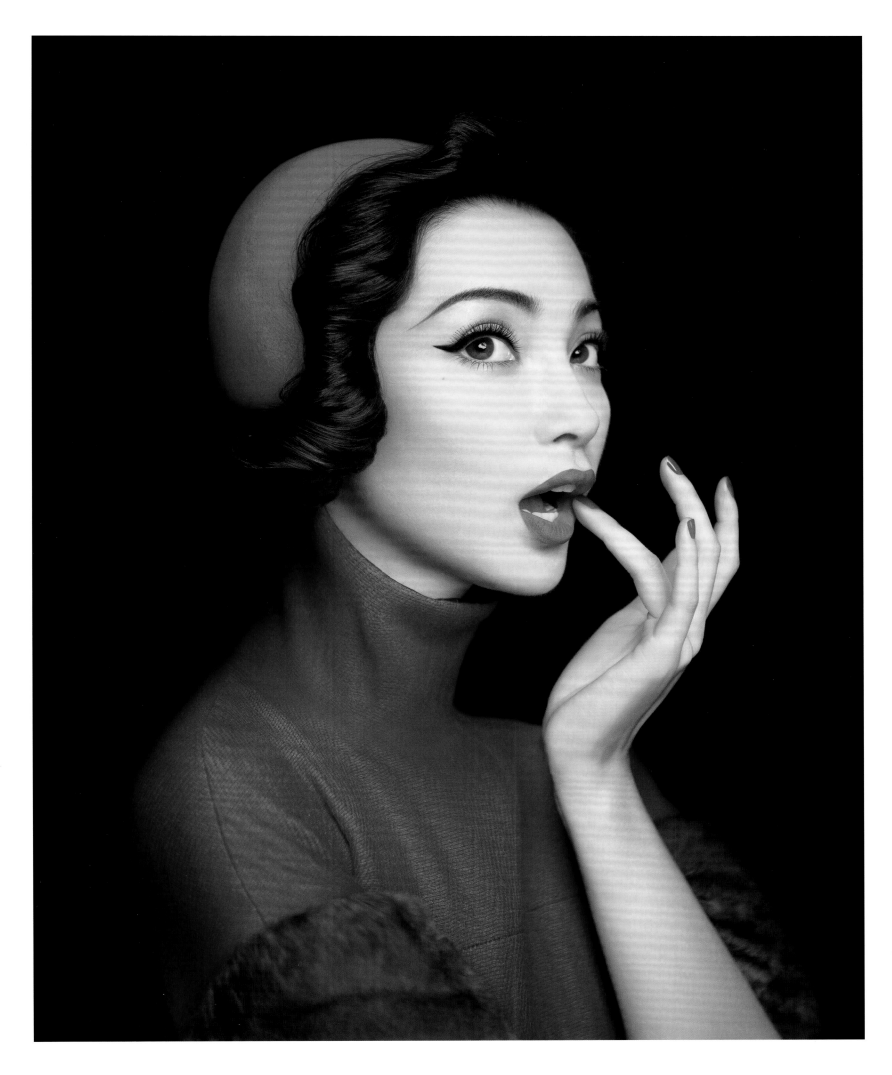

CHEN MAN
Actress Li Bingbing, 2010

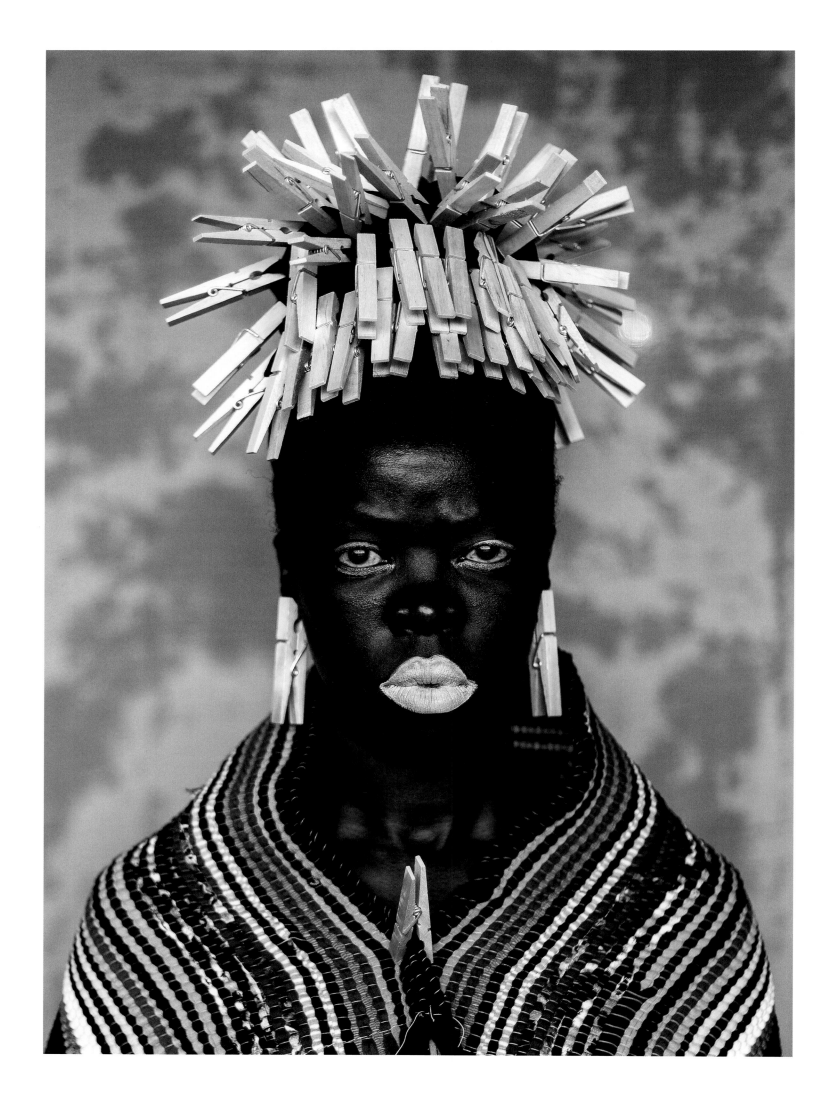

ZANELE MUHOLI
Bester I, Mayotte, 2015

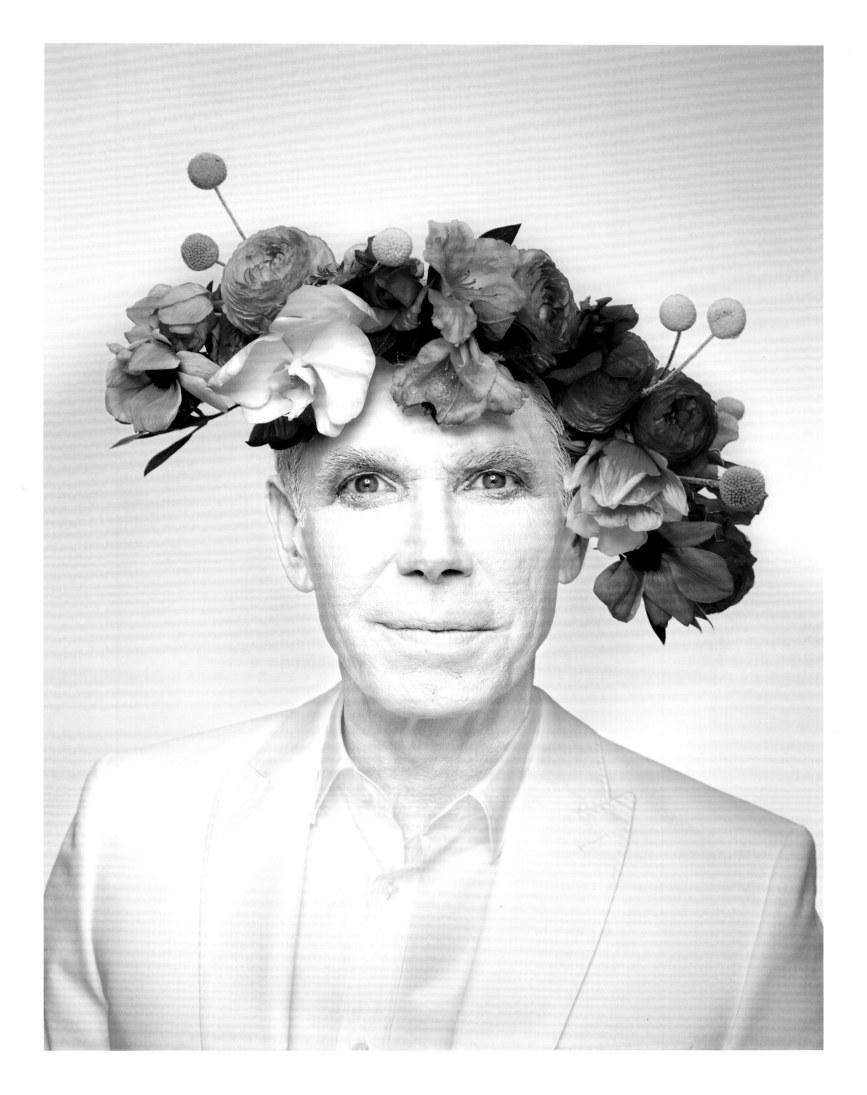

MARTIN SCHOELLER

Jeff Koons with Floral Headpiece, New York, NY, 2013

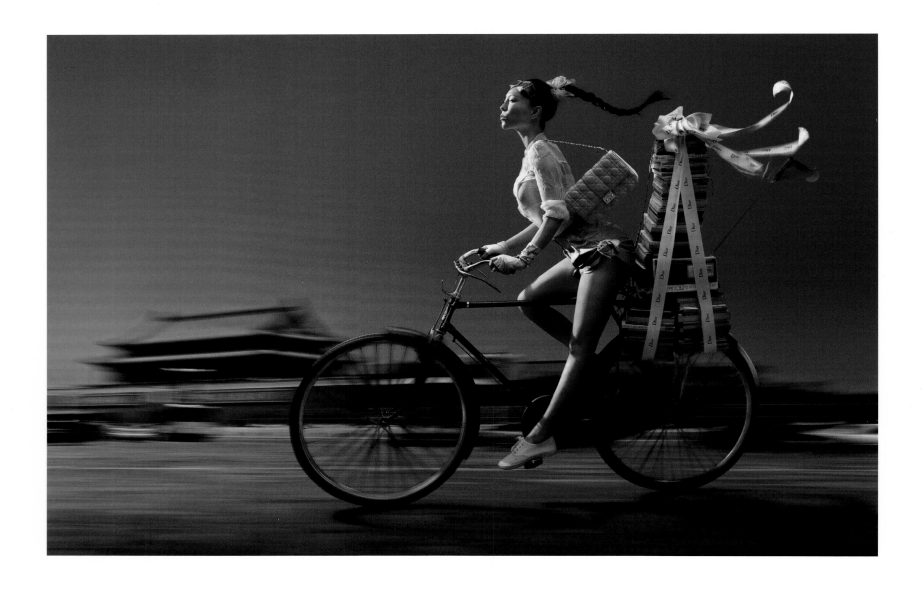

CHEN MAN
Miss Wan Studies Hard, 2011

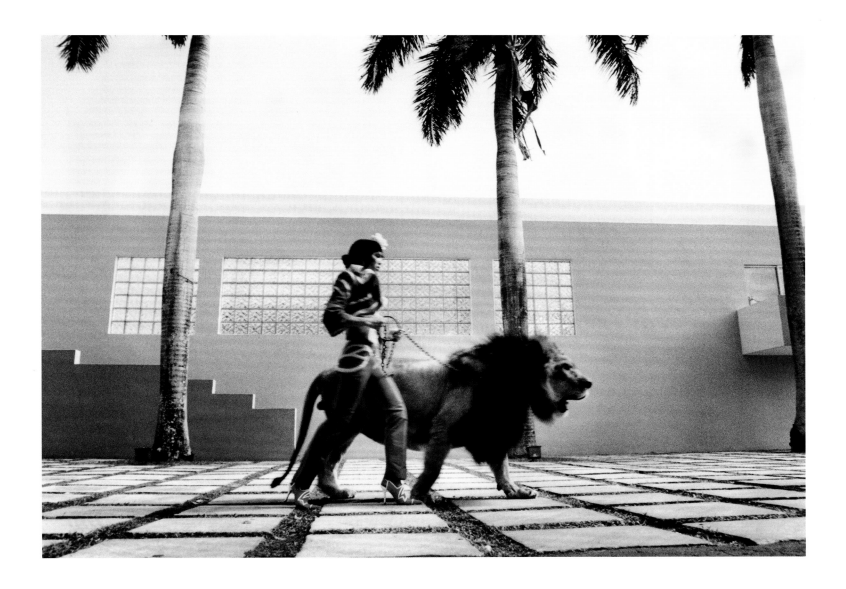

ESTHER HAASE

The Fearless Lola Walking the Lion King, Miami, November 1999

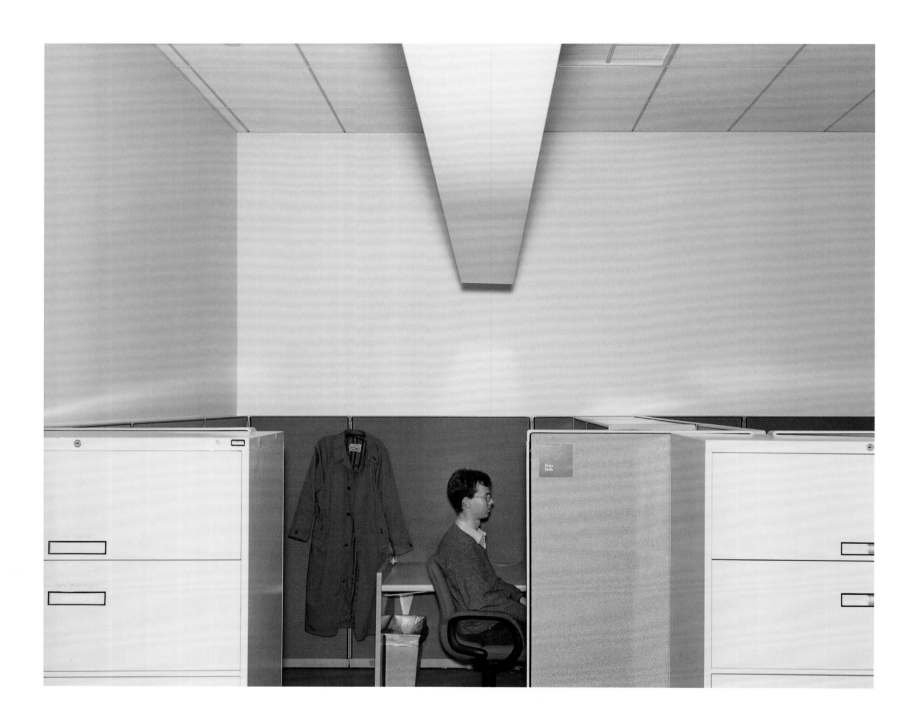

LARS TUNBJÖRK

Reklambyrå, from the series *Office*, New York, 1997

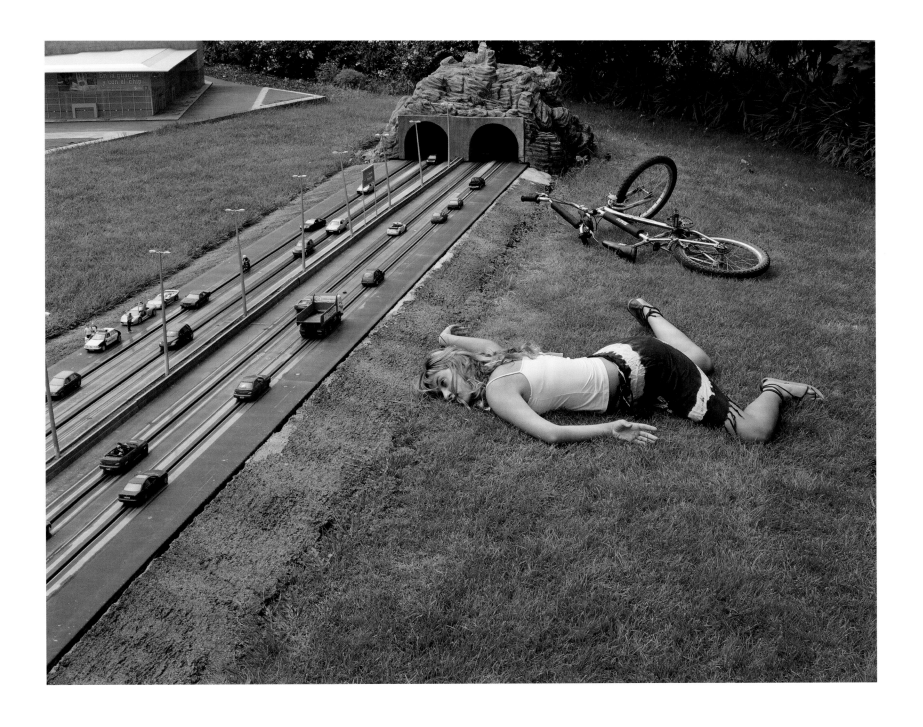

JULIA FULLERTON-BATTEN
Bike Accident, 2005

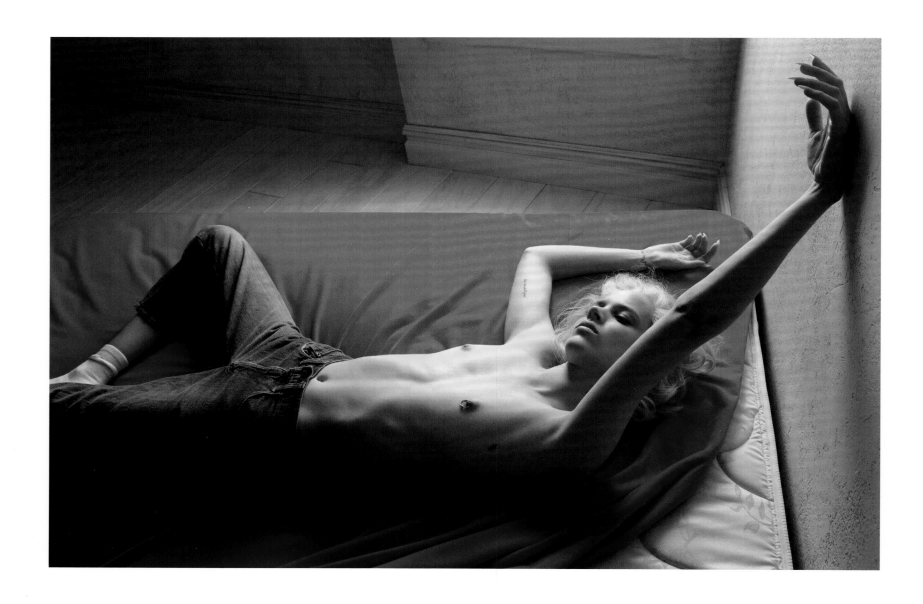

INEZ & VINOODH

Freja on the Red Bed, *Self Service* Magazine, 2008

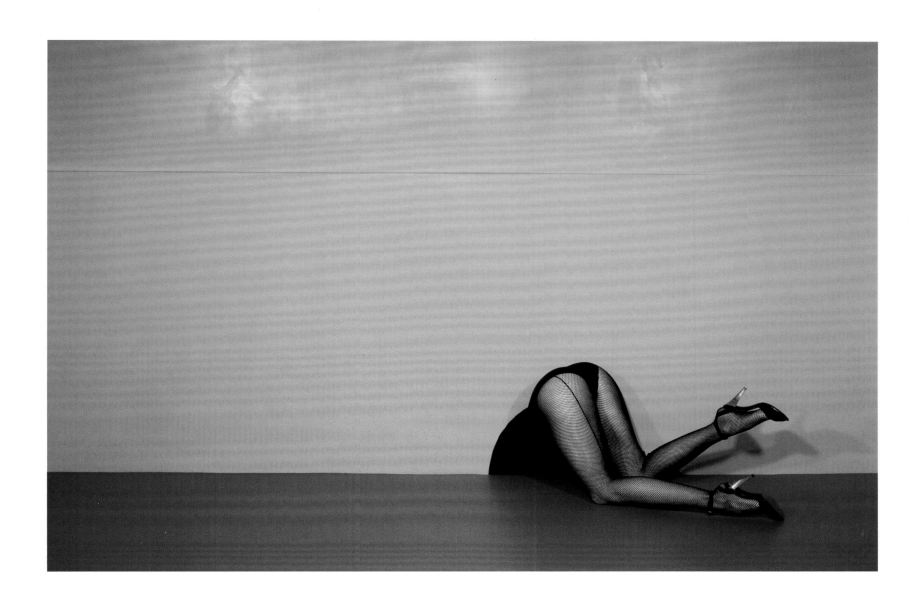

GUY BOURDIN

Charles Jourdan, Spring 1979

"If you want reality, take the bus."

DAVID LACHAPELLE

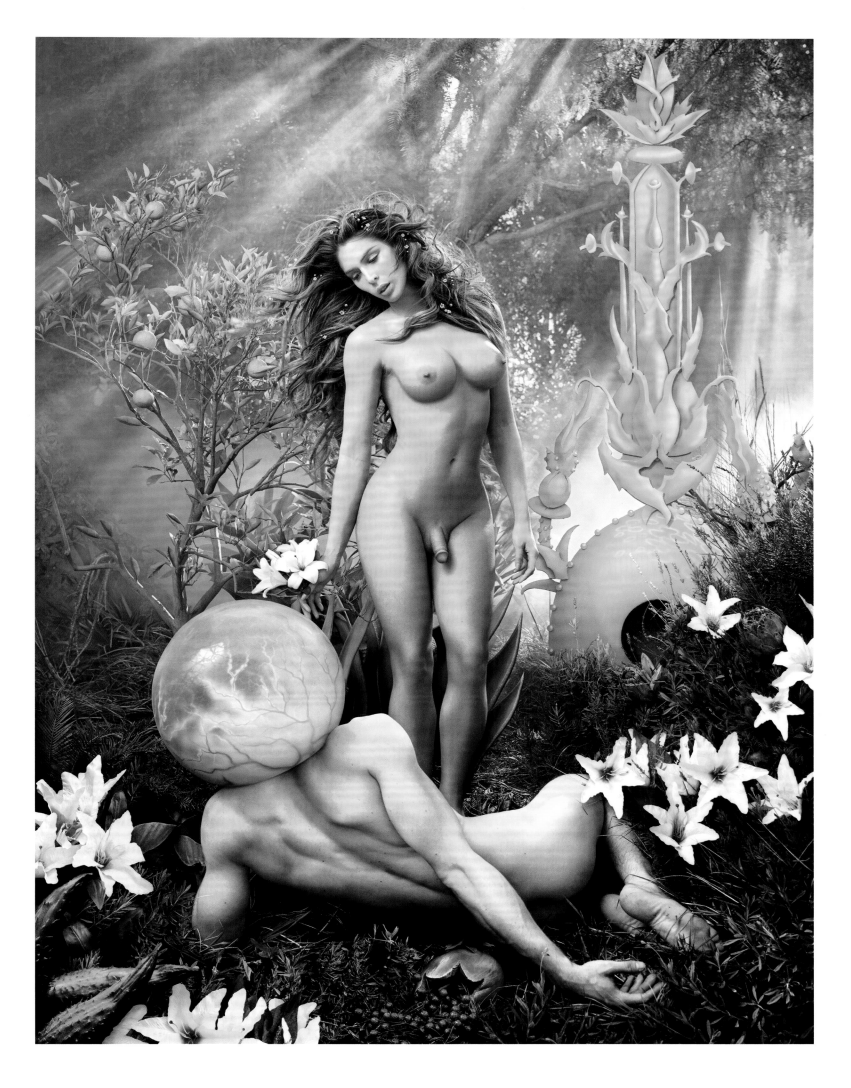

DAVID LACHAPELLE
Once in the Garden (1), 2014

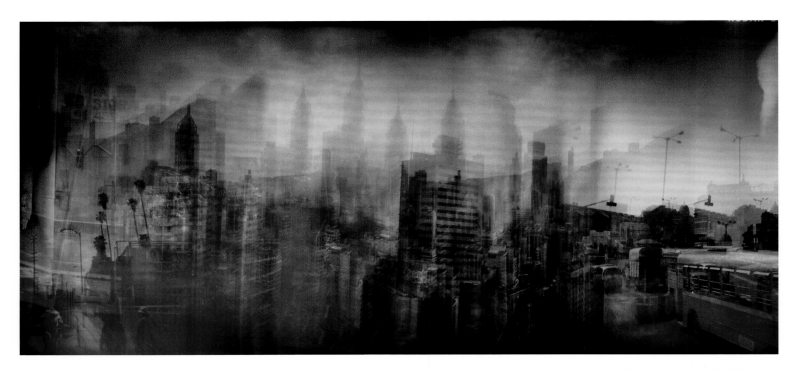

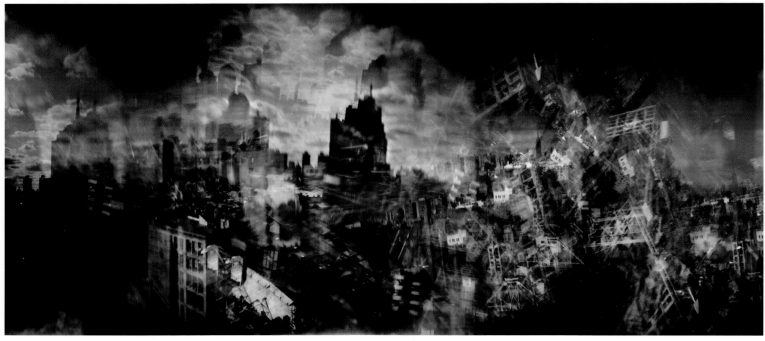

JACOB FELLÄNDER

Los Angeles/Hong Kong/Bombay, 2011. New York 53, 2011

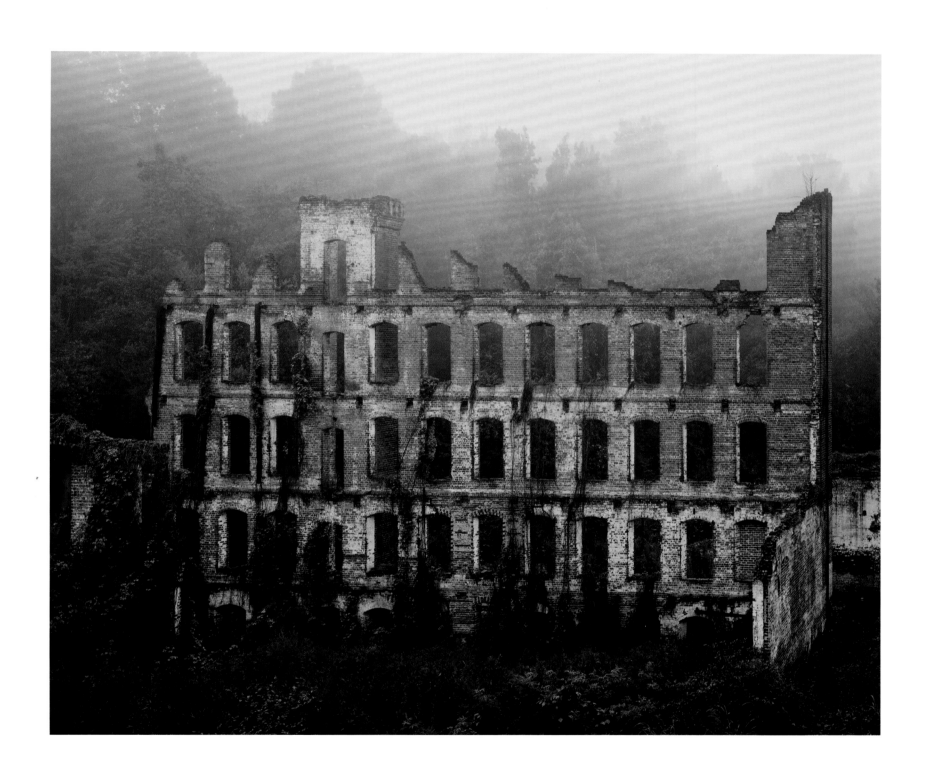

HELENE SCHMITZ
The Cotton Mill, 2013

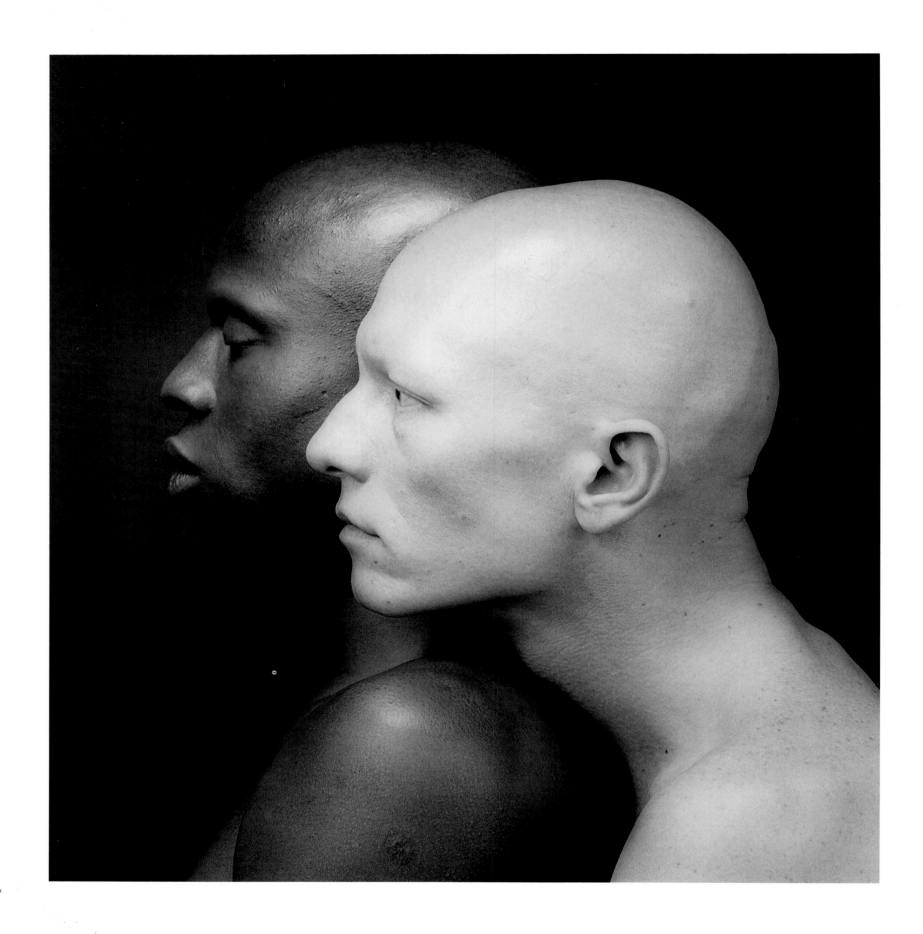

ROBERT MAPPLETHORPE

Ken Moody and Robert Sherman, 1984

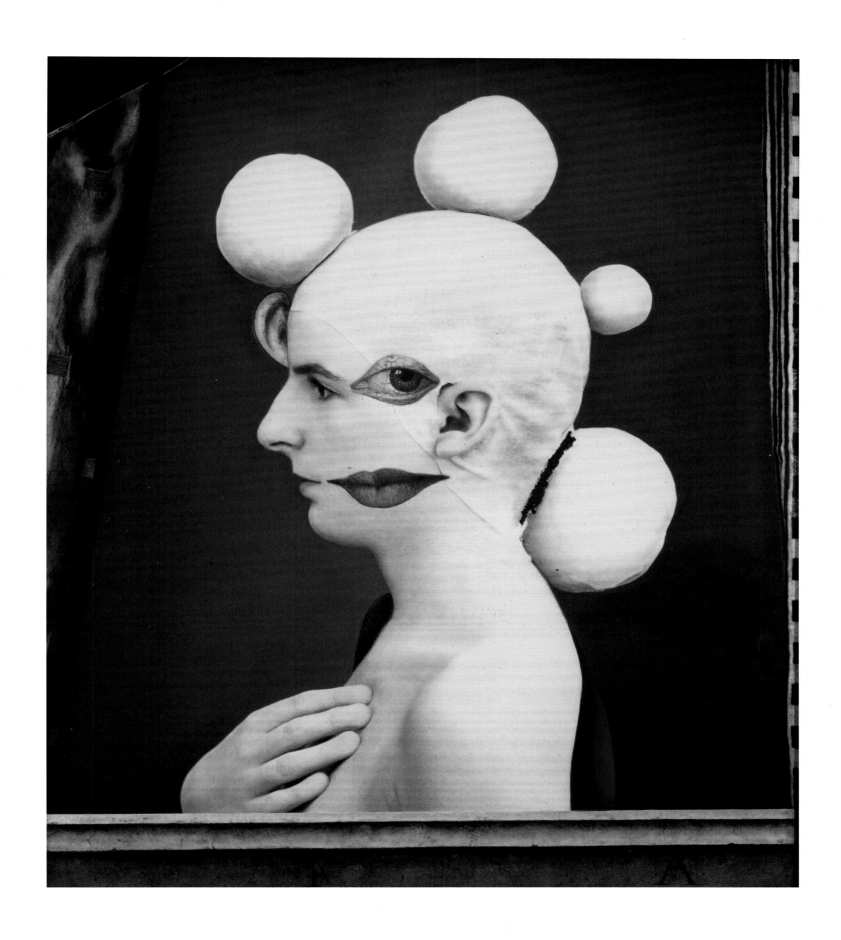

JOEL-PETER WITKIN

Portrait of Clemence L., 2002

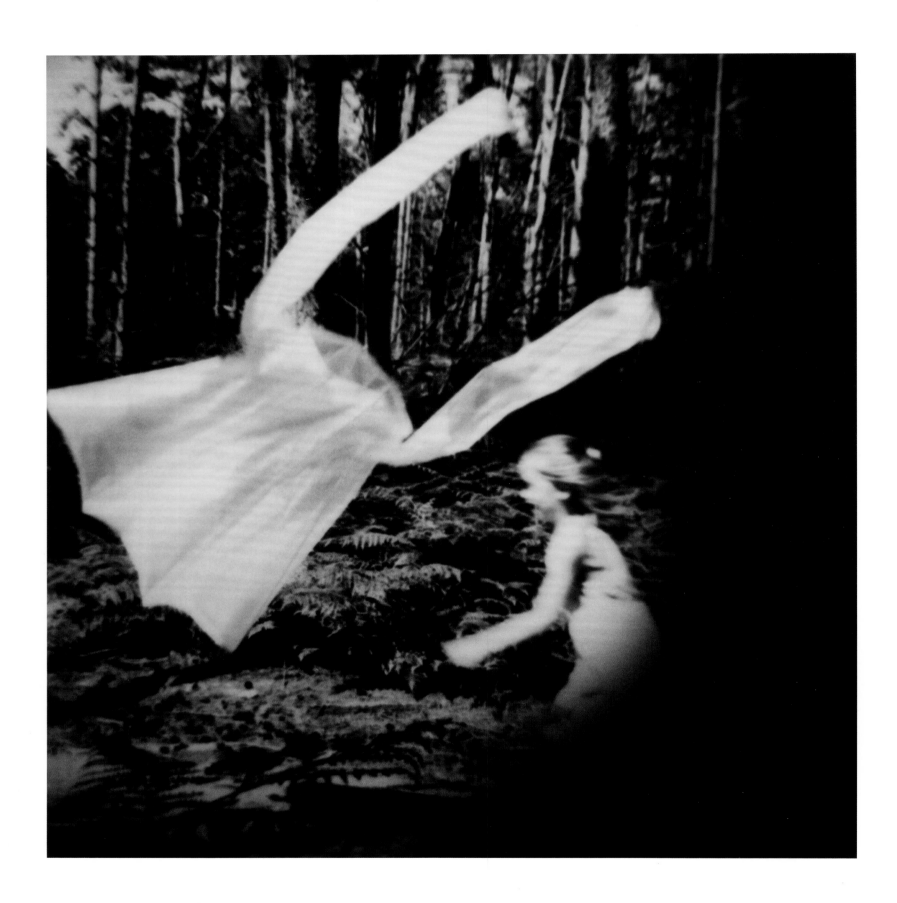

CORINNE MERCADIER

Une fois et pas plus 26, 2000

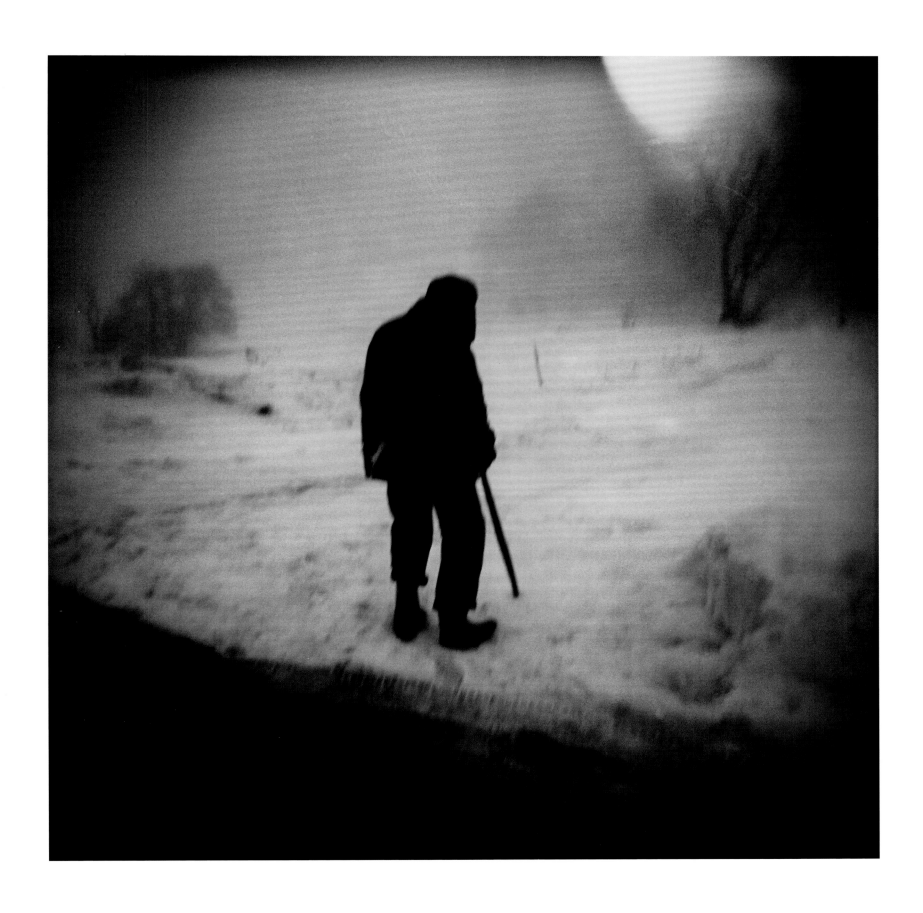

MARTIN BOGREN

Untitled

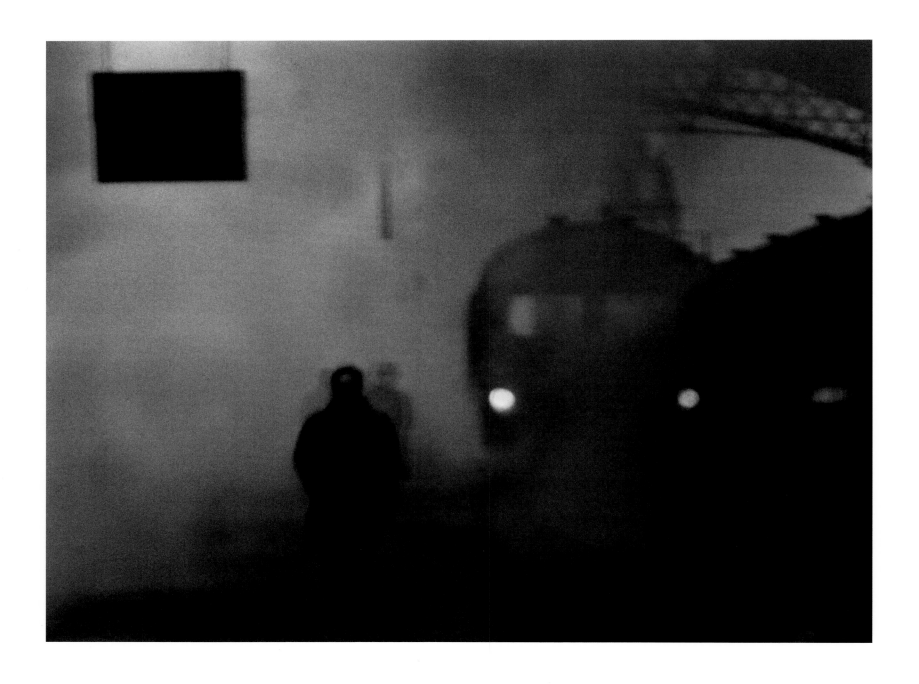

KENNETH GUSTAVSSON
Paris, 1968

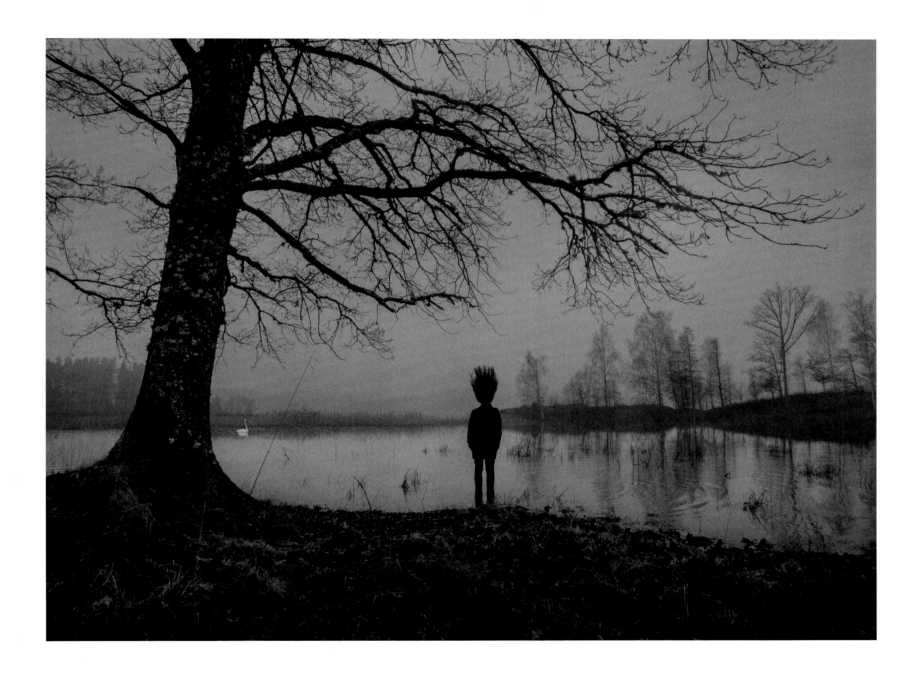

JOHAN STRINDBERG

Girl With Flying Hair Part II

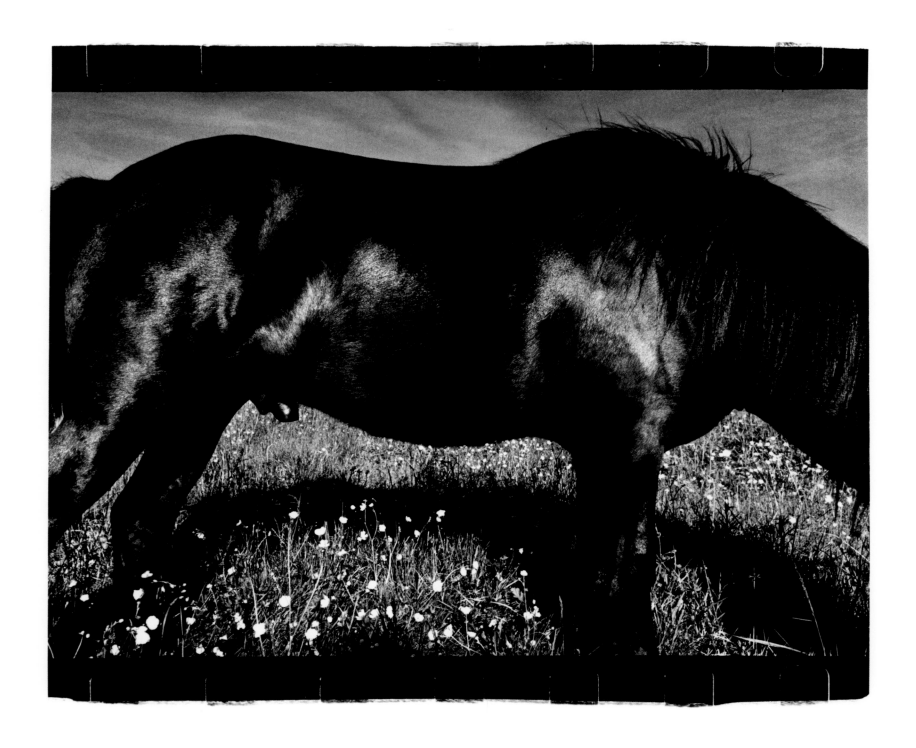

ANDERS PETERSEN

Close Distance, 2002

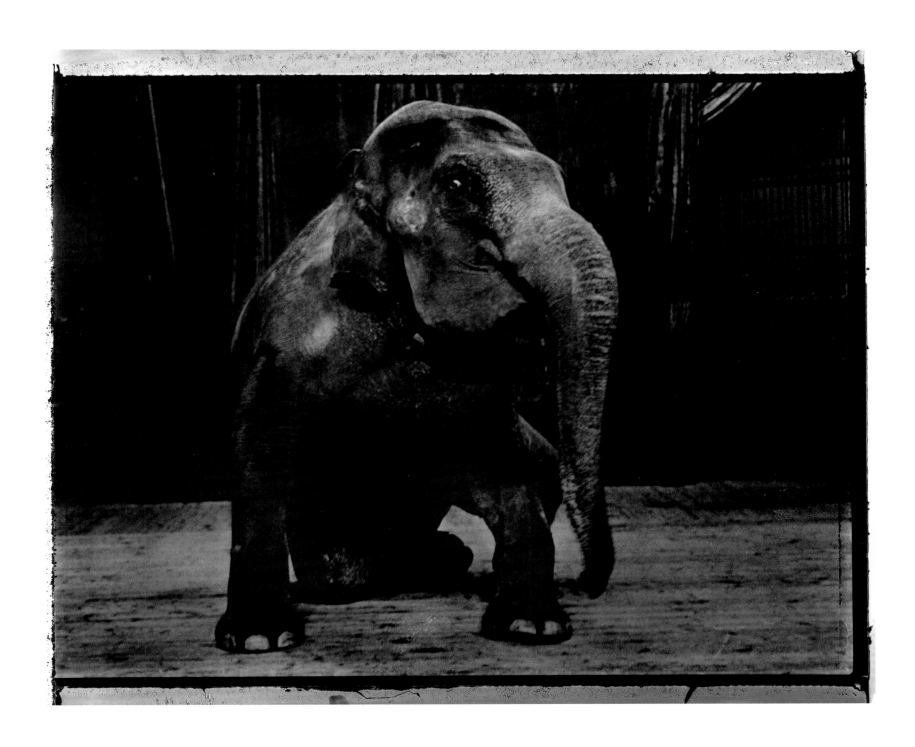

SARAH MOON

L'éléphante, 1999

"Have the outmost respect for your subjects. Love them."

JOYCE TENNESON

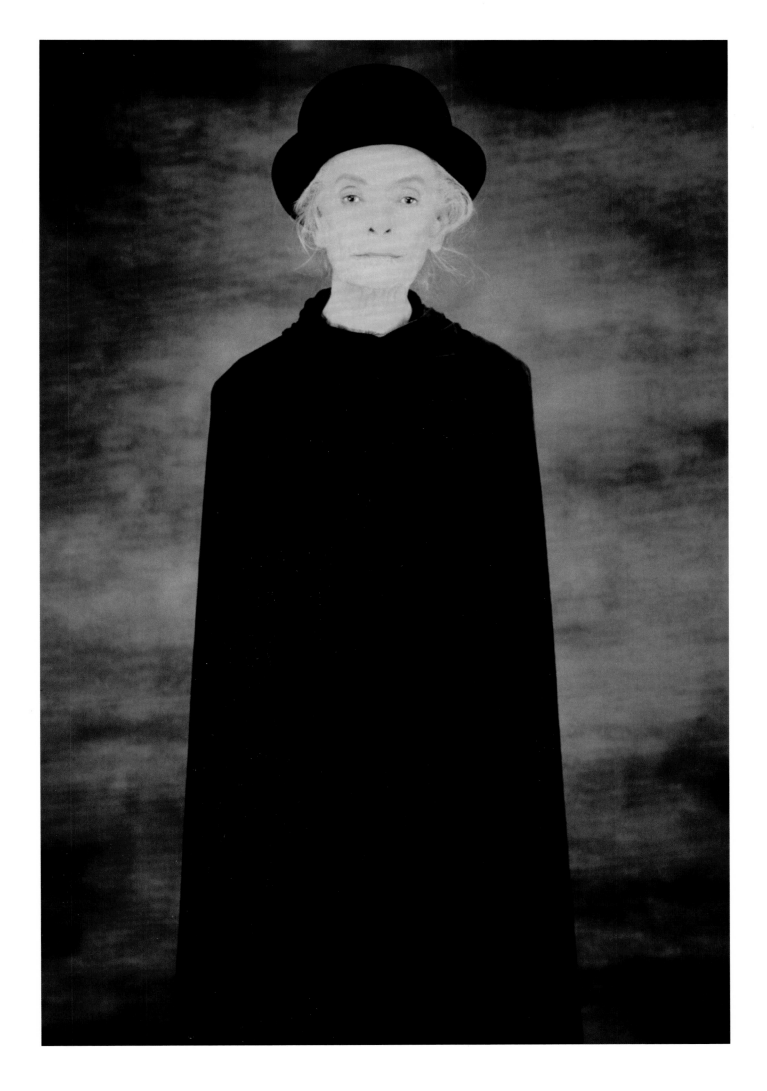

JOYCE TENNESON

Mimi in Bowler Hat, 2002

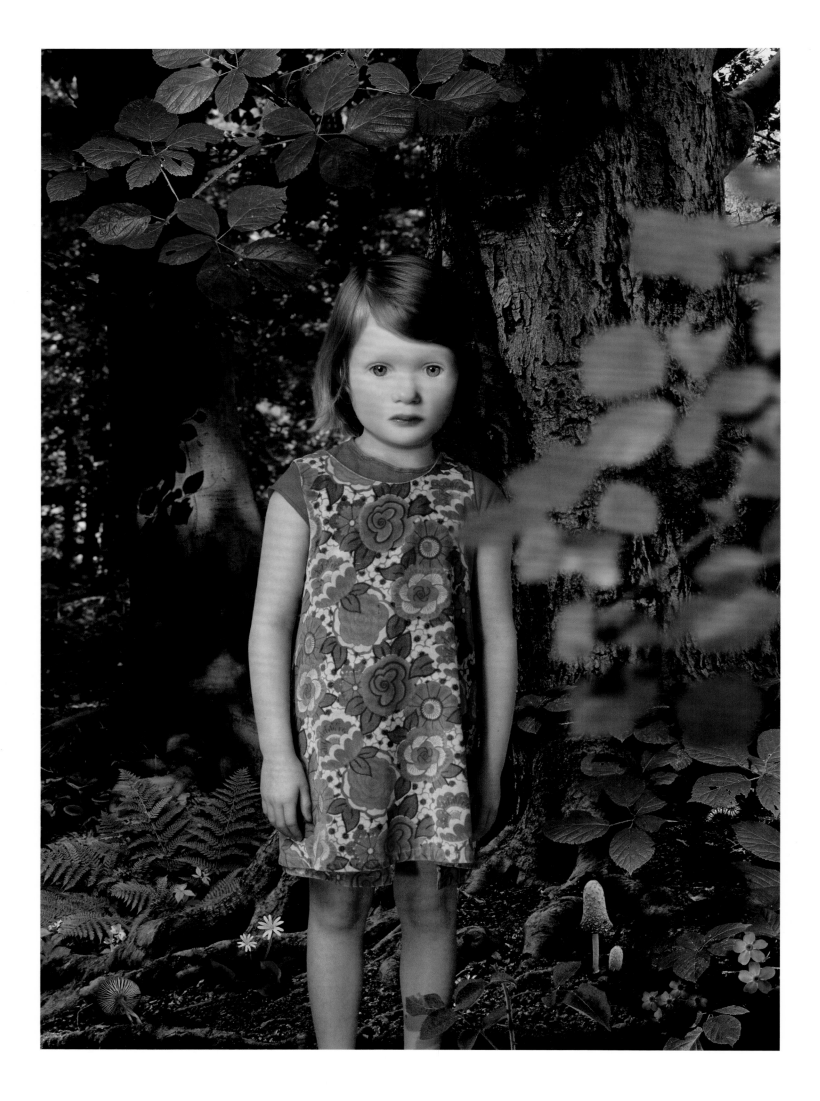

RUUD VAN EMPEL
Study in Green No. 2, 2003

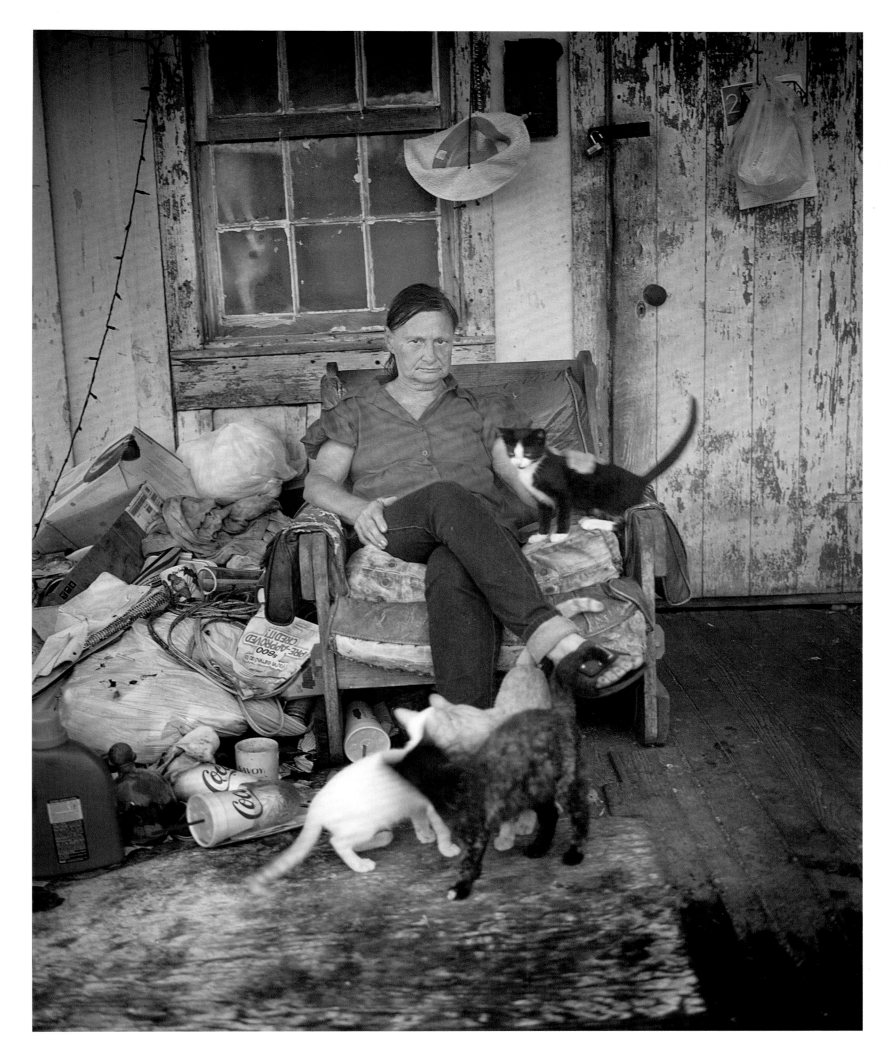

HANNAH MODIGH

From the series *Hurricane Season*

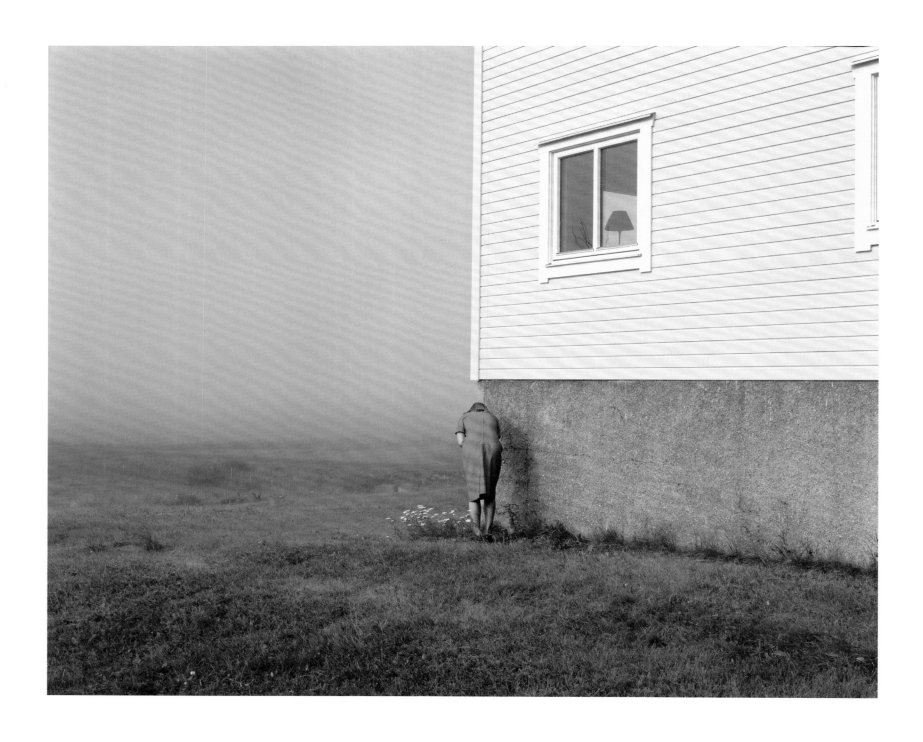

NYGÅRDS KARIN BENGTSSON
Woman by White House, 2004

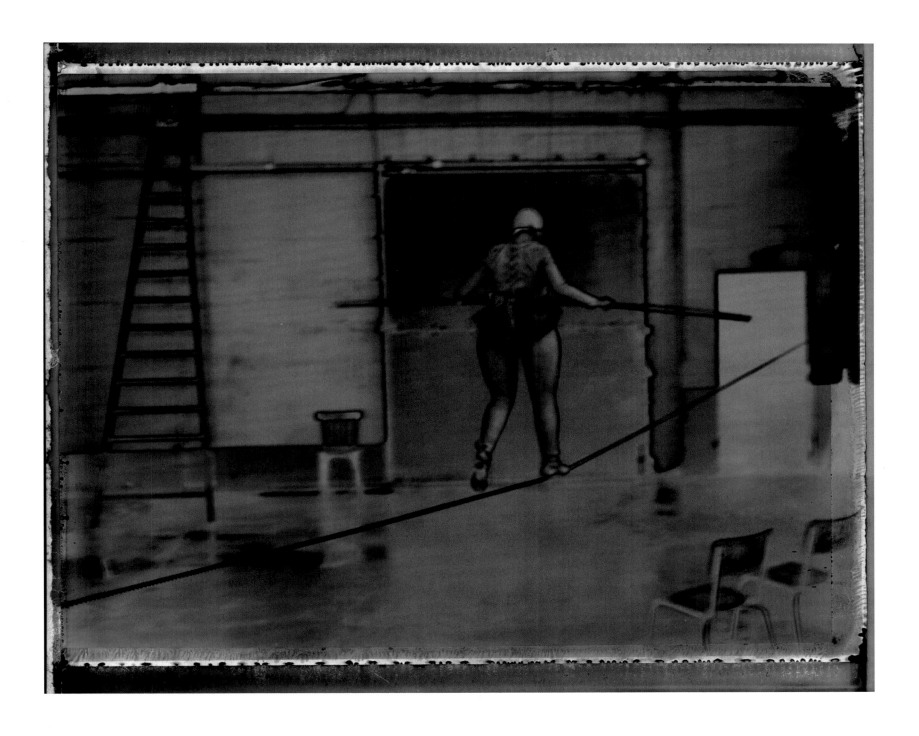

SARAH MOON

La funambule, 2003

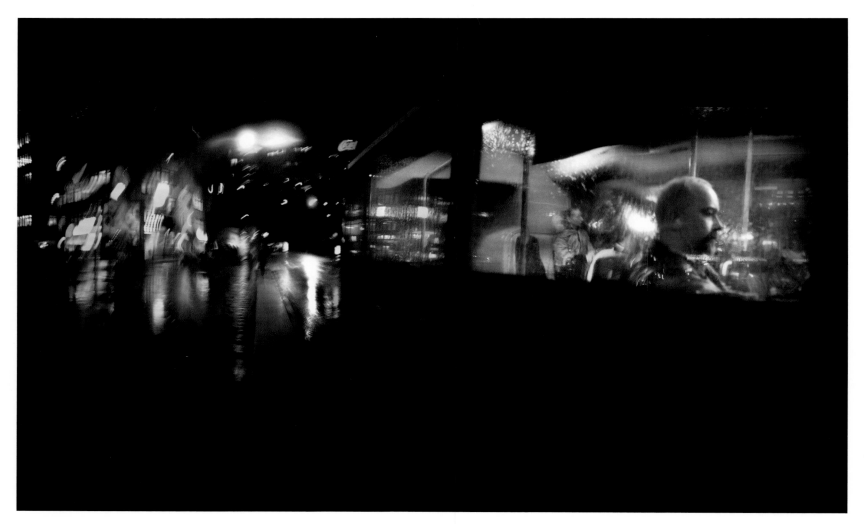

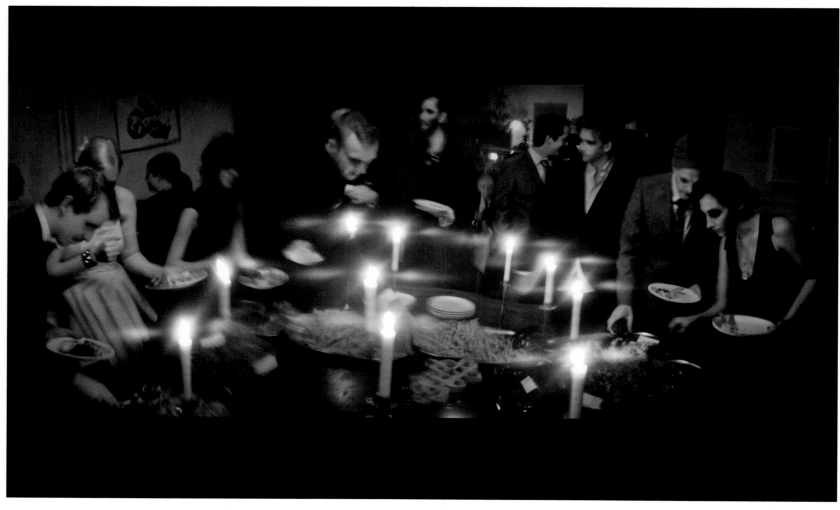

PIETER TEN HOOPEN
Untitled. Untitled

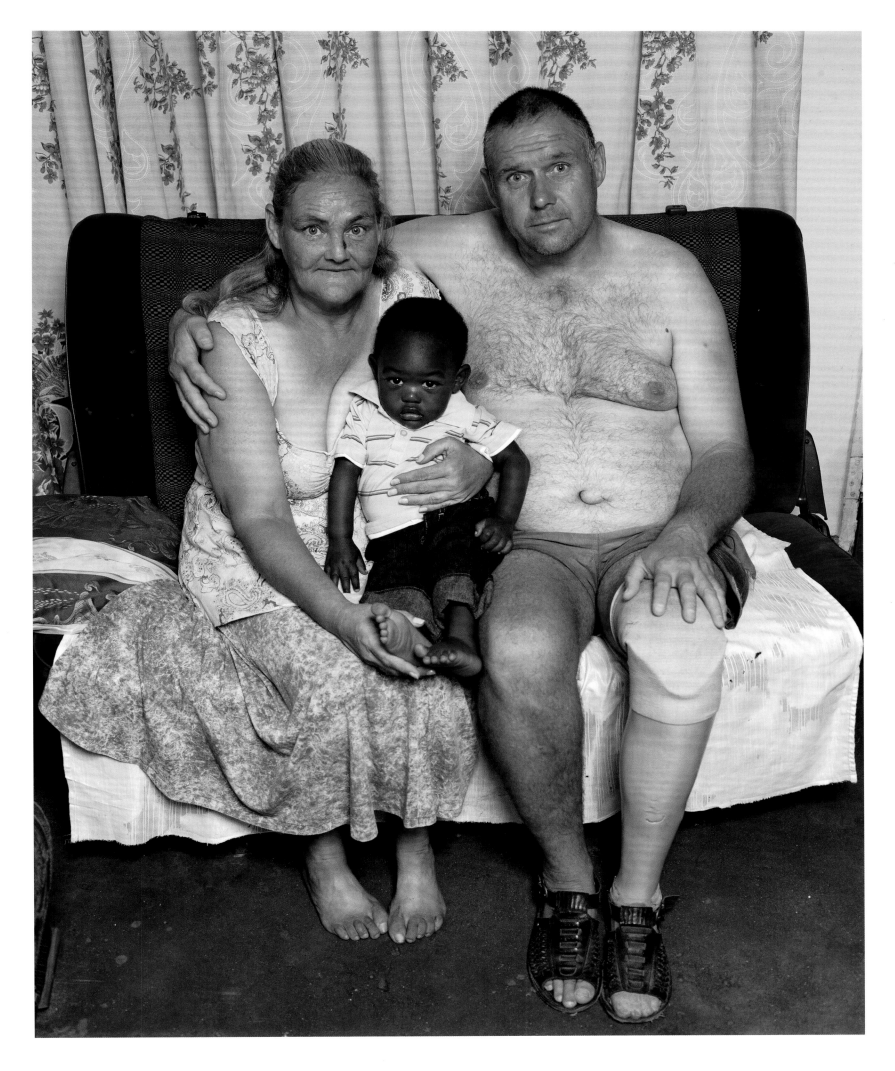

PIETER HUGO

Pieter and Maryna Vermeulen with Timana Phosiwa, 2006

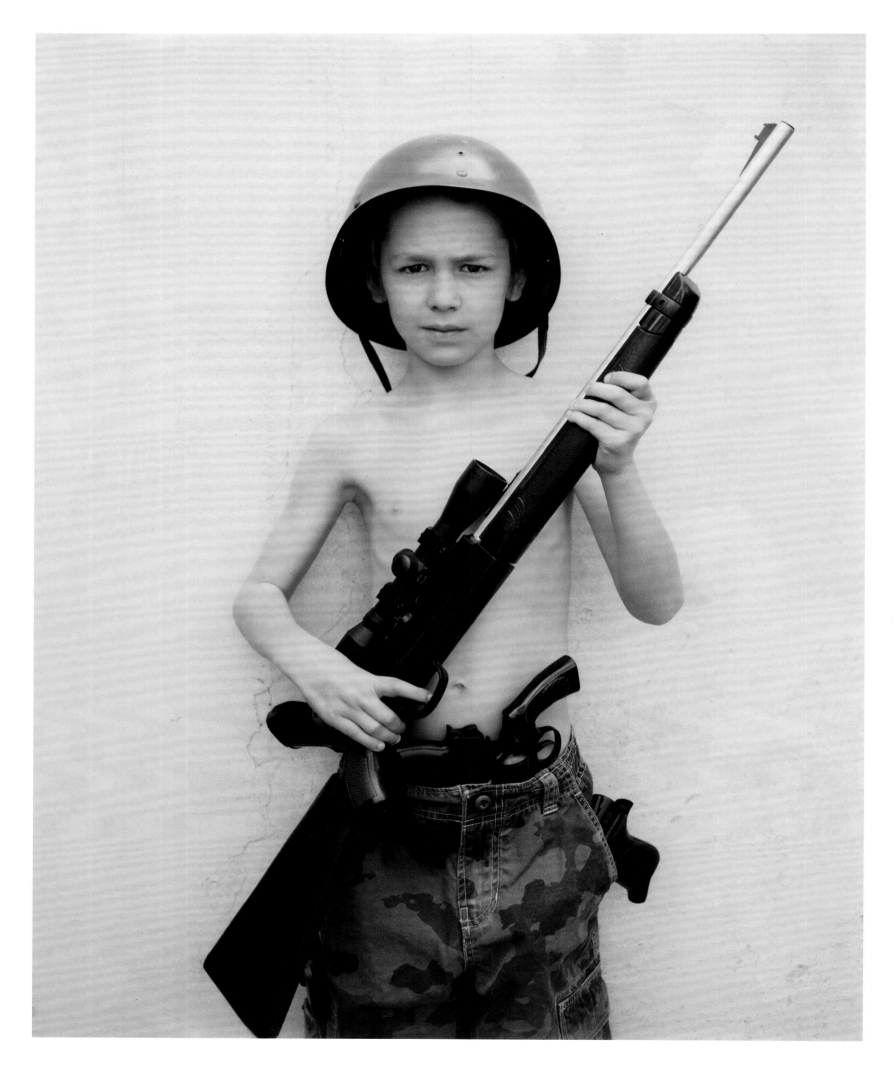

VEE SPEERS

Untitled No. 4, from the series *The Birthday Party*, 2007

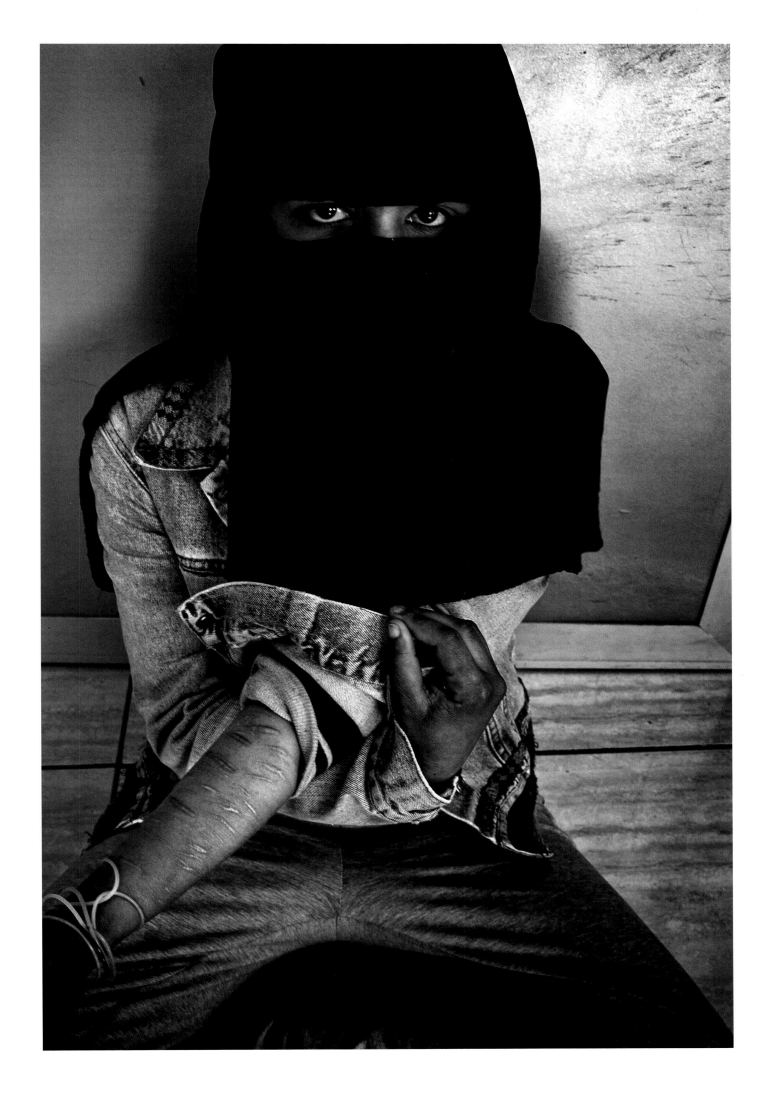

LISEN STIBECK

From the series *Daughters*

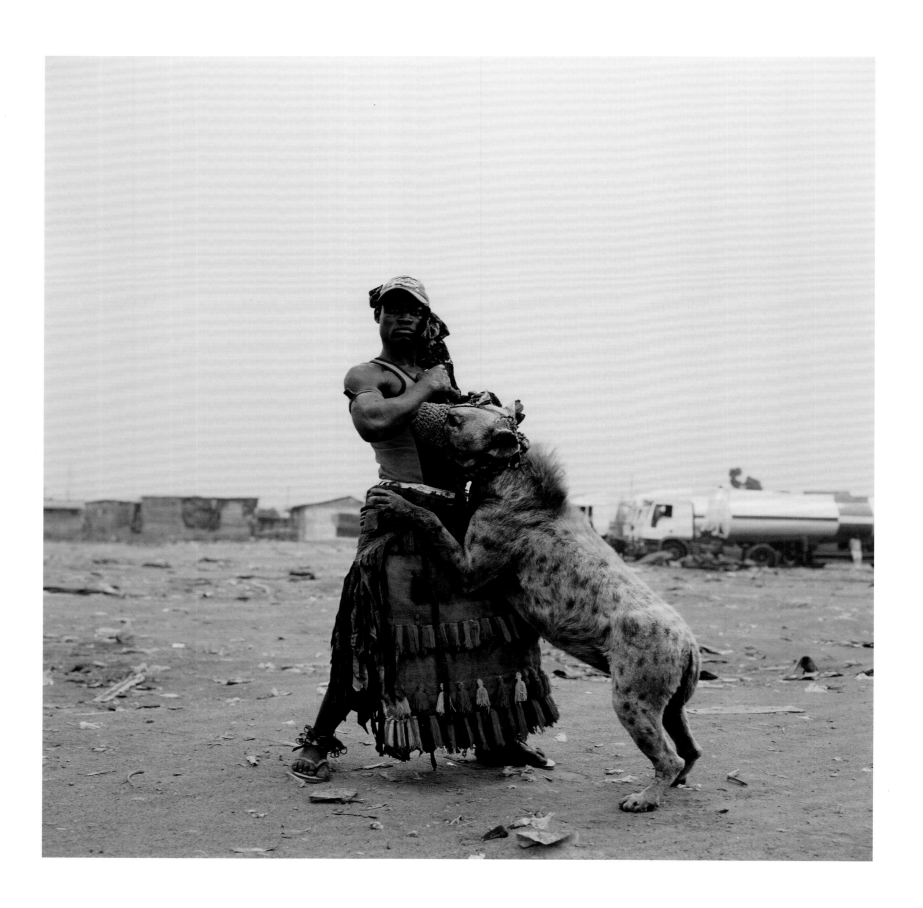

PIETER HUGO

Abdullahi Mohammed with Mainasara, Ogere-Remo, Nigeria, 2007

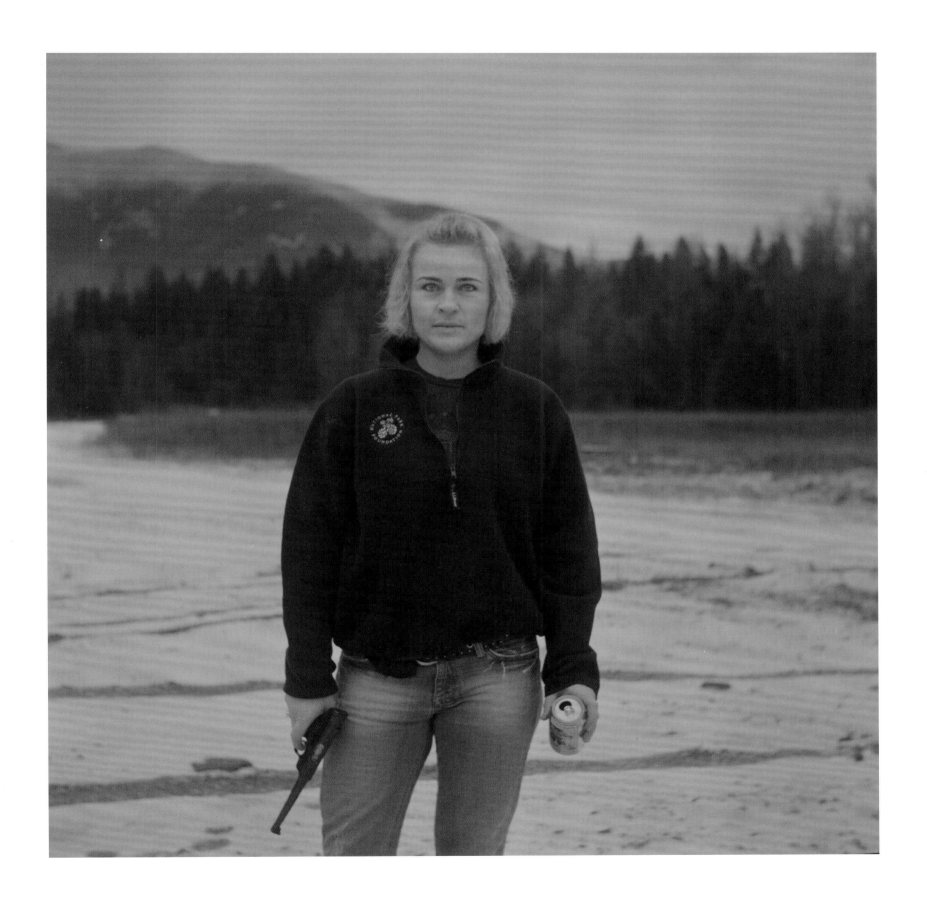

PIETER TEN HOOPEN

Untitled

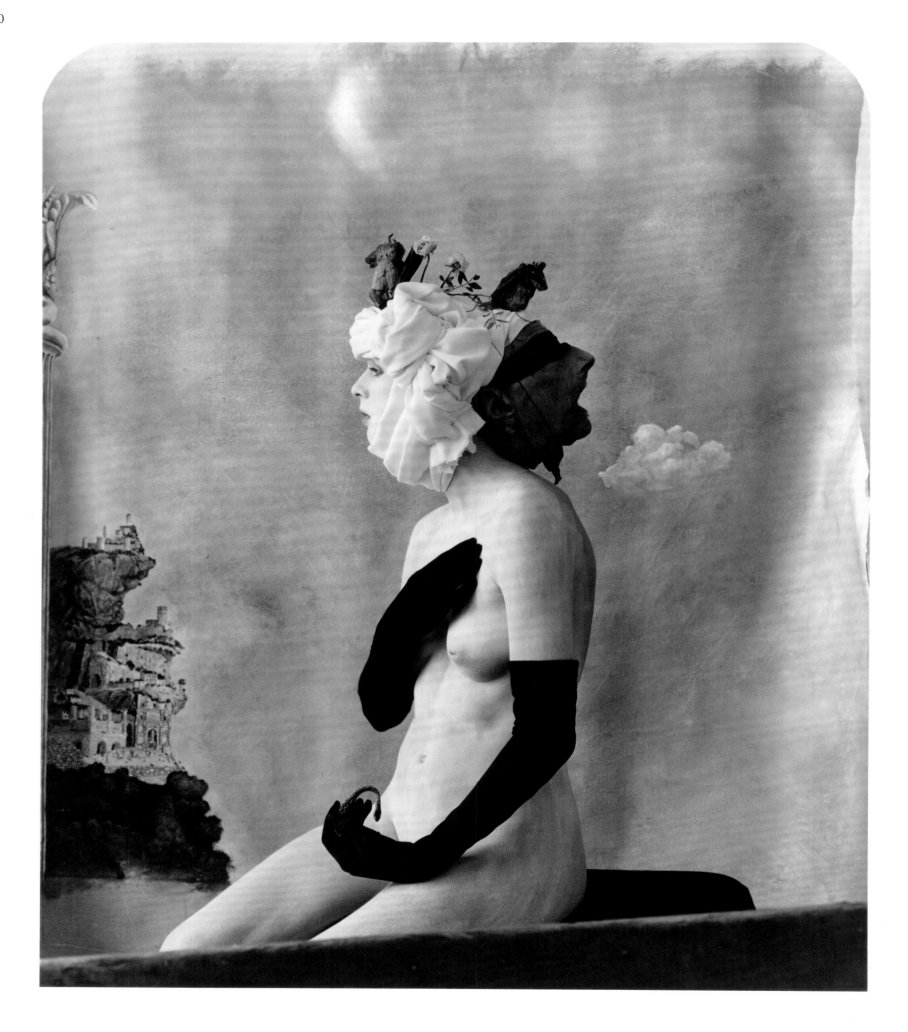

JOEL-PETER WITKIN

Prudence, 1996

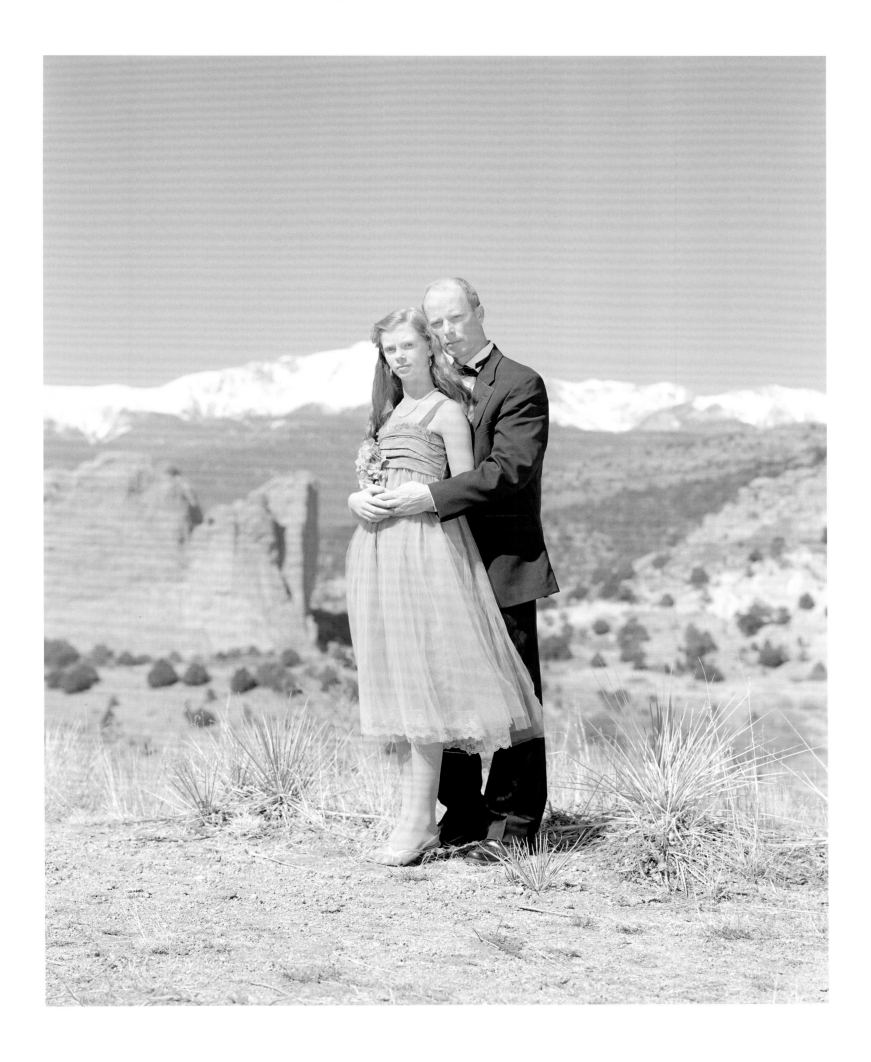

DAVID MAGNUSSON

Grace & Gary Kruse, Black Forest, Colorado, 2011

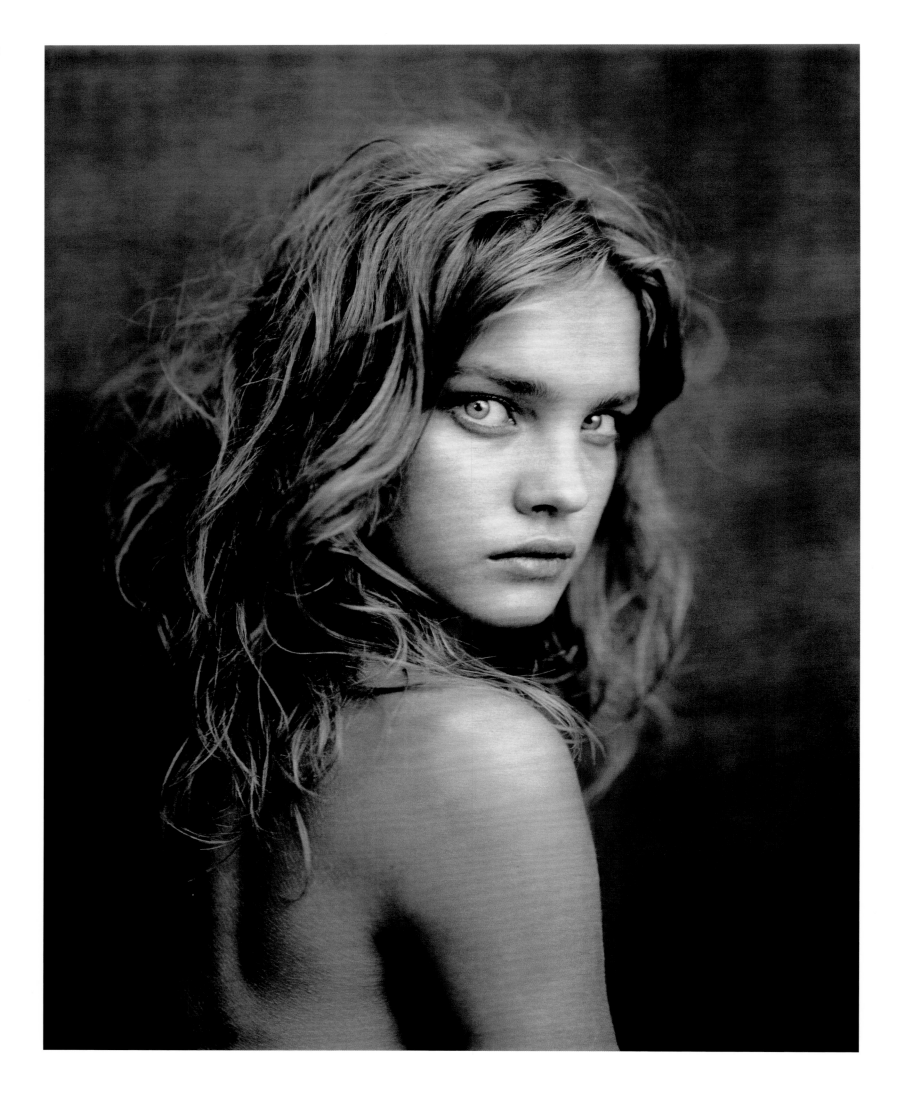

PAOLO ROVERSI

Natalia, Paris, 2003

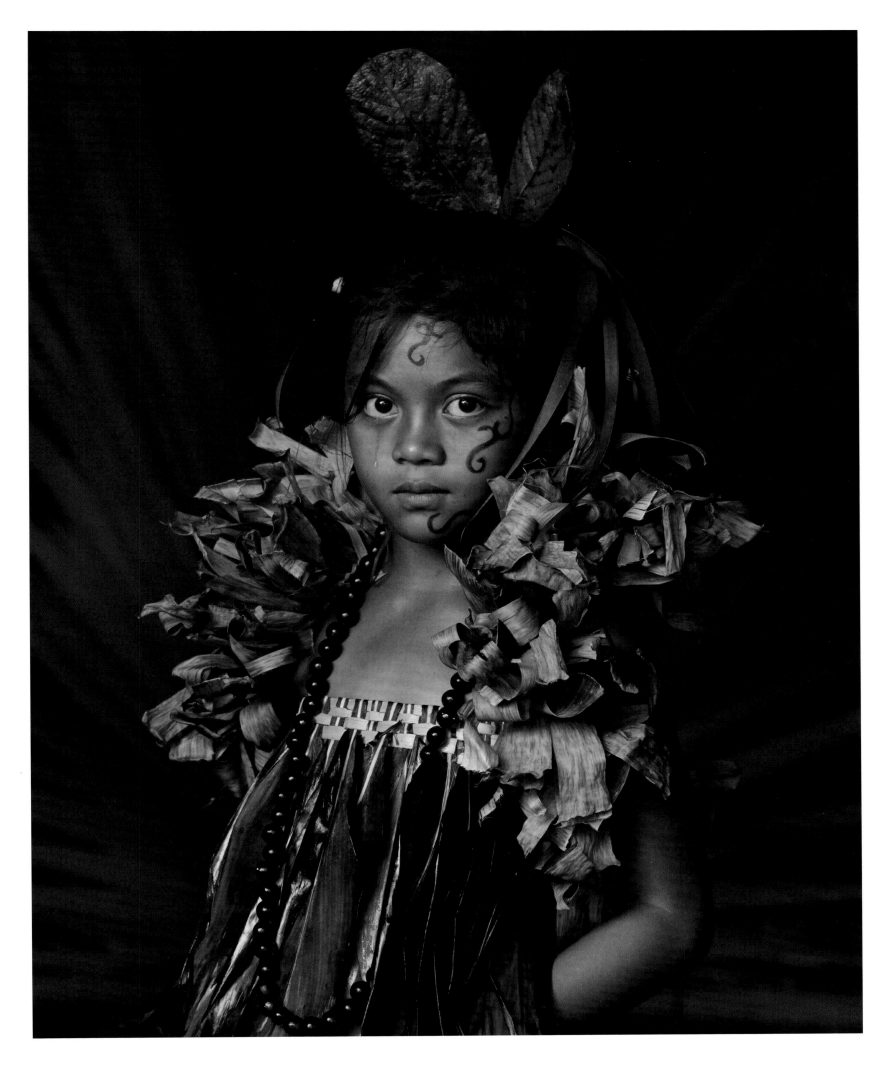

JIMMY NELSON

Te Pua O Feani, Atuona, Hiva Oa, Marquesas Islands, French Polynesia, 2016

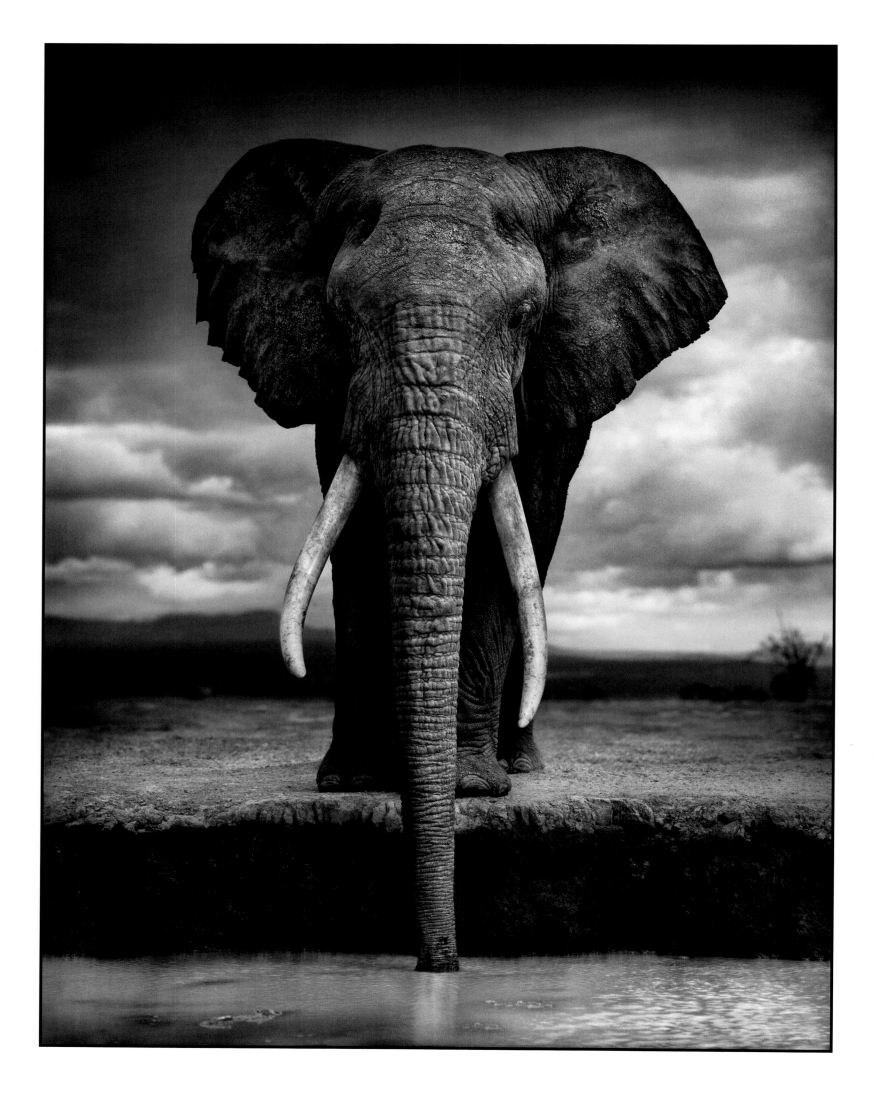

NICK BRANDT
Elephant Drinking, Amboseli, 2007

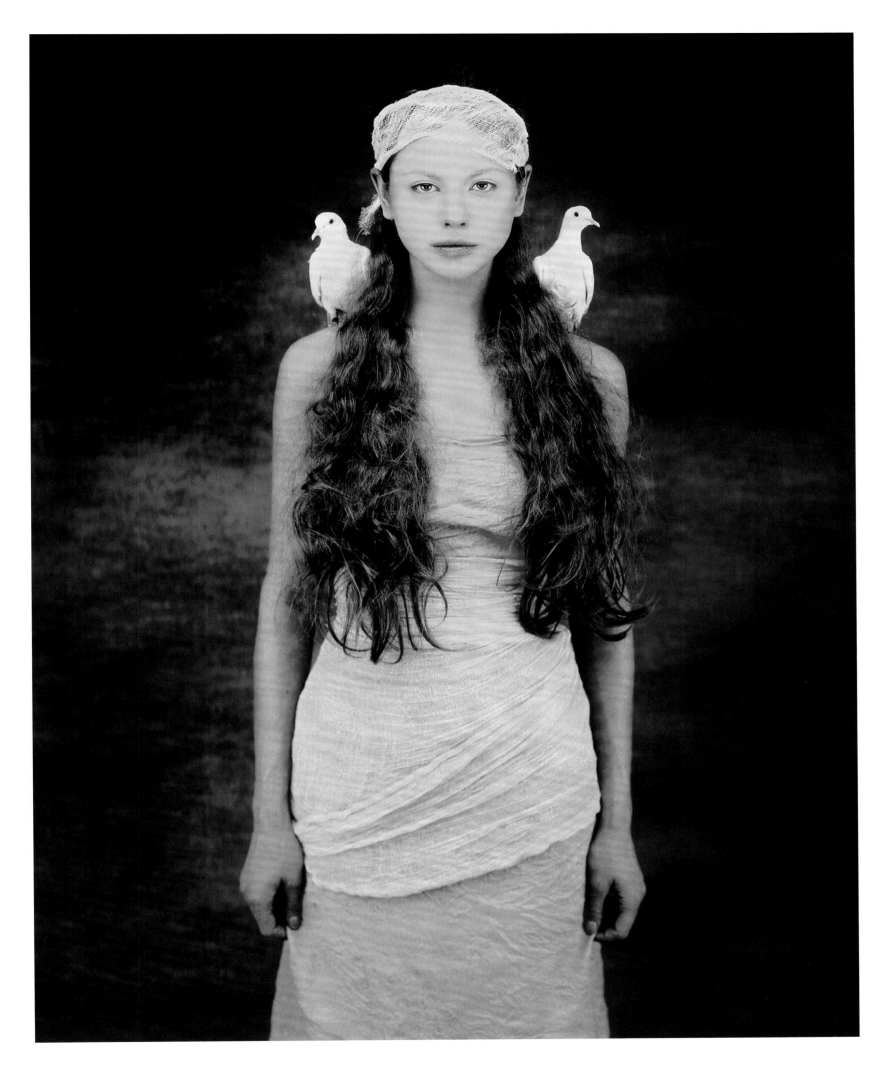

JOYCE TENNESON

Dasha and Doves, 1998

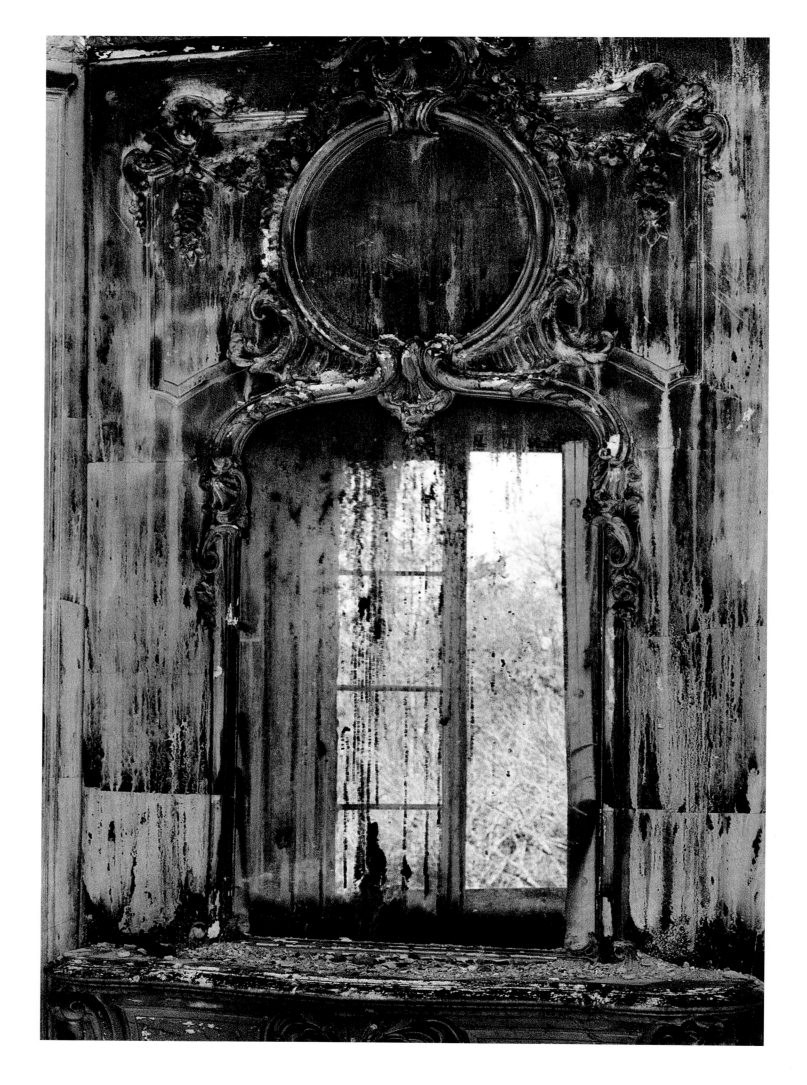

HELENE SCHMITZ

The View, 1996

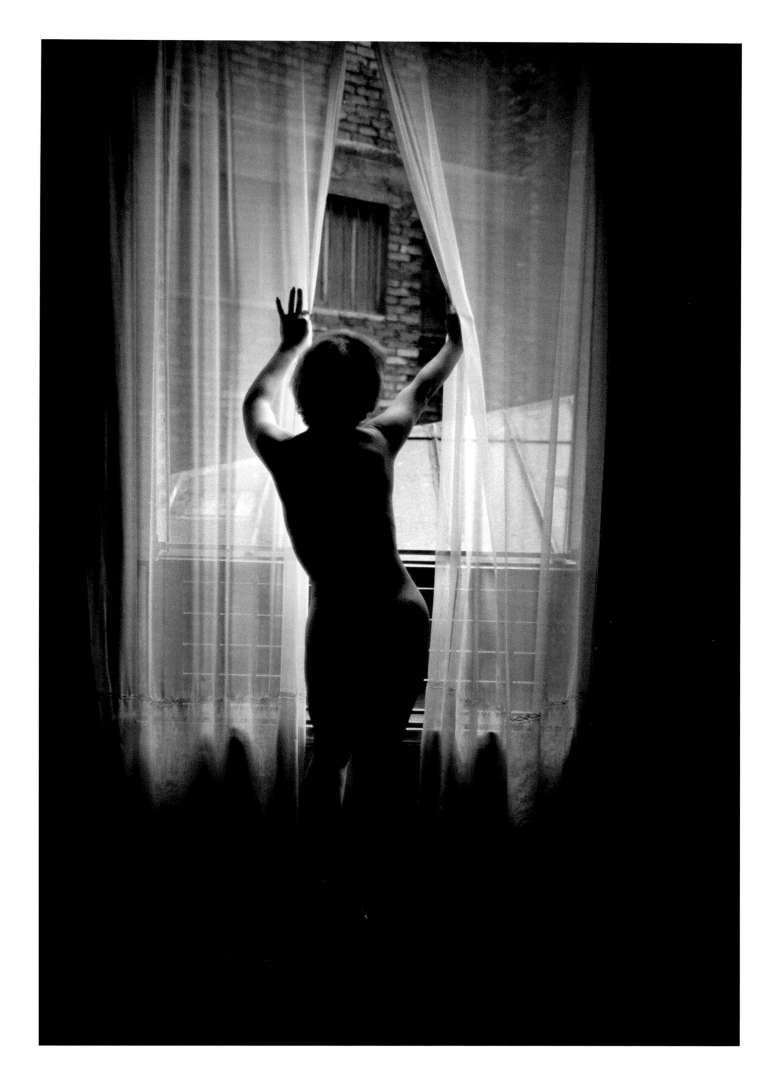

CHRISTER STRÖMHOLM
Miriame Shalimar, Paris, 1960

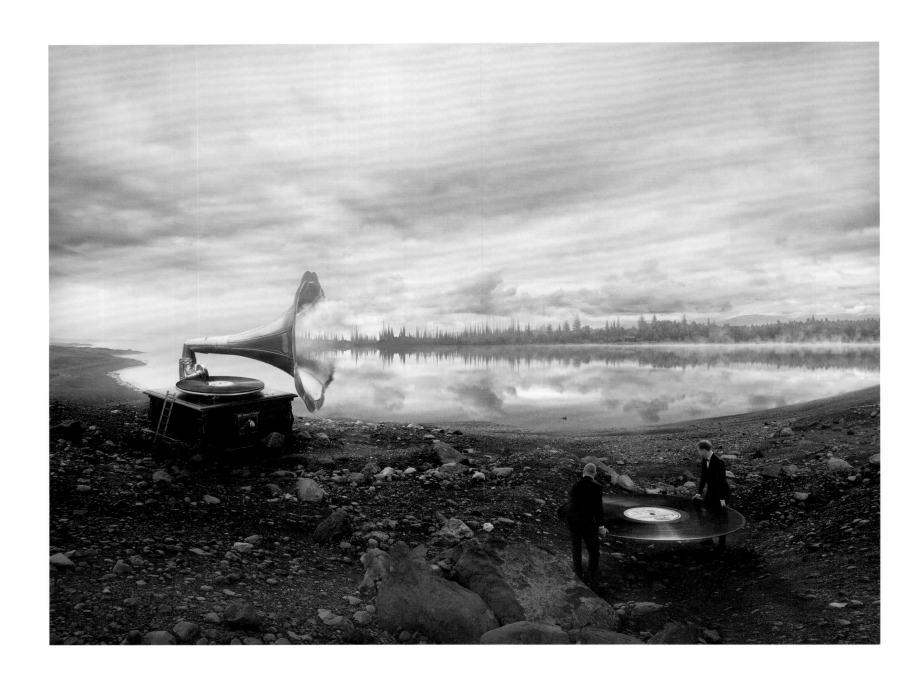

ERIK JOHANSSON
Soundscapes, 2015

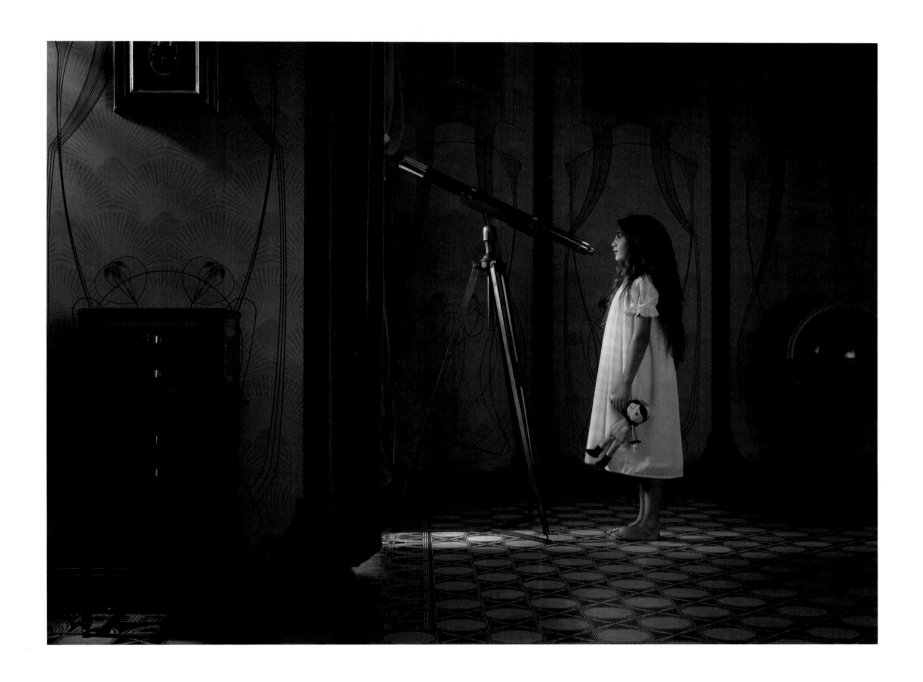

CHRISTIAN TAGLIAVINI

Place des Rêves, 2015

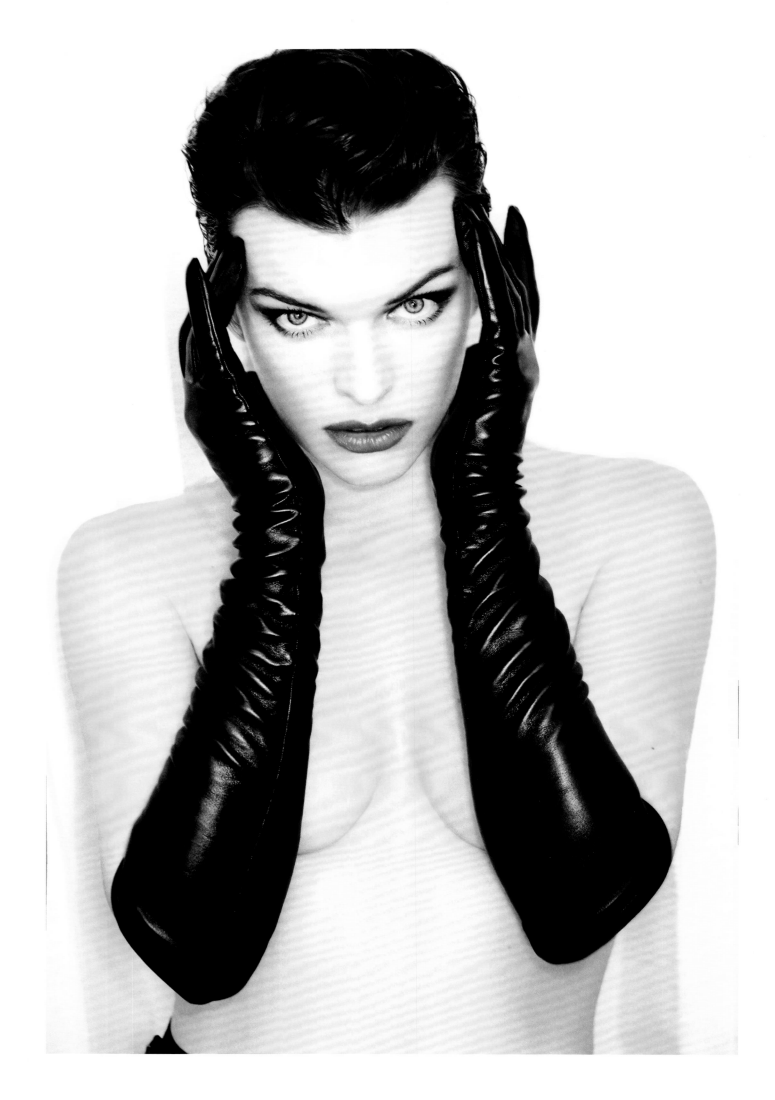

ELLEN VON UNWERTH
Milla Jovovich, 2016

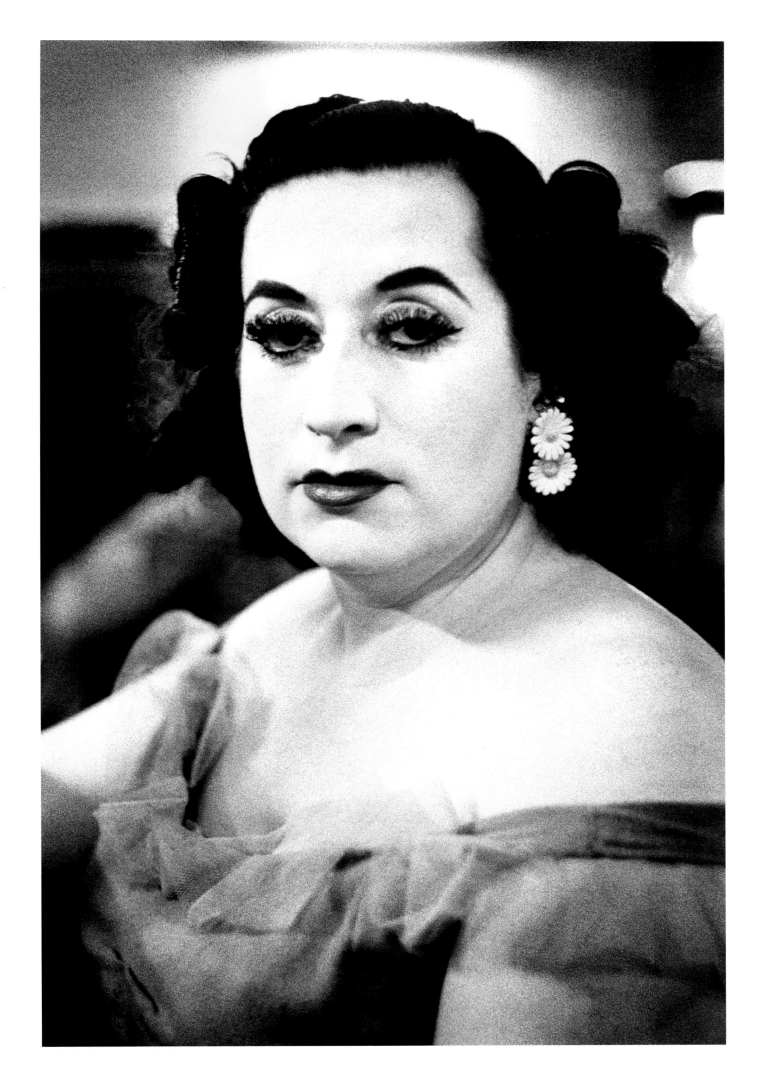

CHRISTER STRÖMHOLM

Pale Lady, Barcelona, 1959

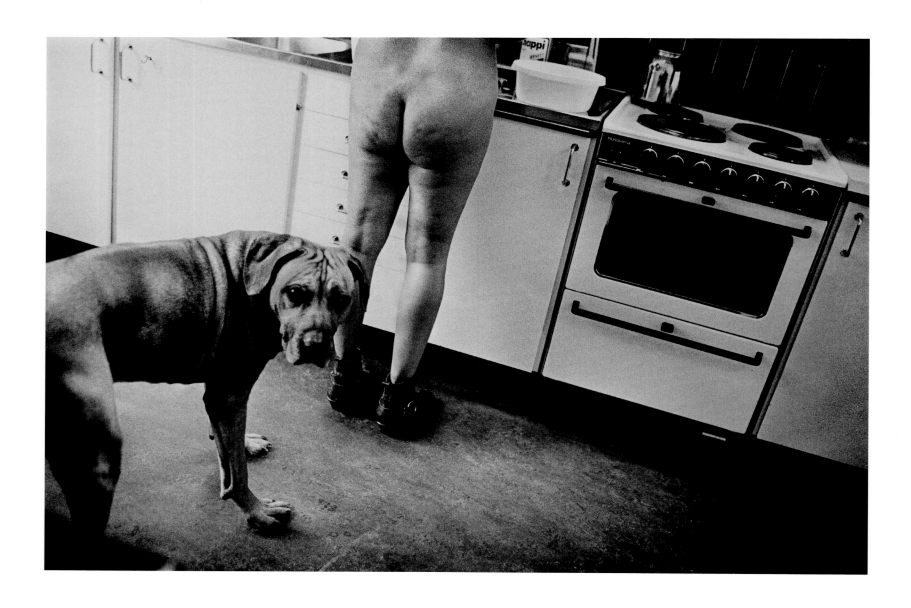

ANDERS PETERSEN

Untitled, from the series *From Back Home*, 2009

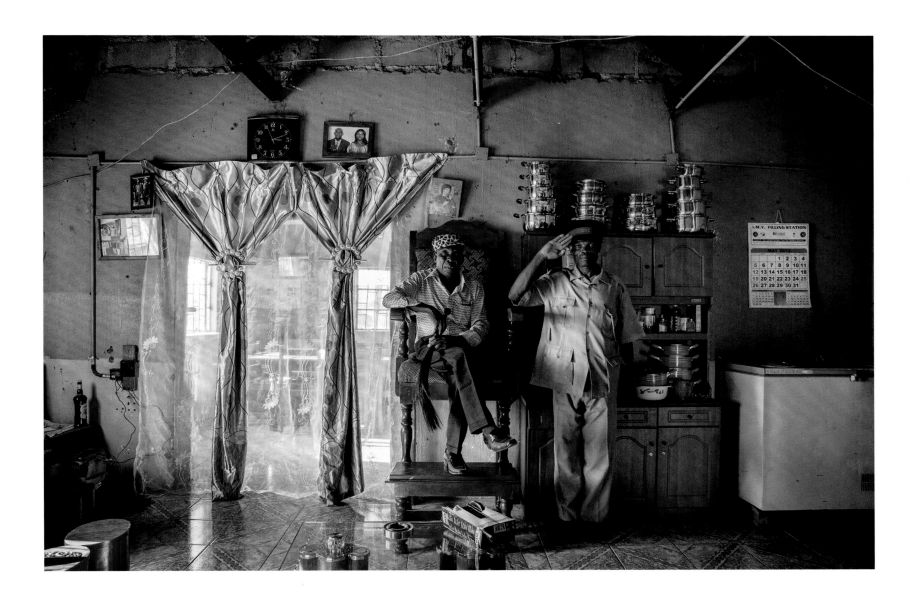

MARCUS BLEASDALE

His Royal Highness the Honorable Cheif Nyalugwe and Farmer, Zambia

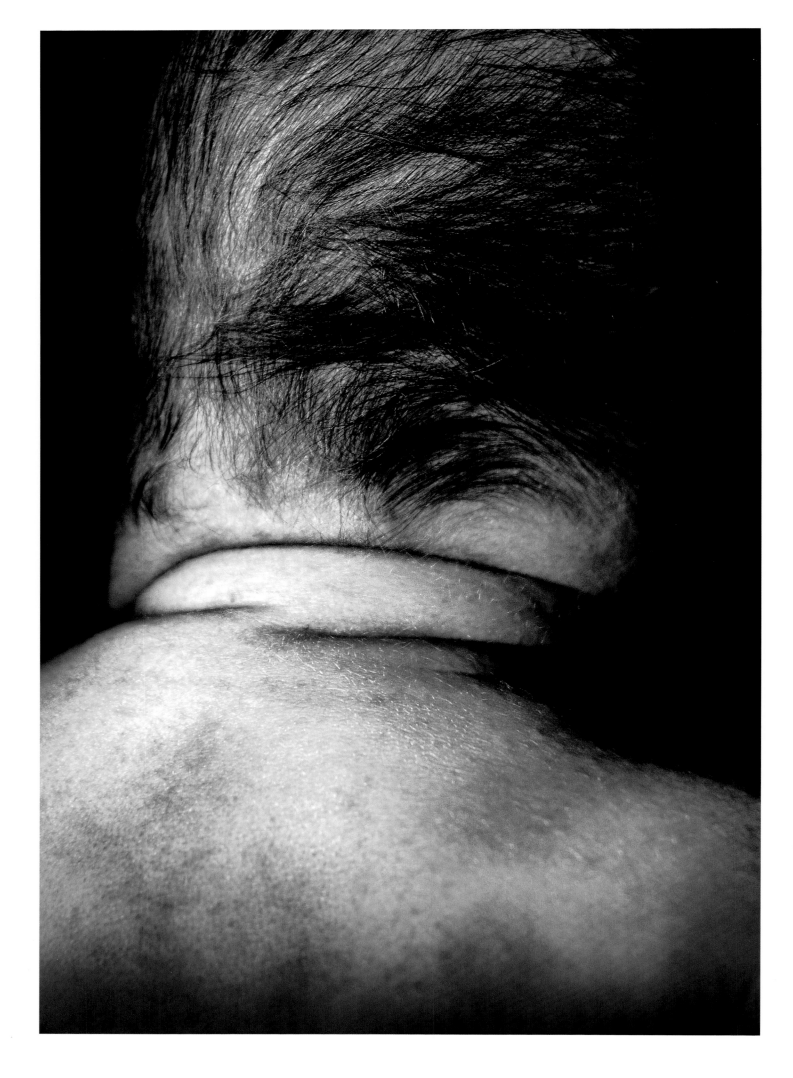

THOMAS WÅGSTRÖM

Necks, No. 44

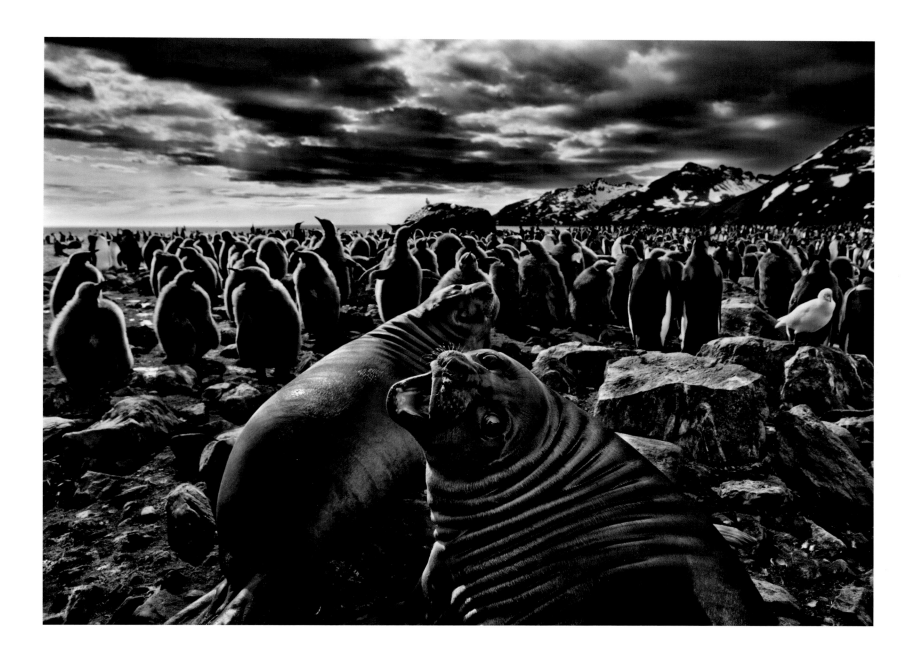

SEBASTIÃO SALGADO

Southern Elephant Seal Calves, Saint Andrews Bay, South Georgia, 2009

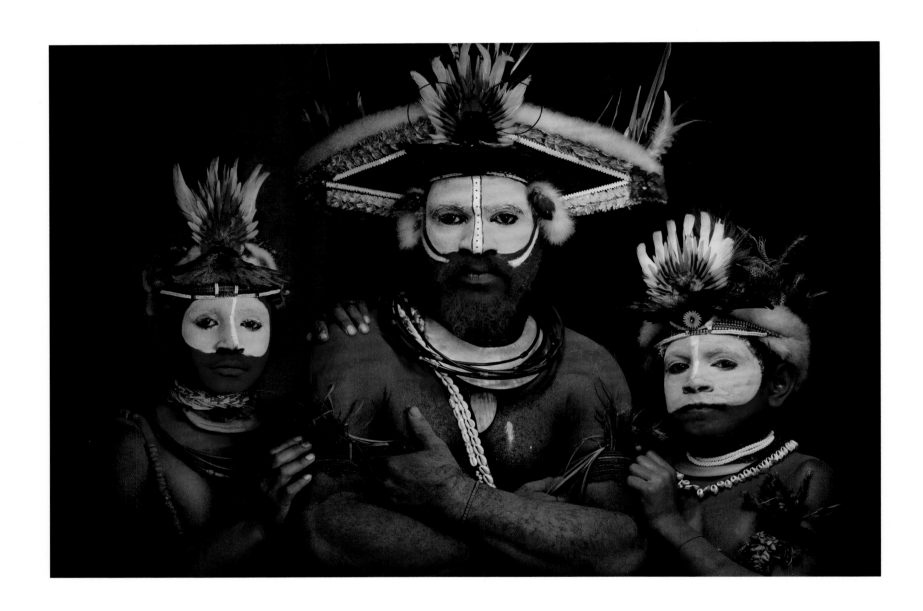

JIMMY NELSON

Huli Wigman, Tari, Papua New Guinea, 2017

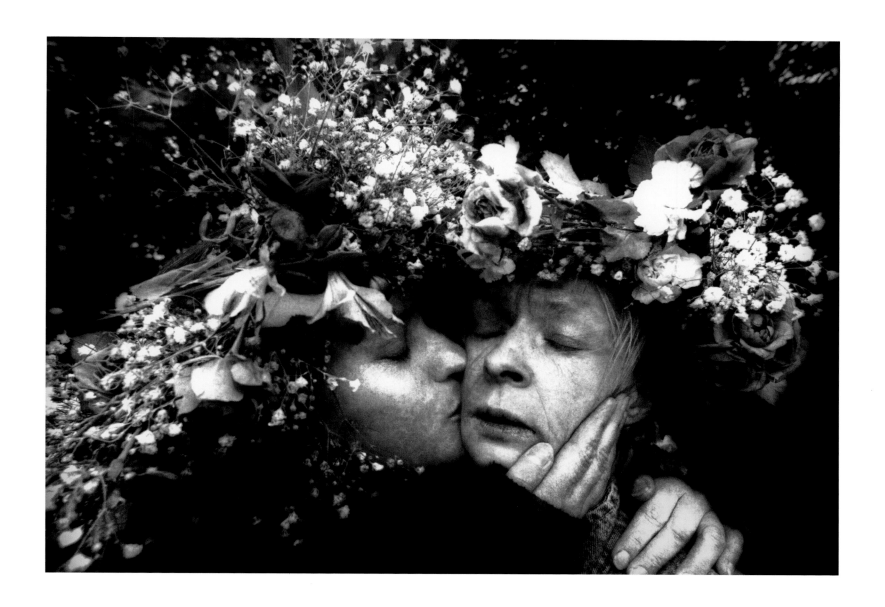

ANDERS PETERSEN

Untitled, from the series *Mental Hospital*, 1984–1994

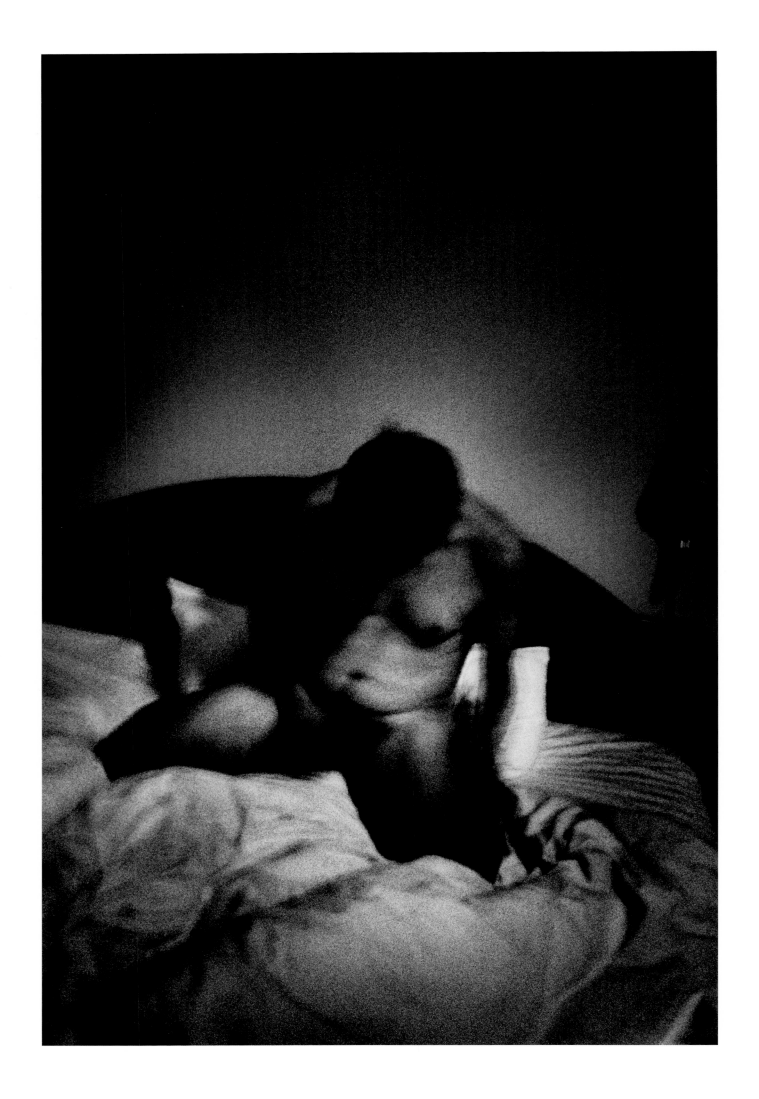

MARGARET M. DE LANGE

From the book *Surrounded by No One*, 2009

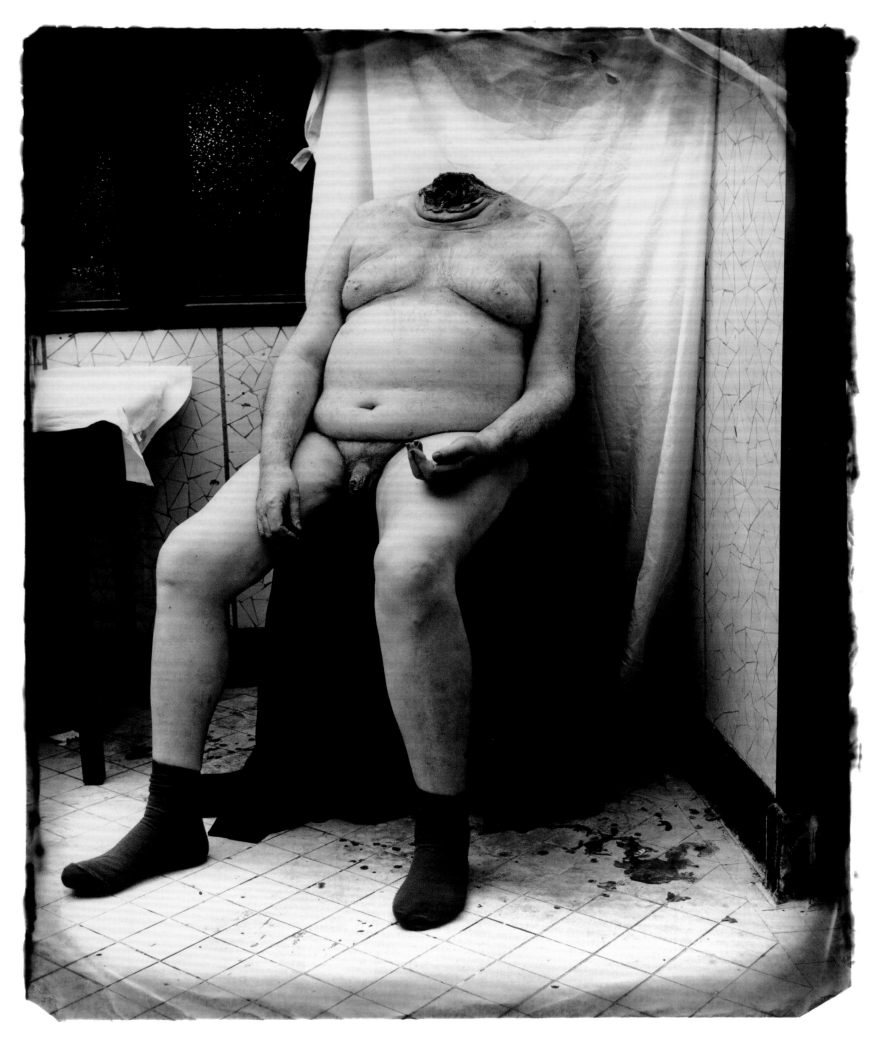

JOEL-PETER WITKIN

Man Without a Head, 1993

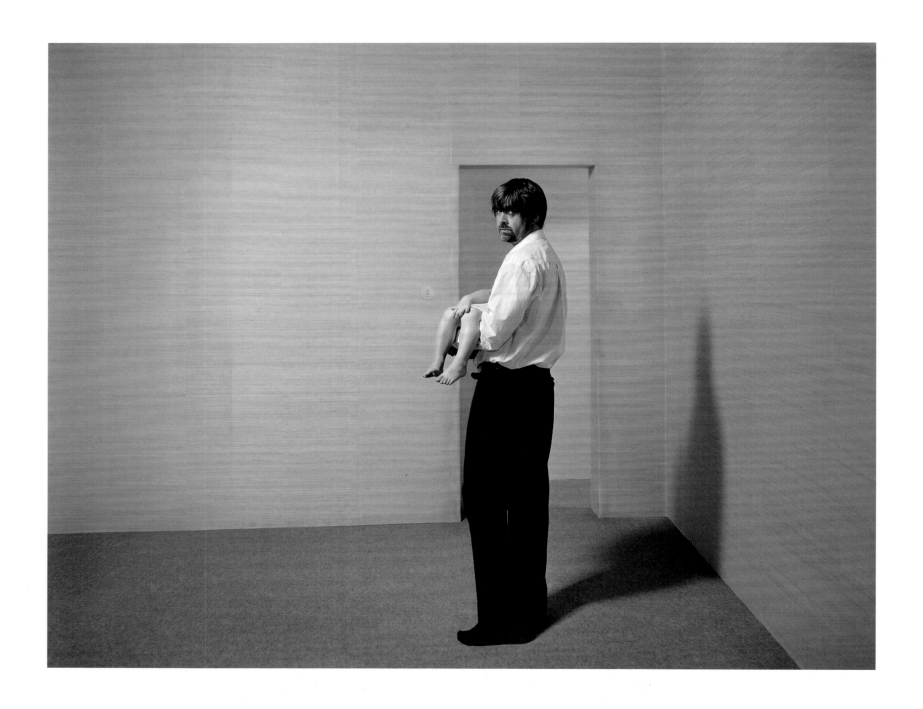

JOHAN WILLNER

Maze, 2006

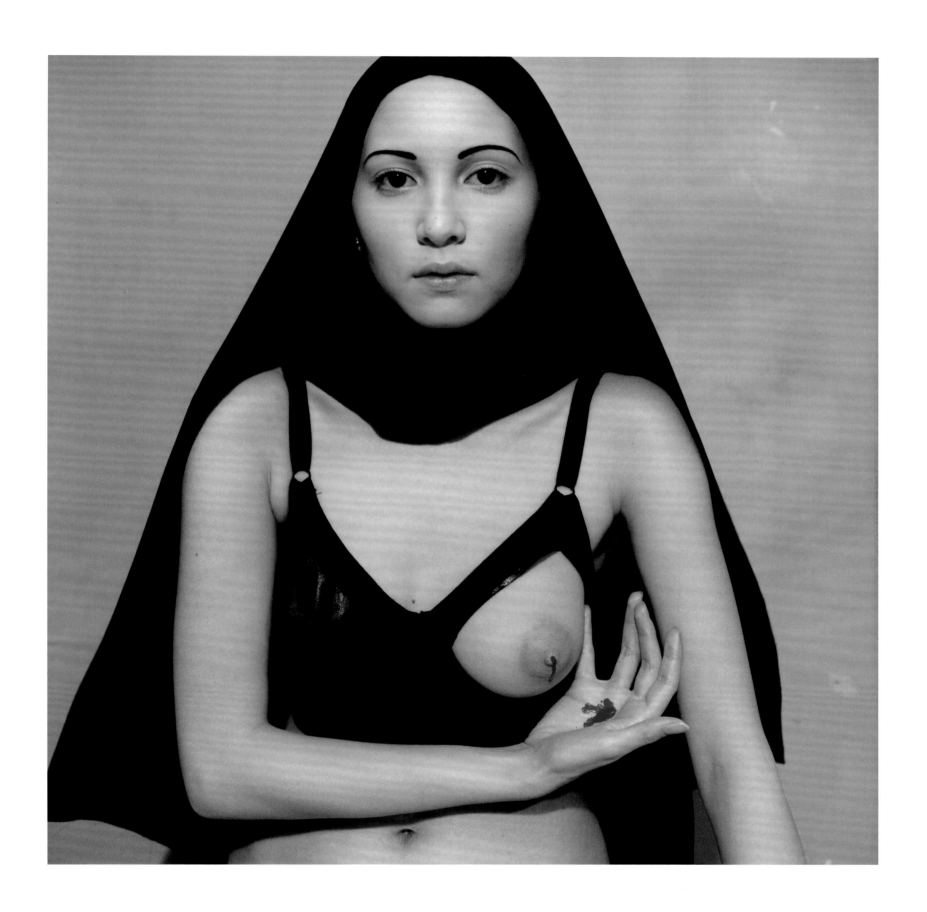

BETTINA RHEIMS

Le lait miraculeux de la Vierge, from the series *I.N.R.I.*, Ville Evrard, March 1997

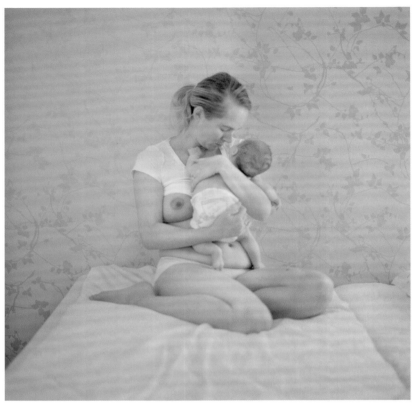
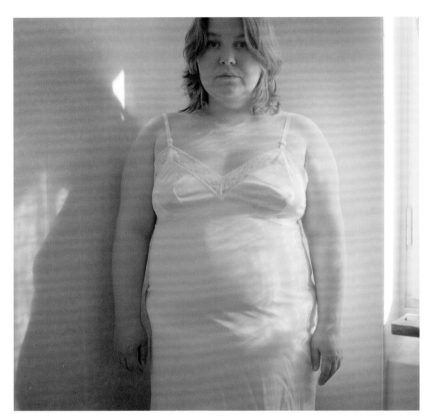
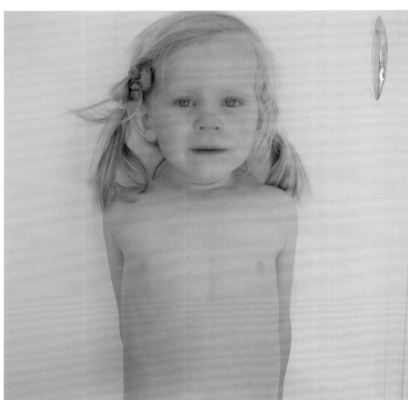
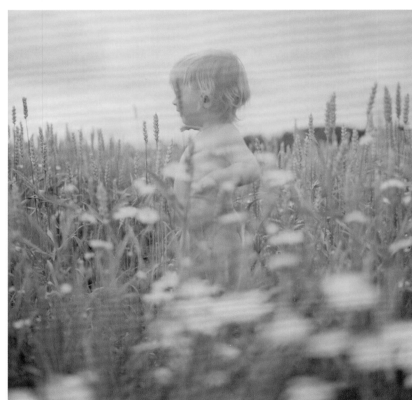

ANNA CLARÉN

From the series *Close to Home*, 2013

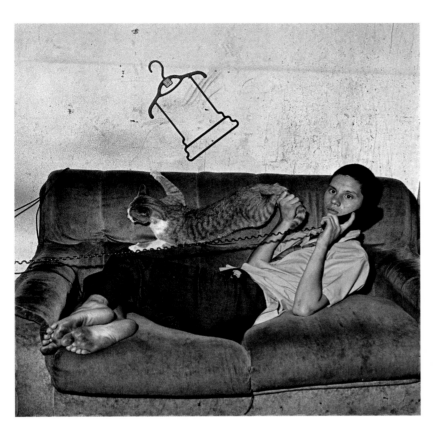
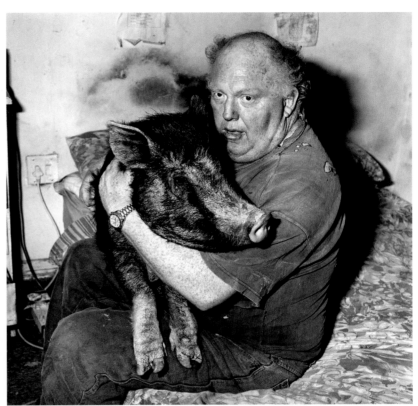
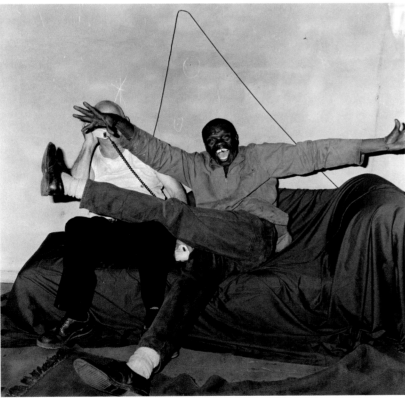
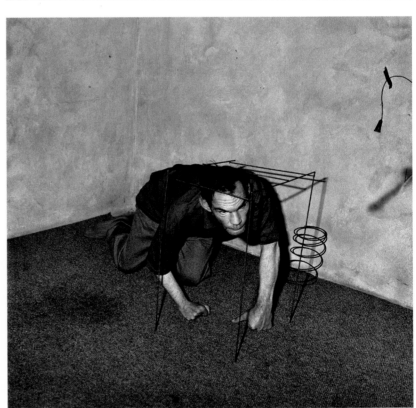

ROGER BALLEN

Eugene on the Phone, 2000. Brian with Pet Pig, 1998. Show Off, 2000. Crawling Man, 2002

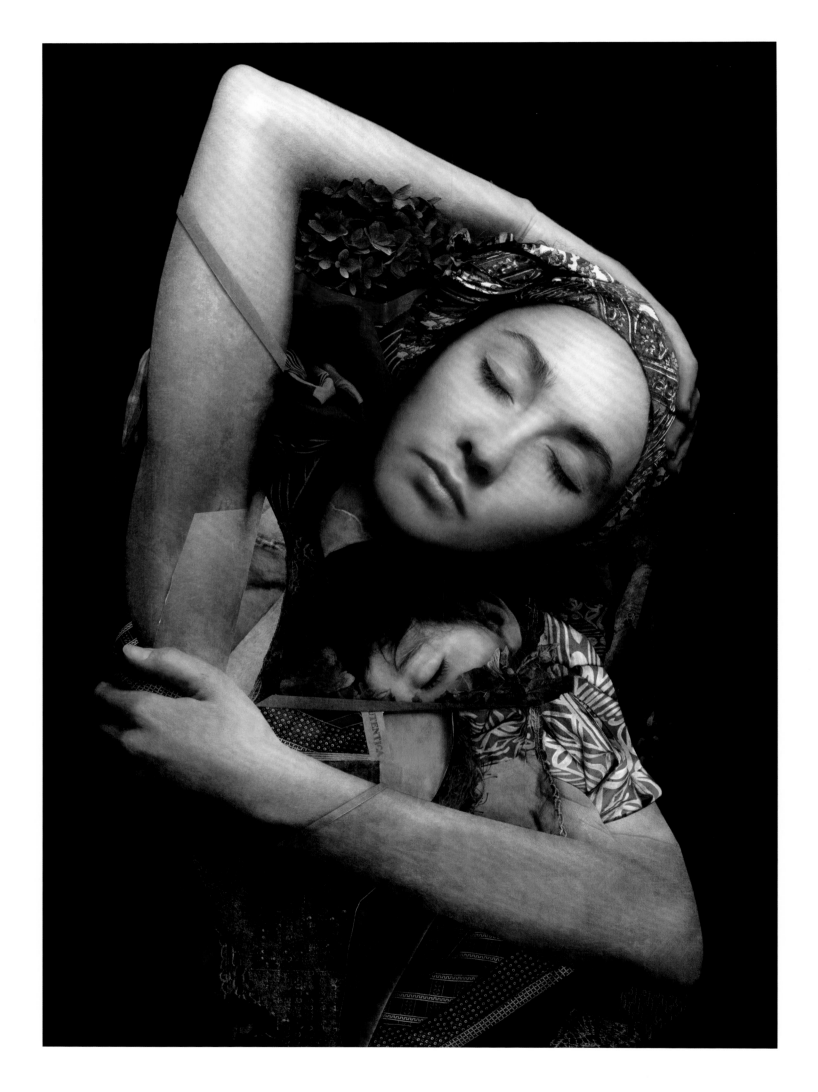

COOPER & GORFER

Holding Vanesa, 2017

DANA SEDEROWSKY

Black Knot No. 8, 2013

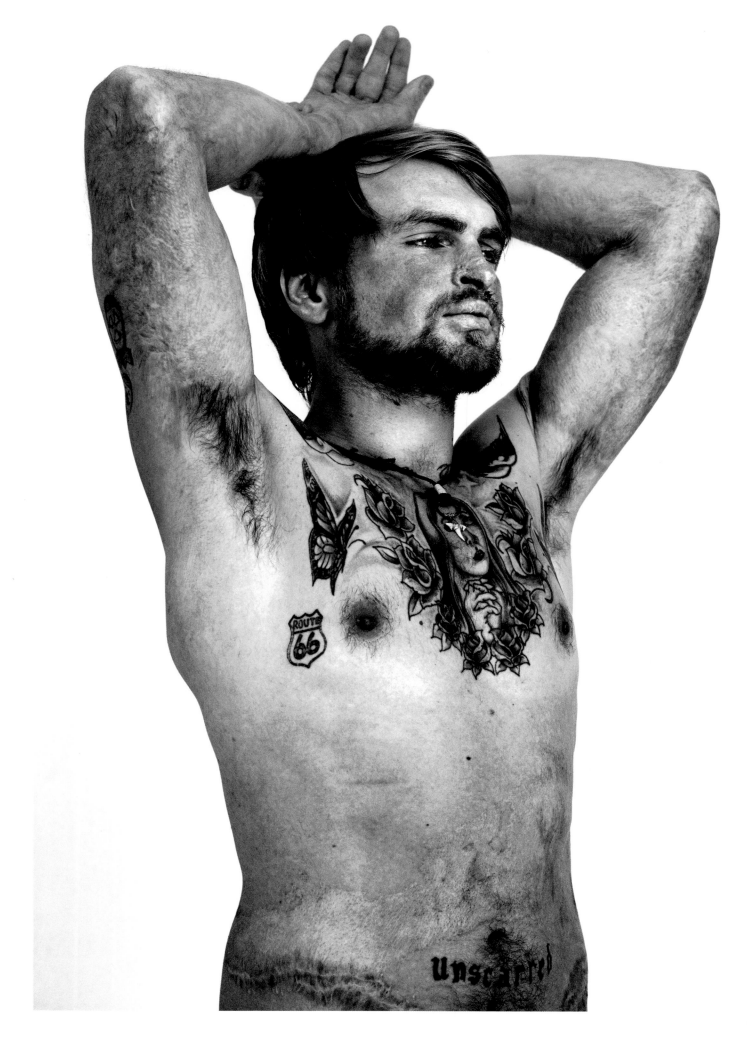

BRYAN ADAMS
Private Karl Hinett, February 2011

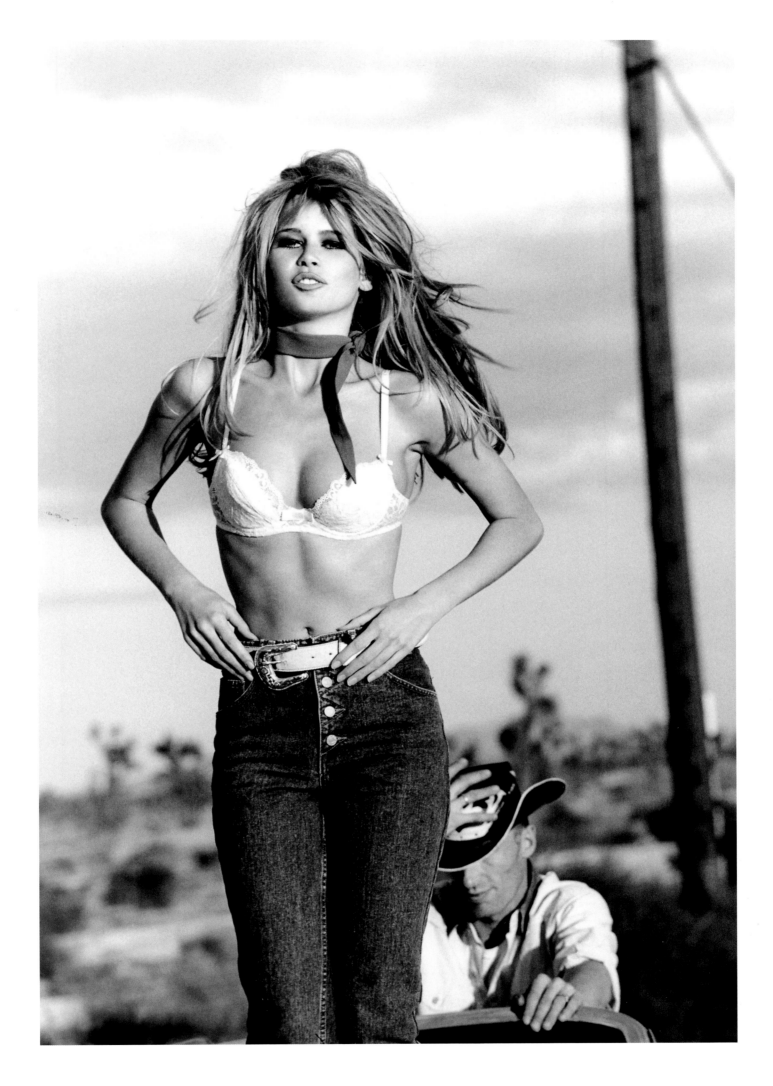

ELLEN VON UNWERTH

Guess Who?, 1989

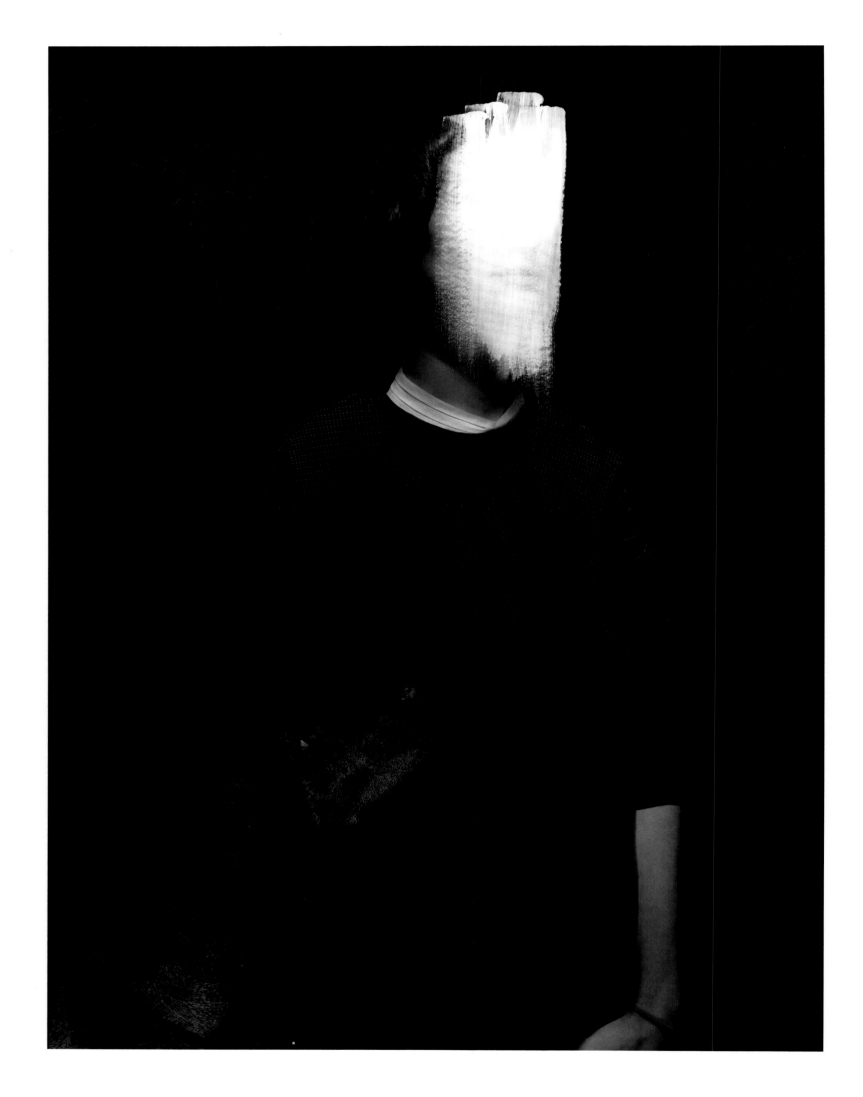

COOPER & GORFER

Sofia and the Dog, 2017

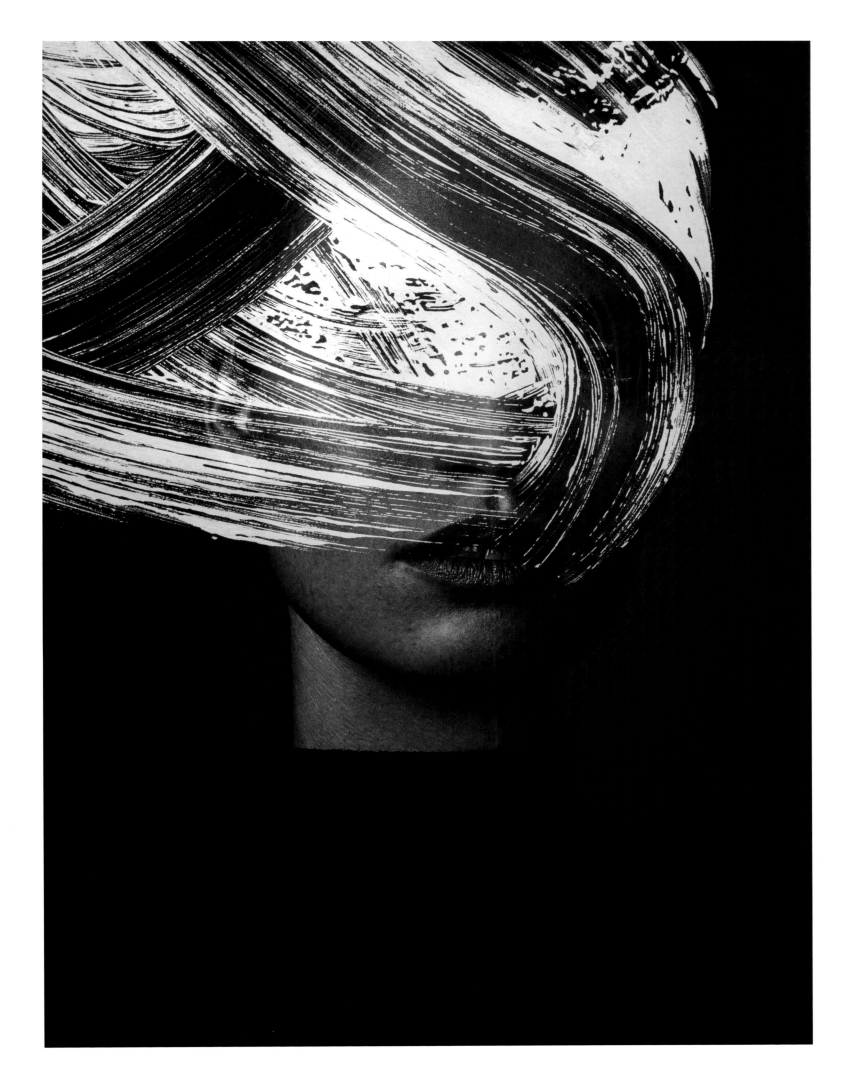

TINA BERNING & MICHELANGELO DI BATTISTA

Luisa, 2017

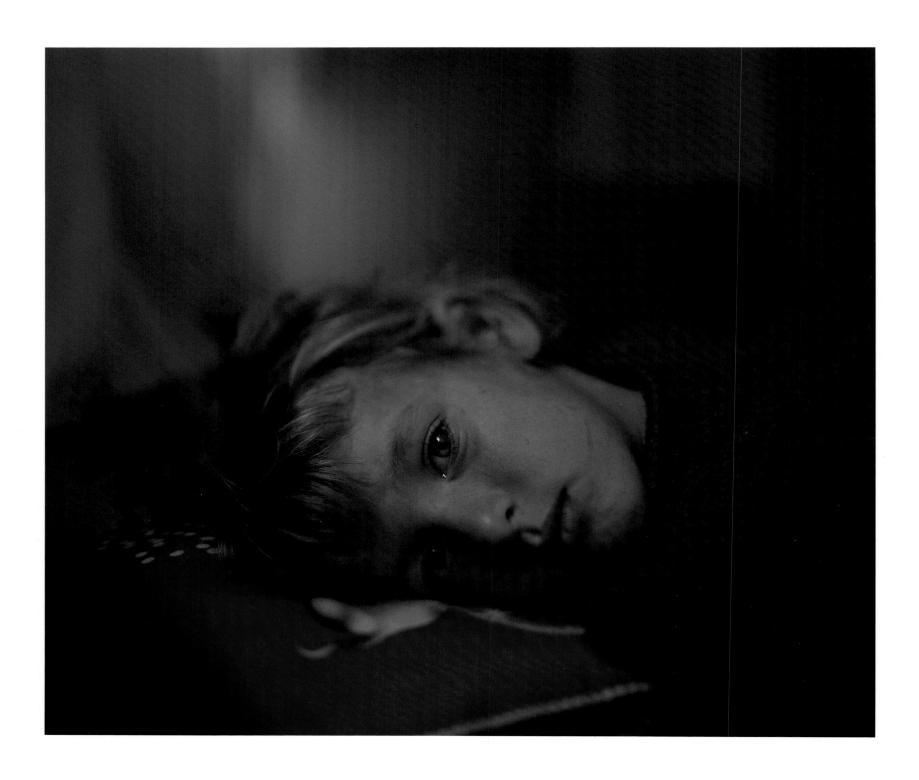

MAGNUS WENNMAN
Walaa, 5 Years, 2015

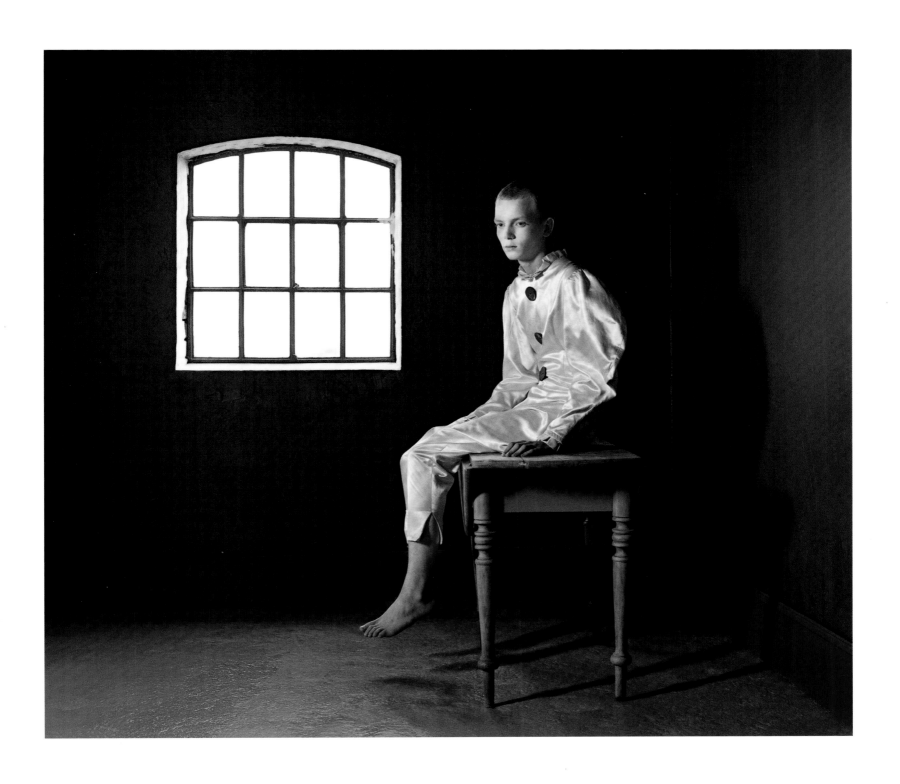

NYGÅRDS KARIN BENGTSSON

The Fool, 2013

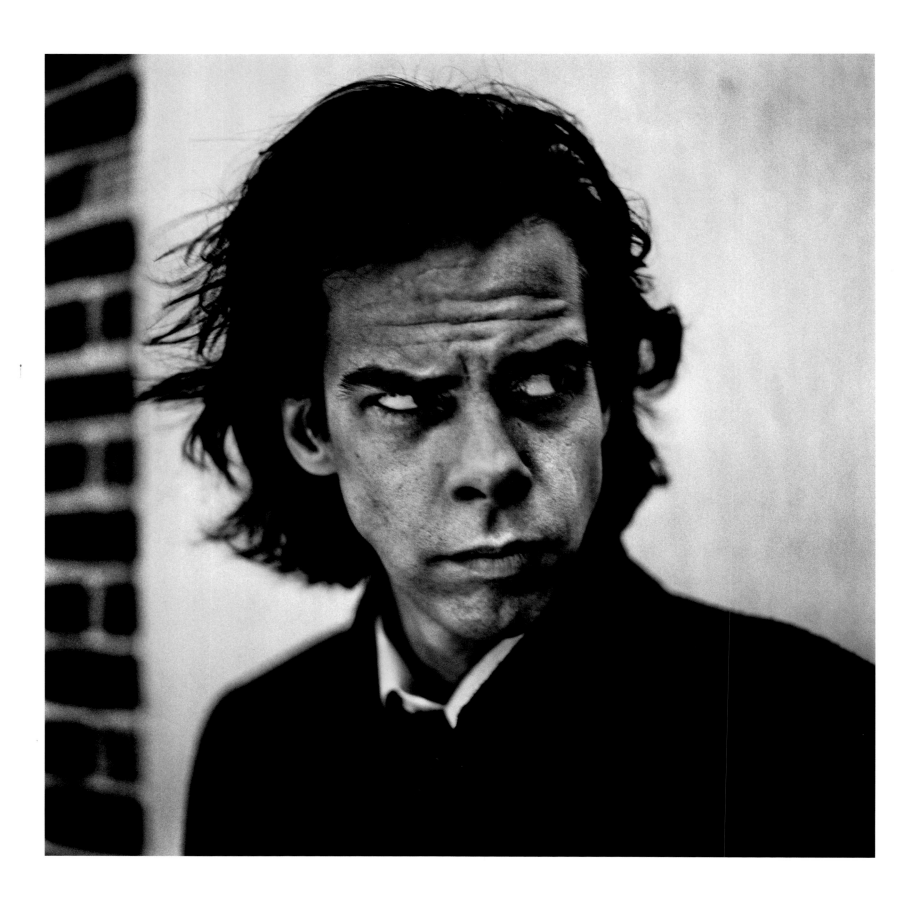

ANTON CORBIJN

Nick Cave, 1996

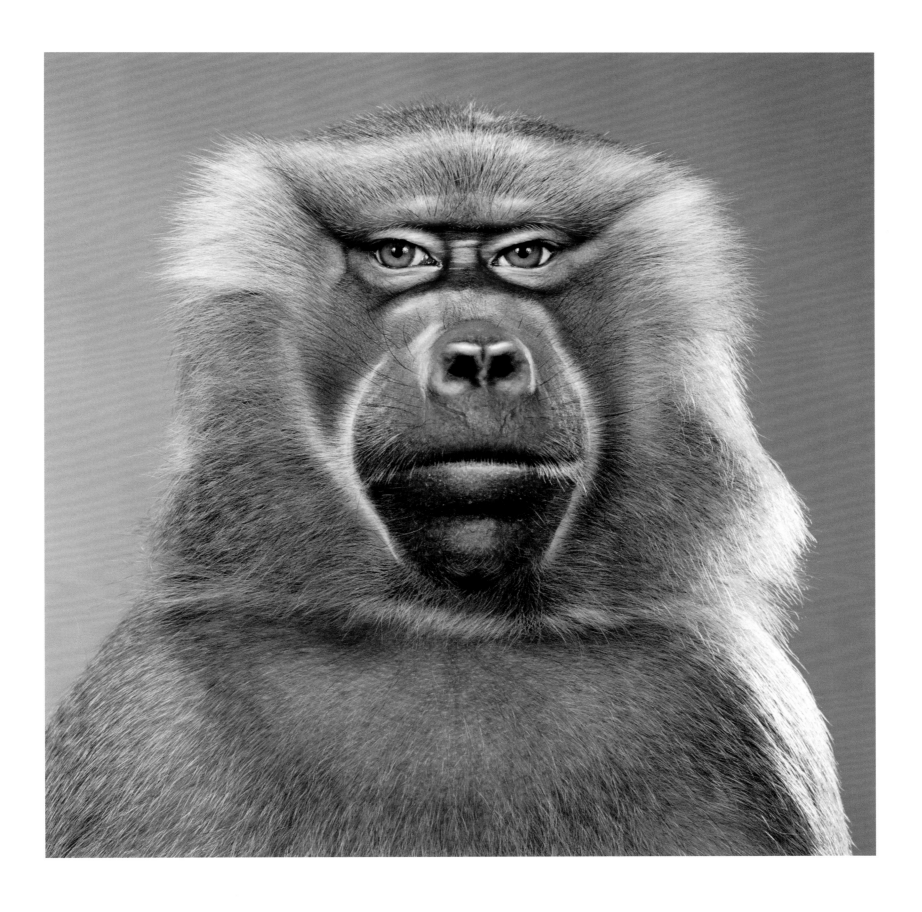

JILL GREENBERG

Georgia, 2003

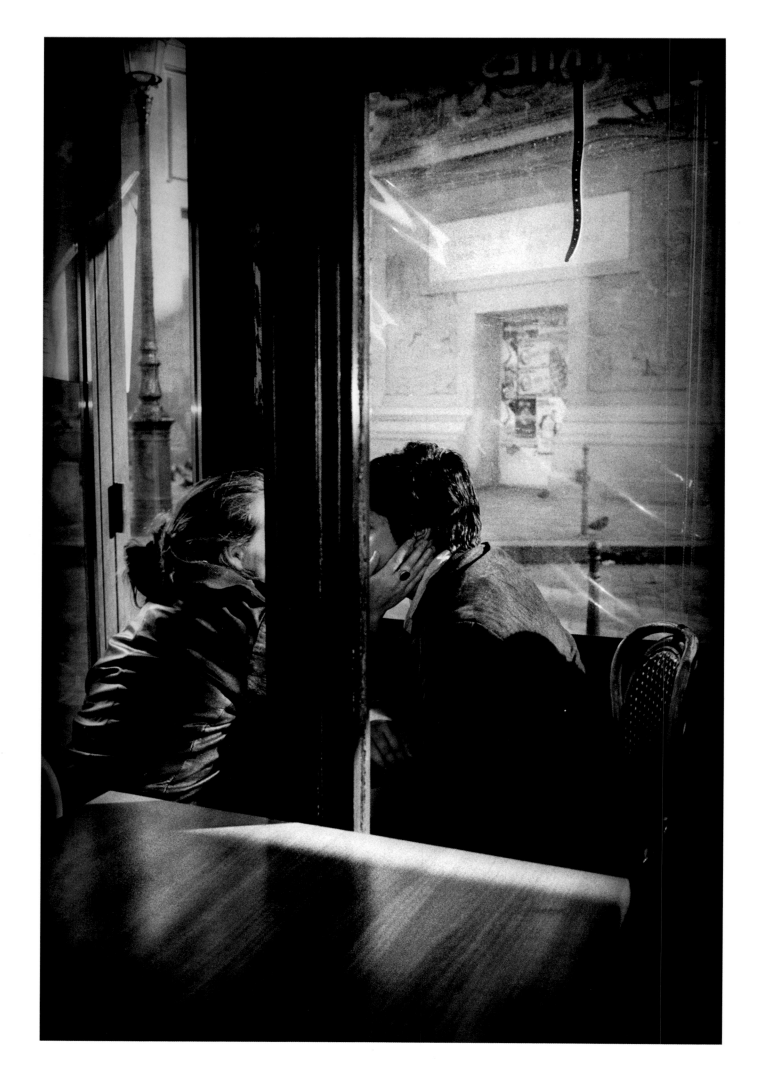

ANDERS PETERSEN
Paris, 2006

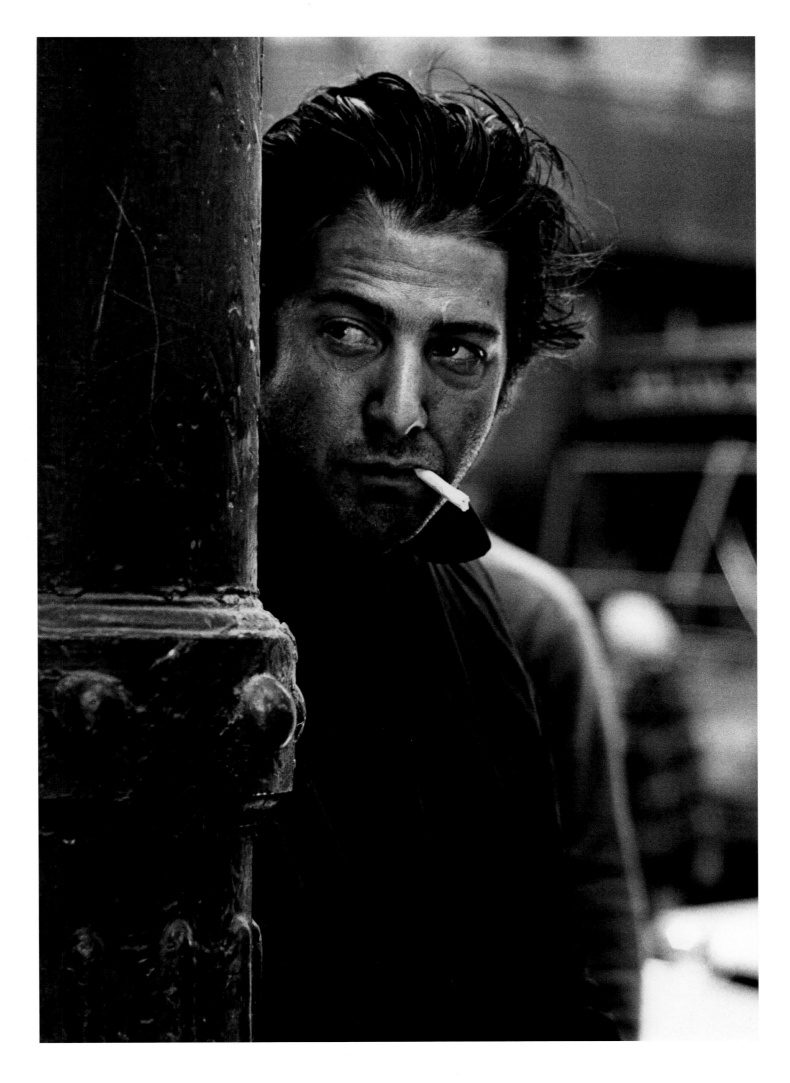

STEVE SCHAPIRO

Dustin Hoffman in *Midnight Cowboy*, New York, 1968

AITOR ORTIZ

Muros de Luz 011, 2005. Muros de Luz 021, 2005

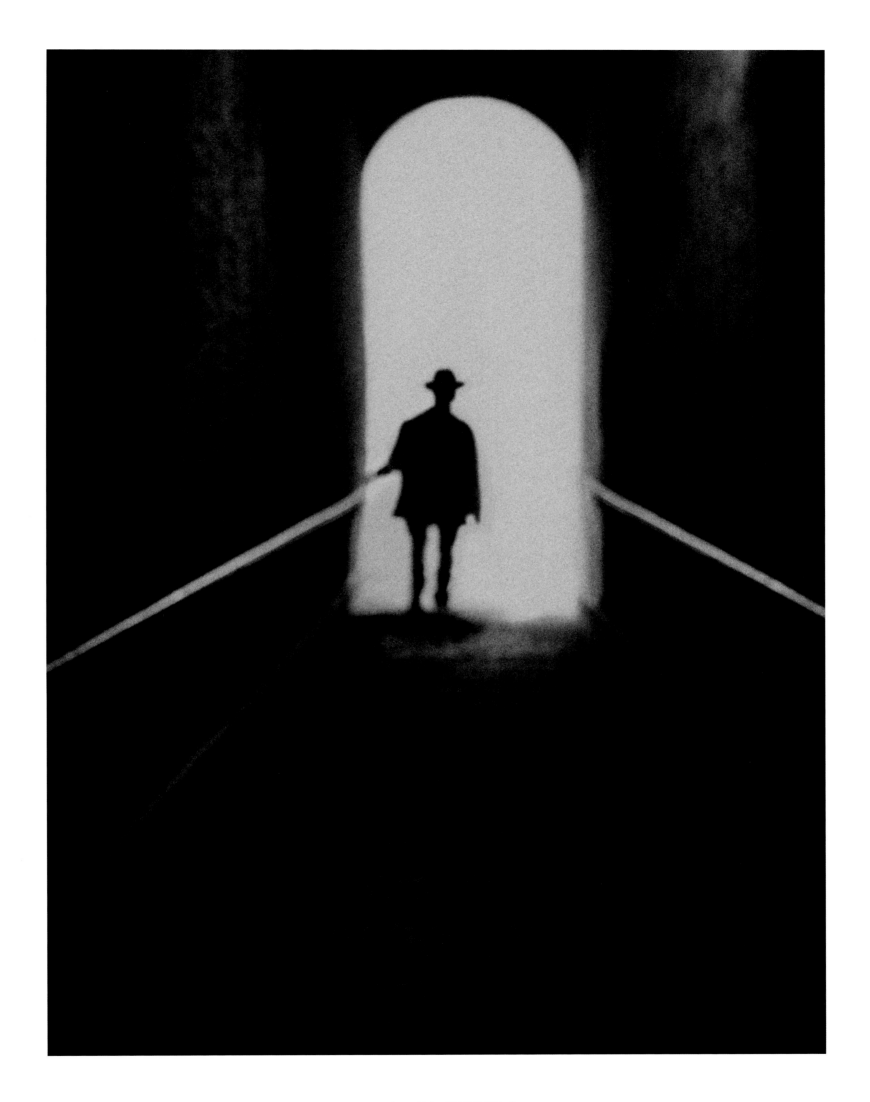

JOHAN STRINDBERG

City Walk

Index

Credits

ADAMS, BRYAN
Private Karl Hinett, February 2011 (p. 236)
© Bryan Adams

BALLEN, ROGER
Take Off, 2012 (p. 38). Sergeant F. de Bruin,
Department of Prisons Employee, Orange
Free State, 1992 (p. 105). Eugene on the Phone,
2000. Brian with Pet Pig, 1998. Show Off,
2000. Crawling Man, 2002 (p. 233)
© Courtesy of Roger Ballen

BENGTSSON, NYGÅRDS KARIN
Deer Room, 2009 (p. 66). Woman by White House,
2004 (p. 202). The Fool, 2013 (p. 241)
© Nygårds Karin Bengtsson
© VG Bild-Kunst, Bonn 2018

**BERNING, TINA & MICHELANGELO
DI BATTISTA**
Black Circle (Leila), 2017 (p. 87). Luisa, 2017 (p. 239)
© Tina Berning & Michelangelo di Battista/
Courtesy of CAMERA WORK

BLEASDALE, MARCUS
His Royal Highness the Honorable Cheif
Nyalugwe and Farmer, Zambia (p. 223)
© Marcus Bleasdale

BLOMQVIST, HELENA
Waterlilies, 2008 (p. 83). Group Portrait in Forest,
2011 (p. 161)
© Helena Blomqvist

BOGREN, MARTIN
Untitled (p. 96). Untitled (p. 126). Untitled (p. 193)
© Martin Bogren/Courtesy of Galerie VU'

BOURDIN, GUY
Vogue Paris, May 1970 (p. 55). Charles Jourdan, Fall
1977. Pentax Calendar, 1980 (p. 61). Guy Bourdin
Archives, 1978 (p. 75, 76). *Vogue* Paris, December–
January 1969–1970 (p. 144). Charles Jourdan,
Spring 1979 (p. 185)
© The Guy Bourdin Estate 2018/Courtesy of Art
and Commerce

BRANDT, NICK
Alleyway with Chimpanzee, 2014. Quarry with
Lion, 2014 (p. 129). Elephant Drinking,
Amboseli, 2007 (p. 214)
© Nick Brandt

BURTYNSKY, EDWARD
Highway No. 1, Intersection 105 & 110, Los Angeles,
California, USA, 2003 (p. 133). Oxford Tire Pile
No. 1, Westley, California, USA, 1999 (p. 134)
© Edward Burtynsky/Courtesy of Metivier Gallery,
Toronto/Flowers Gallery, London

CHEN, MAN
12 Chinese Colors, White, 2011 (p. 84). Actress Li
Bingbing, 2010 (p. 177). Miss Wan Studies Hard,
2011 (p. 180)
© Chen Man

CLARÉN, ANNA
From the series *Close to Home*, 2013 (p. 27). From the
series *Close to Home*, 2013 (p. 232)
© Anna Clarén

COOPER & GORFER
Ena with Eyes Shut, 2014 (p. 85). Amanda and the
Painted People, 2017 (p. 149). Holding Vanesa,
2017 (p. 234). Sofia and the Dog, 2017 (p. 238)
© Cooper & Gorfer

CORBIJN, ANTON
Damien Hirst, 2011 (p. 89). Nick Cave, 1996 (p. 242)
© Anton Corbijn

DE LANGE, MARGARET M.
From the book *Surrounded by No One*, 2010 (p. 72).
From the book *Surrounded by No One*, 2010 (p. 137).
From the book *Surrounded by No One*, 2009 (p. 228)
© Margaret M. De Lange

DEMARCHELIER, PATRICK
Nadja Auermann, New York, 1995 (p. 25).
Christy Turlington, New York, 1992 (p. 80).
Caroline Trentini, New York, 2015 (p. 121)
© Patrick Demarchelier

DUCHARME, VÉRONIQUE
Armour V, 2010 (p. 45). Armour I, 2010 (p. 92)
© Véronique Ducharme

ERWITT, ELLIOTT
USA, New York City, 1988 (p. 155)
© Elliott Erwitt

FARAGO, PETER & INGELA
 KLEMETZ FARAGO
Vicky – Path. Dorothea – Still (p. 109)
© Peter Farago & Ingela Klemetz Farago

FELLÄNDER, JACOB
Los Angeles/Hong Kong/Bombay, 2011.
 New York 53, 2011 (p. 188)
© Jacob Felländer

FRIBERG, MARIA
Painting Series, No. 2, 2011 (p. 33).
 Almost There 5, 2000 (p. 63)
© Maria Friberg/Courtesy of Galleri
 Andersson/Sandström
© VG Bild-Kunst, Bonn 2018

FULLERTON-BATTEN, JULIA
Mirror, 2008 (p. 79). Departure, 2012 (p. 152).
 The Waiting Game, 2013 (p. 174). Bike Accident,
 2005 (p. 183)
© Julia Fullerton-Batten

GREENBERG, JILL
Apocalypse Now, 2005 (p. 122)
© Jill Greenberg 2005 from the book End Times
 published by T.F. Editores in 2013.
Georgia, 2003 (p. 243)
© Jill Greenberg 2003 from the book Monkey Portraits
 published by Hachette Book Group in 2006.

GUSTAVSSON, KENNETH
Paris, 1968 (p. 194)
© Kenneth Gustavsson Estate

GYLLENHAMMAR, CHARLOTTE
Night 1, Night 6, Night 3, Night 5, Night 4,
 Night 2, 2014 (p. 112)
© Charlotte Gyllenhammar
© VG Bild-Kunst, Bonn 2018

HAASE, ESTHER
The Fearless Lola Walking the Lion King,
 Miami, November 1999 (p. 181)
© Esther Haase/Courtesy of CAMERA WORK

HANSEN, PAUL
 Escape to Nowhere, Rigonce, Slovenia, 2015.
 War by Proxy, Slavyansk, Ukraine, 2014 (p. 108).
 Stop Crying Mama, Qana, Lebanon, 2006 (p. 165)
© Paul Hansen

HETTA, JULIA
Untitled, 2011 (p. 143)
© Photography: Julia Hetta for Acne Paper.
 Credits: Model – Hedvig Palm, stylist
 – Hannes Hetta.

HUGO, PIETER
Escort Kama, Enugu, Nigeria, 2008 (p. 97).
 Gabazzini Zuo, Enugu, Nigeria, 2008
 (p. 111). Sophia Hugo on Table Mountain Road,
 Cape Town, 2011 (p. 117). Pieter and Maryna
 Vermeulen with Timana Phosiwa, 2006 (p. 205).
 Abdullahi Mohammed with Mainasara, Ogere-
 Remo, Nigeria, 2007 (p. 208)
© Pieter Hugo

INEZ & VINOODH
 See VAN LAMSWEERDE, INEZ &
 VINOODH MATADIN

JOHANSSON, ERIK
Soundscapes, 2015 (p. 218)
© www.erikjohanssonphoto.com

KOWSKI, LU
Untitled (p. 74). Untitled (p. 94). Untitled (p. 171)
© Lu Kowski

LACHAPELLE, DAVID
Sarah, 2007 (p. 35). A New World, 2017. Gas am pm,
 2012 (p. 62). Icarus, 2012 (p. 135). Milk Maidens,
 1996 (p. 139, 140). Death by Hamburger, 2001
 (p. 154). Uma Thurman: Gossip, 1997 (p. 176).
 Once in the Garden (1), 2014 (p. 187)
© David LaChapelle/Courtesy of Fred Torres
 Collaborations, New York

LIU, BOLIN
Hiding in the City No. 17, Civilian and Policeman
 No. 2, 2006. Hiding in the City No. 26, In Front
 of the Red Flag, 2006 (p. 54)
© Liu Bolin

MACDONALD, MONIKA
Untitled, from the series In Absence, 2015.
 Untitled, from the series In Absence, 2015 (p. 40).
 Untitled, from the series In Absence, 2015 (p. 73).
 Untitled, from the series In Absence, 2015 (p. 119).
 Untitled, from the series In Absence, 2015 (p. 124)
© Monika Macdonald

MAGNUSSON, DAVID
Will & Nicole Roosma, Tucson, Arizona, 2011
 (p. 131). Grace & Gary Kruse, Black Forest,
 Colorado, 2011 (p. 211)
© David Magnusson

MAKOS, CHRISTOPHER
Altered Image, Andy with Black Hair, Holding
 a Mirror, New York, 1981 (p. 100)
© Christopher Makos

MANN, SALLY
Untitled, 1971 (p. 21). Gelatin silver print,
 16 1/4×13 3/4 inches. Sherry and Granny,
 1983–1985 (p. 37). Gelatin silver print,
 8×10 inches. At Warm Springs, 1991 (p. 81).
 Gelatin silver print, 10×8 inches and
 24×20 inches. Was Ever Love, 2009 (p. 128).
 Gelatin silver print, 15×13 1/2 inches
© Sally Mann/Courtesy of Gagosian Gallery

MAPPLETHORPE, ROBERT
Joe/Rubberman, 1978 (p. 26). Ajitto, 1981 (p. 98).
 Ken Moody and Robert Sherman, 1984 (p. 190)
© Robert Mapplethorpe Foundation. Used by
 permission.

MERCADIER, CORINNE
St. Trophime, La Suite d'Arles, 2003 (p. 127).
 Une fois et pas plus 43, 2002 (p. 150).
 Une fois et pas plus 26, 2000 (p. 192)
© Corinne Mercadier. Represented by the
 gallery Les Filles du Calvaire, Paris.

© 2018 Fotografiska International. All rights reserved.
© 2018 teNeues Media GmbH & Co. KG, Kempen

CURATOR AND CREATIVE DIRECTOR: Johan Lindskog
PROJECT MANAGER: Susanna Wendt
GRAPHIC DESIGNER: Josefin Gahmberg, Bäck
PROJECT ASSISTANT: Madeleine Halbauer
EXECUTIVE PRODUCER: Jan Broman
TECHNICAL CONSULTANT: Johan Stålhäll
EDITOR: Johan Lindskog
TEXTS: Pauline Benthede, Jan Broman, Per Broman,
Catherine Edelman, Johan Lindskog, Vee Speers,
Johan Vikner, Albert Watson
TRANSLATIONS: Olsson Diamond Text
PROOFREADING: Victorine Lamothe-Maurin
EDITORIAL COORDINATION: Arndt Jasper, Nadine Weinhold
PRODUCTION: Nele Jansen
COLOR SEPARATION: Jens Grundei

Published by teNeues Publishing Group

teNeues Media GmbH & Co. KG
Am Selder 37, 47906 Kempen, Germany
Phone: +49-(0)2152-916-0
Fax: +49-(0)2152-916-111
e-mail: books@teneues.com

Press department: Andrea Rehn
Phone: +49-(0)2152-916-202
e-mail: arehn@teneues.com

teNeues Media GmbH & Co. KG
Munich Office
Pilotystraße 4, 80538 Munich, Germany
Phone: +49-(0)89-443-8889-62
e-mail: bkellner@teneues.com

teNeues Media GmbH & Co. KG
Berlin Office
Kohlfurter Straße 41–43, 10999 Berlin, Germany
Phone: +49-(0)30-4195-3526-23
e-mail: ajasper@teneues.com

teNeues Publishing Company
350 7th Avenue, Suite 301, New York, NY 10001, USA
Phone: +1-212-627-9090
Fax: +1-212-627-9511

teNeues Publishing UK Ltd.
12 Ferndene Road, London SE24 0AQ, UK
Phone: +44-(0)20-3542-8997

teNeues France S.A.R.L.
39, rue des Billets, 18250 Henrichemont, France
Phone: +33-(0)2-4826-9348
Fax: +33-(0)1-7072-3482

www.teneues.com

ISBN 978-3-96171-113-0
Library of Congress Number: 2017958260
Printed in Italy

teNeues Publishing Group
Kempen
Berlin
London
Munich
New York
Paris

teNeues